CREATIVE SPIRITUALITY

CREATIVE SPIRITUALITY

The Way of the Artist

ROBERT WUTHNOW

UNIVERSITY OF CALIFORNIA PRESS
Berkeley Los Angeles London

University of California Press
Berkeley and Los Angeles, California

University of California Press, Ltd.
London, England

© 2001 by the Regents of the University of California

Grateful acknowledgment is made for permission to quote from *Opus Posthumous* by Wallace Stevens. Copyright © 1957 by Elise Stevens and Holly Stevens. Reprinted by permission of Alfred A. Knopf, a Division of Random House Inc. Thanks also to the University of Akron Press for permission to quote from Jon Davis's *Scrimmage of Appetite*.

Library of Congress Cataloging-in-Publication Data

Wuthnow, Robert.
　Creative spirituality : the way of the artist / Robert Wuthnow.
　　p.　cm.
　Includes bibliographical references and index.
　ISBN 978-0-520-23916-6 (pb: alk paper)
　　1. Spiritual biography—United States.　2. Artists—Religious life—United States.　3. Arts and religion—United States.
　I. Title.
　BL72.w88 2001
　291.1'75 — dc21　　00-046704

Manufactured in the United States of America

10　09　08

10　9　8　7　6　5　4　3

The paper used in this publication meets the minimum requirements of ANSI/NISO z39.48-1992 (R 1997) (*Permanence of Paper*). ♾

CONTENTS

PREFACE

WHEN I WAS A CHILD, I lived in a world that many would have thought devoid of the arts. The dry Kansas prairie was an inhospitable environment for painters and poets. Yet, to an extraordinary degree, my childhood was filled with dazzling opportunities to experience the arts. From the heart-pounding hymns I learned in Sunday school to the wonder of towering cumulus clouds in an azure sky on a hot August afternoon, from the pleasures of attending community concerts featuring itinerant performers from New York and Chicago to the surprise of finding boxes of paintings in the attic—left there by a woman who had become busy being my mother—the arts were nearer than I sometimes imagined.

The world of spirituality could not so easily be overlooked. In my prairie hometown, people flocked to churches on weekends and evenings. Bibles and catechisms were everywhere. The words were to be studied and understood, to be framed in correct doctrinal interpretations, and to be applied in diligent moral practices. It was not until my father's death that I began to appreciate the connection between the arts and spirituality. Sitting in my dormitory room as a college freshman, trying to absorb the shocking news that he had died of a massive heart

attack, I turned instinctively to music and poetry for their power to heal. They were carriers of the Word as much as the doctrines themselves.

I came gradually to the idea of writing a book about spirituality and the arts. As a graduate student at Berkeley during the turmoil of the late 1960s, I was encouraged to think about alternatives to received ways of pursuing knowledge. My training in sociology ranged from learning to interpret multiple regression models to hearing lectures about Blake. While writing my dissertation on new religious movements, I encountered many people who were exploring spirituality through dance, drumming, poetry readings, literature, and avant-garde films. I have retained an interest in these creative expressions of spirituality.

In the early 1990s I began a series of investigations into questions about the changing moral and spiritual logics of contemporary life. In lengthy personal interviews I listened as people articulated their aspirations for themselves and their families. From time to time I ran across someone who was deeply interested in bringing spirituality to bear on these aspirations. As the interviews accumulated, I realized that some of the most interesting and articulate of these people were artists.

When time permitted, I went back over these interviews, took notes, listened for common themes, and tried to think of better questions. I read avidly, visited galleries and exhibits, attended lectures, and talked with colleagues who knew much more about the arts than I did. During a visit to the Grand Canyon in 1995 I was able to clear enough mental space from other projects to pull together some preliminary ideas. At a picnic table overlooking the North Rim, I entered onto my laptop some tentative sentences that were to become an outline of the themes pursued here.

Several years passed before I was able to devote attention to the project. Meanwhile, I read articles, pieced together a bibliography, did pilot interviews, and visited places where I could talk with artists and writers. Through a research grant it eventually became possible to interview one hundred artists candidly about their work, their lives, their spiritual jour-

neys, and their aspirations and hopes. I have tried to strike a balance be-
tween letting them tell their stories and offering my own interpretations.

The book is written with three audiences in mind. One is the com-
munity of artists, to which I add the parallel community of amateur
artists as well as students and patrons of the arts. For these readers, I
offer material for self-reflection, insight, and comparison; I suspect
many within this broadly defined community of artists will find aspects
of themselves in the stories I report. A wider audience consists of read-
ers who are interested in the dilemmas of existence in contemporary so-
ciety and may agree that artists' spiritual experiences have something to
teach us about these dilemmas. For such readers, I hope it will be evi-
dent that there is a bit of the artist in everyone. And finally, I have tried
to address the concerns of people who are especially interested in spiri-
tuality, either as religious professionals or as interested seekers in their
own ways. Although I am aware of the dangers of trying to learn too
much from the spiritual struggles of artists, I am also persuaded that
artists offer insights into the ineffable aspects of the human condition.

I am deeply grateful to the artists, writers, and musicians who gave so
generously of their time. These busy professionals were extraordinarily
generous in other ways as well. Nearly all supplied copies of their ré-
sumés, most gave guided tours of their studios or work spaces, and many
offered newspaper clippings and reviews as well as reprints of their
paintings, CDs, videos, and chapbooks. A few gave private perform-
ances, extended invitations to concerts and book signings, and edited
transcripts of their interviews.

I owe special thanks to my research assistant, Natalie Searl. She co-
ordinated the field research and did much of the work in identifying,
contacting, and interviewing respondents, as well as overseeing the
transcription of interviews. Karen Myers and Sylvia Kundratz assisted
with some of the interviewing. Sandy Kunz helped assemble biblio-
graphic materials as background for the book.

The research was supported by a generous grant from the Lilly Endowment. Craig Dykstra was a valuable source of inspiration and intellectual guidance throughout the project. Sister Jeanne Knoerle, Chris Coble, and Dorothy Bass also provided instructive comments and advice.

As with all such endeavors, this project benefited from numerous opportunities for intellectual discussion, reflection, and repast. Members of the Religion and Culture Workshop contributed more than they often realized to the development of my ideas. Opportunities to learn from Karen Cerulo, Tim Dowd, Paul DiMaggio, Michèle Lamont, Wendy Griswold, Richard Peterson, and Ann Swidler were also valuable.

My greatest debt is to my intellectual and spiritual companion, Sara Wuthnow, and to my dear children, Robyn, Brooke, and Joel.

INTRODUCTION

BEHIND A RAMBLING BROWN-SHINGLED house in Boulder, Colorado, a thick hedge of Norwegian pines nearly conceals a sixteen-by-sixteen-foot work shed. Half of the space is furnished with a cot, a plain wooden table, an electric skillet, a washbasin, and a portable toilet. On the other side of a makeshift partition is a workbench, a stool, a lathe, some rough-cut logs, and a large pile of wood shavings. A young artist bends over the lathe.

The year is 1977; the artist, David Ellsworth. For more than three years he has been supporting himself by making wooden salt and pepper shakers. He has turned out nearly five thousand sets, manufacturing fifty at a time. This work occupies him from sunrise to late afternoon. Each evening, however, he stops, carefully places a plastic sheet over the salt and pepper sets, and then takes up a curved tool and experiments with a new artform, creating wooden pots on his lathe. One afternoon he receives a check in the mail. To his surprise, his pots have started to sell.

Today David Ellsworth is one of the nation's most acclaimed wood sculptors.[1] The wooden pots he began creating more than twenty years ago in Colorado have become his signature. They are extraordinarily delicate, with thin, satiny walls that rival those of an exquisite ceramic vase. Ranging from four to twenty inches in diameter, some are hemi-

spheric cups with burnished edges and brightly polished interiors; others are perfect spheres, mysteriously hollowed through minuscule openings. They exude what one critic describes as "a serenity, a natural grace and an elegant simplicity," providing what another writer summarizes as "a quiet statement about the correlation of nature and craft."[2]

David Ellsworth is one of the thousands of artists, writers, and musicians who in recent years have been struggling to express their understandings and experiences of the sacred in their work, and who in turn are creating new ways of thinking about and practicing spirituality. Some have been working quietly within religious traditions, keeping alive the skills of iconography, creating Christian music, or depicting themes rooted in Jewish experience. Others are pushing the edges of religious traditions by asking questions about language and representation, incorporating narratives of brokenness and redemption into their work, and confronting the ambiguities of teachings about God.

It is through their life stories as much as through the objects they produce that artists' insights about the life of the spirit come into view. Their position in society, as has often been true in the past, is not enviable. Although a few make fortunes, most earn only marginal incomes. Many have been drawn to artistic careers by personal trauma or by extreme disruptions in their families and communities. Such experiences necessitate personal reflection and often result in new perspectives on life.

As with most artists, David Ellsworth's life story illustrates the gifts of critical self-reflection that seem so often to connect artists' creative work with their interest in spirituality. His lanky, angular features contrast sharply with the rounded shapes that emerge from his lathe. Seated in the loft of his present-day studio in northeastern Pennsylvania, he chooses his words carefully: "I think of myself fundamentally as a maker, more than an artist or a craftsman. I turn wood on the lathe—vessels, bowls, pots. The objects that I make are hollow forms, very thin-walled, levitative, somewhat mysterious in their construction."

This emphasis on mystery occurs repeatedly in artists' accounts of their work. It arises from a principled refusal to explain their work and

thus to restrict the variety of meanings it may have for different audiences. But mystery is also one of the ways in which artists emphasize the impossibility of fully understanding God.

From the beginning, Ellsworth's art has been closely connected to his deeply personal sense of the spiritual aspects of life. His pots are neither traditional shapes nor free-form. He denies that they have any utilitarian value. Indeed, they cannot easily be defined. This is the essence that he is most intent on expressing. "Without a definition," he explains, "we're left with wonderment and in some cases with a sense of loss. When we do not have a language about an object, we reveal ourselves very quickly in our emotional response to that object. It was that emotional response as an artist, as a creative person, that I was most interested in."

There is often a close connection between an emphasis like this in artistic work and the way in which an artist thinks about the meaning of life. During those long formative months in Colorado, Ellsworth gradually realized how much his own life was without definition. Although the daily routine provided him with structure, it did not give meaning to his existence. Well educated in the fine arts but unable to find steady employment, he had recently divorced and was largely without friends, alienated. The divorce was particularly painful. "I began to question everything," he recalls. "I was disappointed in myself. I distrusted myself and I distrusted other people." Working creatively with wood provided a way to express his deep emotion.

Being without definition is the key to Ellsworth's understanding of spirituality: "I believe in God, in a higher order that is above the human species. We are not at the top of the chain. There's something bigger than us. But it cannot be defined. If we could quantify it, identify it, catalog it, it would lose its value. It would cease to be what it is." His sense of what it means to be spiritual is so encompassing that he has difficulty describing its exact place in his life: "I'm not certain I can spell it out. I don't get up in the morning and say, 'Well, how spiritual can I be today?' When I am done making an object, I give myself as *much* time as I possibly can in order to understand the spiritual connection between

me and it. Why did it come out? Where has it come from? Where is it going to lead? What influence is it going to have? And if I don't like it, can I feel free to smash it and get it out of my life and experience the smashing so I can go on?" After a moment he adds, "Spirituality is my work. The two are inseparable. When I'm doing it, I'm not thinking about it. There is a connectedness with it that is immediate and direct. I'm like a pianist. I'm not concerned about the technique as I perform. So working at the lathe is similar. It is an avenue through which spirituality can express itself."

If there is a single key to artists' perspectives on the spiritual, it is this: spirituality, like art, must be practiced to be perfected. The way of the artist involves doing, rather than only believing in the possibility of doing. It requires training, discipline, and a considerable investment of oneself.

As a child, David Ellsworth was not reared to believe firmly in the teachings of any single religious tradition. His parents were academics who put in nominal appearances at an Episcopal church but gradually found its services less compelling than their own explorations. His ideas about spirituality took form through college classes in comparative religion. For several years Ellsworth read avidly, gaining growing respect for the writers of the Bible and for the words of Jesus, Muhammad, and the Buddha, but he could not bring himself to affiliate with any congregation. He came increasingly to believe that the truths expressed in religious writings point toward something that is mysterious and ineffable. It is this mystery that he tries to evoke in his art.

"I have to put things together in my own way, move them backward and forward, mix them around," he indicates. "For some people, there is a meeting of the minds, a gathering together, 'in house' as we say, almost like a church. But I'm the one walking around it in the hills. I'm feeling the energy that's coming out of that house. I'm not disconnected from those people. I don't feel alone. And yet I also don't want to conform to their rhythms and philosophies. I think they feel my presence, too. They know I'm out there."

Creative people like David Ellsworth frequently occupy marginal positions in our culture, playing the role of the proverbial lone wolf, the alienated nonconformist, the free spirit. They prefer to do things their own way and sometimes feel genuinely uncomfortable in crowds. Yet they are, as Ellsworth says, a presence in the culture, reacting to it, contributing to its beauty, and enriching the lives of those with whom they come in contact. Ellsworth's exhibited works, not to mention the classes he teaches and the apprentices he mentors, provide lessons about life as well as about art. Like most artists he has been exposed to the teachings of organized religion and has had to search for answers to questions about the meaning and purpose of life. His views about the ineffability of spirituality are widely shared, both among artists and in the public at large. Many Americans would agree that there is something deeply spiritual in what he is trying to express through his art.

Artists and Spirituality

Art critics and reviewers of fiction, poetry, and music have come increasingly to recognize the spiritual contributions of contemporary artists. Even some religious leaders acknowledge quietly that growing segments of the public look to artists for insights about the deeper puzzles of life. Yet this contribution remains poorly understood. References to spirituality in art and music columns are frustratingly vague. Unelaborated assertions such as "this is a deeply spiritual recording" or "the artist sought to convey a spiritual vision" are not atypical. Other depictions too easily pigeonhole or sensationalize the spiritualities of particular artists: it is possible to read in tabloid newspapers about artists who exemplify strange beliefs in the occult or dabble in esoteric religious practices, but it is harder to gain insight into the lives of people such as David Ellsworth who have long been engaged in serious efforts to deepen and to express their understandings of spirituality.

Filtered through the lens of hastily written journalistic reviews, popular images of artists' spirituality are nearly always misleading. One

common image emphasizes entertainers who earn high salaries and lead dissolute lives and suggests that there is little of substance beneath the glamour. In this scenario, artists are depicted as lost souls struggling with substance abuse or greedily pursuing hedonistic pleasures, rather than showing any serious interest in the spiritual life. A different image highlights artists' participation in unconventional spiritual practices. In this view, artists are described as more confused, shallow, gullible, or muddle-headed than virtually anyone else. At worst, artists' spirituality is reduced to the commercial exploits of pop-singer Madonna or the cultic followings of the Grateful Dead; at best, it is sentimentalized in stories about esoteric spiritual quests and wild-eyed beliefs.

None of these images provides an adequate description of the ways in which contemporary artists understand and practice the relationship between their spirituality and their creative work. The popular images are driven too much by the mass media and the entertainment industry. They focus on glamorous international celebrities but fail to consider the middle-range artists whose influence is local, regional, or more specialized, affecting someone who visits an exhibit or attends a workshop. They also miss the fullness of artists' own insights about the nature of life and of God, what they have learned through years of practicing their art, and how art itself becomes an expression of their spirituality.[3]

Learning about how contemporary artists practice their spirituality is richly rewarding for anyone interested in the changing ways in which Americans are searching for the sacred. Many artists have struggled deeply with who they are and with questions about what is important in life. Personal trauma or family turmoil have jostled some artists to think hard about pain. David Ellsworth's anguish during the year he was recovering from his divorce is just one example. A folk singer tells of her estranged existence among illegal immigrants when she could not afford to live anywhere else. A wood carver describes how polio imprinted his development. A painter reveals the connection between being abused and learning to express herself through art. As they sing or carve or paint, these artists turn frequently to themes of brokenness and recov-

ery, pain and redemption, personal courage and transcendent healing. Their insights resonate with the struggles many Americans have faced in recent years with disrupted marriages, job loss, or addictions.

To a striking degree, contemporary artists speak more comfortably about spirituality than about organized religion. As David Ellsworth says, they are the sojourners who wander in the hills rather than the settlers who live easily in the valley. Spirituality seems more authentic to them because they have had to create their own ways of expressing it, whereas religion connotes the teachings of preachers and priests who may have never seriously questioned the tenets of their faith. In this respect, artists are the outsiders still capable of raising questions silenced by civilization. Living in the hills gives them a critical perspective on the settlement below. Yet, in another respect, artists exemplify an attitude toward the established dogmas of institutional religion that now characterizes many Americans. Research on the religious practices of the larger public shows that spiritual seeking often takes precedence over spiritual dwelling. Seekers borrow ideas from many traditions rather than settling comfortably into any one tradition. The typical seeker picks up the latest bestseller about spirituality, reads today's horoscope, talks to a friend raised in a different tradition, occasionally attends a church or synagogue, and periodically goes to workshops or support groups.[4] Younger Americans are especially likely to fit this profile. The eclectic spiritual practices of some artists are attractive to Americans who experiment with one religious idea after another because they have no compelling reasons to settle into a single tradition.

Artists' Lives

The social circumstances that encourage people to be spiritual seekers come into sharp relief in the lives of artists. Many were reared by parents who moved frequently from town to town or from state to state. For other artists, their parents were often busy or traveled or were emotionally distant; some were abusive, many were divorced, and many ex-

pressed doubts about the teachings of religious organizations. Artists come from a surprisingly wide variety of socioeconomic backgrounds: they are by no means the children of a privileged upper middle class. The decision to become an artist is often a costly one; many artists leave home at an early age, do not finish college (or spend long years gaining advanced education), and struggle like David Ellsworth to find the time to pursue their artistic interests. Migrating from community to community and from one relationship to another is not uncommon. All but the most successful remain heavily dependent on the consumer market, playing gigs to entertain coffee drinkers or exhibiting their wares at flea markets and craft shows. In these respects, the buffeting many artists experience is similar to the unsettled lives that many Americans lead, only more intense.

A close look at artists' spiritual practices serves the additional purpose of sorting through the current confusion about broad developments in American spirituality. The phrase "New Age" is a popular way of describing these developments. But its meaning is often ambiguous, ranging from any practice that falls outside the purview of conservative Christianity or Judaism, to beliefs in astrology, magic, or reincarnation. An artist such as David Ellsworth could be associated with New Age spirituality. He does not attend formal religious services, and he pieces together his views of spirituality from many sources. Another artist interviewed for this book believes herself to be a conduit for the teachings of angels and spirit guides. Several participate in Native American rituals, one is a wiccan, another believes in UFOs. But, despite the overlaps, artists' spirituality should not be dismissed as simply New Age. Their ideas and practices are quite diverse. If patterns can be found, they are best explained in terms of artists' religious upbringing, the crises they have faced, and the spiritual practices in which they engage, not in labels about some ill-defined spiritual movement.

Contrary to the view that they are simply dabbling in shallow spiritual practices, many artists design spaces that permit them to work creatively and in a way that resembles meditation. Their best work em-

anates from trying to capture some partly understood mood or experi-ence. Creativity requires drawing connections among aspects of artists' experience that have previously remained separate. Ideas about spiritual connectedness and spiritual wholeness acquire special meaning in these contexts. Indeed, one of the important contributions of artists in any pe-riod is creating narratives and images of wholeness in the face of unde-niable brokenness.

Contemporary artists follow a tradition of intellectual nonconformity that has strong roots in American history. Like previous generations of amateur philosophers and religious dissenters, they question the re-ceived wisdom of their time. David Ellsworth prides himself on having questioned the sturdy Victorian style of wood-turning that dominated the field when he began working in it. Having been trained in ceramics, he was able to bring fresh insights to his work. He continues to be an iconoclast, shattering people's expectations about his pots, shattering the pots themselves when they fail to inspire him. The nonconformity that artists express in their work frequently characterizes their spirituality as well. They are sometimes at the leading edge of creative developments in the world of religion: challenging ideas of male deities through femi-nist art, encouraging a rethinking of liturgical practices through per-formance art, or demonstrating new ideas about the relationship of body and spirit, connecting visualization to healing. In this way, artists keep alive the nonconformity that has been so important in the history of American religion. It is not assuming too much to suggest that artists are sometimes revered because they give others the opportunity to say, "Yes, I also question the established doctrines and I, too, think the mysteries of life are too great to be captured fully in any religious community."

Yet the perfection of art always involves discipline, and the practice of art thus becomes a model for understanding spiritual discipline as well. David Ellsworth's years making salt and pepper sets are like the appren-ticeships that monks and other people of deep spiritual inclinations un-dergo. As he gradually perfected his skills as a wood sculptor, he was shaping himself, gaining self-understanding, and learning to be at peace

with himself. Many artists speak of their work as a form of meditation. For some, the sheer rhythm of the daily routine brings them closer to the essence of their being. Writing all morning or practicing for the next musical performance requires mental and emotional toughness. For others, art is so much an expression of who they are that its quality depends on introspection, prayer, reading, listening, or finding other ways to reflect about life. Many artists emphasize the importance of staying with a single routine in order to learn it well. For spiritual dabblers, the insight these artists provide is that persistence and hard work may still be the best way to attain spiritual growth.

It is for all these reasons that many Americans are now turning to artists for spiritual guidance. Public opinion polls give little indication of this turning, suggesting that people find inspiration only in popular television preachers or the pope or that they hold their local clergy as exemplars of the spiritual life. Yet in personal interviews people speak more candidly. They mention Maya Angelou or Toni Morrison as writers who inspire them to think more deeply about spirituality. When their lives become difficult, they turn more often to the music of Aretha Franklin or Jessye Norman than they do to theologians. Their spirits are uplifted as much by the concert on Saturday night as by the sermon on Sunday morning.

This is not to say that artists believe their approach to spirituality is better than other people's. Most artists, like most other Americans, are reluctant to impose their ideas about spirituality on others. They are for the most part private people who prefer to let their art speak for itself, rather than providing it with too much personal interpretation. Many are by training and personality disposed to think that spirituality should not be reduced too readily to doctrines or creeds.

Many artists have nevertheless focused a great deal of their attention on the trials and failures of contemporary life. Those who work to capture the beauty of nature frequently decry the ways in which the environment is being damaged. Others express strong views about the value

of families and social relationships—often because of relationships in their own lives that proved difficult. Most are keenly aware of the passage of time and voice concern about social problems that may endanger the future. As innovators, they pay attention to the ways in which new ideas, new technologies, and new circumstances are changing our lives. As practitioners of well-established traditions, they also value continuity with the past. As David Ellsworth says, "An artist of any salt will tell you that nothing is new, that it has all been done at some time by someone in some form prior to that."

Artists reveal clearly that any practice, whether spiritual or artistic, requires a balance of dedication and creativity. The secret is internalizing the rules so well that it becomes possible to move beyond them. In their spirituality, as in their art, few artists stay strictly within the bounds of convention. They improvise, believing themselves to be capable—indeed, regarding themselves as having a mandate—to create. They are dedicated to challenging the rules, not in the interest of self-expression alone, but for the purpose of pushing out the frontiers of human possibility. The way their spirituality and their art come together holds the key to a broader understanding of the creative life. They are the visionaries who challenge received opinions, the disciplined seekers who reveal the way of the artist.

1

LEARNING FROM ARTISTS

DAVID ELLSWORTH'S STUDIO serves in its quiet way as a place where ideas about spirituality take shape and are disseminated to others. He often has five apprentices working with him. As they learn his techniques of lathing and burnishing, they absorb his introspective philosophy about the deeper mysteries of life. Although it is possible to appreciate the beauty of his creations without understanding that they are an expression of his spirituality, people who know him realize the connection. He and his wife participate in a loosely knit community of artists that also includes several self-employed businesspeople, professionals, farmers, and neighbors who enjoy sharing what they have been learning from their reading and who support one another in their explorations of meditation or other personal religious practices. The questions that Ellsworth and his friends discuss are similar to those that artists in other locations have been raising in public ways, through installations, lyrics, and poems that deal explicitly with spirituality. How, they wonder, can we understand and relate to God given all the conflicting religious beliefs and the way all religious traditions tend to be skeptically regarded in the mass media and higher education? Their ques-

tioning arises from a personal desire to have a relationship with God or to experience the sacred. It emerges even more forcefully from personal issues that cause them to wonder about the meaning of their lives and to seek strength for the challenges that confront them.

Nancy Chinn is one painter who has been experimenting with new ways of incorporating her ideas about spirituality into her art. Her studio is located in Oakland, California, where spring comes early after the winter rain. Down the street the oleanders are in full bloom and in the distance, half shrouded in late morning fog, one tower of the Golden Gate bridge looms majestically. In many ways, it is also springtime in Chinn's personal life. Although she is in her late fifties, she bubbles with the excitement of someone who is just discovering herself. She speaks enthusiastically of her explorations in feminist spirituality, her teaching, and her art. The tiny, cream-colored, blue-trimmed bungalow in which she lives and works fairly teems with her creations.

Many of Nancy Chinn's watercolors focus on religious themes.[1] Some are abstractions inspired by the wisdom literature of the Hebrew Bible and are painted in muted pastel tones, while others represent distinctly religious images, such as stained glass windows, lilies, and angels. Her interest in these themes reflects a long spiritual pilgrimage, some aspects of which she is still struggling to understand. Although she lived with both parents as a child, she says she was effectively left to raise herself. Her father was a salesman whose work required him to travel extensively, as well as moving the family from state to state at random intervals. Her mother was clinically depressed, on medication much of the time and periodically institutionalized. As a child, Chinn attended whatever church happened to be within walking distance, finding friends and learning about God, but also feeling that she could not quite believe the way other people did.

During high school and college she continued to question and to seek companionship. She married young, devoted herself to raising three children, followed her husband from one town to another, and took an occasional art class. Before the youngest two children were through high

school, she was moving away from her husband intellectually and emo-
tionally. After they divorced, Chinn turned to her work as an artist and
to pursuing her interests in spirituality. Slowly, she started to feel that
she was coming alive, but the process has been filled with pain as well as
joy. She has expressed it in a series of paintings about wolves. One is a
garish image of a wolf split open, revealing its inside, with nails holding
down the skin. Another is a crucified wolf wearing a crown of thorns.
The one she cherishes most, though, is of a huge she-wolf, a four- by
six-foot painting that dominates her living room. "I can lean against her
and she protects me from behind," Chinn explains. "But as soon as I've
rested enough, she nips me and moves me on."

A different perspective on spirituality emerges from a Cuban restau-
rant in a rustic Pennsylvania river town where motorcycle gangs and as-
trology buffs congregate on weekends with antique hunters and the-
atergoers from New York City. At the back of the restaurant is a low
stage. A tall woman with curly blond hair and a billowing denim dress
tunes a Taylor jumbo maple guitar. Her name is Jennie Avila. Soon she
is joined by her singing partner of seven years, Amy Torchia. The two
folk singers accompany themselves with acoustic guitars, conga drums,
and Appalachian lap dulcimers.[2]

Tonight they perform a selection of original compositions, singing of
mermaids and water spirits, of loves lost, and of journeys taken. Several
songs focus on homelessness, domestic violence, and poverty. The music
is not simply entertaining; it evokes a deeper, reflective mood as well.
Avila tells the audience that a song about the richness of life was com-
posed for the recent funeral of her best friend in high school. Another
song lamenting a wounded (three-legged) deer was written by Torchia in
recognition of the ecological costs of suburban development. Still an-
other combines childhood memories of making snow angels with drum-
ming reminiscent of American Indian cadences. The audience's re-
sponse is electrifying. The performers' energy, the rhythm, and the lyrics
blend to achieve what Avila later describes as a "spiritual connection."

A related, but different, spiritual connection can be seen in the work

of Jamel Gaines, a choreographer and artistic director of the Creative
Outlet Dance Theater in Brooklyn. Since 1992 he has created liturgical
dance events at the five-thousand-member St. Paul Community Bap-
tist Church in Brooklyn for the Reverend Johnny Ray Youngblood.
"Youngblood's jazzy, eloquent sermons aren't the only reason thousands
flock to his three-hour services," a writer for the *Village Voice* observes.
"They also come for the rapturous gospel choir, and for the dancers who
whirl about the altar to the rhythm of African drums."[3]

Jamel Gaines is a strikingly handsome man of African, Italian, and
Native American ancestry. Seated in his living room, which has been
turned into a dance studio, he explains that he began dancing when he
was in elementary school and continued to be involved in performances
throughout high school. The oldest of six children in a working-class
family, he was encouraged to work hard and go to college. By the time
he graduated, he was a member of the Jubilation Dance Company and
for the next six years toured internationally, as well as performing in
Brooklyn and Off-Broadway. Gaines says that the group he founded,
Creative Outlet Dance Theater, is "a reflection of the community." It
stages productions that bring dancers, actors, vocalists, and visual artists
together, and it works with local schools and churches to provide train-
ing in the arts for children.

His work with Reverend Youngblood began inauspiciously as a men's
exercise class but quickly became what the *New York Daily News* de-
scribed as the only "formal, full-time dance ministry" in New York
City.[4] "We do theater as a means of ministering, healing, saving, em-
bracing, capturing, and teaching," Gaines explains. "Most people think,
'Oh, it's a church production. You're going to have kids standing around
singing, you know, "Silent Night" and so forth.' But we bring in sets and
strive for the highest professional level. It's like a Broadway production."
It has also been an opportunity for Gaines to develop his understanding
of the spiritual aspects of dance. At first, he remembers, there were crit-
icisms because people in the church associated dancing with immorality
and sensuality. But Gaines has become convinced that dancing can be an

act of praise. He is one of a growing number of dancers seeking to incorporate this form of praise into the worship services of their churches.

Yet another interpretation of spirituality can be seen in a small village south of Santa Fe, where a quiet man hides from the world as often as he can to think and write. Jon Davis's poetry speaks often of the tragedies of life and of the quest to make sense of these tragedies.[5] Much of it is autobiographical. Davis was four when his father deserted his mother and his three brothers. For a time he was sent to live with relatives. At one point his father, an alcoholic who succumbed periodically to fits of violence, kidnapped him and his brothers and threatened to kill them. His mother took him regularly to the Catholic church, hoping it would somehow provide comfort. Instead, it filled him with fear. "I found the whole thing terrifying," he recalls. The priests' stories of divine punishment gave him nightmares. He became more and more withdrawn, feeling secure only when he could escape into the dense Connecticut woods to be alone.

By the time he was in high school, Davis was writing nature journals as a way to communicate with himself. A seventh-grade teacher had exposed him to Ralph Waldo Emerson's idea of the poet as priest. He remembers being attracted by James Joyce's idea of epiphanal breakthroughs and of eventually turning to Martin Heidegger, whose work taught him that though the gods have fled it is still possible to explore the truth hidden beneath the surface appearances of ordinary life. For a number of years, Davis's poetry served mainly as his personal window into the deeper mysteries of life. He worked as a day laborer, digging trenches and laying foundations, went back to school in his late twenties, earned a Ph.D., and found himself still digging trenches while he searched for part-time employment on campus after campus. Now in his mid-forties, he considers himself lucky to have steady employment. His poetry has ripened over the years. The death of a brother in a motorcycle accident, his own divorce, living in so many different places, and having time to reflect on his upbringing—all have forced him to think deeply about spirituality. On many occasions, he still feels that the gods

have fled. But he also believes that the essence of spirituality is present in the mystery of life. Sometimes his poetry gives him a connection with that mystery.

Spirituality in the Arts

The artists' experiences just described are not isolated examples. Across the nation, evidence points conclusively to a resurgence of interest in spirituality, not only in the scattered quests of individual artists but also in the organized activities of galleries and concert halls, churches and museums, and professional associations. Artists' current interest in spirituality has been particularly evident in a number of prominent exhibitions. One was "Negotiating Rapture" at the Museum of Contemporary Art in Chicago, featuring work by Joseph Beuys, Lucio Fontana, Shirzeh Houshiary, Agnes Martin, Ad Reinhardt, and Bill Viola. Another was "Reaffirming Spirituality," sponsored by El Museo del Barrio in New York City as part of its twenty-fifth anniversary celebration and featuring more than three dozen prominent Latin American and Latino artists, including Pablo Yglesias, Miriam Hernández, Antonio Martorell, and Andres Serrano.[6]

Some of this interest in spirituality is rooted in efforts to embrace greater racial, ethnic, gender, and lifestyle diversity. As Susana Torruella Leval, the curator of "Reaffirming Spirituality," explains: "Many Latin American and Latino artists deplore the modern isolation from, and discomfort with, dimensions of experience that involve the spiritual, the sacred, the supernatural, and the magical. Thus an important part of their work involves recovering these spiritual traditions and values and restoring them to a place of familiarity and importance in contemporary life."[7] Feminist spirituality has also been influential. At Cleveland's "Inner Light" exhibition, feminist artists Nancy Azara, Heejung Kim, and Martha Posner displayed works that included representations of the maternal aspects of the divine and drew on traditional Christian and Buddhist themes. Diversity in contemporary art has also revived inter-

est in aboriginal, druid, and other pre-Christian forms of spirituality. At
the Dreamtime Gallery in Santa Fe one exhibition focused on the con-
nections between lost aboriginal worlds and psychic loss in the contem-
porary world.

Religious organizations also foster current connections between spir-
ituality and the arts. According to one national study, 38 percent of re-
ligious congregations sponsor some kind of choral singing (other than at
regular religious services), and 24 percent offer other performing arts
activities (such as dance, instrumental groups, or theater).[8] Another,
nonsystematic survey, comprising responses from approximately 300
congregations, revealed more than 2,200 instances of dance being used
in worship settings.[9]

Beyond the worship experience, congregations have become loca-
tions for a wide variety of spiritual expressions through the arts. At St.
Gregory's Episcopal Church in San Francisco, sixty mural-sized icons
commissioned over the past two decades include a flowing interpreta-
tion of the creation by a Maori artist, an Ethiopian calendar, and large
portraits of Malcolm X, Anne Frank, and John Muir. In Jackson, Missis-
sippi, several congregations have helped to launch the Ballet Magnificat,
a full-time professional Christian ballet company that gives more than a
hundred performances annually. At St. John's Lutheran Church in
Minneapolis, the Metropolitan Boys Choir, whose members practice
twice weekly in the church's facilities, has grown to the point that more
than a dozen separate ensembles are sent on national and international
tours each year.

Convents, monasteries, and retreat centers have become another
popular venue for workshops and exhibitions. Visitors at the Pendle Hill
Center near Philadelphia take classes in pottery-making that emphasize
the similarities between art and spiritual development or enroll in week-
end workshops on the spiritual aspects of Toni Morrison's novels. At the
Kirkridge Center in rural Pennsylvania, sizable gatherings sign up
months in advance to hear lectures by writer Madeleine L'Engle or par-
ticipate in workshops on sacred dance, while those at another site in

Pennsylvania, the Temenos Retreat Center, participate in seminars such as "The Creative Process as Spiritual Pathway."

Colleges and universities have been instrumental in encouraging interest in spirituality within the arts. Outside Boston, at Brandeis University's Rose Art Museum, the multimedia "God Project" attempts to engage students and visitors in issues of art and individual beliefs about spirituality.[10] At Wheaton College in Illinois, the Billy Graham Center Museum sponsors an annual "Sacred Arts All-Media Art Exhibit," based on a juried competition in each major category of the visual arts. At the Villanova University Gallery, events have included a jazz combo–led worship service, an exhibition of works by contemporary artists called "Celebrations of the Spirit," and an exhibition entitled "The Language of Art," co-sponsored with neighboring churches.

The mass media have also played an important role in popularizing the ways in which artists conceive of spirituality. One example is Bill Moyers's popular 1995 PBS series and best-selling book, *The Language of Life*, featuring poets Robert Hass, Daisy Zamora, Marilyn Chin, and others who have written about spirituality. Other examples include double–Grammy winner Kathy Mattea's album *Love Travels*, widely publicized as having been inspired by the singer's spiritual journey, and such motion pictures as Disney's *Lion King* and George Lucas's *Star Wars*, which contain lyrics and images that critics have associated with spirituality.

Seeking Guidance

Most Americans still look to the churches for their primary cues about spirituality, rather than seeking guidance from the arts. In national surveys approximately seven of ten Americans claim to be members of a church or synagogue.[11] Only 8 percent of the public indicate they have no religious *preference*, while 58 percent identify with Protestant denominations, 25 percent with Catholic churches, and the remainder divide themselves among such traditions as Greek or Russian Orthodoxy, Judaism, and Islam. The number who participate regularly at their

places of worship is harder to determine, but some studies indicate that between 35 and 40 percent of Americans may be present at religious services in any given week, while more skeptical appraisals suggest that only a quarter of the population attends.[12]

With some 340,000 congregations, the religious establishment is well positioned to shape the spiritual leanings of most Americans. Organized religion takes in approximately $57 billion annually from charitable contributions, amassing more than half of all individual contributions to nonprofit organizations, more than three times the amount donated to educational causes, and more than five times the sum given to health-related organizations.[13] This income, together with that from the sale of goods and services (such as fees for weddings and funerals, seminars, and music lessons), pays for the employment of approximately 371,000 full-time clergy.[14] In addition, each year volunteers contribute approximately $12 billion in time to religious organizations.[15]

Yet there has been a great deal of ferment in American religion during the past half century. The 1950s were in many ways a high-water mark in the strength of organized religion. Fueled by Cold War fears and nurtured by the child-rearing concerns of millions of young families, the nation's churches and synagogues boasted record attendance and membership rates. The civil rights movement and antiwar protests of the 1960s were reinforced by activist congregations and clergy. But the 1960s brought about cultural changes that undermined the authority of established religion as well. College students turned to other sources of inspiration, including social and political movements, science, psychology, humanistic philosophies, and Eastern religions. Despite a resurgence of evangelical and fundamentalist piety in the 1980s, the religious establishment has continued to be a venue for contested truths more than a place of quiet consensus. Theologians debate the very possibility of creedal truth, while feminist spirituality, New Age practices, reports of near-death experiences, books and television programs about angels, and psychological treatises on the inner self dominate popular discussions of spirituality.

Americans' response to this ferment has been to emphasize the complex *experiential* aspects of religion instead of traditional dogmas and creeds. Most Americans insist that individuals should arrive at their views of spirituality by themselves rather than being guided too strongly by theologians or clergy. Although they may attend faithfully at a local house of worship, few Americans understand—or care much about—the nuances of particular confessional or denominational orthodoxies. A majority of churchgoers routinely engage in practices that theologians of the past would have branded heretical, such as consulting horoscopes, reading Tarot cards, or expressing belief in reincarnation. Encounters with angels and reports of near-death experiences are popular because they are grounded firmly in personal life: skeptics who may be able to dispute philosophical proofs of the existence of God cannot touch these experiences because they are beyond observation or scientific description.

This experiential emphasis takes a variety of forms. Although it may be especially evident in emotional, firsthand reports of mysterious encounters with God, it is by no means limited to fringe or heterodox religious expressions. Millions of Americans have been drawn to charismatic and Pentecostal churches in recent decades because they can experience the mysterious workings of the Holy Spirit in their personal lives. Participants in liturgical worship services speak of the meaningfulness of these experiences, even though they may deny understanding the creeds they recite. In small groups, discussions of biblical texts quickly move from theological interpretations to the personal experiences that validate or invalidate these texts. Faced with friends and co-workers who have been reared in different denominations or even in different religions, Americans emphasize the religious beliefs and experiences that stem from their own personal journeys. Religious leaders themselves reinforce the view that faith is more important to spiritual life than abstract knowledge, and they encourage followers to recognize the full range of emotions with which their spiritual yearnings may be associated.

Artistic expressions of spirituality correspond especially well with this current interest in the experiential aspects of spirituality. On the one

hand, art is capable of bringing into sharper relief emotions associated with the most profound experiences of human existence. The music of Jennie Avila and Amy Torchia evokes a spiritual connection because it reminds people of their own experiences of grieving or the questions about God that have troubled them; as Torchia says, "My songwriting has been like therapy to me, hopefully in a universal way." On the other hand, art points to the mysterious dimensions of life—the "undefined," as David Ellsworth calls it. The poignant lines of a poem, the rhythm of a song, or the images expressed in a painting can connect our spirituality and our sense of the multiple dimensions on which life is experienced.

Defining Spirituality

But what messages about spirituality are artists communicating? Although the term "spirituality" refers to an aspect of life that is concerned with transcendence, wholeness, or ultimacy, it carries many connotations and is often used to suggest a realm of personal experience or being that cannot easily be communicated to others. Like David Ellsworth, many people seem to believe that the essence of spirituality lacks definition. Yet artists are often able to describe their understandings and experiences of spirituality with eloquence.

Nancy Chinn has been searching for satisfactory ways to fulfill her desire for spirituality for as long as she can remember. "I think the first adult experience I had of spirituality was walking into my house one day when I was about sixteen," she recalls. "I felt the cool on my face of the ocean breeze and the phrase 'God is a spirit' flowed into me and I understood in a kinesthetic way what that meant." This experience became emblematic of her understanding of spirituality because it brought together two aspects of her religious upbringing that she had previously been unable to integrate. The first was a vivid, yet often wavering, conviction in the existence of God. From third grade, she went every Sunday to a church within walking distance of her home. Chinn learned the biblical stories and came to think of herself as a Christian. Yet "the

faith," as she terms it, was largely a system of beliefs external to herself. It belonged to "other people," from whom she often felt alienated. Although she never completely doubted the reality of God, this God remained in a remote corner of her universe. The other unintegrated aspect of her upbringing was an intuitive sense of the supernatural. She sometimes saw "auras on people" and had "waking dreams" in which she heard internal voices telling her what to do. "I never talked about any of that with anyone," she remembers. But Chinn's experience at age sixteen drew a connection between her belief in God and her inner sense of the supernatural. The ocean breeze was a tangible sensation, while the idea that "God is a spirit" gave religious meaning to this sensation.

When Chinn talks about spirituality now, it is this image of a direct experiential connection with God that is uppermost in her thoughts. She describes herself as a "questioner" who finds it difficult to believe the teachings at the Catholic, Episcopal, and Presbyterian churches she attends most frequently. She finds it necessary to replicate the "kinesthetic" experience of God's spirit in order to feel that she is truly relating to God. She means this quite literally. Spirituality, she believes, should be sensual; relating to God should be so emotionally fulfilling that it generates bodily movement. It should border on the erotic.

In contrast to Nancy Chinn's emphasis on an inward, personal sense of being connected with God, Jennie Avila focuses more on an indirect sense of transcendence experienced through her connections with other people. It is significant that she stresses the "spiritual connection" she experiences between herself and her audience when she sings. As a teenager, she tried to establish a direct relationship with God. For several months, as a born-again Christian, she read the Bible a lot, prayed repeatedly, simplified her wardrobe, and entreated God daily to cleanse her of immoral and impure thoughts. Later, she went through a "nature worship phase," which included taking long walks in the woods and lying on the grass at night while closely observing the moon and stars. She has retained her affinity with nature, but her relationships with people have been her most enduring way of relating to the sacred.

Avila's awareness that transcendence could be attained through interpersonal relationships started to blossom when she left home at eighteen to become a folk singer. For the next four years she lived among migrant farm workers in California, earning a subsistence living from her performances and pouring most of her energy into César Chávez's United Farm Workers movement. She was touched by simple acts of kindness among people in the movement and found that her singing was often the best way to overcome cultural barriers. Yet many of her closest social relationships over the years have been broken, causing her to emphasize the psychological and spiritual ties among people more than someone's physical presence or absence. Over the years she has tried to cultivate this sense of spirituality through meditation and prayer while remaining active in efforts to promote peace and to help the needy. Although Avila finds it difficult to summarize her ideas about spirituality, she is convinced that there is some "spiritual force" that unifies everything. Getting in touch with that unity and "living more in tune" with it is her goal. The unity that emerges through her singing is one of the clearest ways in which she is able to realize this goal. "Sometimes while I'm singing," she explains, "I'll get physical sensations of tingling. I know that I'm actually really touching somebody and there're energy exchanges that happen. It's an exchange of some kind of spiritual encouragement."

Jamel Gaines draws a distinction between spirituality and religion and then emphasizes the value of relating the two. As a child, he attended Sunday school and worship services regularly at an all-black Baptist church. He knew the church's teachings and practices, but during college and while he was traveling with the Jubilation Dance Company he became less interested in religion and more accustomed to talking about spirituality. Rather than mentioning God or Jesus, his fellow dancers referred to the Creator, and their idea of spirituality focused on the energy or spirit that might be evident in dance itself. Gaines himself now emphasizes the holistic aspect of spirituality—the idea that spirituality pervades everything and yet is more encompassing than any

of its specific manifestations. In contrast, for him, religion connotes formal teachings and a particular place of worship. He regards religion as a way to focus the diffuse power inherent in spirituality; places of worship permit people an opportunity to think about God, to minister to one another's needs, and to be healed. This is why he enjoys his work at St. Paul Community Baptist Church.

Jon Davis is less sure than Jamel Gaines about the existence of God; indeed, he sees himself as living in a world from which the gods have fled. It is thus impossible for him to conceive of spirituality as a direct connection between himself and a divine being. He also has difficulty with the idea that transcendence emerges from the relationships people forge with one another. That idea seems to place too much emphasis on the heightened emotions that sometimes derive from human interaction. His understanding of spirituality is more philosophical. Davis believes that some form of Truth or Reality is present in the universe, but this Truth or Reality is hidden from us by the language, symbols, and material artifacts that make up our culture and influence our perceptions. All that can be hoped for, he believes, is an occasional breakthrough. Momentary glimpses of the sacred can be attained by reflecting on our perceptions and by manipulating the symbolic world in which we live in ways that bring about new perceptions.

Davis's view of spirituality brings him repeatedly to an awareness of how little we know—and can ever know—about the deepest mysteries of life: "I'm deeply disturbed when people think they have spiritual knowledge. Two things can happen. One is that it eliminates the possibility of belief. If something is true and we've seen it, well then, where is faith? The other is that people who think they have the Truth start to torment and torture the rest of us." He thinks the Spanish poet Federico García Lorca captured the idea when he wrote that only mystery makes us live. And yet Davis continues to believe that the struggle for spirituality is worthwhile because the search itself heightens our awareness of mystery. In one of his poems he writes: "The sacred is not found in the sudden whorl of fingerprints, the /spider's web, the oyster drill waving

its tiny trunk,/the trumpet worm sunk in silt, its pink fronds/scything the waves' repetitions—though each/quickens our longing."[16]

Unifying Elements

Despite the differing emphases, these artists' remarks on spirituality contain unifying elements. At the core is a strong conviction that some reality, being, force, or spirit exists which cannot be fully comprehended or experienced. Nancy Chinn refers often to the mysteriousness of God. She does not believe that God is entirely unknowable but that God's attributes are continuously being revealed as people strive to experience God's spirit. This is why the kinesthetic experience of feeling the wind or capturing beauty in a painting has spiritual meaning. Jennie Avila finds it more difficult to describe her beliefs in god-language. Despite going to church regularly as a child, she recalls having questions that never seem to have been answered, and during her years with the United Farm Workers, the Catholicism to which she was exposed emphasized doing good rather than discussing theology. She nevertheless feels that her upbringing left her with a deep desire for transcendence: "I want to find some kind of unity or meaning in life." Jamel Gaines tends more than either Chinn or Avila to believe that God can be known if people have the time to spend studying the Bible and other religious teachings, but at this point in his life, God remains largely unknown. Indeed, Gaines says the best way to live is to try to be "Christ-like" by serving others and remembering that the Creator is beyond our comprehension. Jon Davis's conviction that another, mysterious plane of reality exists originated in an intense Catholic upbringing that led him to consider becoming a priest and at the same time generated nightmares about God's wrath. As he matured, he never stopped believing in the existence of this other reality, even though he questioned religious teachings. He was especially influenced by the writings of philosopher Alan Watts. Like many of his generation, Davis learned from Watts that the rational mind is often a barrier to being open to the deepest mysteries of life.

If the spiritual dimension is ultimately a mystery, these artists never-theless insist that it can be experienced partially and momentarily. Its re-ality is most evident when an individual feels transported beyond the realm of ordinary sense perceptions. For Nancy Chinn, the nearly audi-ble voices she heard as a child have been replaced by powerful dreams in which she feels that God is communicating to her—"There's a guiding spirit somehow. I don't know how to say it any other way." Jennie Avila and Amy Torchia believe the spiritual connections they experience with their audiences point to the existence of some spiritual force in the uni-verse. Jamel Gaines does not recall any experiences either as a child or as an adult when he felt a direct connection with God, but he does feel that some divine spirit empowers him from time to time when he dances. Jon Davis is still attracted to the idea of epiphanies, and he sometimes experiences them when he is in nature or while he is writing.

Although the experiences reinforcing their conviction of the reality of the sacred are largely unanticipated, these experiences become more memorable, gain added meaning, and are even stimulated by the words, music, and visual images of these artists. Nancy Chinn says one of her most moving experiences came when a pastor opened the worship serv-ice by asking the congregation to walk around, examine the paintings hanging on the walls, and then stand in front of their favorite "until they heard a name for God." During the invocation, each person called out the name he or she had heard. The paintings, Chinn feels, encouraged people to think about God in new ways.

Jennie Avila, who started practicing meditation several years ago, has become interested in the uses of aural and visual images during medita-tion. In addition to chanting and listening to music, she has learned—through a course on "Visionary Art"—to quiet her thoughts and draw the images that come to mind during this subdued state of conscious-ness. This method reminds her of how the music in Sunday school moved her to a closer relationship with God as a child or how playing the piano and painting pictures helped express her spiritual yearnings as a teenager. It has given her new insights about herself as well. From ex-

amining her drawings, she realizes that she tends to emphasize light, positive images, and she is trying to become more aware that life also includes evil. These insights sometimes come spontaneously but are more often the result of conscious effort. "I take images and ideas and change them artistically and go back into meditation and just keep exploring and trying to get to the root of things," she explains.

Jamel Gaines has not always found it easy to reconcile his Baptist upbringing with his career as a dancer. He recalls how painful it was when a close friend in his dance company who was also from a conservative religious tradition decided the tension was too great, gave up his career, and refused to have any further contact with Gaines and the other dancers. Yet Gaines's involvement in Reverend Youngblood's church has given him a new appreciation of the relationship between spirituality and dance. "Art has given me the breadth on the spiritual level to create, to go on, to excel, to gather information. Do the impossible. Spiritually it's like some people go to therapy and they do their thing. This is what feeds me." In turn, his spirituality enriches his dancing. It gives meaning to his work, and it provokes questions about his work, such as whether it is cleansing and empowering him, and whether God is touching other people through him.

Jon Davis believes poetry—indeed, language and symbolism of all kinds—is the best hope for drawing connections between the world of human experience and the great unknown beyond our experience. He admits this view of language is not popular in academic circles, but he senses a mystical affinity between symbols and the deeper mysteries of life. Experimenting with forms of expression is his way of making discoveries. Taking haiku as an example, he explains, "Putting two dissimilar things together and finding connections, the third line being the connection, seems to me a way to open things up that were closed to us before." He elaborates, "My idea of spirituality is that it exists outside of cultures, and that the sentence and syntax are the enemies of true discovery. So what you're constantly trying to do is get out of the cultural constructs that keep us from seeing what's real and what's true."

Putting Spirituality to Work

These artists' views of spirituality are closely linked with how they pur-
sue and interpret their artistic work. Nancy Chinn's conviction that spir-
ituality should be sensual has encouraged her to produce paintings, altar
cloths, banners, and large artistic installations that enliven the spaces in
which people worship or the ways they think about God. She remem-
bers going to an Easter service at a Protestant church where the pastor
wore a black robe and the lilies that flanked the pulpit seemed to be wilt-
ing under the solemnity of the occasion. "I wanted to put more color,
more texture, more sensuality into the service. I could literally feel my
fingers itching to make altar cloths." Years passed before she had an op-
portunity to do so because she was busy being a mother and lacked time
for further training. As she explored the relationships between spiritual-
ity and art, she was "transfixed by the contributions of non-Christian vi-
sual artists to their respective faith communities." In contrast, she found
within her own Christian tradition that "the contemporary contribution
of visual artists was almost nonexistent, decorative at best, relying on
sentimentality, familiarity, romanticism and narrative content to carry
the work."[17] That was not enough for her. She eventually had time to
take classes and started doing artistic projects for local congregations.
Almost immediately she began receiving calls from other churches and
within a few years gained a national reputation as a liturgical artist. In
1993 she served as resident artist for the Re-Imagining Conference, an
ecumenical gathering of women in Minneapolis, to consider the theo-
logical and practical implications of feminist spirituality.

"I designed a project for the four days of the conference where every-
body would draw or respond visually to whatever was going on," Chinn
reports. She provided acrylics and a huge roll of paper on which hun-
dreds of women painted pictures depicting what they were experiencing.
"At the end of the day, the symbol of Re-Imagining is to keep what you
need to and throw away the rest. We would tear out the part that we
wanted to keep and throw away the rest and . . . keep going." Getting

the conferees to work together was a primary goal. "I wanted them to begin to integrate with each other until they eventually would make an altar cloth for the last service of milk and honey."

Nancy Chinn currently divides her time about equally between collective projects like this and her own painting. In both, she uses art to give form to the spiritual yearnings that she senses intuitively. Many of her paintings are inspired by reading the Bible: a biblical character such as Eve, Lot's wife, or the daughter of Jephtha captures her attention, and she creates an image that expresses something about this character. She sometimes prays with other women, finding that collectively invoking the presence of God stimulates her creativity. Nature provides another source of inspiration.

Although she sometimes has a clear theme in mind when she begins a project, Chinn says it is more typical to let the process guide her. "I just start out with a gesture, almost like a yearning, a prayer. I don't plan these paintings ahead of time. They're a way for me to see what my intuitive side looks like with me working as the witness to what happens with the paint, rather than the imposer on the paint of what happens." At the end, she sometimes chooses a title for the painting from a biblical text. "So there is a visualization that hopefully leads people toward a greater understanding of what that text is." One example is an abstract watercolor that conjures up images of sunshine breaking through clouds over a turbulent seascape; titled *Wisdom's Laughter*, it includes an inscription from Proverbs 1:20–27a that speaks of wisdom crying aloud in the open air. Other paintings express aspects of God that Chinn was unaware of beforehand. She says it can be "shocking to people" to see an image that challenges their conventional ideas about God. "Putting the work out there is a political act after it leaves my interior spirit."

For Chinn, however, this artistic work is not *only* a way of expressing some inner yearning. She believes there is a spiritual and material reality beyond herself, which interacts with her during the creative process. "One does not use the materials to express oneself. The way I make art is to work with materials so that they also express their own voice. It's a

much more intuitive process for me. I don't impose on the materials what it is I want. I show up. They show up. We work together and then we look at what has happened. It's more relational."

She adds: "I see my work as research and the research is into the unknown. What is this next painting going to look like? What is that feeling and that mood inside me? What am I thinking that I can't think out loud? What is it going to look like? That sense of the adventure, the imagination, the wonder of creating something. My work is about mystery. My work is not about revealing the mystery, but saying that 'Mystery is present here. Notice it!'"

Jennie Avila and Amy Torchia's music is as deeply influenced by their sense of spirituality as Nancy Chinn's paintings are by hers. Few of their lyrics speak of God, and they seldom use religious language or sing directly about spirituality. Yet the spiritual connection they achieve with their audiences stems from their engagement with the deepest meanings of life. One of their songs tells how Torchia's mother keeps a map on the wall with colored pins depicting her travels and her relationships. The red pins show where her soul mates live and the black pins locate where she has lost a friend. The song is about growing older and coming to terms with aging. The lyrics weave signs of aging and impending death ("chill winds have started to blow") together with images of settling in and living more simply (friends come to visit and the cool country air rattles the back porch chimes). Avila says one of the basic attributes of the mystery of life is the constancy of change: "Things get bad. Things get better. You learn and just when you think you've got it figured out, something slaps you in the face. You're starting from scratch again."

Avila's song "Mermaid's Dream" expresses a more whimsical side of her spirituality. She recalls that she was not consciously thinking about writing a song but had been musing about mermaids, especially what it might be like to move back and forth between ocean and land. In the song she likens herself to a mermaid moving between a mundane and a more spiritual level of experience. She imagines herself doing house-

work and then "going off on a little spiritual journey" so that it takes for-
ever to get the dishes done.

She has been working on another song that asks, "If I were a shell in
the ocean that washed ashore at your feet, would you hold me to your
ear but not hear what I mean and toss me back?" Through this and sim-
ilar images, she tries to evoke questions about the relationship between
the human and the spiritual. "The ocean for me is a real metaphysical,
spiritual image. It's like the subconscious or getting more in touch with
those spiritual realms, and having a shell wash up from the ocean is get-
ting that message and can you hear it? Do you keep it? Do you toss it
back? Should you keep it? It's all these dilemmas, these questions that
keep going around in circles and keep recurring in my life at the same
time."

Speaking more broadly, Avila claims a reciprocal relationship be-
tween her interest in spirituality and her music. "A lot of songs come to
me out of dreams and [meditation] and then to actually perform them
and have the audience response" is fulfilling. "People say they find the
performances transformative or they keep coming out because they're
having a hard time in their life and it makes them feel better. And know-
ing that makes me feel better."

Jamel Gaines articulates the connections between his dancing and his
sense of spirituality somewhat differently. When he reads in the Bible
about people dancing in praise to God, he sees this as confirmation that
dance is literally a way to show joy or excitement. He remembers di-
recting a production of *Black Nativity*, a version of the Christmas pag-
eant written by the Harlem Renaissance poet and playwright Langston
Hughes. During the production, Gaines's choreography of "Glory to
the Newborn King" resulted in people in the congregation standing up,
swaying, waving their hands above their heads, and applauding.

Because he regards spirituality as a kind of energy that flows through
and empowers people, Gaines considers dancing spiritual when it in-
spires and energizes people. Just as a fine painting or musical perform-
ance may inspire someone, dance can be an uplifting experience that en-

courages people to seek God or to aspire to higher levels of performance in their own service to God. "When I dance, I'm abandoning myself [to the point that] I can touch someone in the audience. It will make a difference, and they'll be like, 'That was just breathtaking—not even just because you did five turns, but just the way you reached out and the subtlety and the beauty of that and the spirit of the face and your chest and the way your legs move. I just feel like *I* could have gotten up there. You represented me up there.' That's who I do my art for!"

As a ministry, Gaines's dance instruction and choreography serve also to bring people together, forging relationships, building skills, learning personal discipline, and gaining self-confidence—all in a community where they can then reach out in service to others, such as children, fellow church members, and neighbors. He says St. Paul's has "spiritually connected" him to people in his dance company and given him a vehicle for developing his and their talents. From the start, he recalls, "I was developing choreography and building these skills around people that are not professional artists, but they had a spirit that was so big and they had a life experience that was just so beautiful to work with because they can bring many more different things to the table and the development of work."

Reflecting on the past decade, Gaines says the most important thing he has learned about spirituality is the "ability to pray and work with people." Through dance "I minister to people in ways that my pastor said I am not really aware of." Sometimes Gaines ministers by teaching; for example, he finds it rewarding to teach a dance class at the church for people who have never danced before. It gives them an opportunity to exercise and cleanse their bodies. He sometimes tries more consciously to communicate messages through his choreography as well. For instance, he noticed on several occasions that the younger people he knew seemed not to have love relationships and perhaps did not value them or know how to establish them. In response to this concern, Gaines choreographed *The Quiet Storm* "to show the spiritual intimacy, the subtleties in a relationship." He remembers hearing people saying things after the

performance like "Oh my God! I just want to be in love" or "I just want to sit down and have a nice cup of tea with my mate." He was thrilled. "They got it! It's not the sexual part that is most important. My intentions were to show the intimacy, the spirituality, the beauty of the bodies, and the beauty of love."

Jon Davis uses his poetry to work around and through the conventional realities of daily life to the point where he gains insight into the unfathomable dimensions of human existence. His brother's death haunts his imagination. Davis has searched in Christianity, Buddhism, and other traditions to gain a better understanding of death and grief, but he recognizes that the loss of a loved one must be experienced by each person in his or her own way. One of his poems is a bitter lament: "My brother is gone and the world, you, me, are not better for it. There was no goodness in his death."[18] But the poem also raises the question, "Perhaps even loss is lost?" Davis says it was several years after writing this line that he came to a better understanding of its meaning. "It is important for me to keep that sense of loss, maybe in the place where my brother was. I don't want to lose that sense of loss; I want to carry that around with me."

Davis's poem "The Ochre World" is a forty-three-page sequence of short poems, which he describes as the best single statement of what he has learned in the course of his spiritual journey.[19] Written over a four-year period, it attempts to break down the barriers between public and private life and to examine the possibilities of being part of a community. At a deeper level, it is concerned with the tensions between the unconscious life of the individual, on the one hand, and the invariably artificial or imposed aspects of cultural systems, on the other hand. Davis does not regard the poem as a solution to these tensions, but as a way to heighten the importance of asking questions about them. He continues to read the poem to dredge up questions buried in his subconscious mind when he wrote it. "You know what I've learned?" he asks. "I've learned that it's important to keep asking questions, to keep open, and not to close down or accept any particular system. It's strangely com-

forting to try to keep yourself in that position. I guess it's comparable to keeping the loss of someone in the place of that person, keeping an awareness of this big mystery that we're a part of."

He says poetry contributes to his spirituality by tugging him back into the world so that he can look closely at the world, and at the same time it unsettles his view of the world. "I try to disrupt the ways I've seen the world in the past. The hope is that new forms give new knowledge, and that disrupting the way you've seen it yesterday gets you closer to something that you hadn't seen before."

Davis tries not to begin writing with an idea in mind but in a spirit of emptiness that can be filled from beyond himself. "Writing poetry is an emptying and a waiting rather than a thinking or a planning," he says. Writing poetry is like prayer—indeed, often is prayer—insofar as he tries to listen and be attentive to whatever may be imparted to him. While Jennie Avila and Amy Torchia gain their spiritual connection mostly through other people, Davis finds his through his engagement with words. "The poem on the page doesn't happen entirely by my will. It happens out of a kind of will-lessness, and there's a kind of coherence to that. When I turn myself over to that [process], there's still coherence. It gives me a feeling of freedom and trust."

The Question of Religion

These artists vary in whether their interests in spirituality result in connections with established religion. After giving a lecture at St. Gregory's Episcopal Church in San Francisco, Nancy Chinn attended a worship service, became acquainted with the church's programs, and discovered a supportive community there. "It's not very head-centered. Most of the people in the church are connected in some form with art; there are a lot of writers, playwrights, artists, and musicians. I think we just see life differently." She continues to attend services at this Episcopal church several times a year, but occasionally worships at Catholic or Presbyterian churches as well. Although Jennie Avila is often too busy to attend reli-

gious services, she occasionally participates in activities at a local church, composed mostly of artists and seekers who are trying to simplify their lives. She says, however, she is basically not a "joiner." Philosophically, she is more comfortable with the idea of spirituality than with organized religion: "Religions become stagnant or stiff, not flexible; lots of rules and things that don't take individuals into consideration." Jamel Gaines usually attends services twice a week, and he enjoys this, but his main reason for participating so often is that his dance company generally performs during the services. In contrast, Jon Davis does not attend religious services at all, although he spends a great deal of his time reading books about spirituality.

In national data, 20 percent of artists say they currently have no religious preference, significantly more than in the public at large (where 8 percent give the same response). Still, most artists continue to have some affinity with organized religion: approximately half say they are Protestants, 17 percent are Roman Catholics, 6 percent are Jewish, and 5 percent have some other religious preference. When asked how often they attend religious services, 23 percent say every week; 18 percent, between one and three times a month; 28 percent, several times a year; and 31 percent, less than once a year. Although these figures suggest artists are less involved in organized religion than the general public is, artists are by no means devoid of such involvement.[20]

Whether they identify with organized religion or are alienated from it, artists interested in spirituality generally find a supportive community or network of relationships that helps to reinforce this interest. Although Nancy Chinn attends worship services occasionally, her spiritual community is composed mostly of the women she has met through the Re-Imagining Conference and at other feminist gatherings. A few live near enough to visit and pray together; she stays in touch with others via the Internet. Not being a joiner, Jennie Avila has fewer relationships to which she can turn for support, but she counts on her singing partner to lend a sympathetic ear, and she shares her spiritual experiences with her boyfriend and people she has met at workshops on meditation. Jamel

Gaines's support comes from the dozen or so dancers, including his wife, with whom he works most closely. Jon Davis identifies his supportive community as his wife, daughter, and a husband and wife with whom he is close. "I'm not a very social person, so my circle of real friends is always very small. Those are the people that I go to. They have in common this drive to be ethical, which I think is related to spirituality."

The Wider Context

Despite their distinctive talents and interests, these artists' search for spirituality resembles that of many Americans. Although opinion polls show that more than 90 percent of the public claim to believe in God, personal interviews reveal that most people regard God ultimately as a mystery. A substantial minority of the public appears to believe that God is fully and exclusively revealed in the Bible or through the life of Jesus, but this belief has by no means limited people's capacity to sense the presence of God in a wide variety of contexts. Nature, sexual encounters, giving birth, times of grief or suffering, and near-death experiences are commonly mentioned as occasions for strong feelings of being in the presence of something sacred. Paintings, folk songs, dance, poetry, and many other forms of artistic work provide opportunities for such experiences as well.

Large numbers of Americans are *potentially* exposed to spirituality through the arts by participating, at least casually, in some form of the arts. According to a national survey, 41 percent of the population had attended at least one of seven arts activities (jazz, classical music, opera, musicals, plays, ballet, or art museums) during the preceding year.[21] Attendance at art museums and galleries was the most common, representing approximately 50 million adults. More than 25 million adults had attended a play, 20 million a jazz concert, and nearly 9 million a ballet performance. In the same study, 19 percent of adults had watched a dance performance on television, 41 percent had visited an art or craft fair, and 54 percent had read at least one book in the preceding year.

According to another survey, about one person in ten participates in a literary, artistic, or discussion group.[22] The number of Americans who personally engage in artistic performances and other creative activities ranges from approximately 14 million who are involved in creative writing to 12 million who act in plays to 8 million who perform classical music.[23]

Unlike their experiences in religious organizations, Americans' exposure to the arts may have little to do with spirituality. Yet surveys suggest that many Americans recognize the deeper significance of the arts. In one study, 89 percent agreed that the arts and humanities "inspire people's minds and spirits," and 81 percent agreed that they "play an important role in communicating moral and ethical values."[24] In another survey, 32 percent said they had experienced "a strong sense of being in the presence of something sacred" while attending a musical performance.[25] In personal interviews, many people indicate that the arts have significantly influenced their spiritual development. They speak of musical performances at their places of worship, listening to Mozart, being inspired by their favorite poet, or remembering from their childhood home a painting that made them think of God.

Artists themselves seldom say it is their job to advocate specific interpretations of spirituality. They are more likely to emphasize how their work encourages people to raise questions and to explore spirituality in their own ways. In doing so, artists nevertheless serve as spiritual guides. Nancy Chinn speaks of the prophetic or visionary role that artistic installations can play in churches. Jennie Avila and Amy Torchia describe audience members weeping because their song lyrics elicit memories of loved ones or thoughts of mortality. Jamel Gaines describes a performance he choreographed that drew people's attention to their need to work for social justice. Jon Davis mentions a priest who incorporates into his homilies Davis's poetry.

Nancy Chinn insists that the way of the artist is something to which everyone can aspire. "It's really how you approach life. It's paying attention; it's having your antennae out. It's always snooping, always

thinking, always noticing." Jennie Avila advises people to "keep explor-
ing." Jamel Gaines says the arts are not about going to the theater and
being judged by your clothes, but about "being able to see better" and
"doing your inner work." Jon Davis emphasizes the necessity of seeking
and yet realizing that the search is for mystery: "Our voices go into the
night, but the night happens outside the voices, outside the languages we
have for the night. The mystery of the night air is full of the unsayable—
the language, untranslatable, of howls and night sounds."[26]

Why It Matters

The number of contemporary artists who emphasize spirituality in their
work may be small compared to the hundreds of thousands currently en-
gaged in some form of artistic, literary, or musical career. But artists like
Nancy Chinn, Jennie Avila, Amy Torchia, Jamel Gaines, and Jon Davis
tell stories that one hears again and again in talking with artists and read-
ing their biographical statements. They have been unable to ignore the
sacred. Through confronting pain in their own lives and by refusing to
turn away from this pain, they have been forced to search for ways to
make sense of it and to achieve wholeness. Spirituality is their way of de-
scribing this search. Sometimes it results in a rediscovery of the power
of religious tradition and community; sometimes it leads in a lonelier di-
rection. The common element is that something powerful emerges—an
experience or insight that defies ready interpretation. In their various
ways, artists seek to express these experiences and insights through the
symbolism and imagery of their work.

The wider public is often exposed to this work, either in such re-
stricted settings as workshops and congregations or through more gen-
eral media such as CDs and books. Education and affluence make it pos-
sible for many middle-class Americans to experience the arts in these
ways. Others are often exposed to the arts through radio and television
or at their places of worship. There is considerable interest in artists'
work, not simply as entertainment but also for its deeper meanings.

Many people have dealt with the same frustrations that artists have. Artistic work gives expression to what others have also experienced.

The changing character of American religion provides favorable ground for artists' contributions. Although a large minority of the public claims to understand everything there is to know about God because of having read the Bible, most Americans view holy writ as one of several ways in which God is revealed. Music and art can be expressions of grace as well as means of worshipping. When artists say they do not fully understand God, their candor strikes a resonant chord with many Americans. People are similarly attracted to the idea that faith is most genuine when it arises from the turmoil that seems to have become so characteristic of contemporary life.

2

DRIVEN TO EXPLORE

WHEN CONTEMPORARY ARTISTS embark on a spiritual
journey, it is typically a journey into the unknown, rather than one lead-
ing along well-traveled paths. Artists interested in spirituality character-
istically bring creativity to this quest. The undefined, mysterious aspects
of spirituality encourage them to explore beyond the religious traditions
with which they are most familiar. Like many Americans, they are
influenced by a consumer-oriented culture that emphasizes prepackaged
spiritual practices and quick solutions to their personal problems. Yet
their quest is often marked by an intensity preventing them from settling
for the casual spiritual shopping that pervades our culture. They are
driven to explore, almost as if by some design beyond their control, and
often at great cost to themselves.

Art criticism and art history generally pay little attention to the de-
tails of artists' lives, focusing instead on the art produced as worthy of
examination in its own right. Although artists themselves may reveal
portions of their biographies in published statements, it is relatively rare
to have information from lengthy interviews about the most intimate as-
pects of their lives. Such information may be of interest because artists

are public figures or because it provides a clearer understanding of the intentions shaping their work. But here I want to suggest it may also offer a new perspective on the spiritual searching of so many Americans. This searching has been roundly criticized, even condemned, by religious leaders and scholars alike. Religious leaders worry that spiritual seekers are making up their own answers to ultimate questions rather than looking to the wisdom of religious communities. Scholars view spiritual seeking with disdain because it offends their penchant for rationally grounded intellectual arguments. Still other critics see it as symptomatic of the casual shopping that pervades American culture and suspect it is driven more by advertising and the desire for easy gratification than by serious interest in religion.

Although these criticisms are often well founded, they overlook an important exception—people who are driven to explore, whether by personal circumstances or by questions and yearnings. For these people, spiritual seeking is not something they pursue to escape boredom, but a kind of pilgrimage that consumes more time and energy than they ever imagined it would. Such people are not uncommon. Social circumstances make it impossible for many people to live comfortably within the religious communities that embraced their parents and grandparents, pushing them instead to explore elsewhere for the sacred. Whether by temperament or because their spiritual searching awakened creative impulses, artists seem to be among those who have found it virtually impossible to ignore the spiritual implications of personal dislocation.

A Bead Artist's Journey

The personal experiences encouraging artists to be creative in their spirituality are evident in the life of Wendy Ellsworth, a bead artist who is married to David Ellsworth. Her studio is located on the couple's twenty-acre farm in northeastern Pennsylvania. It has floor-to-ceiling windows situated to take full advantage of its southern exposure. As the winter sunlight streams in, it illuminates the beads on her worktable and

reflects off the baskets, mandalas, and pouches hanging on her walls. In recent years she has specialized in abstract bead sculptures measuring four to seven inches in diameter and composed of thousands of glass seed beads woven to resemble flowers, shells, geodes, crystals, and waves.[1]

On her twenty-first birthday she drove up from Boulder, Colorado, where she was attending college, to a point on the Continental Divide where she hoped she could feel close to God. War was raging in Vietnam. She could make no sense of people being asked to die. She could make even less sense of what it might mean to live. Sitting on a rock that day, tears streaming down her face, she screamed at God, "I need to understand why I don't understand the meaning of life. Help me. I need direction. I need understanding. I want it. I'm ready." She knew she was ready to follow wherever her spiritual longing might lead.

Wendy Ellsworth had grown up in the comfortable northern Virginia countryside in the 1950s. Her father was a successful Washington attorney, and her mother, a frustrated opera singer, devoted herself to caring for her five children (Wendy has an older brother and sister and two younger sisters). She recalls feeling that her family was a part of Washington "society" and that all her parents' friends were "proper people." Her parents attended an Episcopal church, drawn to it especially by the high quality of its music and the prestigious occupations of its members. They sent her to a private elementary school, which she remembers fondly: "I was very happy there. I had a wonderful group of friends, and did a lot of singing and dancing. They had a wonderful creative arts program there." She also enjoyed riding her own horse, sauntering aimlessly through the wooded acres of her parents' farm and periodically visiting the owners of an adjacent estate, Jack and Jackie Kennedy.

When she was in ninth grade, her parents sent her to a girls' boarding school. She hated it and considered running away but managed to suppress her impulses for four years, although she became increasingly alienated from her parents and the values they symbolized. Her goal in selecting a college was to get as far away from her parents as possible.

She wanted to attend the University of California at Berkeley, where her sister was a student, but her parents vowed they "would not make that mistake again," so she settled for the University of Colorado. She majored in history and, like many of her classmates, became involved in the antiwar movement. Her interest in spirituality was awakened during her senior year when she took a course in philosophy that exposed her to Buddhist and Hindu teachings.

As she sat there in the Rocky Mountains on her birthday, Wendy Ellsworth somehow realized that she would receive the answers she was seeking only if she put herself in a situation where they could come to her. This realization led her to embark on a journey that has permanently shaped her life. When she graduated, she moved in with a man she loved and from whom she felt she could learn. They lived together in a remote canyon, eventually marrying and building a log cabin in which they lived for seven years. He was a skilled bead artist, and she became his student. They filled their days making beaded designs, baskets, sun catchers, and purses. Periodically they loaded up their work and drove to Aspen, where they sold enough to tourists to purchase food. They had two children. It was a good life. Her decision to leave her husband was not precipitated by personal conflict or economic necessity. She was convinced that she simply had to move on if she were to grow.

Her decision was prompted by an inner compulsion that she could understand only in spiritual terms. Often it seemed that her life was governed by karma or by some other supernatural force over which she had no control. She had been persuaded that such a force existed from the day she conceived her first child. That afternoon she was riding her horse on a muddy mountain road when her three companions decided to gallop ahead. Although she was a skilled horsewoman, when she spurred her horse to a gallop, it slipped in the mud and fell. "As she was falling with me, I recognized it as my death. I recognized that I've always known I would die that way. There was an instant of recognition. The only thing I could do was surrender to it. So I did. The last thing I did was in my heart call out the name of the man I was living with."

Even though her lover was now a half mile ahead, he sensed her call and retreated to look for her. He and his companions found her lying in a fetal position in the mud. As they turned her over, her eyes rolled back and she stopped breathing. "What they saw was a death. They saw me die." She felt her soul leaving her body. Then she heard a sound, and her consciousness started to return. "I can hear you but I can't get back to you," she said over and over in her mind. Eventually she opened her eyes and was able to sit up. Nothing was broken, but she was badly shaken. A few months later she realized that she had conceived that very morning. That day seemed a major turning point in her life, a moment of death and rebirth. She knew she was in the hands of a force larger than herself.

After her divorce, she moved to another valley, where she lived for two and a half years. She continued beading, but with two children to support spent most of her time eking out a meager living. She grew vegetables, picked fruit, and sold homemade cider. Whenever she could, she found work in construction, hanging insulation and putting up plasterboard, and in the evenings worked as a barmaid. Deciding again that she had grown as much as she could, she moved on, this time back to Boulder, where she was able to find a full-time job. It was here that her acquaintance with David Ellsworth, whom she had met briefly a few years before, developed into a relationship. Seven months later he persuaded her to move with him to a farm in northeastern Pennsylvania.

Although she still lives on this farm and has seen her beadwork blossom into a stable career, Wendy Ellsworth continues to be a spiritual explorer. For several years after she moved to Pennsylvania, her spiritual practice relied heavily on yoga, which she had learned in Colorado. Eventually she quit yoga but continued to meditate in a way that fit her interests. She searched for answers to her spiritual questions by reading, sometimes feeling that books came almost magically to her attention. Scott Peck's bestseller *The Road Less Traveled* was one of her favorites; Barbara Brennan's *Hands of Light* was another.[2] She took classes on the "new therapies" at a psychotherapy center, experimented with spirit

guides who "channeled" messages from spirits, and participated in peace rituals and Native American drumming circles.

The force that drove her to pursue these various spiritual activities was one that she did not understand. She felt restless, dissatisfied with her understanding of life, and sometimes formulated specific questions she wished the universe would answer. Yet it was unclear why her spiritual explorations took on an intensity that seemed lacking in many other people. The answer emerged gradually and painfully, but when it came, everything fell into place. In the early 1980s her youngest sister tried to kill herself. During her sister's recovery in a psychiatric ward, Wendy was the member of the family who supported her most closely. Her sister believed she had been sexually abused as a child and that the abuser had been their father. Wendy found it credible that her sister had been abused, but could not believe the part about their father. Within a few years, she and her sister stopped communicating with each other, partly because of this disagreement. In the meantime, Wendy was suffering from a new round of spiritual anxiety of her own. Her sister's near-suicide had prompted questions about how one finds the will to live. Wendy Ellsworth knew the answer had to do with the spiritual force she believed was inside her. Yet she was having difficulty reaching this force.

She remembers having an argument with her husband David and feeling that she was somehow "shutting down." When David asked her what she was feeling, she realized that she felt nothing at all. She began asking herself when she had started doing this and decided that it was a lifelong pattern. She could not get at its source. The various spiritual practices she pursued nevertheless helped identify the problem. Reading a book about chakras drove home that her "heart chakra" was dead. On another occasion, a spiritual guide told her the same thing. On yet another occasion, she attended a workshop at which participants drew pictures in hope of gaining insight into repressed aspects of their lives. Wendy drew a beautiful blonde girl crying crocodile tears. She knew it was a picture of herself as a child. Then at another workshop involving

deep breathing and meditation, the breakthrough came. "All of a sudden, what I was experiencing was being a four-year-old in my bed, being molested by my father. I had no idea. I had all the clues in the world. And it was just like somebody had handed me the final piece of the puzzle of life, my life, and it all cleared up. All of a sudden, the whole picture, the whole image became clear, because all these things that had happened to me, all these things that I had drawn into my life, it all made sense. It all made sense."

She was devastated and angry but also exhilarated by this realization. She immediately phoned her sister. "I said, 'I want to let you know that it wasn't just you. It happened to me, too.' She said, 'What are you talking about?' I said, 'He did it to me, too.' It was just incredible, and it was just a reunion that was so powerful." She said to her husband, "There's no holding me back. I'm pushing through this one. It's a biggie." And every morning for three months the two of them sat together on their porch while she explained the changes she was experiencing.

As in many cases of repressed memory, it is impossible to know exactly what happened when Wendy Ellsworth was four years old. The one thing she is sure of is that her journey toward greater spiritual awareness is not over. She remembers a dream she had several years ago of a wild bird in a cage. The bird was dying. When she woke up, she knew she was the bird. She knows her spirit is too wild to be caged. She knows she needs to keep moving.

Through it all, there has been a connection between Wendy Ellsworth's spiritual explorations and her art. As a child she pursued the arts because they were a way of gaining an identity other than the one her parents represented and from which she felt alienated. She fell into beadwork because of her spiritual pilgrimage, more than from a desire to perfect this particular craft, and later she realized that the mandalas she was making had spiritual significance. Her artist friends and her husband David serve as a network of people who pursue spirituality in unconventional ways. Many of the spiritual practices and therapeutic methods she has followed, such as visualization, drawing, and movement, reflect

interests to which artists are attracted. When she was anguishing about her lack of emotions, she was unable to pursue her bead artistry. Having resolved some of those issues, she has resumed her work, finding that the rhythm of beading gives her peace and stability.

For the first time since she was in the children's choir at the Episcopal church, Wendy Ellsworth is able to sing. Yet the relationship between the creativity she has shown in her artistic work and the creativity evident in her spiritual life is difficult for her to describe. She knows only that the phrase "creative force" seems to be the best way to characterize what she means by spirituality. This is the force that has driven her to keep exploring. Although she has pursued many different spiritual practices, she is scarcely a spiritual dabbler. She is engaged in a serious quest that will take her a lifetime to fulfill.

Many people would not have had the luxury to pursue the bohemian lifestyle that Wendy Ellsworth chose. She benefited from an upper-middle-class background and, as a member of the '60s generation, from a period of relative affluence. In being influenced by the Vietnam War and the counterculture that emerged on the nation's campuses at the time, she resembles the baby boomers who have been characterized as spiritual shoppers. But her story stands as an example of someone who did not simply dabble with spiritual fads. It is a story of perceived abuse, of repressed memory, and of profound alienation. It is also a story of taking the risk of asking God for answers and then paying the cost of searching for those answers. If people such as Wendy Ellsworth have been led to artistic or other creative expressions of their spiritual search, it is because they experienced such personal dislocation that conventional religious organizations seemed incapable of providing answers.

The Impetus of Trauma

Like Wendy Ellsworth, Katie Agresta is an artist whose creative impulse has compelled her into a passionate spiritual journey. In Agresta's experience, however, the connection between art and spirituality seems

tighter—indeed, the two seem inextricably entwined. She provides a clearer illustration of how a career in art can itself become the impetus for serious spiritual exploration.

A singer, multi-instrumentalist, composer, author, and lecturer, Katie Agresta was born into a musical family—her mother is a Juilliard graduate in piano; her father was a singer; and a sister and a brother are also professional musicians. She started piano lessons when she was five, continuing them until she was thirteen, when she switched to vocal lessons. Her voice teacher immediately recognized her talent and encouraged her to prepare for a career in opera. By the time she was fifteen, she was singing solos at weddings and funerals, and when she was seventeen she started teaching voice and guitar. She majored in music in college and after graduation pursued her teaching and singing. "I hung out for three years going to the clubs every night," she recalls. "I learned all about monitors and sound stages and equipment and [the singers'] needs and what they were actually doing with the voices and what would go wrong and how to practice. And at the same time I was pursuing a career in classical singing. So I had this double world where I was studying Puccini and teaching people who were singing Led Zeppelin. It was very crazy!"

Although she continued training for opera, she found it difficult financially and psychologically to pursue her classical interests. Meanwhile, the demand for her teaching was growing to the point that she relocated from Long Island to Manhattan. One of her first students there was Cyndi Lauper, and when Lauper became famous, Agresta did too.[3] That year she turned away four hundred students. Still, she became so busy with students that she abandoned her own singing and nearly worked herself to death. She managed her own school and kept herself and seven other teachers busy training some three to four hundred students at a time.

It was storybook success. Yet from the beginning there were strains. For reasons she does not fully understand, Agresta never related well to her parents. She remembers that her grandfather's death when she was

three and a half left a "big hole" because she had been closer to him than to her parents. She thinks she tried to fill this hole by pursuing her musical interests. As she recalls, "There was always a [family] crisis, and so I took refuge in the music. I took refuge actually more in listening to music than I did anything else. I listened to music around the clock; I'd go up to my room and just listen to the radio and my records." Although her parents encouraged her to sing, they gave her mixed signals about music, perhaps because they felt ambivalent about their own careers in music.

Agresta's music and her troubles with her family were integrally tied to her changing interests in spirituality. When her grandfather died, it comforted her to know that he was in heaven. Her parents were devout Italian Catholics, so she found comfort in the teachings and rituals of the church. She especially liked to sit in the church when nobody else was there, looking at the sculptures and candles, and praying. At parochial school she learned Gregorian chants and found support for her singing. But gradually her attitude toward the church changed. "The brutality of the nuns and the priests and the physical beatings took their toll on me. I became very frightened as a child." She hated it too when the Latin Mass was replaced. "I loved how sacred and beautiful it was—the fact that it was mysterious and that it was untouchable."

During high school, she was deeply influenced by the assassination of President Kennedy and by the cultural changes symbolized by the Beatles and the beginning of the counterculture. She was even more deeply influenced by her growing alienation from her father. He was "very brutal at times. Very raging and used to hit us a lot, although he doesn't remember any of it. I turned away from all of it and then felt very much adrift and very lost. Didn't really feel like I had any spirituality, and I didn't care." Whereas the church had once been a source of comfort, it now seemed "evil and mean and hypocritical and violent."

"When I got to college, I took a job in the library and started reading about Buddhism and Zen and Eastern philosophy. I started to embrace anything that wasn't what I came from. Started reading about healers

and psychics and spiritual teachers, and the Dalai Lama. The spirituality of the hippie philosophy of peace, love-dove, and everybody love each other and all, that started to become my spirituality, and I got interested in all the stuff that went with that—the crystals, the Tarot deck and the occult, and astrology and the Celtic traditions."

After college, she continued to explore alternative spiritual practices. "I met a woman who turned me on to the whole mystic [world] of the angels and the David Kingdom and the garden in Findhorn, Scotland. Then I met an American Indian who taught me how to read clouds. He said you should be a vegetarian, and he taught me how to do healing work on people. Then I became a Reiki Master. Eventually I hooked up with this yogi and started practicing tantric yoga."

Over the years, she has pursued other spiritual and therapeutic disciplines. She took courses from Yogi Bhajan, Bayard Hora, and Deepak Chopra; became a Dimensional Macro Structural Alignment instructor; worked with a metaphysical counselor; and participated in twelve-step groups and seminars focusing on healing the inner child. The twelve-step work was particularly helpful: "I was able to reconnect with the original love that I had of Christ and the Mary stuff I'd been brought up on and God. For many years I saw God as my enemy, and then the twelve-step work brought me home to myself again. I took a long journey around to come back, and being as intelligent as I am and as willful and as strong as I am inside, I put up a big fight!"

Indeed, she would have had little inclination to struggle with spirituality at all had she not been pressed to do so by forces beyond her control. At the height of her career, she nearly died. At first, she merely found herself crying and feeling depressed. Then on two occasions she suffered what seemed to be nervous breakdowns. Eventually her doctors came to believe there was a physical cause for her severe symptoms and gave her three months to live. Finally they determined that she was having a serious reaction to birth control pills, so serious that her pituitary gland was badly malfunctioning. At about the same time, her voice teacher, her most stable source of emotional support since college, died.

The combination of her physical illness and her emotional trauma forced her to evaluate her entire life. As she started to recover, she realized there must be a reason why her life had been spared. "I sat there for five hours talking to God saying, 'Okay, what do you want? What do you want because I'm supposed to be dying and you're not letting me die, so there must be something you want me to do!' I didn't know what it was, that's for sure. But it was the biggest awakening moment. Those five hours, I think, changed my whole life. Until then I was a wild child. I was out there. Party animal and the whole thing. I had always felt tremendous love for my students, but I didn't feel enough love for myself."

The realization that she had to come to a better understanding of herself set her on a path of exploration that she couldn't resist. As she examined who she was, she found not only that her ability to accept herself increased but that her creativity expanded as well. She acknowledges that much of her experience as a child and as a young adult was "brutal" and "awful." In contrast, she says her eclectic approach to spirituality has helped her to be more "open-minded" and "happy." She especially values the insights she has gained about the necessity of creating one's own realities. She still has the strong will that enabled her to survive her many negative experiences, yet she tries to balance that willfulness with an understanding of her need to surrender to the spiritual realities that envelop her. She does not feel that she has found all the right answers, but she thinks she is better able to ask the right questions

The common factor in Wendy Ellsworth's and Katie Agresta's stories is that both women experienced trauma as children that alienated them from one or both of their parents. Because they were reared in church-going families, these women's alienation from their parents caused them to feel distant from the conventional religion of their childhood. Their subsequent spiritual exploration was driven, on the one hand, by their learning to take spirituality seriously and, on the other hand, by a sense that they could not find love or security within their childhood faiths. As baby boomers, both women were helped in exploring new avenues of

spiritual expression by attending college at a time when alternative lifestyles and religions were flourishing. Their artistic interests put them in continuing contact with other people who were pursuing alternative forms of spirituality.

During the 1960s and early 1970s, sexual liberation, a new emphasis on self-expression and personal freedom, and the unsettling effects of the civil rights and antiwar protests all had an impact on people's thinking. Many young Americans at the time became disillusioned with their parents' religions and lifestyles, and they never returned to the familiar values of the older generation, even though they eventually settled down to raise families and earn livings of their own.[4] As Katie Agresta muses, "I feel like in many ways I'm still a hippie at heart. I'm a retired hippie. I now work!" Artists like Wendy Ellsworth, who was fortunate enough to have financial backing and privileged schooling, and those like Katie Agresta, who was fortunate enough to work with the right people, managed to gain sufficient economic security from their artistic work to pursue their interests in alternative forms of spirituality. Yet it would be wrong to conclude that the passion for intense spiritual exploration comes only from having the right opportunities, just as it is wrong to assume that spiritual exploration necessarily involves a complete rejection of the faiths in which people are raised. For many artists, the drive to explore is evident even when they remain within established religious traditions.

Tweaking the Human Family

Bob McGovern is a passionate spiritual explorer. He is a big man with a kind, gentle face. Surrounded by his books and art, he sits in a wheelchair, his legs paralyzed from a bout of polio at age sixteen. He is a woodcarver, but his artistic interests include painting, sculpture, and pottery. Now in his late sixties, he has raised several children, been widowed, and is increasingly reflective about life. The role of the artist, he

muses, is "to tweak the human family and say, 'It is possible to be serious and playful at the same time.'" At least he tries to.[5]

The counterculture came too late for Bob McGovern; by the 1960s he was already established in his career. But he did not need the counterculture to pry him loose from mainstream culture: polio had been sufficient. Raised Catholic, he pretty much took religion at face value until stricken with the disease in 1947. "When I got polio, it was a real shocker. God and I still have to settle up on that issue! But I did undergo a conversion. I would have liked to undergo my conversion standing on a mountaintop, but I underwent it and I was wretched. I guess I reached out. One mortal human being should never be ashamed to do that. I reached out and I think God was there. A lot of stupid people were there with him. It was like a Fellini movie. God had all these weirdos with him. There was a menagerie!"

Besides unsettling his views of God, polio gave him the opportunity to become an artist. At the parochial elementary school he attended, he barely passed most of his subjects because of his budding interest in the arts. Public high school furthered this interest. When polio forced him to drop out, he at first had only a home tutor but through a state disability program was soon able to attend art school. "It was magical. I thought I was pretty good, but now I was up against some really good people. That was lovely. My teachers were very caring and demanding."

"I knew basically that I wanted to be expressive and I wanted as much freedom as I could cut away for myself," he remembers. Yet he was from a poor family and knew that he would have to find a way to earn a living, rather than simply expressing himself. He took courses in magazine illustration, which helped him find work almost immediately. His first jobs were with Presbyterian, Baptist, and United Church of Christ magazines, all of which were published in Philadelphia. These jobs put him in contact with seminary students who ran summer and weekend programs for at-risk youth from the inner city. By teaching arts and crafts at these programs, he discovered his interest in becoming a teacher. By

age twenty-three, he had been hired by the University of the Arts in Philadelphia.

As his career developed, his repertoire expanded to include a variety of painting styles, sculpting, and woodworking, and he sought a balance between his desire for self-expression and his need to earn a living. The two were inevitably in tension, however, and he found himself on a life-long quest to make sense of their relationship. He thinks one part of him reflected his father, a sensitive man who earned a sparse living painting houses and suffered from alcoholism. The other came from his mother, a pragmatic woman who cared for the house and worked as a soda jerk. Both parents were tenacious, giving him a strong sense of "stick-to-it-iveness," yet he regarded both as fragile, vulnerable, and in their own way mysterious.

McGovern characterizes his journey as a struggle to reconcile the mysterious aspects of life with its pragmatic side. He romanticizes his origins, describing his father as a "lover of life" and his mother as "a magical person," and he enjoys emphasizing his descent from the marginalized peoples of Ireland and northern Europe. At the same time, he describes himself as a thoroughly practical man who works hard, plays fair, and tries to be honest. Not wanting to identify too closely with ordinary middle-class values, however, he insists that the "life process" is more complicated than he is able to describe: "Life is really a drama about living. It's participating in a mystery. That came through very early in my life. I had the paradox of a father I loved who was a victim. He crumbled before the onslaught of a little alcohol. And a mother who was so busy keeping things together that she was marvelous, if that makes any sense. I would love to buy the big package of our society's values, but I think life is about living. And you are forced to live it at the level of mystery and desperation. One only gets to the mystery through some desperation."

McGovern was still young when he recognized what he now calls the "double-edged, scary and comforting business of spirituality." He encountered the scary part at his parochial school, where the nuns seemed "cruel and unbearable and stupid." The comforting part appeared in

the daily and weekly religious rituals, such as saying the rosary and refraining from meat on Fridays. Like his father, he found the rituals appealed to his poetic, melancholic side and drove him "deeper into the forest." He remembers the nuns making him write "I won't talk in line" in his notebook a thousand times and then going out in the rain, dropping his notebook, and seeing the words, written in soluble ink, disappear. This memory symbolizes the ironic contrast of form and mystery in all spirituality.

While he was hospitalized with polio, McGovern met people who reinforced his conviction that he had to set his own rules to survive. He recalls taking over the kitchen one day in protest against the meals the hospital patients were forced to eat. He was particularly influenced by a man in the next bed, an ex-sailor with polio who gave him a copy of Thomas Merton's *Seven Storey Mountain*. He soon became an avid reader of Merton, fascinated by the contemplative aspects of the Catholic tradition. He also remembers the man in his ward who was confined to an iron lung and suffered from indescribable bedsores. Although the man died, his struggle to spend even a few hours out of the iron lung was a lesson in courage. From him McGovern learned that bravery means "you don't necessarily have to win by other people's standards."

McGovern has "never ceased the religion," but his spiritual explorations have been an "odyssey." He thinks the typical pattern for Catholics (unlike Protestants, who focus on a moment of salvation) is to be "imprinted" at an early age and then embark on a pilgrimage. His own journey has been "exquisitely marked with a potpourri of vice and virtue that stretches like a crazy quilt." In retrospect, he believes he has always been guided by Providence, but he thinks it has been helpful to be free-spirited as well.

In early adulthood, he became part of a movement of young artists in Philadelphia known as the Resurgency. They were atheists, Jews, and renegade Catholics who shared an interest in bringing spirituality to the arts. He also belonged to a Jesuit group engaged in contemplative spiritual practices, and through it became friends with the brothers Daniel

and Philip Berrigan, Catholic priests whose antiwar activism was start-
ing to draw national attention at the time. When the Berrigans were
sentenced to prison, McGovern communicated with them regularly, ex-
changing poetry, drawings, and letters. About the same time, he fell in
love with an "extraordinarily wonderful" woman, married her, and fa-
thered three children. Seven years later she died of cancer.

"How does one pair the torments, as it were, the torments of living an
odyssey and at the same time meeting those turns that make the hang-
ing on or even sometimes the celebrating of the life process possible?"
he asks. "I would like to know, but it's human arrogance to want to know
it. I have to accept the mystery and continue on the journey."

He remembers driving home one winter night after visiting his wife
in the hospital. Dirty snow covered the ground, the wind was cold, and
he felt as desperate and lonely as he had ever been in his life. Suddenly
the scene before him seemed to brighten. It wasn't a miracle; he knew
immediately that it was only the streetlights reflected in the snow. Then
he heard a voice. It was his own voice, but it was as powerful as if it had
come from an angel: "It doesn't matter; it really doesn't matter." It did
not lessen the pain that his wife was dying; that fact still mattered enor-
mously, but he realized there was a larger meaning in life that tran-
scended loneliness and pain. The thought comforted him then and still
guides him. He believes with all his heart that the experiences we cannot
understand and the events we find difficult to accept do not matter that
much because they are part of something larger. This idea is hard for
him to communicate, but it is the main message of his art.

By his fortieth birthday, McGovern had married again and was seri-
ously taking stock of himself as an artist. Over a period of several
months, while painting a series of autobiographical pictures, he came to
think of himself as a "flimflam" man, focusing too much on pleasing the
market and too little on what was in his heart. He felt compelled to con-
tinue his spiritual explorations, letting them guide him even when there
seemed to be no answers to his questions. "I was searching for spiritual

nutrients," he recalls. For a while, he followed Merton's lead and turned for inspiration to the religions of China and Japan. He reread with new interest James Joyce's *Portrait of the Artist as a Young Man*, paying particular attention to the passages about the "wretched" condition of the church.

Although he still thinks of himself as a pilgrim, he also realizes, "I'm settled. I've settled into this wretched church. I'm like a sharpshooter sitting in the back of the church. It's terrible. But I'm a Westerner. I'm not about to go do something else that's crazy." Though living within his Catholic tradition, he regards spirituality, more than the church itself, as the center of his faith. "Spirituality is the currency of existence. It's how one barters the moments."

The woodcuts and plaster casts that have accumulated on the shelves of his studio provide rich metaphors of the odyssey he has taken. On one high shelf is a drummer boy from his childhood and an African painting bequeathed by his father. These stand next to a brass candlestick that is slightly askew. On another shelf is a head study of Saint Brigit and the castings for two works commissioned by the writer Andrew Greeley. Closer to the center is a large carving called *Our Lady of Victory*. Other shelves are lined with carvings and figurines. One piece in particular captures his fancy: a cherrywood cross, marred by a large knot. It remains unfinished.

Bob McGovern's story demonstrates the tenacity that is sometimes a part of people's yearning to have a better or deeper relationship with God. All the odds are against them. They could easily resort to despair, drugs, or the narcotic of daily routines and material pleasures. But they are driven by a desire for an authentic form of spirituality big enough to encompass all they have experienced. Not surprisingly, given the devastating emotions they have experienced, they do not settle easily for a faith that emphasizes intellectual arguments. They are drawn to artistic expressions of spirituality because they have experienced life in a way that cannot be reduced to words.

Beyond Broadway

Catholicism provided a big enough tent for Bob McGovern to carry out his spiritual quest within it; although he has learned from other religious traditions, he regards himself as a Christian. For others, reconciling art and spirituality is sometimes harder because their tent is smaller. Clark Sterling is a case in point. Raised Protestant, he was compelled to switch denominations and examine other religions; yet he has been able to follow his spiritual inclinations without abandoning Protestantism entirely.

A singer, actor, dancer, and producer, Clark Sterling has performed on Broadway but resides in the San Francisco Bay Area.[6] Although he could be mistaken for a Wall Street executive because of his clean-cut looks and well-polished manners, he has followed the spiritual path of a restless artist.

As a child, Sterling experienced little of the personal turmoil that encouraged Katie Agresta and Bob McGovern to question their spiritual moorings. He was raised by both parents in the same house in the same southern California community until he went to college. His parents sent him to Sunday school at the Presbyterian church they attended regularly and where his mother was active as a deaconess and on church committees. Instead of experiencing a dramatic conversion, he grew up thinking of himself as a Christian and enjoyed being involved in the church. During his years at Stanford University, where he was a political science major and sang and acted on the side, he still defined himself as a faithful Presbyterian.

Moving to New York to pursue his musical career broadened his religious horizons. The church he attended there encouraged him to think in new ways. It challenged him to pay greater attention to the diverse paths through which people realize their spiritual yearnings. So did making friends with actors and musicians from different religious and ethnic backgrounds. Despite his success in gaining roles on Broadway as well as in regional theaters and commercials, he felt restless about his acting's relationship to his religious identity. Part of him wanted to con-

tinue performing, while another part wanted to explore a career change that would take him into religious work.

To resolve his ambivalence Sterling temporarily gave up music and acting in favor of attending the San Francisco Theological Seminary. His decision was prompted by failing to obtain a role in the New York City production of *Les Misérables*. Yet, soon after moving to San Francisco, he obtained a part there. For the next year and a half he devoted his nights to *Les Misérables* and his days to classes at the seminary. "It was pretty strange," he chuckles, "to be sitting backstage reading Kierkegaard and Karl Barth!"

What he learned came less from reading theologians, however, than from experiencing life. "I used to want answers. I used to want my faith, my version of Christianity, to say, 'It's this way. This is how we're supposed to act. This is bad, this is good.' I guess because of the type of Presbyterian faith I was given as a child and a young adult, that was something that I just expected and looked to religion for." Instead, he has become more comfortable with the ambiguities of life. "I think life happens. You go out in life and meet people who see things in other ways. I didn't want to think, 'Oh, well, they're wrong,' because I saw value and love and meaning and wonderful things in people with different opinions. So this faith that had been so black-and-white without ambiguity became difficult because it didn't seem to be true to who God was showing me I was and who other people around me were."

At first, Sterling was sufficiently troubled by this ambiguity that he tried to find a more structured alternative. Having read some work by the conservative evangelical writer Francis Schaeffer, he traveled to Switzerland to take a seminar from Schaeffer. There he met Schaeffer's son Frankie, a budding writer and artist with broad interests in the arts who was having increasing difficulty with his father's dogmatism.[7] Sterling remembers Frankie telling him about showing some abstract paintings to an audience of conservative Christians: One man in the audience asked, "What's Christian about this painting?" Frankie responded by taking the man outdoors to look at the Alpine landscape and

said, "If you don't mind my suggesting the comparison, what you just asked me in there would be like looking up at this tree and saying to God, 'What's so Christian about this tree?'"[8]

Sterling returned from Switzerland convinced that ambiguity rather than pat answers was closer to his emerging understanding of spirituality. His seminary training propelled him along the same path. "You don't lose your faith necessarily, but your faith gets turned upside down and you look at it from all different angles. We had this speaker my first year who said, 'I've gone from a religion with answers to a faith with questions,' and that sort of became my mantra throughout the rest of seminary. I would say that's been my journey too. I've come from a much more rigid theology to one that's open to and more comfortable with questions."

In recent years his faith has been deepened by interacting with people from different traditions. "I've settled on less settlement. I've settled on more diversity. I wasn't wanting to sit in a Presbyterian church of the type I was raised in every Sunday—I wanted to go other places, I wanted to experience other faiths, I wanted to worship and interact with people who expressed themselves differently." He has appreciated opportunities to worship in different traditions, not because it is fun, but because he is better able to see the deep spirituality of people he meets. "It's an awareness of the validity of that life."

Sterling emphasizes not only the shift from a religion of answers to a faith of questions but also the continuity that ties his spirituality together. Little in his childhood experience or training encouraged him to explore spirituality on his own. Yet he remembers times of feeling that he was in the presence of the sacred. "Many of them involved music. If I think of what early on struck me as sacred, most often it was something artistic and most often it was beautiful music. It just touched me more than other things. The musical expression of Christianity, whether it was from a contemporary Christian singer with a guitar and a group, or a pipe organ in church, something about the beauty of the music really reinforced the sense of being created by a creative God, that it wasn't

just some cosmic accident." Music has remained his most distinct way of relating to the sacred.

Although he is unsure where his music will take him, he is trying to juggle a career that combines recording and acting with singing for church audiences and at religious conferences. He enjoys singing inspirational music that encourages people to feel closer to God, but he is increasingly recognizing that music can depict the complexities of life and the mystery of God as well. Although he dislikes violence, for example, he believes that it has a place in the arts because it is a terrible fact of life and people need to be confronted with its existence. He feels too that music can give people a greater appreciation of the small details of life, rather than simply directing their thoughts toward the sublime. One of his favorite songs is "Take the Moment," by Richard Rodgers and Stephen Sondheim. It says simply, "Take the moment, let it happen. Hug the moment, make it last."

As he has become more comfortable with questions for which he has no answers and with ambiguity that cannot be resolved, Sterling has experienced criticism from friends and family members who worry that he has become a spiritual dabbler. Like critics of the wider culture, they fear that the explorations of contemporary artists reflect too much of an accommodation with the diverse perspectives and lifestyles that have been championed by the mass media and heightened by information and affluence.

Such concerns are worth pondering, for it is evident that people like Wendy Ellsworth, Katie Agresta, Bob McGovern, and Clark Sterling have been shaped by the pluralistic, market-oriented culture in which they live. Encouraged from early childhood to form their own opinions, many Americans choose to pursue their own understandings of spirituality rather than conforming to the received wisdom of their religious traditions. A society rooted in market transactions encourages its members to shop for spirituality, even if the result is a pastiche of beliefs and practices purchased from a variety of spiritual vendors. Yet there are important differences between the superficial spiritual shopping so promi-

nent in the wider culture and the spiritual explorations evident in the journeys of many contemporary artists.

In Clark Sterling's case it is evident that living in diverse surroundings, straining to figure out the kind of career he wants to pursue, and questioning theological traditions have influenced the very nature of his ideas about religion. He has given up pat answers and come to terms with the reality of ambiguities. Doing so has not required him to leave the church; in fact, it has renewed his commitment to serving the church. But it has also earned him the disfavor of church friends whose views differ from his.

How unusual is Clark Sterling's story? Few people get the chance to sing on Broadway. But millions of people move from one community to another, hit snags in their careers, and search for ways to gain greater meaning from their work. In these respects, he is probably typical of many.

A Serious Spiritual Exploration

The contrast between shopping and serious spiritual exploration is further illuminated in the experiences of Rick Vise. This Pennsylvania-based musician, who specializes in guitar, Celtic harp, and African and Middle Eastern drums, supports himself by driving a truck for a private courier service four days a week and working as a massage therapist one day a week. He quit college in his sophomore year, when his rock band became successful enough to go on tour and make recordings. He toured full time for three years, first with a band called Silk Wind and then with one named Sugar Daddy, but eventually realized he needed to do something different with his life because the rock culture and nightly performances were too much for him. After working at various temporary jobs, taking classes, and traveling, he settled into his present routine. Yet, he admits, his music "remains the most important part of my path." He occasionally performs, composes, and choreographs, and he teaches seminars that integrate art, music, poetry, movement, and spirituality.

Rick Vise's interests in spirituality date from early childhood. As long as he can remember, he has had "an overriding sense of God," which he attributes to his mother's devout Catholicism and the many occasions on which she talked with him about her devotional life (his father was a lapsed Southern Baptist). He remembers walking into the desert near Phoenix, where his family lived while he was in elementary school, and almost literally feeling that he was in God's presence. A periodic heart arrhythmia and several bouts with pneumonia limited his ability to take part in athletics and other physical activities at school, so he became somewhat withdrawn and focused on what he now calls "the inner life." Although he tried to maintain a critical attitude toward them, he was fascinated by his dreams, his reflections, and his experiences of the sacred.

In high school he vowed to overcome his chronic illnesses by becoming a vegetarian and taking karate lessons. His introspective interests continued as he avidly read authors in his father's library, particularly Emerson and Thoreau, and dabbled with Buddhism and yoga. One of the teachers at the Catholic school he attended guided him through these explorations, warning him about extreme diets and pursuing altered states of consciousness, but encouraging him to examine the various practices of the world's major religious traditions. By the time he graduated, he had explored the Catholic mystical tradition and read some of the classic texts in Buddhism, Hinduism, and Islam. He was deflected from these interests while traveling with his band, but in his mid-twenties he took college courses, traveled, and broadened his interests in spirituality to include the healing arts and holistic health.

"For two years I studied and prayed," he recalls. "I went across the country, to Florida, New York, Kentucky, Georgia, Arizona, New Mexico, California. I stayed in monasteries. I studied holistic health and got some certification." Although Vise had some contact with the fundamentalist religious groups that attracted attention in the late 1970s, he soon realized that he needed more freedom than they offered. He settled into a loosely knit group in Philadelphia that attracted him because of its

religious and philosophical eclecticism. Its philosophy was "you're not supposed to stay in one place for very long; you learn what you can and then you go somewhere else."

During the year he was involved in this group, he was particularly attracted to the Sufi leaders who visited from time to time. "They were very wise, and the methods they taught incorporated not only meditation and prayer, but some of the most advanced movement I've ever encountered. More advanced than anything in the martial arts. Advanced breathing techniques combined with movement combined with drumming combined with meditation combined with completely opening your heart and being totally vulnerable. All the elements that were only partially present in other approaches were there with these Sufi sheiks. I was very impressed with them."

He read extensively in Muslim and Sufi texts, learned basic Arabic, consumed the poetry of Jelaluddin Rumi, gained further certification as a holistic health practitioner, and supported himself with a job in construction. Like Wendy Ellsworth's departure from the mountains, Rick Vise's decision to leave the group was prompted simply by the conviction that it was time to move on. He found a full-time job as a massage therapist at a holistic health clinic, devoted his spare time to reading religious texts, and learned to play the Celtic harp. He also married, had a daughter, and two years later obtained a divorce, retaining custody of his daughter.

The clinic where he worked soon collapsed from internal friction, and he set up his own practice with clients referred to him by a local chiropractor. Because his income was meager, he lived simply in a small apartment crammed with books and musical instruments. He continued to study Arabic and interacted as much as he could with Muslim and Sufi graduate students. "One thing I've learned about the burgeoning spirituality of our time is this: if you want to taste the essence of a spiritual tradition, you had best learn the etiquettes of that tradition. Because if you don't, you're going to have to sneak in the back door and steal the secrets. And if you're caught, you're going to get lightning bolts thrown

at you! Going in the front door is much better and that means knowing the etiquettes."

By "etiquettes," Vise means the daily devotional practices through which people in a religious tradition have learned to express their spirituality. "I wanted to experience the divine presence in their way. So I figured, 'I'll learn all these etiquettes.' Meanwhile, I'm falling in love with them. I was shocked, believe me. I'm thinking, 'Oh, my God. I can't be going in this direction.' So I started doing the formal prayers. For the first time in my life, my spiritual journey took on a conventional form. In the context of this Islamic experience I was being moved in my heart. By doing this prayer that millions and millions and millions of people do, I was experiencing something that was deeper than my own meditation had ever been. And I was shocked by that."

For the past decade, Vise has continued to learn about Sufism and follows some Muslim practices, such as praying five times a day. However, he has "pulled back" from the more structured aspects of Islam and has cultivated a more "open" or eclectic style of spirituality. "I saw that the social structure was something I would have to leave. I would have to leave that garden, but I did so with incredible respect for it." He recalls one of his Sufi teachers saying, "Respect all traditions and transcend them in your heart." His daily prayers, meditation, and reading, as well as his music, serve as the core ("the deep well") of his spirituality; being part of an informal congregation of Christians and Jews who come together for worship and who "contact the divine through a sense of creative ritual" is his way of being open.

Here is an example of someone who has clearly devoted an inordinate amount of effort to a spiritual quest. For critics concerned that spirituality cannot be genuine apart from a religious tradition, it also suggests the value of settling into a tradition. Unlike Bob McGovern and Clark Sterling, who made peace with the broader Christian communities in which they had been raised, Rick Vise turned to a different tradition. His story suggests the value of learning the wisdom inscribed in the practices of a tradition.

The larger point his story illustrates is that an unsettled life is not sufficient in itself to result in a serious and sustained life of spiritual growth. Effort, determination, and perseverance are also required. For Rick Vise, the possibilities of a new tradition were not fully apparent at the start. It was necessary to devote time to it before it became meaningful. When that happened, the journey did not end; instead, it continued to deepen.

More Than Shopping

The distinction between spiritual shopping and an intense spiritual journey comes into sharp relief in stories like these. Shopping for forms of spiritual expression can prevail in a society dominated by markets and market transactions. A society based on markets is driven by the need to keep prices low and to reduce the costs of making transactions, and it turns things into commodities. "How-to" books offering easy paths to spiritual enlightenment, flashy television episodes about guardian angels, and sermons providing simple formulas for salvation are examples of spirituality packaged for a society of shoppers. The consumers of such goods are lured with expectations of positive gratification.

Mass markets have become effective at generating and distributing goods, and shoppers are often pleased to have a plethora of choices. Markets nevertheless encourage people to keep their options open and to consider alternatives that may be cheaper or more gratifying, rather than remaining committed to a single course of action for an extended period of time. In the religious marketplace, shoppers switch congregations to find ones more appealing to their immediate interests, and they pursue the latest spiritual fads brought to their attention by savvy publishers or television preachers.

The spiritual explorations of artists like Rick Vise bear some resemblance to spiritual shopping. He has seldom felt obligated to stay in a single church or even a particular religious tradition; when there were teachings he did not understand or practices he disliked, he moved on,

only later and after considerable personal investment coming to realize the value of settling into one tradition. Bob McGovern and Clark Sterling have been more faithful to the traditions in which they were raised, yet they have been influenced by the ready availability of spiritual alternatives. Wendy Ellsworth and Katie Agresta have participated in organizations that marketed a blend of popular therapeutic and spiritual practices.

Yet the differences between these artists' intense spiritual exploration and spiritual shopping outweigh the similarities. In their search for truth, beauty, and a deeper experience of the sacred, these artists have made decisions that were personally costly. Each admits it would have been easier to stay put than to move on. Although they were products of their culture, they generally rejected its conformity and materialistic standards. Their search for spirituality was hardly an efficient one; it required huge investments of time and effort.

In each case, the spiritual journey entailed some shifting from one religious tradition or practice to another, yet the various encounters included significant involvement as well. Whereas shoppers emphasize their freedom to make choices, these artists generally felt they had no choice. They were instead driven by an overpowering need that they could not escape. At the same time they were aware of life's uncertainties, realizing that any decisions about career or marriage might not produce the desired result. Whereas the job of a successful marketer is to persuade shoppers that they have found the right answers to their problems, these artists typically recognized that uncertainty is inevitable and perhaps even desirable.

Rick Vise's view of what it means to be a spiritual explorer illustrates these differences. He thinks a genuine spiritual quest stems more from desperation than from the titillation of dabbling with something new. His exploration beyond his Catholic heritage was one he felt compelled to make. Yet he also thinks people may be pursuing something that is rooted in their early religious experience and for this reason bears more affinity with it than they realize. "What we are looking for is a reflection

of what we already have experienced," he explains. "In other words, we're looking for a reflection of something other than the crassness of the world. We want our soul to be reflected back to us."

Living with Dislocation

That the drive to explore is often rooted in some unsettling personal experience cannot be emphasized enough. Wendy Ellsworth was drawn into an alternative lifestyle in reaction to the alienation and possible abuse she experienced in her childhood. Katie Agresta's upbringing included serious tension with her parents. Bob McGovern's polio and Rick Vise's childhood illnesses limited the activities they could pursue and led them to read about spirituality and become interested in the arts. Clark Sterling says he has been remarkably free of personal crises, but it was unsettling for him to move to New York and make friends with people so different from his childhood friends and family.

The trauma that leads some artists to embark on spiritual quests suggests that the creative spark may be (as is sometimes argued) rooted in personal pain wrought by social dislocation. For Jennie Avila, the traumatic spur was leaving home at eighteen; for Jon Davis, being raised by a violent father; for Wendy Ellsworth, coming to terms with remembered abuse. Among all the artists interviewed, 95 percent said they had been deeply influenced by personal crises, of which the most common were parental divorce or fights, loss of a loved one, and an accident or serious illness; nearly half had been afflicted by multiple crises. A high proportion were themselves divorced or separated; more were raised in families that moved around than in families that lived in one place; and a substantial minority had moved frequently.[9] Such crises have played a role in the creativity on which artistic accomplishments so clearly depend. Although it is possible to be creative without having experienced personal trauma, such experiences often jolt people into asking questions that other people have no reason to ask and gaining a new perspective on realities that other people take for granted.

What most distinguishes these artists, however, is the introspection with which they respond to personal crises, and how their artistic work expresses the resulting emotions. The story of one woman who had been in a serious automobile accident when she was sixteen illustrates a typical response: "It made me much more introspective; actually, since I'm an introspective person anyway, it gave me the opportunity to do more introspection." As she reflected on her life, she decided to be different from her parents and follow her own path, which eventually led her to become a painter. Another painter describes her most traumatic moment as "the volcanic explosion that occurred within me"; she has clearer memories of how she was feeling inside than of any precipitating factors in her environment. A writer observes, "I think all artists are influenced by some trauma or another. I wouldn't be willing to talk about mine, but, yes, there was trauma; it puts you in a position to use your ability as an artist to try to understand the trauma." Without introspection, it is doubtful that crises alone would result in creative work. Introspection involves paying attention to the pain and confusion one feels, rather than blocking it from consideration or dealing with these feelings in purely intellectual terms. Even more important, introspection requires personalizing experiences and thus having to deal with them in unique ways. Creativity is necessary if only because no other person has been in exactly the same situation.

Why personal crises compel some artists to engage in spiritual explorations while others do not may be partly attributable to childhood religious experiences. Artists having no childhood exposure to religion are less inclined than other artists to regard spirituality as a relevant aspect of personal crises. Artists who simply take their religious traditions for granted may have little inclination to explore alternatives when crises occur. Those most likely to embark on spiritual explorations have experienced the sacred in a meaningful way during childhood and, even if they later become disillusioned with formal religion, remain convinced that the sacred may again be experienced through personal explorations.

Katie Agresta recalls a powerful childhood experience of the sacred.

Although her parents did not encourage her to explore spirituality, they did send her to church and to parochial school, where she had ample opportunity to think about God. A weekend retreat brings back fond memories: "We had to stay silent for three days in a convent with the nuns, and that was a big turning point for me. I'd never experienced silence, and I sat in the chapel all day long and just prayed the whole time. It was so wonderful." Later in adolescence this experience remained meaningful for her, even though she was repulsed by the harshness of the church's teachings and practices. Clark Sterling's feelings of being close to God when he listened to music and Rick Vise's memories of sacred experiences in the desert reinforced their conviction that spirituality was worth pursuing.

If they take their spiritual exploring seriously, these artists nevertheless emphasize that the passion to explore should be tempered with an element of wonder and thus with an attitude of playfulness. "There needs to be some humor," Bob McGovern asserts, "not humor in the sitcom sense, but humor in the sense of a divine comedy." He believes that the ability to sit back and smile at oneself is the best protection against taking oneself so seriously that one's efforts to do good become evil. A playful attitude makes it possible to focus on the seemingly trivial details of life ("the drift") instead of looking for big battles to fight. "Everyone focuses on the river," he says, paraphrasing something he read, "but we also need to pay attention to the drift."

Paying attention to the drift is his way of saying that God is in the details. To the artist, these details are often an occasion for reveling in the grandeur of life. They are the "whorl of fingerprints" that Jon Davis claims quickens our longing for the sacred. Unlike the river, with its insistent pull toward its final destination, the drift is quieter, less enticing, and easier to ignore.

But noticing the drift may be the key to staying alive, especially for the adventurous wanderer. To illustrate this point, Bob McGovern tells the story of a strapping young man: "David would go out hunting with his buddies on New Year's weekend. He was refreshed with alcohol, but

he was the strongest of the group. They pulled up to a little island. He and the other two guys got out of the boat and followed the game. They didn't moor the boat very well, and the boat started to drift out into the river. The other guys are not as strong as David, and David says, 'I'll get it.' David goes out for the boat. The boat teases him further and further and further. So this mighty young man meets his end."

The story is about paying attention to the details as one explores, rather than living unreflectively or focusing only on end goals. It shows the importance of being passionate about one's spiritual quest and of paying attention to the moment-to-moment attractions that can be deadly seductive. "When I talk of drift, I mean something very important. As the story shows, drift is not a little thing. It's a big thing, it's paradoxical, it's ironic, it will trap you. For people in the spiritual life, if you get deadly serious about religion, you'll be very busy about the river. Just don't forget to pay attention to the drift."

Paying attention to the drift is thoughtful advice for spiritual explorers. It means observing the currents that carry one along—whether, for instance, one becomes entranced by the latest spiritual fads or grows so serious about one's faith that life itself slips from view. Many Americans dabble in shallow spiritual waters because the consumer market brings them an abundance of spiritual titillation. Many others work hard at finding an enriching religious tradition or following the dictates of their conscience. An artistic approach to spirituality recognizes the need to settle in, rather than being swayed by a consumer mentality. Being driven to explore means that the search for a spiritual life goes well beyond a trip to the spiritual supermarket to escape the boredom of a lonely afternoon. Intense spiritual exploration involves commitment and sacrifice. It pays heed as well to the value of levity.

3

MAKING SENSE OF ONESELF

I'll never forget her face, and the somber tone of her voice. She
said she had finally found her home, she was no longer in exile.
I thought she meant her house. . . . But she said no, she had
found her home in words. Words provided the comfort never
given by her mother. She blanketed herself in words, they kept
out the coldness of her estrangement. She was ever so grateful.
Words had given her a place in the world.

Michele Zackheim, *Violette's Embrace*

THESE SENTENCES APPEAR near the end of Michele
Zackheim's fictional biography of the French writer Violette Leduc, an
intimate friend of Simone de Beauvoir and the author of such works as
Mad in Pursuit, In the Prison of Her Skin, The Taxi, and the confessional
La Bâtarde.[1] In Zackheim's novel, Leduc emerges through the eyes of
an admiring American artist as an elusive figure whose personality ex-
ists in the fragmented memories of her friends and the faded scrawling
of her letters. She is the product of an illegitimate birth, a lonely and in-
trospective childhood, and an impoverished upbringing. As an adult,
she suffers marginalization from being Jewish, unmarried, and female
in a society dominated by masculine roles. Although she seeks com-
panionship among her friends, they one by one become victims of the
dislocation of World War II. Leduc gives birth to herself and main-
tains her sanity through writing. "Violette employs her art, her writing,
to seek understanding and forgiveness," Zackheim observes. "Even
though she was yearning to exact revenge for her wretched childhood,

she was also attempting to integrate her life, to give herself a reason for living."[2]

The novel can be read as illuminating the struggles many artists experience in trying to make sense of who they are—and, indeed, about the unsettledness many of us face in today's world. It is certainly as much about Michele Zackheim as about Violette Leduc. In the closing paragraph the author confesses, "Violette Leduc is my sister, my shadow"; similarities between the two women emerge throughout the book.[3] Zackheim, like Leduc, grew up Jewish in a predominantly Christian community that was often blatantly anti-Semitic; both were lonely children who found comfort in books and in their artistic interests. After one year of college, Zackheim moved to New York City and struggled to support herself as a graphic artist; her career emerged slowly and, like Leduc, she turned to writing to make sense of herself.

The broader question that Zackheim's rendition of Leduc raises is: How is it possible to be shunted from place to place, to experience alienation and even abuse, and yet to emerge as a fully functioning person? In the case of artists, many have been compelled to search for spiritual answers because the very foundations of their lives were shaken by illnesses, broken relationships, dysfunctional families, and other traumatic experiences. But some of them manage to piece their lives together. How? Their creativity may be nurtured by hardship, but being able to pursue their art over a period of years requires discipline. The scattered bits of their self-image have to be put back together. What is involved in this process?

This is one of the most important spiritual questions of our time. If spirituality relates us to God, it must relate all of us—our whole being—to God. There must be healing and integration. What artists struggle with in this respect is similar to the experiences of most of us. We live with broken expectations and in fragmented communities. Creating some semblance of wholeness in our lives becomes a prevailing spiritual problem.

Insights gleaned from studies of trauma victims provide a way to

think about this problem. Trauma disrupts the usual mechanisms by which we make sense of the world. It rips people from supportive ties and from daily routines that provide a tacit sense of their personal identity. Simply returning to these routines may not help because we now have questions we did not have before. Some active efforts to reconstruct one's identity, such as therapy or counseling, are often needed. And the crucial aspect of these efforts appears to be storytelling. New narratives about oneself and about one's experiences provide tissues with which to weave an identity, and perhaps even to connect that identity with an understanding of God.

Artists are typically in the business of storytelling, either as creative writers or through the lyrics of their songs or the representations in their visual art. Their personal journeys are frequently embedded in their stories as well. By examining their stories, we learn both how art plays a role in personal healing and what forms the most helpful of these stories may take.

At her home overlooking a valley north of Santa Fe, Michele Zackheim acknowledges that she is more comfortable letting her life reveal itself through her writing than speaking directly about it. She describes her childhood as "traumatic" and characterizes the community in which she was raised as a "sterile, stupid, redneck area." In her novel she elaborates, "Two times I was ambushed by a gang of abusive white boys. Each time they jabbed at me, called me 'nigger lover,' shoved me down, and left me with my dress pulled up and my panties showing. I finally got smart. I sharpened the corners of my black lunch pail and swung at anyone who came too menacingly close. After a couple of bloody encounters, I was left alone."[4]

Besides defending herself, she sought refuge at a nearby Catholic church, where she often sat quietly and looked at the altar. As there were no local synagogues, she regarded this as the best place to seek the security of religion. Growing up, she became an avid reader, filling her bookshelves with fiction, philosophy, and theology. Increasingly, she painted to give expression to her thoughts and feelings. "I live in an interior

world," she explains. "I'm influenced by my matriculation through my life. As questions arise that are psychological or spiritual, I start to think about them. If there's an issue, I'll start to think about it and from that comes the work." Turning to writing seemed less a conscious choice than the result of internal issues moving her in that direction. Like Violette Leduc, her words help her to know who she is. "With my work," she says, "I am trying to make sense of a multitude of contradictions."[5]

Her comment points to a pervasive theme among contemporary artists. Often driven by personal crises and by an irresistible impulse to be creative, they experience the fragmenting contradictions of American society with particular force. Making sense of these contradictions is seldom easy because artists are generally reluctant to settle into conventional community roles that define their existence for them. Instead of adopting the worldviews of a particular religious or philosophical tradition, they piece together distinctive understandings of who they are. In large part it is this process of constructing an identity that draws David Ellsworth to the undefined spiritual aspects of his woodworking and encourages Katie Agresta to pursue her varied spiritual disciplines and therapeutic practices. It is integral to Wendy Ellsworth's long journey toward greater self-understanding and to Jon Davis's efforts to probe his psyche through writing. Amy Torchia's song about pushpins on a map expresses the dispersion of personal experiences that makes such integration difficult. And yet, through the music and the images—through the words that give them a place in the world—the spiritual reflections of contemporary artists suggest ways in which to draw the fragments of personal experience into a coherent whole.

The Language of Recovery

In their struggle to make sense of themselves, many artists rely on language that emphasizes therapy, healing, spiritual awareness, and especially the idea of recovery. Although narratives of recovery sometimes draw explicitly from the language used in Alcoholics Anonymous or

other twelve-step groups, the self-help lingo has become so widespread in our culture that many people resort to it almost unconsciously. Artists, however, show how this language can be deployed creatively and how it must be adapted to personal circumstances to be effective.

Take the example of Cynthia West, a visual artist and poet who, like Michele Zackheim, makes her home in Santa Fe.[6] In commenting on her artwork in a gallery handout, she emphasizes her "journey through change, self-examination, doubt and faith." One painting has become emblematic of her life. Entitled *Healer*, it depicts a Native American woman against a dark blue background, eyes closed in meditation. Behind her is a rainbow and above are three angels and a large white bird, all beaming light into her body. In turn, a ray of light emanates from the healer's heart and enters the body of a second woman near the bottom right of the picture; a pueblo and mountains are in the background.

For as long as she can remember, West has made sense of her journey by mingling the rich imagery of artistic work with her personal experiences. In childhood, as an adopted daughter, she came to understand her origins from fanciful paintings done by her adoptive father showing her arrival on a giant amanita mushroom surrounded by fairies and dancing onion people in a forest of smiling trees. Her elementary school teachers encouraged her to draw and praised her generously for her efforts. Her drawing provided refuge from an otherwise turbulent home and school environment. When her parents separated, she sought comfort in reading and came to love mythology so much that she hoped to study with the comparative religionist Joseph Campbell when she went to college. Instead, she pursued her artistic interests at the Rhode Island School of Design, but became pregnant and quit before graduating.

Over the next five years she gave birth a second time, divorced her first husband, married again, experienced the grief of her mother dying, moved to California for a few years, and then settled in Taos. There she and her husband served as hosts to hundreds (she thinks perhaps thousands) of itinerant young people visiting the desert in the late 1960s in search of themselves. The summer she was pregnant with her third child

she and her husband lived in a teepee while they constructed an adobe house. Several years later, now with a fourth child, she left her husband and relocated in Santa Fe. She learned much about art and life from the Native Americans who lived nearby and from the constant flow of visitors, but it was not until her youngest child started school that she was able to resume painting as a way of expressing her spirituality and her understanding of who she was.

For the next decade West painted every day while the children were at school. Married now a third time, she was able to establish a studio in a building her husband owned. "I wanted more technique," she recalls. "I wanted to express my connection with God and my love for God and my love for life and everybody. To do that, to make something so extraordinary and unusual, I wanted to have the tools and the techniques to express myself and to make it the most available possible to people."

Her efforts were eventually successful. In the late 1980s people began flocking to her exhibits at Santa Fe's leading galleries; her paintings sold for as much as $10,000. But interest in her work soon faded. "Strangely enough, every effort I made, every gallery I approached, everything I did absolutely fizzled. It was just horrible. Everything that had worked suddenly stopped working. It was as if a veil were thrown over me and all of my work. It made me invisible. Nobody could hear anything I said. It was just a nightmare."

Because she had always tried to integrate spirituality into her art, the problems in her career were accompanied by a serious crisis in her spiritual life. "Physically I was never at the point of death, but it was as if one lifetime ended and another lifetime hadn't yet begun. I was in a state of erasure, removal, extinction. I was out." Still, she kept working, experimenting with new methods of painting, learning pottery, and trying her hand at glazing and painting still lifes. "It was years of deaths that just extinguished my creativity. The effect was like damming a river. I was struggling along, doing all the same things and trying to sell things and praying and living my life. But it was slowly strangling me to do so. It was as if it had all become some sort of a syndrome, an addiction, an in-

credible attachment. There was an enormous amount of grief connected with my lack of success. I wanted recognition and the paintings wanted it, too. They're real, living things to me, the paintings. They wanted to be out there, talking to people. They were demanding of me and driving me, so I was doing everything I could to make that happen and I was just running into a brick wall. I was forced to quit for my own survival. I was just put out to pasture. I guess I needed it. I had exhausted myself and drained my reservoirs and demolished myself entirely."

Abruptly canceling an exhibit, West literally put herself out to pasture, spending days taking long walks through the meadows near her home, musing about her life, scribbling in her journal, and writing an occasional poem. Working with clay provided further opportunities for self-reflection. "The pure, simple spinning of the form and centering the clay and centering myself and just being with the spirit of the earth," she remembers, were a vital dimension of her healing. Over the following months, she was able to remold her understanding of herself in a way that brought the various strands of life into greater harmony.

It became apparent to her that she had always suffered from feeling out of place. Knowing that she had been adopted, and being separated from her adoptive father after her parents' divorce, she "had the worst feeling that I'd gotten off at the wrong train station. I did not feel comfortable in this life. I knew I had made some awful mistake, that I'd just taken the wrong turn and that I wasn't with my people." She remembered more vividly how she had found comfort as an adolescent taking walks along the California coast. One of her poems recaptures that sense:

> Mother Pacific, you prayed through me
> When I was very young
> When you were strong, exultant and unharmed.
> You swam, enfolding me
> In tides that bore the same salt as my blood.
> You cared for me
> In ways my mother never could.[7]

She also gained a better understanding of her fascination with Native Americans. Having lived with them for more than three decades, she has been influenced by their thinking in ways she cannot easily put into words. She remembers being attracted to them as a child and to their music as a young adult. Yet she realizes that part of her spiritual crisis coincided with American Indians' efforts to reassert their identity and to take a more critical stance toward white New Mexicans borrowing their culture. She has gained a greater appreciation for herself as a white person and learned to distinguish more sharply between herself and the Native American healer in her painting.

West summarizes the last few years as a process of recovery. Her artistic work once again energizes her; she is experimenting with computer software for manipulating images as well as continuing to work with pottery. Asked to name her most satisfying accomplishment, she mentions her well-known kachinas and her mastery of computer graphics. But her greatest satisfaction comes from her personal growth. "I have managed, I think, to clean out quite a bit of my past through the living of this life and to make myself a clearer vessel than when I was born."

Her understanding of recovery is similar to Wendy Ellsworth's story of death and rebirth on a mountain road and Katie Agresta's journey from nearly dying to being able to work again. Recovery is deeply spiritual as well as physical because it is about the larger meaning of one's life. The resulting coherence comes from painfully separating with the past. Cynthia West says her time of trial nearly annihilated her. "It caused me to put away all that I held dear. Even though I didn't stop the relationship with my husband, for instance, I questioned it, and it stopped inside of me and then started again as if it were new. I questioned everything, all my roles, all my functions, all the ways I've proceeded. Everything had to be given up. And in some cases I'm allowed to pick things up again and in some cases I'm not allowed to pick things up." Separation from the past facilitates greater detachment from the present as well. Yet the main result of being able to tell one's story as a

narrative of recovery is forging a clearer understanding of who one has been and where one is going.

This example shows that a narrative of recovery can play a valuable role in knitting together the parts of oneself that have proven ineffective and in persuading oneself that healing has taken place. The narrative can be developed in visual form as well as through poetry or writing in one's journal. As West's painting *Healer* illustrates, the first steps toward recovery may involve expressing one's hurts or hopes in images that have not yet turned into words. Art can provide a way to crystallize these feelings so they can later be expressed in verbal form. There is also clear evidence in West's story that time must be set aside to let one's feelings ripen. The dead hand of ordinary work can then be replaced by a more creative perspective.

The Journey Home

Instead of invoking narratives of recovery, other artists make sense of themselves through stories about returning "home," often drawing on biblical narratives. Sometimes their stories map a literal return from life amid competing communities and responsibilities to the secure surroundings of childhood. More often, they turn the childhood home into a metaphor for the security sought later in other venues.

Warren Cooper—a prominent gospel recording artist, producer, and host of a weekly program on Philadelphia's jazz station WRTI—is one artist who integrates his understanding of himself through a narrative about returning home.[8] Specifically, he uses the biblical story of the prodigal son as a template for understanding himself. "Churchgoing was never optional," he says of his upbringing. As an African American preacher's son, he was simply expected to be involved in church, and these activities became a central part of his identity. By fourth grade he was singing in the children's choir and performing at funerals. But by the time he reached high school, he began having doubts about the church. He felt that the church people either expected too much of him

or attributed his budding musical success to having special privileges at the church. "You get mixed up in all the political stuff [at the church] and you become jaded!"

He recalls storming into his father's study one day just as his father was preparing the Sunday sermon. Cooper was trying to reconcile something from Sunday school about how the world began with his own views on the subject. His father, impatient at being distracted from his work, counseled him just to accept what he had been taught. Cooper remembers leaving his father's study all the more determined to think for himself.

His "rebellious years" included the four years he was away at Oberlin College. "I rejected the church. I had developed an allergy to all that church stuff because of all the negative experiences I'd had with it." College provided him with opportunities to develop his musical interests separately from the church. He sang in a college choir, became the assistant director of another choir, performed at concerts, and became involved in radio broadcasting. Even though he devoted much of his spare time to music, he pursued other interests. His decision to major in philosophy rather than music was partly an attempt to gain distance from the church contexts in which his early musical interests had emerged.

When he returned to Philadelphia after college, he resumed some of his musical activities at his father's church, but he continued to distance himself from the church emotionally and intellectually. Performing at weddings and funerals increasingly became simply a way to earn money. He continued his gospel singing, but mostly at other churches. Gradually his repertoire expanded to include jazz and rhythm and blues. He wrote songs for local recording artists, sang in bands and choirs, and went on occasional tours; to hedge his bets, he also attended law school and worked part-time as a law clerk.

By the time he was twenty-seven, Cooper knew that a career in law was not for him. Even if it meant existing on a modest income, he knew he had to be true to his musical interests. But figuring out how to pro-

ceed was difficult. He had already married, had a daughter, and gotten a divorce. He was directing the choir at his father's church, but felt increasingly drawn toward working as a jazz musician in New York City, and he was devoting time to recording and establishing his own production company.

His spiritual interests were taking him into new territory as well. He started attending meetings at the Circle Mission Church, one of the last vestiges of the Father Divine Peace Mission movement that flourished in New York and Philadelphia between the two world wars.[9] Cooper was attracted by its emphasis on achieving personal moral and spiritual victory through true faith in God. Although Father Divine's philosophy was Christian, it was sufficiently different from that of Cooper's father to offer new insights. After four years at the Circle Mission Church, Cooper reaffiliated with his father's church (although a few years later his father retired as head pastor).

Warren Cooper had come home. Yet his understanding of himself had enlarged considerably during his time away. He now thought of himself more as a child of "the king of righteousness" than as a member of a particular church. He had resolved the tension between the church's teachings and his own thoughts about spirituality in favor of the latter. Freedom to believe and to accept others had become more important than following a particular tradition.

The role of music in Warren Cooper's story is particularly revealing. At one level, the transition from one kind of music to another was simply the occasion for him to be more or less involved in the church. It was, in this respect, no different from the work or hobbies that draw everyone into various circles of influence. But music was also the way that Cooper expressed his changing understanding of himself and his relationship to God. He shifted from music that defined him as a loyal member of his congregation, to music that identified him as a free-thinking individualist, and finally to music that emphasized his unique personal relationship to God. The home to which he returned was thus

not the same as the one he had left. It was a new, enlarged sense of God's kingdom.

Michele Zackheim also draws on the story of the prodigal's return home to make sense of herself. Her observations about Violette Leduc's writing emphasize the exile's search for a home. In Zackheim's account, Leduc finds coherence as much through the daily rituals of her home (especially cooking and cleaning) as in her writing—rituals that Leduc had to rediscover after long years of living without them. Zackheim herself reflects fondly on her own home as a place of security: "When I sit on the porch of my studio, in the perfumed air of the roses, with the summer breeze ringing the Japanese temple bells, it is my daytime paradise."[10] But the symbolic security of returning home is more evident in her visual art than in the serenity of her porch. One of her most widely acclaimed artworks is *Tent of Meeting*, a 1985 installation composed of earth-tone mountains, trees, pillars, clouds, wings, and hundreds of detailed pictures that have been hand-drawn, photocopied, enlarged, and then painted on a tent-sized canvas covering 1,100 square feet.[11] Inspired by Zackheim's knowledge of the major world religions and a trip to Israel, the installation symbolizes the common Abrahamic origins of Judaism, Christianity, and Islam. Although she did not realize it initially, the tent has come increasingly to symbolize a home as well. Despite its references to patriarchy, she regards it as a feminine vessel that makes her feel safe. Like Violette Leduc, who blanketed herself in words, Michele Zackheim has created an artistic canopy that integrates her identity as a Jew with that of living in a religiously pluralistic world.

Both the tent and the domestic rituals illustrate another way in which people find spiritual integration: by constructing a space in which their understanding of themselves takes on visible expression, almost like a sacrament. For some, building the home of their dreams accomplishes this task. More commonly, they value a space that combines something of their personal history with tangible symbols of religious meaning. A place of worship that resembles the one in which a person was raised is

an example. When such a space cannot be found, reminders of one's journey may be symbolized in the singing of traditional hymns or in time-honored liturgy. Or returning home may be accomplished through a family altar adorned with a treasured Bible, an icon, or a picture, perhaps accompanied by family photographs or childhood mementos. Such a space serves as a reminder of the continuities in one's life.

Spiritual Conversion

In their search for self-understanding, some artists emphasize an especially meaningful moment of conversion, a spiritual awakening that becomes a turning point in their lives. Although conversion narratives are typically associated with Protestant fundamentalists who believe in a distinct moment of transformation when they become "born again," references to similar experiences can be found in various artists' accounts of spiritual journeys. Unlike the gradual healing depicted in recovery stories and in narratives about returning home, these conversion narratives highlight the possibility of a sudden dramatic change in one's life.

Sharon Thomson's understanding of herself is organized around a conversion narrative. She is an accomplished writer who serves as poet-in-residence and national program developer for the Grail, an international movement founded in 1921 for women seeking to deepen their spirituality.[12] Thomson was in her twenties when she experienced a spiritual turning point or conversion. She had been raised Catholic, but did not remain active in the church after high school. In college she pursued interests in writing and read widely among religious and secular writers who focused on spirituality, feminism, and social activism. Dropping out of college to marry and start a family, she found herself a few years later divorced and in a trying battle with her ex-husband for custody of their daughter. She immersed herself in secular and religious feminist groups and through one of them participated in a weekend retreat at a Benedictine monastery in upstate New York, where she remembers being at Mass one morning: "What they had to say wasn't very enlight-

ening. Yet I was being moved and I understood the symbolism. The symbolism, the cross, the language, the music, all of it was deeply embedded in my psyche from childhood. I remember thinking to myself, 'I don't know if this is true, but the place that it's taking me is true.' It was a vehicle that could take me to a true place. At that moment I was willing to redefine myself once again as a Christian. That was a choice I made at that moment, and I followed it through for a number of years, with all the insights that it brought to me."

More than two decades have passed since that morning, but the event is still a pivotal episode around which Thomson organizes the scattered details of her life. It links her adult life with her childhood. "My home life was very chaotic, a lot of alcoholism and things like that, so church turned into my home and Mary was my mother and Jesus was my brother." She learned early to retreat within herself and to experience the sacred there in a comforting way. "I'd talk to God. God would talk back to me. I would cry. I would do the stations of the cross and I could feel the nails going through my hand. By the time I finished doing the stations of the cross, I was in a frenzy, an emotional, spiritual, cathartic frenzy, and I loved it." Her interest in poetry grew from these cathartic childhood experiences. Her conversion at the Benedictine monastery drew her into the same interior reality and made sense to her because of those experiences.

It has also served as a model for more ordinary ways of relating to God. For years, as a substitute for the Catholic Mass, she practiced a method of breathing she learned from a Zen master. It served as a "vehicle" for taking her to the same place of truth. "Whenever I would let go and more of my body began to breathe, there was this tremendous emotional catharsis. This was a spiritual practice, and it was a psychological event. So here I am a Christian, but really my main spiritual practice wasn't the Mass." Breathing in this way was similar to the turning point she had experienced in her twenties.

In her forties, Thomson experienced a second major conversion. She was living in Portugal at the time and remembers being "very productive

as an artist" when she learned she had breast cancer. She underwent a partial mastectomy and received six weeks of radiation treatment. "It was an extraordinary time. I was so alive, and through that entered into this whole spiritual movement of what it is to be healed. I returned to breathing as the main source of my healing. I did not have side effects from the radiation. I felt terrific, and I discovered a whole bunch of thinking about the ways in which we create reality. Somehow our interpretation of what is happening becomes what is happening. And it is possible to reinterpret, to make a choice about the way in which we want to perceive reality. This became for me a way of experiencing life and re-understanding it. I wasn't even concerned at that point about whether this works with Christianity or not. I was much more involved in experiencing the spiritual life, which for me is really about the essence, the point of contact with something greater than myself, the moment when I know that there's something more going on than this moment that I can perceive with my senses."

During this second turning point, she gained a new awareness of God's love. "There was a work I was supposed to do that I hadn't done yet, and that connected to being a poet. I was here to do this work for a reason, and it wasn't just about me. It was about something I was supposed to contribute to the world, to the species, to the energy field that's part of our planet. I was supposed to do something here and make a contribution, and that was one of the reasons I was here. The other reason was that there are certain spiritual lessons and those are related to love and to God. I hadn't completed them yet, so I couldn't go until that was complete."

This turning point was similar to Wendy Ellsworth's sense that her life had been spared for a reason. It gave Sharon Thomson a second start, much like the one Cynthia West experienced after the low point in her professional career, when no one would exhibit her paintings. "What it brought me to was my poetry and, [in the Grail] community, to living out a mission through culture and ritual and the integration of spirit and politics. That's the reason I'm here. My great spiritual chal-

lenge now is to believe as I'm doing this work I don't have to worry so much about it because the spirit is here and helping to make it happen, and it will happen. I just have to show up. There are certainly details I have to perform, but I don't have to worry. It's going to be taken care of. I'm doing the work I'm supposed to do. I am the vehicle."

As Thomson's story suggests, conversion narratives can be constructed from events involving spiritual insights from a variety of religious traditions. At the same time the prominence of Christian imagery in American culture serves as a kind of template for such stories. People do not have to invent a framework for their stories. Moreover, the conversion does not need to be all-consuming to seem legitimate; indeed, many such stories contain admissions of doubt. It is the very familiarity of such stories in our culture that helps to persuade us that spiritually transforming experiences can be part of the lives of ordinary people.

In artists' conversion narratives, two other features are also evident. First, when accompanied by creative renderings, the narratives take a unique and highly personal form. Rather than saying that the experience was like that of the Apostle Paul, the artist expresses his or her own vision on the Damascus Road through a poem, a painting, or a song. Second, conversion narratives frequently help artists explain why they gave up hopes of success and turned to more personally gratifying pursuits. In a world where linear trajectories toward success are seldom easy to sustain, this may be an important insight for everyone.

Reinventing Oneself

A final type of narrative that needs to be examined emphasizes explicit, self-conscious efforts to redefine oneself. Narratives of recovery, returning home, and conversion sometimes include descriptions of conscious searching and moments of decision, but many of these stories focus on events beyond the person's control. In contrast, stories about reinventing oneself suggest that deliberate effort is sometimes the most effective way to piece together one's identity.

Berrisford Boothe sees a time of conscious self-redefinition as the major turning point in his life. Born in Jamaica, he emigrated to the United States at age ten and eventually became a visual artist specializing in paintings with layers of gestural and color field abstraction. "Throughout all the works, however faint, the presence of amorphous cosmic cores are evident," one critic remarks. "Boothe's work traverses into the realm of the sublime; it is an intriguing and spiritual journey."[13]

Boothe's moment of self-redefinition came toward the end of his first decade as a professional artist. "When I was about twenty-nine years old I got bored with technical proficiency. I got bored with the ability to make things. I felt that I had basically begun to chart my future as an artist and that I was dependent on the business of art. I didn't think that was a smart move. So one day while working on a large painting, I proceeded to cut it into nice little strips and took all my brushes and parceled them up together and packed up my studio and put it nicely with little bows outside for the garbage man to take away, and started over. That had a profound impact in terms of a spiritual journey. It led me to where I am now. It forced me to say to myself, 'I am the artist. I am the one who will make the decisions. I will sink or swim. It is not about proclamations outside of self.'"

Boothe realized that he did not want to pursue an art form that would place him in a category. Instead, he wanted to stake his own "individual claim on life." To do that, he decided to make a new start. "I saw the only way I could do that was to go back to some of the initial drawings that I did when I was a child in Jamaica. So I got into doing a series of automatic drawings. A friend of mine who is a musician and a bit older than me took me under his wing. He was an improvisational jazz musician and he said, 'Well, let's work with that.' I needed somebody else because I still did not have enough confidence to just go back to making scribbles. And so we worked together for a year and a half with the stipulation that everything I made would remain with him because I was simply too close and too worried about anything that I did and I ran the risk of destroying them in the rush to try to find something in there."

About a year later Boothe returned to look at the drawings his friend had kept: "I went through hundreds of these little doodles and sketches and automatic drawings to music and I discovered what I wanted, which was some sort of order. Not necessarily that this was better than that, but that all of them, no matter how insane they may be to the art market or to an art critic, had a certain pattern, a certain way that I approached a compositional structure, a certain flair, a certain thing that was mine, and that the thing now was 'How do I develop that into a body of work?' I was reeducating myself to what I wanted to do with the rest of my life as opposed to what I wanted to do for someone else."

Being able to stake his claim to being an artist and a unique person was difficult because of his childhood circumstances. One of eight children, he received little encouragement to enter a profession as financially impractical as art. When his teachers spotted his talent, they encouraged him to learn representational art in order to gain employment as an illustrator or designer. His lack of artistic identity was also a result of his relationship with one of his brothers. This brother was the one everyone recognized as having enormous talent, but he disgraced the family by joining the Rastafarians (which Boothe says was viewed as becoming a hippie or a drug addict). Boothe tried to take his brother's place, painting like his brother to prove to his family that his brother's talent had not been lost. As an immigrant, he also found it difficult to honor his own traditions and tried instead to identify with the majority culture. He says he had never regarded himself as black until he came to the United States; but here, he was not accepted by African Americans because of his background, while white Americans shunned him because of the color of his skin.

His decision to reinvent himself as an artist forced him into a fundamental reconsideration of his personhood. He characterizes this rethinking as a spiritual turning point. "In my art I was trying to ordain myself instead of being ordained from the outside. That's what I was looking for, the ability to ordain myself with the knowledge that I'm doing this not because it's running away from anything or running to-

ward anything or any kind of momentary blindness, but the ability to accept my spirit, the sum total of all my experiences." Unlike Sharon Thomson, who reaffirmed her Christian identity, Berrisford Boothe rejected his Christian upbringing and in the process rediscovered some of the traditional practices of his native Jamaica. In them he found ideas about the pervasive spiritual qualities of all reality that were sufficiently broad to encompass the life changes he had experienced.

Both Boothe's and the other artists' stories serve as a way of envisioning some larger purpose or meaning than might be found in the daily work of making art or in the scattered experiences of living in different communities and developing tenuous relationships with lovers and friends. For artists who have in some way felt marginal in society, these narratives of spiritual recovery or awakening become the bedrock of self-definition. These stories, including those modeled on religious lore, show the importance of spending time reflecting on the meaning of one's experiences. Bereavement, loneliness, family conflict, dislocation, racial division, and professional frustration acquire new meaning in these accounts because artists deliberately try to make sense of these experiences and because they draw on understandings of spirituality that give coherence to them. The subsequent trajectory of their life and work is shaped as much by how they interpret their experiences as by the experiences themselves.

Searching for Continuity

Yet there is more to the quest for an integrating sense of personal identity than drawing on narratives about recovery, returning home, conversion, or self-redefinition. The continuity provided by thinking of oneself as an artist is also important. Most artists start to think of themselves early in life as having artistic talent or interests, and they continue to identify themselves as artists even though their places of residence, styles of working, professional interests, economic fortunes, friends, or spouses may change.

Artists' accounts of how they became artists provide the clearest evidence of this continuity. Michele Zackheim explains, "You don't become [an artist]. You just are. You have things to say and you hone the talent to say it. I mean, I didn't *choose* it. It was never a choice. It was just who I am. I'm always amazed that people can actually choose, but I don't think it's a matter of choice. I can't do anything but this." Cynthia West observes, "I think I've always been a painter. The first thing I remember is that my father painted pictures of great imagination with characters from German folklore. So I had this sort of influence from the start. I knew it was okay to make anything that my imagination could conceive." Warren Cooper's account is similar: "I was always musical as a child." Sharon Thomson also dates her interests to childhood: "When I was a child, I said I was going to be a writer and asked for my first typewriter, and it was given to me. It was a big business machine and I wrote stories." Although Berrisford Boothe did not think seriously about becoming a professional artist until he was in college, he had drawn pictures since childhood and he relied on these early experiences in redefining himself.

Besides emphasizing the continuity of identity, such stories point to a steady development or progression, accentuating the artist's sense of personal growth. Warren Cooper, for example, remembers that he first learned to play the recorder and then "I began to take some piano lessons when I got a little older. I don't remember exactly when that was, but it was somewhere around maybe seven or eight years old. I did choir in school. I had bands, maybe four or five of them through high school. That was back in the coffee club days, and I did a lot of fairs and festivals." During this time he was becoming increasingly interested in composing as well. He progressed from making up songs as he practiced the piano to writing choral music to eventually taking classes in composition at Oberlin. Cooper's account of his development shows that identity, though continuous, is not stagnant, and it suggests the benefit of hard work and personal discipline.

Defining oneself as an artist not only suggests continuity but also

helps to make sense of the pain, dislocation, and alienation that many artists experience. Michele Zackheim and Cynthia West find value in their lonely and traumatic childhoods because those experiences encouraged them to be introspective and to devote time to developing their artistic interests. Both attribute some of the turmoil of their childhoods to having parents who were artists. Bob McGovern's story about his father's vulnerability to alcohol is similar: he regards his own interest in the arts as an alternative way of expressing vulnerability. For Sharon Thomson, writing came increasingly to be a way of coping with pain after her divorce: "Here I was now, this very depressed mother with this small child, and there were these little moments in between those feeding times and caretaking times. So I found that poetry became a medium for writing out my thoughts and feelings." Berrisford Boothe's experience, like that of Bob McGovern, was shaped by being handicapped. A Thalidomide baby, he was born with both hands and one arm deformed. His artistic interests, he says, emerged as a way of presenting something to the world that was not deformed.

Being an artist, perhaps more than work in other occupations, is associated with the whole person, rather than with a particular job or set of skills, and so thinking of oneself as an artist is a way of unifying or centering one's identity. In this regard, it seems important that so many artists date their interests to early childhood, unlike interests that emerge only in college or after experimenting with different jobs. Their personal development and their artistic development become impossible to separate. The feeling that they did not have any other choice, as Michele Zackheim emphasizes, keeps artists from regarding their occupation as different from their personal makeup. Significantly, most artists say they have never seriously thought of giving up their artistic pursuits; like Cynthia West, they persevere through difficult times by expanding their artistic interests.

The close association between their personhood and being an artist is one reason that artists see a connection between their work and spirituality. As a core aspect of their selves, spirituality cannot be divorced from

their work. Warren Cooper says, "My spiritual journey and my musical journey are connected at the hip. In fact, my desire is to cause them to be synonymous. All of the things that I am doing musically, with no exceptions, are things that are about my spiritual journey and that relate directly to my spiritual journey. The two are different wings of the same experience. I'm able to do what I'm able to do artistically because of who I am in my spirit." Cynthia West draws a similar connection: "It all goes together. It's not separate, that's the point. Art is spirituality and spirituality is creation."

Openness

Artists' understandings of spirituality are naturally influenced by the connections to their work. Their stories of recovery, returning home, conversion, and self-redefinition do not follow conventional scripts that end with someone settling comfortably into a familiar community or tradition; instead, they take unanticipated turns, often defying society's rules, and they suggest ways of being open, unpredictable, and creative.

Warren Cooper's story is instructive. His narrative, unlike that of the prodigal son, does not end with a happy reunion with his father. He comes home to his father's church, but his understanding of who he is spiritually transcends the church. He says that his spirituality has become more personal, that he can carry it with him in other contexts. Indeed, the church has less authority than it seemingly did in his father's generation. In Cooper's opinion, "Churches as institutions are dissolving because the churches as they exist in institutional form are political entities." Even though his music keeps him involved in the church, he says most of the church is "business" and that has "about 0.2 percent" of an effect on his spirituality.

In a different way, Michele Zackheim has also modified the story of the prodigal's return. Although she finds home a secure place in which to work, it can become so familiar that it thwarts her creativity and her personal growth. When that happens, she engages in what her husband

lovingly refers to as "walkabouts"—lengthy international journeys. During the past two decades she has taken six of them, including the one to Israel that inspired *Tent of Meeting*; two to France, where she researched the life of Violette Leduc; and one to eastern Europe. Each trip has challenged her to grow psychologically and spiritually. "It takes away my anchors. When I take my anchors away, all of a sudden I'm faced with this horror of the realities. Here I am, I have no husband, I have no children, I have no friends. I'm in a strange place, I don't know anybody. What in the hell am I doing here! That helps me become a stronger person because I have to access that part of myself that gives me the courage to get through that particular day."

Yet another modification of the prodigal son story arises when the artist does not experience the initial home as a secure and loving place. Flo Wong, a Chinese American silkscreen artist, printmaker, and watercolorist who lives near San Francisco, is an example. She is the youngest of six daughters of immigrant parents, who worked seventeen-hour days at their restaurant in Oakland. Because boys were valued more highly than girls, her birth brought her parents shame, and she has always been acutely aware of this shame. Her art has provided tools to construct the home she never had.[14]

The opportunity to construct her identity as an artist did not come until her early forties. Although she had been an "art groupie" in elementary school, she was not encouraged to develop her artistic talents; after graduating from the University of California at Berkeley in English literature, she married and devoted herself fully to raising two children. When they were in high school, she realized she needed to follow her "inner voice," so she started taking art classes at a nearby junior college. "I wasn't creating for the product; I was creating for a process. I was trying to get at some mysteries that I held within me and so I kept persevering to see if my voice could be manifested through my heart and my fingers. I was interested in who I am. I was interested in my past. I was interested in my place in my family. I just wanted to know my environment, psychological and emotional. I knew my physical environment.

That was very well defined, so there were a lot of unarticulated mysteries that were puzzling me, and I just found that by attempting to do visuals I came up with answers that I didn't know were there."

Her *Oakland Chinatown Series*, consisting of thirty-five paintings over an eight-year period, was the result. "I began to create the *Oakland Chinatown Series* out of a need to draw human figures in a way that the figures would speak for me. I had been in life-drawing classes, and I used pastels and other tools, but the tools weren't creating the products that could carry what I was going after. And so I formed an art collective with some other women, and we did life-drawing classes in our homes. Then from that I segued into my family's photo album. When I did that first drawing of my mother and a relative—and these are photorealistic drawings done from photographs—when I did that first drawing of my mom and a relative standing in front of our restaurant in Oakland, California's Chinatown, I realized that I had captured something." She was flooded with memories that had been suppressed because they were painful. The drawings filled her with "a feeling of smokiness, a feeling of distance, a somberness and grayness."

As the memories came back, she transformed them into a more positive image of her upbringing. One memory was of her father being shot. Too young to have understood it at the time, she knew only that he was accused of stealing money from the neighborhood lottery and was shot by a relative. Her reconstruction of it is *Eye of the Rice: Yu Mai Gee Fon*, which means "there is raw rice to cook dinner." It is a wall-size piece "composed of cloth and plastic rice sacks, some which are fragmented, and every piece is hand sewn and it's embellished with Lee See, which are tiny red sacks, and sequins, beads, lace, and rice." It includes an antique watch which reminds her of the one that deflected the bullet that otherwise would have killed her father. Tendrils embroidered on the rice sacks show the family's tears. "There are seven rather complete rows of tears, which represent my siblings and myself, and we're connected to these orbits, these spirals, that are inspired by Vincent Van Gogh's *Starry Night*. There is commercial text on the surface of the rice sacks

and I co-opt the English words and the Chinese words and then on top of that I create new text, and the text that I put on came from my non-dominant hand because the story that I tell is a family secret and a community secret and my right hand would not write the text. It allowed the sewing and it allowed the start of the piece, but it would not tell the story in the cryptic way that my nondominant hand, which supposedly represents my inner child, allows [me] to tell the story."

She regards the work as "a tribute to my mother, who when my dad was shot, ran and caught the assailant. She left my father bleeding on the floor and she ran out and caught him on the Oakland Chinatown street and held him until the police came. It is also a piece of identity for myself because I was an infant. It was a preverbal experience for me. I was in the house when this occurred. Three of my sisters were at school and two of my sisters were at home, so after my dad was shot by the relative, then my mom ran out of the house wearing her slippers and my two sisters, two above me, ran out of the house chasing my mom and following her, and I was left there with my father. So on the sack I've written, 'Where was I? All I know is I was there.'" The work has given her new appreciation of her mother and of herself.

Moving beyond her family's negative view of women has been the most difficult part of Flo Wong's search. She helped found the Asian American Women Artists Association to gain the support of others engaged in a similar quest, and her *Oakland Chinatown Series* challenges traditional gender roles. "I was tired of the Fu Manchu depictions and the exotic Suzy Wong images," she notes. "I wanted to see us as the ordinary people that we were." Her paintings and installations have also focused on immigration laws that forced Chinese women to lie about who they were and conceal their marital status. "I don't have a need to make us cutesy or exotic, but I have the ability to make us real because we are real. I touch upon the universality of Chinese as human beings."

Spirituality has come gradually to be part of her work. As a child she attended a Southern Baptist church with her friends, but it had no con-

nection with her family and she became alienated from its rules as she grew older. Later, she attempted to learn about Confucius and Chinese spiritual traditions, but was dissatisfied with their emphasis on male authority. "The spiritual journey now is coming through the practice of yoga and meditation and becoming acquainted with this deep need to integrate my body and mind and spirit. So it's really an independent route that I'm taking. It's a part of me that I turn to on a daily basis. I know that I am off-center without it. I began to practice my spirituality through making art at the age of forty and for the longest time that was enough for me, but just solely staying in the studio to make art put me out of balance, even though it opened up the roads to what I needed to retrieve. So now I am becoming more balanced in that I'm doing physical things, I'm doing spiritual things, I'm doing aesthetic activities—so it's a combination. My definition of spirituality is maintaining that balance that allows me to offer my gift to the world."

Wong claims that she wouldn't have been able to draw without tapping into the spiritual energy inside her, and that artistic work has helped her become more aware of this energy. Her identity is clearly that of an Asian American woman, and yet she feels most at home as a citizen of the world. "While I talk about things that are personal, the human experiences that I talk about are universal, and it is that universality that has opened up to me. I hope to have contributed to the value of caring for the soul, of respect for culture and ethnicity, and to say that this respect for cultural ethnicity is not the negative aspects of balkanization. I believe in strong self-identification, not for the purpose of separatism, but for the purpose of finding universal qualities where we can link to each other to find our similarities and to be less afraid of each other."

Like Flo Wong, Sharon Thomson has found an identity that did more than return her to her roots. Her story of conversion is open-ended in a way that resembles Michele Zackheim's emphasis on taking her anchors away. She says the Grail community has become "her

church." Many of the women who belong to it live communally, while others participate in it regularly for emotional support and as a place to worship. It gives them a way to celebrate the Eucharist, but protects them from having to interact with the patriarchal structure of the Catholic church. In this sense, the Grail is a home. Yet its message is more about living in the wider world than about remaining at home. Thomson says the Grail movement taught her to appreciate the liberating and prophetic aspects of spirituality and to think more broadly about the relationships between symbolism and truth. "The Grail was part of this prophetic, mystical stream that has always existed. I discovered a way to come back to the symbolism and the story and the myth of Christianity in such a way that it could be meaningful for me again. I use the word 'myth' not to mean something that isn't true. Myth for me is a psychological, poetic way of perceiving and articulating reality. But it's not a lie—it's a way of speaking about the truth."

Berrisford Boothe's time of self-redefinition did not result in a clear set of spiritual answers or a fixed understanding of who he is. "I'm a verb spiritually," he asserts. "I haven't settled into anything. I'm still in process." He does not mean this in the sense that he is looking for some clearer insight to emerge in the future. Indeed, he has increasingly been questioning such notions of development. He is drawn toward precolonial African ideas of time that focus more on an appreciation of the present. "How dare you project?" he asks. "What a waste if you're not here and now, resolving, living, dying, whatever!" His thinking about these issues is still in flux.

Artists are perhaps emotionally programmed to want openness in their lives: their creativity may depend on rejecting rigid answers to life's deepest questions. But it is important to recognize how openness can be part of a narrative that provides a strong sense of integration to one's self-identity. Too often, religion has been viewed as a belief system that necessitates adopting someone else's understanding of who you are. The artistic approach to self-identity builds on insights from religion but includes a place for creativity as well.

Exposure to Diversity

Artists' narratives about their spiritual identities are often open-ended because of the religious diversity to which they are exposed. Many artists have traveled extensively or lived in communities with people from many different backgrounds, so they are probably exposed to more religious and cultural diversity than the typical American. But diversity has increasingly become a feature of the entire culture, if not through personal exposure, then at least through the mass media. How artists maintain their personal convictions amid such diversity is, for this reason, of general interest.

Unlike the prodigal son, who realizes that the heterodoxy of the far country is not for him, Michele Zackheim constructs a tent to include Christianity and Islam as well as Judaism. Cynthia West has been influenced by living among American Indians and by traveling abroad. One of her most memorable religious experiences occurred on a trip to the Middle East with her children when they were still little. They visited an elderly Sufi sheik who lived in a cave near Hebron. He taught her to sing zikr. "For many years I've sung zikr. 'Zikr' means remembrance of God in Arabic. It's just the repeating of the name of God—'la e-la ha, il a-la.' There is no reality but God." Although Warren Cooper says he has not borrowed specifically from other religions, he sees his religious thoughts as developing "in the presence of differences." He is aware that other people believe differently and asks himself why they believe as they do. Berrisford Boothe's thinking has been influenced by learning more about the diverse religions that shaped his early experiences in Jamaica, and he is increasingly attracted to Buddhism because of its emphasis on living in the moment. Flo Wong is coming to terms with the spiritual implications of being both Asian and American.

For these artists, exposure to religious diversity has not resulted in an eclectic brew, combining a little of everything, but a sharper realization that there is more to spirituality than any individual can understand. Sharon Thomson articulates this realization in describing what she has

learned from Native American practices and African American churches: "I can go there and be touched and filled, but I really can't own it. I really can't have it because that expression of spirituality is coming out of a complete life. These folk are having a deep spirituality that's come out of an experience of suffering. It's coming out of an experience of everyday believing in the midst of a world that would tell you that nothing matters. They have a faith that transcends a level of oppression and deprivation that I don't know about and that I can't know about unless I am willing to go and live that life and then come back and praise God."

Thinking of oneself as a spiritual seeker, pilgrim, or sojourner is a way of claiming an identity amid such a diverse array of experiences. As Sharon Thomson emphasizes, it is important to avoid simply being a casual consumer or worse, an exploiter, of other religions and cultures. But the serious sojourner learns, as Warren Cooper suggests, to focus on an understanding of spirituality that differs from its particular social manifestations. Thomson's idea of communities and practices as "vehicles" that take one to a place of truth is similar. Berrisford Boothe shares Thomson's disdain for the consumerist approach to spiritual seeking. "Everybody's trying to get on the *Oprah Winfrey Show* by claiming to be a witch or a goddess or something," he complains. He believes a true sojourner should be quieter and more focused on the interior life. "It's about the ability to say, 'I have found that the journey is here, and I can be right with that journey within myself to the degree that it does not allow me to afflict you with anything or subjugate you.'"

Although spiritual seekers move from place to place, their sense of who they are is seldom a construct that exists only in their thoughts and feelings. It is to a great extent rooted in their efforts to create a safe space in which to live and work. Cynthia West's appreciation of the physical space in which she lives stems from its natural beauty and from the American Indians' understanding of space as the mediator between human creativity and the divine. In one of her poems she writes:

I live on the mountaintop
Where earth and sky
Unite.
Breath vivifies
 the space between
Communion seen and not.
Realities conjoin in me
And fiery veins
Demand
To waken those of clay.
I must stand as conduit
To translate
Passion past belief
Into elixirs suitable
For fragile earthen jars.[15]

Another Santa Fe artist describes his studio as "a sanctuary for creativity." He says it is "the ultimate tool" because it is a reflection of his life. The few paintings on its walls, he indicates, are "pieces of me." A musician in Pennsylvania offers a poignant example of the relationship between herself, her creativity, and the physical terrain of her daily life. She recalls a cold winter when she had no place to stay except for a borrowed teepee in a farmer's pasture. Her marriage had fallen apart and her musical career seemed to be going nowhere. Yet, in the seclusion of her tent, she was able to recover her identity and her creativity returned. "The songwriting took off. I felt very connected to the earth, very connected to Spirit, and I was in balance."

Michele Zackheim insists that the coherence of one's identity often depends on the tangible realities of daily life to a greater extent than on abstract philosophical schemes. Her walkabouts, when she is removed from the daily routines of her life at home, convince her of this link. Indeed, she deliberately re-creates some of these tangible realities in order to maintain her sense of who she is. "When I travel alone, I do lit-

tle rituals. I always travel, for instance, with incense because I'm very sensitive to smells. Because I rarely have the money to stay in any place that's decent, I try to make the smell in the room better. I carry a scarf with me that I can put over a lamp to cut down the harshness. Everything is sort of green or yellow, and it's very unpleasant for me, so I carry a purple scarf that I put over things. I carry little talisman things from the children or my husband or from the desert, and I set up a space where if I look over it catches my eye. Aha, it's like home." Her experience, like that of other artists who have made comfortable places in which to work, shows that a personally integrating sense of space need not be imparted by some community in which one happens to have been raised; it can be created.

But ultimately the coherence of these artists' lives depends, as it did for Violette Leduc, on being blanketed with words (or whatever medium the artist chooses). Like a woolen covering, the words can be woven and rearranged to suit the artist's needs. They are at the artist's disposal, tools from which to fashion an integrated expression of life. At the same time, they exist independently of the artist; they give expression to a reality that is more than the interior life of the artist. "When I'm writing poetry," Jon Davis says, "I do express myself, but that's never my goal, because I'm trying to express something beyond myself. My goal is not to express myself, it's to make something beautiful." The reality beyond himself is not one that he can readily describe, but he explains, "If you believe in the muse, it's coming from somewhere else, some other source, whether you want to call it God or spirit or something else."

His thought is similar to that of T.S. Eliot, who wrote that "Against the Word the unstilled world still whirled/About the center of the silent Word."[16] Cynthia West draws on another line from this poem, which she memorized in high school, to summarize her understanding of herself and of life: "Teach us to care and not to care./Teach us to sit still."[17] Her interpretation of Eliot's words is that "there's an endless vastness, a hugeness that is unlimited and there isn't any end to it in any direction and it's inside of me. It's not like I'm inside of it. It's all inside of me.

God is inside of me. It's so vast and it's freedom and it's ecstasy, lightness of being and body and freshness. It's energy. It's an endless flow of creativity."

Michele Zackheim resists even the terminology of spirituality because it seems to separate one part of life from the rest. She does not mean to deny that there is more to life than can be known through the senses, but insists that all of life, including her physical and psychological and spiritual makeup, is one. Prayer is the occasion on which she tries to be aware of this oneness. "It's a moment to gather myself together so that I'm with myself. I'm not floating around in other places. When you write, you float around in lots of other places in lots of people's brains and lots of people's hearts. Oftentimes at the end of the day, I just sit quietly to get back to myself. To me that's prayer. I can just feel the eminence of being alive. And that to me is an answer to prayer."

The lives of artists in many ways exemplify the jarring, centrifugal forces that have been unleashed by contemporary society. Artists are often the products of families that failed to blanket them with security and of communities that proved too fragile or too stifling to earn their long-term commitment. Exposure to diverse, faltering relationships makes it harder to develop a clear, consistent sense of who one is. Yet the spiritual journeys in which these artists have engaged suggest the possibilities for achieving personal coherence even amid frayed social conditions. Some coherence is gained from the dogged development of personal talents and interests, whether in painting, music, writing, or some other form of personal expression. Some is achieved through the daily rituals and familiar artifacts that provide a secure space in which to be oneself. Greater coherence comes from narratives of recovery, return, conversion, and self-redefinition. These narratives mark major turning points, giving the narrator a way to interpret the past and to chart a course for the future. They are vehicles, as Sharon Thomson says, that take one to a place that is true.

Many of the religious communities that have flourished in the United States have encouraged adherents to create narratives about their spiri-

tual journeys. These narratives were often called testimonials and de-
picted a sharp point of spiritual rebirth, after which the sojourner found
forgiveness and new hope. Such narratives are still prominent, and
many people speak of finding God in times of despair or point to recur-
ring episodes of feeling close to God. The culture provides many ways
in which to tell these stories. Some people model their spiritual journeys
on stories of biblical characters; others pick up on themes from medi-
cine, therapy, literature, and music. Whatever their format, these narra-
tives of spiritual journeys remain significant as ways of finding coherence
in a tumultuous world.

4

ART AS SPIRITUAL PRACTICE

THE WAYS THAT ARTISTS ENGAGE in spiritual practice vary as much as their understandings of spirituality do. Some employ methods of prayer and meditation adapted from faiths outside the Judeo-Christian heritage, while others' practices stem from Christian or Jewish traditions. Artists also differ in how they integrate their artistic work with these spiritual practices. For many, spiritual practice is set off from the rest of their day as a special time for communicating with and listening to God. For others, the routine of firing clay vessels or perfecting dance movements becomes a spiritual exercise. How their practices contribute to their spiritual growth depends greatly on the particular meanings these practices have in their personal lives. Yet there are also general insights to be gained from these practices, both about the importance of practice itself and about how it can be nurtured to embrace discipline and creativity.

Chanting

Ann Biddle, a dancer, is one of many contemporary artists who express their spirituality in daily devotional practices that fuse with and

influence their artistic work. In 1992, inspired by her multicultural
Japanese, Native American, and European heritage, she founded the
multiethnic Solstice Dance Company in New York City to give greater
expression to women crossing cultural boundaries.[1]

Her interest in spiritual practice—which she regards as regular, disci-
plined activities that increase her awareness of the sacred—dates to early
childhood. Living in Thailand, where her father worked in international
business, she was fascinated by the diverse religious practices of the Thai
people. Although neither of her parents was religious, she besieged them
with questions about God and asked them for a Bible. "I remember pray-
ing a lot. I had a little altar that I had set up. I was five years old, but I had
this place in my room where I would pray to God." She pictured God as
a powerful being who would protect her if she prayed hard enough. She
also remembers going with an African American friend to a black Baptist
church in Bangkok. "I really enjoyed the service because it was very lively
and there was music and clapping. It was a vibrant kind of service that
definitely appealed to me." Another formative experience was spending
summers in Vermont with her grandmother, a free-spirited woman who
meditated and found God in her garden as much as at church. There, the
young Ann Biddle attended a Congregational church, went regularly to
Sunday school, and sang in the choir.

Like many artists, Biddle's interests in spirituality were heightened by
personal trauma. Her parents divorced when she was twelve. By this
time she had lived in Rhode Island, New York, Pennsylvania, and
Washington, D.C., as well as Thailand and Vermont. A few years later,
her mother sent her to a Quaker boarding school. "My mother got re-
married. She moved to Florida with her new husband. My dad had a fel-
lowship at Harvard, so he left Washington. I really had nowhere to go.
It was a tough year. I had a lot of depression. It's all connected to my
spiritual journey, because when you encounter these kinds of personal
problems, you have to find a way to deal with them." She remembers
desperately wanting to be invisible, feeling suicidal, and identifying with
the anguished poetry of Anne Sexton and Sylvia Plath.

But her artistic talents were also emerging. She was a member of the choir, played the flute, took up painting, edited the school's literary magazine, and was the lead actress in several plays. Her achievements earned her admission to Brown University, where both her parents had gone. The problems in her personal life continued, however. When her grandmother died, she was devastated because she had always depended on her grandmother for emotional support. "I was trying to respond to the pain that I was feeling inside of myself, and I think that sent me in a lot of different directions. I was so fragile as a person that I was very shaky. I would shake a lot physically. I just wasn't very stable." After taking a year off, she transferred to Kenyon College, took up dance, and graduated magna cum laude with a major in English.

Her interests in dance then took her to New York City. She won a scholarship at Columbia University and earned a master's degree in dance education, developed a summer arts program for children, taught classes in aerobics and creative movement, and worked as a dancer. A romantic relationship that went awry, a serious illness, and continuing emotional turmoil resulted in an intensification of her search for spirituality. Over a five-year period she shopped widely for "instant answers"—attending workshops on rebirthing and past-life regression, psychic healing, yoga, and Tarot; consulting an astrologer; regularly visiting a therapist; and learning transcendental meditation. Through a Jewish friend who was following a regimen of Buddhist meditation practices, she started meditating as well. These practices, which she has done every day for more than a decade, have proved more helpful than anything else.

The core of Biddle's spiritual practice is a forty-minute period of chanting each morning and evening. She recites five prayers each morning and three prayers each evening. She also spends part of the time meditating on her activities and afterward writes about these thoughts in her journal. She says she noticed almost immediately that the chanting has a "kinesthetic, physiological" effect. "I could feel something happening to me. My life was in such a bad state at that time that the

changes were just amazing." She continues this practice because it creates "an awareness of my relationship to the universe and how I fit into the whole picture." It also helps develop "a deeper level of faith."

Her daily spiritual practice and her dancing are closely related. "My practice is not separate from my life; it's all integrated. My choreography, my performance is all a reflection of my practice." The kinesthetic effect of chanting is especially meaningful because it resembles the bodily transformation that occurs from dancing. Both are ways of reaching within herself to discover thoughts, feelings, and experiences that have been submerged. "You do work out a lot of things when you're moving in your body. There's a transformation. I've done a lot with getting in touch with my roots and about getting in touch with the spirits of my grandmothers and great-grandmothers on both sides of the family, on the Japanese side and on the Native American side. Every single dance piece is a personal journey for me to deal with some issue."

Both dancing and chanting allow her to express her spiritual inclinations in her own way. "Everybody chants differently. I like this practice [because] nobody tells you how to do everything. I would never belong to an organization or religion that was so narrow in how you have to chant or what you're supposed to chant about. There are some guidelines, but everybody's different and everybody's going to have a different response to the practice." Expressing her individuality is important because she believes everyone's spirituality is distinct.

But chanting as she pleases is balanced by a commitment to engage regularly in this practice. Just as in dance, she considers it essential to stay with a single practice over a long enough period to learn it well. "It's important to have a spiritual practice and to take it seriously and to be consistent. I'm always studying and I'm going forward and I take it very seriously. I'd say it's really the center of my life."

She contrasts her present commitment with a time in her early twenties when she was dabbling with many different forms of spirituality. "I was constantly seeking, seeking, seeking, and never settling. At some point, you have to settle, because otherwise your nature is hungry. You

just want to keep eating and then that's not enough. So then you go to something else, and that's not enough. To practice is not easy. [Chanting] is a hard practice. It takes a lot of commitment."

Although chanting is confined largely to her morning and evening rituals, it influences how she dances. By helping her overcome depression, for example, chanting has given her a more optimistic view of life, which she tries to demonstrate in her work. Sometimes ideas for choreography come directly from chanting. A performance called *Restoring an Eclipsed Moon*, for instance, dealt with the struggle she imagined her great-grandmother experiencing as a "half-breed" Native American. It incorporated Native American sign language as a symbol of striving for faith in a divided land. "When I choreographed that piece, it came from a spiritual place. It came to me when I was chanting. That's when I can really trust what is coming up. It's like a door will open in my mind and new material comes in. It comes from some source. I don't really know where it's coming from, but I know it's very deep and I trust those images."

Ann Biddle summarizes spiritual practice as "learning how to live your life creatively. That doesn't necessarily mean to produce in an art form. It's about reaching your fullest potential. It's about creating artistry in any area of your life, through your practice. It's about opening up your mind to the possibilities of who you are and to see the uniqueness of who you are. It's about making an impact on the world in a creative, innovative, forward-thinking way."

As this example suggests, spiritual practice and artistic work can be drawn from different traditions and play different roles in one's life. Yet any serious devotional practice that occurs regularly over a period of years is bound to affect all of one's life, including both artistic and nonartistic work. It is especially interesting in this case that chanting, which has been used in all major religions as a method of prayer, can follow a highly specified regimen and yet make room for creativity. Its purpose is not to restrict personal expression but to serve as a means of deepening one's relationship to the mysteries of the sacred.

Art Equals Spirituality

Ann Biddle's spiritual practice is concentrated in her chanting (which then affects her dancing). In contrast, other artists integrate spirituality so fully into their art that the practice of one is virtually synonymous with the other. Willi Singleton, a ceramicist who operates Pine Creek Pottery near Hawk Mountain in northeastern Pennsylvania, is an example. His massive wood-fired kiln and pottery building are located behind a century-old house and barn that belonged to his grandparents. After graduating from college in 1981, he spent two years as a ceramics apprentice in the United States and then lived for eight years in Japan, where he studied traditional Tamba pottery and learned the Anagama method of firing. Although much of his work consists of what he calls "bread-and-butter" craft production (such as plates, cups, mugs, and teapots), he also creates exquisite artistic urns and vases that sell for more than $1,200 apiece. In addition to his artistic and commercial work, he lectures widely on Japanese folk art.

Like Ann Biddle, Willi Singleton moved repeatedly while he was growing up and was exposed to cultures outside the United States. The son of an anthropologist, he was born in Micronesia and by age ten had lived in California, Japan, and Pennsylvania. After high school, he went to college in Maine, where he majored in sociology, but then moved to the state of Washington, where he finished his degree in ceramics at Evergreen State College. During his years in Japan he married a Japanese woman, but after his return to the United States she joined the Peace Corps and went to the Philippines, and eventually they divorced.

His childhood exposure to religion consisted only of sporadic attendance at Quaker meetings with his parents. "My folks were very focused, very aware, very concerned individuals, but I think our whole family has a problem with established religions and dogmatic institutions, so whenever things start to look at all like that, we just duck our heads and head for the hills." To this day, he has trouble with religion and even hesitates to talk about spirituality because it somehow seems too pious ("It's like

underwear; you shouldn't show it to people"). Still, he has thought a lot about the deeper meanings of his life and his relationship to the forces that govern the universe. He remembers in college feeling alienated from students who seemed intent only on having fun, and he worried about what he could do in order to "feel right about things." Through a friend he started practicing transcendental meditation and found it helpful for quieting his mind. He was increasingly attracted to art because it too was a way of disciplining his attention.

"I realized that I wasn't really interested in living the way I saw a lot of people around me living," he explains. "I didn't want to be part of the general mass of Americans who were making money doing something they really didn't want to do and then spending money trying to have fun. What might be called leisure activities or entertainment or whatever, it just didn't make sense to me. I was trying to find a place for myself where I could be of service and thinking about what I might be able to do in that regard. I was interested in pottery and that seemed to fit the bill."

As his skills developed, he came to understand pottery as a form of spiritual practice that went beyond simply supplying people with pots and plates. His present understanding is "not so much that I'm the one making the pots, which somehow get scattered around and end up in other people's lives. It's kind of an illusion that I make the pots. I'm a potter, but through the years working in Japan and here, I've come to realize that I'm probably about ten percent of what makes the pot, if that much. Maybe one percent. It's hard to put a number on it, but one of the reasons that I stayed in Japan for a period of time is that there are ways of making ceramics that involve more than just the potter. This is the idea behind the wood-firing, searching out natural clays, throwing on the kickwheel. If you choose processes of making pots that have inherent characteristics in and of themselves, there is a power that you can harness and it kind of moves into the pot." It is this power that he strives to be aware of and serve.

He illustrates the power involved in making pots by describing his

understanding of wood-firing. "When you put a pot in a wood kiln and it becomes licked by the flame and ashes are deposited on the pots and the flame is surging over the pots and changing the color and texture on the surface of the pot, there is a very dramatic transformation. It's different from a gas or electric kiln, where there is no particulate matter going through the kiln. In those processes there is no ash and the flame moves at a more consistent rate than in a wood kiln. In a wood kiln it is a much more chaotic situation. In fact, scientists look at wood kilns now with chaos theory in mind. So the wood kiln basically does things to the pots that *I* don't do to them. When the pots come out of the kiln, then I can decide which one is good and which one is bad, which one I like, which one I don't, which one I'll sell, which one I'll break or give away. But that's almost the extent of my power at that point. I didn't *make* the firing. I *participated* in the firing. I built the kiln, I split the wood, I put the wood in the kiln, but I can't make fire. Nature makes the fire."

A disfigured jar on his back porch is graphic testimony to the fire's power. During the initial round of firing, it cracked; he glazed it and refired it to see what would happen. "When I pulled it out, it had these wings that open up. It's like an owl with wings sheltering its offspring. It took on a form that had absolutely nothing to do with what I thought was going to happen. It embodies the way I feel about the process, kind of bowing to the fire."

As Singleton participates in this process, he experiences a meditative transformation that is similar to the feelings Ann Biddle has when she chants. Although he had meditated before, he started to regard pot making as a form of meditation during his apprenticeship in Japan. "I began to feel a connection between meditation and throwing on the wheel. When you're on the wheel and you're throwing the same object over and over and over again, you almost fall into a trance. You begin to feel something happening, which is very much like meditation. It gets to the point of being a meditation-like state, where your perceptions are changing. You begin to see things in a different light, things that are lying dormant at other times." These times of meditation are especially

meaningful to him because he feels his inner spirit participating in something that clearly transcends himself.

Other aspects of his work have acquired spiritual meaning as well. "I go out and I dig the clay from Hawk Mountain. I'm using a lot of the clay from the top of the mountain here. It's a pain to make that clay and it often breaks in the kiln. It slumps easily. It's difficult to throw, but this clay has a character, a very strong personality that when you look at the bare areas of clay, I mean, it looks like earth. It looks like nature. It has that kind of power—like when you look at mountains or when you look at water flowing in a creek and the kinds of textures that it has, the way it reflects light. It's amazing stuff." This intrinsic quality of the clay—the fact that he cannot fully control it—puts him in contact with the very essence of life.

He tries to leave an imprint of this essence in his work. "Throwing it on the kickwheel (it's a slow-turning wheel) leaves interesting asymmetrical effects on the pots unless you wipe them off, which I make an attempt not to do." He then glazes the pots with natural materials, such as cornstalk ash, wood ash, and clay from a nearby creek. "The glazes made in this way have a feeling of where they come from. The local clays and the locally available glaze materials then produce a pottery that is exactly local. It's from the natural environment."

Making pots this way plays a role similar to Ann Biddle's chanting. It provides a focal point that puts Singleton in contact with himself and with the cosmos. The sacred has always been more evident to him in nature than anywhere else. As a boy, he learned to hike, backpack, ski, and spend time in the woods; these experiences impressed him with the power of nature. When he is participating in nature through his work as a potter, he feels some of the same power. It makes him feel right about himself to be doing this work. "The most important thing is that I keep doing something that is of service, something that I feel is the right thing to do. Making pots is just something I've got to do."

Such remarks about service and feeling the necessity of what one does occur frequently in comments about spiritual practice. Although artistic

work is generally done alone, just as prayer and meditation are, artists feel that it is in a small way serving others, and this is part of what gives it spiritual meaning. Creating works of beauty contributes to the lives of others. The feeling that one "has to" do a particular spiritual practice, whether this is making art, praying, or meditating, is more difficult to explain. Although people may choose to do other things, there is a habitual quality about practice that leaves them feeling empty when it does not occur. For some, there is also a feeling that spiritual practice is like a skill or talent that will inevitably diminish if left unused.

Thanking the Blessed Mother

Willi Singleton's and Ann Biddle's spiritual practices have been influenced by their exposure to Eastern religions. Artists who identify themselves as Christians sometimes forge similar links between the daily practice of their art and the devotional activities that constitute the core of their spirituality. One example is Lydia García, a native of Taos who lives in an adobe house built by her grandfather more than a century ago. She learned woodcarving as a child from her father, but until a few years ago most of her adult life was devoted to raising five children and working as a hairdresser. She carved and painted brightly colored *santos* and *retablos* only in her spare time and usually for church functions or as gifts for friends. One day her eldest son sold one of her *retablos*, and gradually she started to devote more and more of her time to them.[2]

Lydia García is a humble woman whose formal education ended in sixth grade when her family's financial needs forced her to quit school. She scrubbed floors at the local hospital, worked as a maid for several wealthy families in the area, and eventually moved with one of them to Los Angeles. Soon after her sixteenth birthday, she married and moved with her new husband to San Antonio and then to Chicago. They had little money, and she encountered more prejudice against Hispanics in these cities than she had imagined possible. To compound her troubles, her husband was often drunk and violently abusive, and on more than

one occasion he threatened to kill her. At age nineteen, with three children to care for, she ran away and sued for a divorce.

Back in Taos she secured help with the children from her family while she studied for her high school equivalency examination and resumed working. At twenty-two, she remarried, but only ten months later her husband was killed in an automobile accident. A year later she married a third time. Over the next few years she had two more children and settled into her routine as mother, hairstylist, and part-time artist. Then, after twenty-five years of marriage, her husband left her; she has been alone now for more than two decades.

Her interest in spirituality mirrors the culture in which she was raised. She attended a Catholic church with her parents, grandparents, and siblings; went to a Catholic elementary school; and worked at a Catholic hospital. "It was just the way I was brought up. We used to pray the rosary as a family. We used to sing. My dad used to play the guitar, so none of those things could be separated." She remembers some bad experiences, especially when the nuns at school were unable to communicate with her in Spanish or hit her hands with a ruler and washed her mouth with soap. But praying, going to Mass, and singing religious songs with her father were positive experiences. "It was a lot of storytelling and most of it was Scripture reading. The Bible, the Bible always. My dad would let us experience different things as far as Scripture and angels. He always said angels were with us and not to be afraid, and not to be afraid of death because there was life after death."

During low points in her life, her spirituality has been an important source of comfort. "I have to seek my Jesus," she says. She seeks and waits, hoping to feel God's presence, and often she is disappointed, feeling nothing. But on several occasions Jesus and the Blessed Mother have come to her and given her "a beautiful feeling." Once time she was in an automobile accident, badly injured with a broken back, and she could hear the doctors saying she "probably wouldn't make it." At that moment the Blessed Mother came to her, held her hand, and told her it was going to be all right.

Making *retablos* has been her way of thanking the Blessed Mother. These are fashioned from weathered boards on which she paints icons or affixes objects to form a flat wall hanging or an altar in which a candle can be placed ("*tablo*," she explains, "is board, so *retablo* means redoing the board"). Each one is different, but many depict biblical subjects, such as the birth of Jesus, angels, or the Blessed Mother, while others are of animals, saints, or crosses. They measure from twelve inches to more than three feet in height. Some strike a light-hearted tone, such as one called *It's Bath Time* showing the Blessed Mother and several cherubs giving the baby Jesus a bath; others express agony (such as that of Jesus on the cross) or show the sorrows of the Blessed Mother, while still others capture the Blessed Mother in moments of prayerfulness.

It has been difficult for García to offer her *retablos* for sale because it seems wrong to take money for them. She thinks of them as a means of worshipping and of communicating her faith. She has developed a large network of people who come to see her working and to seek her advice. She always adds a handwritten inscription to the back of her *retablos*. Sometimes they are simple prayers; many are verses copied from her Bible. She has read it so many times that the margins are filled with notes and many of the verses are underlined in red, yellow, or green ink.

But she considers herself a plain woman with ordinary doubts and fears, rather than someone of exceptional faith. "Some people think if you don't go to the Catholic church you are *nada*, nothing. But I'm not that way; I just don't see it that way. For me, it's just 'Seek ye first the kingdom of God.' That's what we're all looking for." She says it is hard to be as faithful to God as she would like. "When you're in church, you feel like you know yourself and you know God, and then the minute you walk out you start stumbling." She doesn't doubt the existence of God, but she struggles with her feelings. "I don't know," she sighs, "I miss my children and my mother and dad; it's the loneliness." Living as she does on an uncertain income, she also worries about her future. "It's not like I get up and it's 'ha, ha, ha' all day. There are days that I feel like I'm out in the desert."

What keeps her going are her daily devotional practices and being able to express her interest in spirituality through her art. Generally she rises long before dawn to work on her *retablos* and then stops at six o'clock to attend morning Mass. "I go a lot to Mass because I receive Eucharist. That's my Jesus. It's the jewel of my life. But it doesn't stop there. I need to come home and do something with it." She prays and reads her Bible, and sometimes listens to religious music, but she also describes her artistic work as prayer.

Working on her *retablos* quiets her mind, disciplines her emotions, and focuses her attention on God. She often feels that God's spirit has been guiding her. "Sometimes I reflect on my work and I look back and say, 'Thank you, God.' I think sometimes that I have done everything that I can do. I've used everything that I can. Then I am surprised when something new comes out. I feel the spirit of God just pouring out." She says it is impossible to separate her art from her spirituality.

The humility evident in Lydia García's narrative is especially compelling. Even though people who engage in spiritual practices over long periods of time frequently feel that they are better able to communicate with God or more faithfully follow God's teachings, many of them also recognize that they have far to go. This is one reason that practices, even when they are performed alone, require interaction with others. During periods of doubt and despair, spiritual practitioners benefit from the advice and support others can provide. At the same time, Lydia García's story illustrates that it is reassuring to others when she is able to admit her own vulnerabilities.

Performing in Service to God

More than two thousand miles from Lydia García's home in Taos, another Christian explains how his art blends imperceptibly into his devotional practice. He is Paul Kim, a concert pianist who emigrated from Korea to the United States when he was nine and now lives in New York City. His father was a professor at Seoul University and his mother

taught high school in Korea. Both were talented musicians, although neither performed professionally. They left Korea in order to give their three sons greater opportunities to develop their talents. Sacrificing their own careers, they settled in Los Angeles, where they earned a modest living operating a clothing store. Seven years later, they moved to New York so that Paul could attend Juilliard.[3]

Paul Kim's interest in being a concert pianist stems from a memorable encounter when he was thirteen. He had been playing since he was five, but his enthusiasm often waned because of the long hours of practicing and because none of his friends were musicians. His transforming encounter was with Arthur Rubinstein. Having read Rubinstein's autobiography and played his music, he went to a performance of Beethoven's Piano Concerto no. 5 ("Emperor") by Rubinstein and the Los Angeles Philharmonic Orchestra. After the concert, he rushed backstage to meet Rubinstein. Although their conversation was brief, Rubinstein's manager arranged for him to come back the next day for an audition. Rubinstein praised his talent and encouraged him to continue playing.

"Prior to that experience my practice hours would be rather small," Kim confesses. "I would practice maybe an hour and a half a day, two hours maybe on certain occasions, maximum. But after that, my time spent at the piano would be so long, and I wouldn't even notice the time going. I would practice for six, seven, eight hours, and I still couldn't get enough. I would try to devour all kinds of music and repertoire. I started listening with a different ear to the beauty of the music and how I would approach that piece. I could get a taste of that beauty and I could produce it. That was enough for me, and it was intoxicating. It was a huge incentive for me to study."

Moving to New York, however, was a sobering experience. "I thought I was a big shot in southern California. Coming to New York, I noticed kids who played far better than me. It gave me the proper perspective and incentive to do even harder studies." One of Kim's teachers at Juilliard was the accomplished pianist Martin Canin. "He taught

me to look at music in a more concrete and structural way, meaning look at what's on the music, the score. Open up the score. Don't just look at the notes, but see how each note relates to the other and what the composer marked as far as articulating certain ideas. It made me think more deeply about the music that I was studying. At first it was a struggle, and I only became more comfortable with it after many, many years of further study."

The next decade was filled with arduous study. Besides refining his technical skills and expanding his repertoire, Kim read voluminously to deepen his philosophical understanding of music. He was particularly drawn to Edmund Husserl's phenomenological philosophy emphasizing the individual's perceptions of the world. In this perspective, "you try to shed all the knowledge and prejudices that you may bring to the work and just try to meet it head on between yourself, your pure ego, and the work." Increasingly, his goal as a performer became that of articulating "the pure experience between the self and the music." Achieving this goal required personal reflection as well as scholarly knowledge. "The inner person—what you're feeling, what your mindset is, what is coming out of you that you want to express—is of utmost importance." As he became more aware of himself, he realized that he wanted his performances to be done in service to God or some other high aim, rather than merely to please his audiences. He realized, too, that he was often lonely and that his music was only one form of companionship.

Before finishing graduate school, he became friends with a Korean American soprano who shared his understanding of music; within a few years they married. Her companionship sustained him during the difficult years of becoming established as a concert pianist and as a teacher. "We were both musicians and musicians are a different breed. Most musicians always have a thirst for something. We are both travelers in this world, pilgrims in our walk on earth as well as in music. We're so fortunate that we are married and that we are both musicians who can understand each other."

There were times when Kim doubted his ability to succeed as a mu-

sician. "I can't go on in this music," he would murmur to himself. "Who can pay the bills? Our love alone can't provide all these things. We need concrete support." By this time his family had moved back to California, and neither they nor his wife's family were able to provide financial support. "So we went through a lot of hardship at first, she working sometimes three jobs. We were also teaching, both she and I, almost around the clock, aside from our times devoted to studying." They lived in a one-room apartment, and he took odd jobs with moving companies and delivery services to pay the rent.

Despite these difficulties, his love of music remained powerful and continues to be a source of endless fascination. During performances he often becomes so absorbed in the music that he is oblivious to being on stage. The music transcends his ordinary thoughts. "It's a beautiful thing. I'm able to get a taste of the eternal." These experiences are so close to his soul, he says, that it is difficult to describe them. "But the more of these transcending experiences one goes through as a musician, the more one appreciates the greatness of the music and one's human frailness when compared to, for example, the great Beethoven Symphony no. 9. That sort of work transcends the ages. It really does move the soul."

The time he spends practicing is a constant reminder of how music nurtures him spiritually. But music is not the only means through which he pursues a relationship with God. A fourth-generation Christian, he grew up attending church regularly, took his beliefs for granted, and then in high school rejected them almost entirely. In his early twenties, during a time of loneliness and despair, he wandered into a church in New York and felt reassured as he sat looking at the cross behind the altar. "More than anything else, I felt a peace in my heart that made it possible for me to get my life together, be organized, and go after things that are truly important." He started reading the Bible and praying, and these activities have continued to be his daily practices.

He prays regularly because this is his way of staying in close communication with God. "Spirituality is two-way communication. It's not just

you facing God, but it's God facing you, and there has to be that inter-action. I feel that strongly and I feel that God is speaking to me and that he's leading me. How do I know that? I'm going by belief. I'm keeping the channels open through prayer and Scripture reading."

Sometimes he prays by blocking out all other thoughts and just con-centrating his attention on God. The process is similar to concentrating on the music when he is performing. Usually his prayers follow a specific pattern. "I try to look at what happened during the day, what things were good and what things were bad, and I bring them up in my prayer. If there are conscious sins that I have committed, I ask for God's for-giveness. I ask for strength to withstand the temptations of the world. I pray for these things, and I fail sometimes and I'm successful sometimes in my daily life. I bring my concerns to God and I ask for God's help."

In his prayers, just as in his music, he emphasizes that the most im-portant element of spirituality is learning to live a life of faith. "I'm not qualified to be a spokesman for anybody else, but for me the important thing is being sincere in one's deepest conscience and soul, being sincere to God, and opening oneself. You have to admit that you don't know the answers. There are many limitations, endless limitations for human be-ings, for myself, and if I'm sincere and I open my ears, open my heart, there will be a communication and what comes of those communica-tions, I think, is spirituality." It is this opening of his heart that contin-ues to animate his life and his music.

Paul Kim's experience, like that of other artists, demonstrates the ex-tent to which dedication is a prerequisite to serious accomplishment in an artistic career. His story suggests that spiritual growth requires ded-ication as well. However, it is important to remember that in the Christian tradition, so central to Kim's spiritual life, emphasis on "works" has always been tempered by arguments about God's grace as a free gift to all who have faith. One need not be a spiritual concert pianist to experience this grace.

In this example, there is also an important lesson about striving for balance in one's spiritual life. Just as Paul Kim has recognized the need

to spend time with his family, people who devote all their time to prayer and contemplation or to church work and evangelism need to recognize the value of spending time in other ways. Of particular significance is the fact that Kim spends time studying the Bible and attending church. While his music draws him closer to God, these other activities contribute to his thinking about the nature of God.

A Sculptor in the Cathedral

The emphasis that Paul Kim attaches to opening his heart takes a different turn in the life of Greg Wyatt, an artist whose spirituality draws on a wide variety of traditions despite his association with a mainline Protestant church. Wyatt is sculptor-in-residence at the Cathedral Church of St. John the Divine on New York City's Upper West Side, where he created the forty-foot *Peace Fountain*.[4] A clue to how Wyatt relates his spirituality to his work as an artist is the fact that he describes his religious preference as "spiritual art." The son of a painter in the Hudson River valley, he developed an early interest in art, and by the time he was in high school he was engaged in formative apprentice relationships with several leading artists. But he also credits going to the Catholic church with his mother as a significant contribution to his art. "Questions about our very nature are the things that interest an inquisitive young mind, and that has to do with developing one's sense of an artistic voice," he explains. During college, as an art history major at Columbia University, he brought his interests in art and spirituality together by studying the history of church architecture and religious paintings. After college, during three years of study at the National Academy of Design and further training in Italy, his interests in spiritual art deepened.

Wyatt likens his spiritual journey to that of creating three-dimensional art. "Visual artists are experts in imaging and in thinking in nonverbal ways. Our language is a tactile or visual perception that has invisible and visible phases. The act of drawing is putting an idea into

tangible form. That creative act is fuzzy, it's not very well formed, it's not tested. It might be absolutely brilliant, but it's not known how brilliant. It might be an utter failure, and there's a good chance that it will be. But it is the first act of bringing into a physical presence things that are within a conceptual world. In that initial phase, you try to clarify what it is you're trying to communicate. You can't find shortcuts or ways to instantaneously present mature art forms." This, he says, is why gallery exhibitions and art histories focus on the practice of art, rather than only the end product. After the initial drawings, many of which are discarded, come clay models, plaster casts, and only later the bronze sculptures. In his view, spiritual development follows a similar path, drawing ill-formed sentiments from within the person and through a process of reflection and activity helping to shape the person around a spiritual center.

He tries to incorporate this understanding of spiritual development into his daily routine. Each evening he sets aside a time for meditation: "I close down my living space. I illuminate by candlelight or by soft lights or no lights. I do what Rodin did, which [is] to darken my world and try to revisualize exactly what it was that I was attempting to do in an active way in the studio. It's not only about visualization, it's about a sense of 'Is there a connection that is palpable to what I define as God or divinity? Is there something that's clear? And if there is, how can I clarify it? How can I amend it, revise it, develop it more?'" He focuses on clearing away "frictions, tensions, and static" from the day. He does this by compartmentalizing the things that were productive from the things that were destructive. "I think that's absolutely fundamental to the development of one's art as a practice, and that's part of the spiritual journey."

Wyatt's daily routine continues the next morning when he spends fifteen to twenty minutes "collecting an essence of the day's purpose." His time of meditation the evening before helps him do this. Having reflected on what was good and what was destructive, he is able to think more clearly about the new day's meaning and to set priorities. Doing

this gives him strength for the day. He then tries to devote at least two hours to the quietest and most creative aspects of his work. Often he draws or creates small forms because these are closest to his inner spirit. By late morning he may turn to a project in a later stage of development, and in the afternoons he generally tutors students or tends to the business aspects of his work.

Unlike Paul Kim or Lydia García, his daily meditations seldom include Bible reading; instead, he often includes visual art, such as William Blake's illustrations of the Book of Job, to focus his attention spiritually. He is particularly fond of Shakespeare's plays and sonnets, because they raise questions of good and evil and prompt him to think more fully about the relationship between his inner life and his behavior. Each Saturday afternoon he meets with several other artists to read and discuss Shakespeare together. He is especially intrigued with *Hamlet:* "The great question of *Hamlet* is 'Who's there?' It reverberates throughout the play. That play is fabulously wealthy with knowledge about spiritual conduct."

He hopes his own art can help others engage more seriously in their spiritual journeys. "Art is not simply a pretty picture or something to glance at as you go by, but to be meditated upon. It is like a library of great truth, and certainly that helps to promote one's quest on a spiritual journey."

Greg Wyatt's story illustrates what many artists seem to be paying increasing attention to: spiritual practice need not be limited to reciting prayers or, for that matter, to reading sacred texts. Although he includes time each week to read and discuss the Bible, his daily practice consists more of visualization than of anything involving words. He assumes that there is something primordial about his feelings and that these need to take form gradually. This is a view that some religious leaders would find disturbing because it places heavy emphasis on the imagination. Yet, even for those who might feel uncomfortable with literally following his example, Wyatt's metaphorical connection between visualization

and spirituality is instructive: often the first stab at bringing one's heart into a closer relationship with God is ill conceived or incoherent; second and third tries often bring improvement.

The Nature of Practice

For each of these artists—Ann Biddle, Willi Singleton, Lydia García, Paul Kim, and Greg Wyatt—the essence of spiritual practice is engaging in a regular pattern of activities to deepen one's understanding and experience of the sacred, to strengthen one's relationship to God, or to establish a closer connection with the ultimate ground of being. Whether it consists of special activities like chanting or meditating or is integrated with playing the piano or firing pots or making plaster casts, it is defined by the person's desire to be in the presence of the sacred and to become more fully aware of that presence. The daily work routine is a way of concentrating on the sacred and expressing deeply felt spiritual yearnings. Prayer and meditation help bring these yearnings to the person's awareness.

A potter who has been meditating for more than twenty years elaborates this point when she describes the many different methods she has tried and says the most important aspect of meditation is just to sit "with the intention of being in the presence of God." She believes that God is always present, but people are often not aware of this presence. So her task is just "to be there as fully as I can be." Another woman describes prayer in much the same way: "It's an opening to God's presence, an opening of my being to God's presence." She used to think of God as a distant being but by praying regularly has come to a more intimate view: "I see the energy of God as being a part of my energy, the life force."

These artists deem spiritual practice intrinsically worthwhile, even when the sense of divine presence remains elusive. Lydia García acknowledges that she would like to know God, but often feels that she doesn't. "I don't know who I am and I don't know who God is. That's

when prayer is most important. I can at least trust and say, 'Father, just help me. I don't know where I'm at. I just don't know.' There are so many times like that."

When they fail to pursue their spiritual practices, these artists feel a void. Ann Biddle asserts, "When I don't have a consistent practice, my life goes to hell." Lydia García says, "There's an emptiness. If it's one day, for whatever reason, I feel it. There's a crying. 'My soul cries for you, oh, Lord.' I need to do it. It's just like breathing. I have to do it." Another artist acknowledges, "I don't feel centered. I feel like my life is out of balance. I find myself getting angry and saying things I don't want to say to people. I don't feel connected to goodness, to God, to creation."

For those who believe in the existence of a divine being, spiritual practice usually includes talking to God, listening to God, or simply becoming more aware of God's presence. Greg Wyatt says prayer is basically about improving his relationship with God. "That's what I pray for, improvement and greater understanding." Paul Kim's "two-way communication" with God focuses especially on his desire to learn and be obedient to God's will: "I have a deep longing to do what is right. There are things that I want to do just for myself. So daily I go through many trials. Sometimes I fall on my face, but over a long run I can see that God has been there for me in important times." Lydia García observes that she talks less now and listens more. "I do a lot of quiet time and listening, instead of just pray, pray and talk to God. For me it's real important to be quiet." When she does this, she experiences "a peace within." She often tries to listen to God as she works on her *retablos*, and sometimes she has to stop working and take a walk or go fishing. "I go to the lake and just reflect on the quiet of the water. Water is very cleansing and healing. It's hard to explain the spiritual; maybe that's the closest I can come to it."

For other artists, spiritual practice does not focus on a divine being but puts them in contact with something transcendent. Willi Singleton links his experiences of transcendence directly to the wood-firing method he uses in his pottery work. He sees the electric kiln that many

ceramicists use as enhancing the potter's control over the process, and in this way standing as a metaphor for the self, rather than letting larger forces play a role. "You want to be able to create exactly what comes out of your brain [with an electric kiln]. It's a domineering approach to the clay. You make your idea in the clay. You put it in the kiln. You fire the kiln with the glazes that you have fabricated from industrially processed minerals and then you take it out. Then this piece of pottery is an expression of yourself." In contrast, the unanticipated ways in which a wood-fired kiln produces its effects are his metaphor of the sacred.

Spending Time

These artists emphasize that personal and spiritual growth results from diligently focusing on a particular set of activities over an extended period of time. Ann Biddle feels strongly that people should work at whatever their spiritual practice may be. "It's just like going to the gym. People need to put energy into developing a spiritual practice. It shouldn't be something that's just extra or on the side. It's a core part. To become a balanced person, you need to develop your spiritual side. I think it's going to become a given that everybody will have some kind of spiritual practice. They might even build it into the workday. Who knows! It's just like people coming to understand how important it is to maintain good health or exercise."

But the benefit from engaging in spiritual activities is not so much achieving a well-defined goal as feeling that one's daily life has been enriched. This is a lesson Ann Biddle has learned slowly. When she began chanting, she was drawn to it for purely goal-oriented reasons, such as overcoming depression, creating a happy marriage, or achieving success in her career. Increasingly, she focuses more on altering her attitude toward life. "I just know that my life is a lot richer when I have a deeper practice. I appreciate things. I appreciate my husband. I get along with my husband a lot better. I enjoy my job. I have a deeper sense of my mission, more confidence, courage, hope, joy."

Willi Singleton's view of spirituality is similar to Ann's, even though it is also virtually indistinguishable from how he thinks about art. He doesn't regard ceramics as a way to accomplish a goal, such as achieving fame or happiness; instead, his daily life is enriched by the connection his work establishes between himself and his sense of the universe. "It's what makes me know I'm not alone on the planet." Lydia García's daily prayer and participation in the Mass enrich her life the same way. Things don't change, she reflects, but you see them differently.

These examples suggest that it is important to be creative in one's spiritual practices, rather than dutifully conforming to the ways other people pursue them. Ann Biddle stresses the freedom that results from following a practice that strengthens her confidence in herself. "The definition of absolute freedom in my practice is not being run over or affected by external things, but being autonomous and being strong in yourself. Whatever hits you, you're going to be able to rebound and go on, no matter what." Willi Singleton makes a similar observation: "To find one's own spirituality in this day and age, you have to think it out, so creativity is essential. If you don't have some potential to do that on your own, in your own way, it's going to be pretty tough." From a different angle, Lydia García points to her art as increasing both her confidence and her sense of freedom: "It gives me that freedom to express myself and not be afraid."

Although Paul Kim spent years learning the rules of music, he too emphasizes the freedom to express himself spiritually through his music. "There is no limit to the differences one can include [in a performance], even if one follows the directions to the letter. One performer's idea of crescendo is different from another's, and tempo, ritardandos, and so on, and one's own involvement in the music, one's spiritual involvement in the music is so different."

Paradoxically, these artists insist that their ability to create is enhanced by following a well-established set of procedures. For Ann Biddle, the regularity of chanting has a calming effect that unleashes her imagination from fears and inhibitions. For Lydia García, the daily rou-

tine of working in her studio, going to Mass, and then working again makes her feel secure enough to experience a kind of freedom. Paul Kim observes that "you go step by step and learn the music, the technical elements, the fingering, the rhythmic formulations, the dynamics, the tempi, and everything else." Only then is it possible "to open up your ears and hear what the music is telling you."

In similar fashion, Willi Singleton emphasizes the orderly sequence required in making pottery. "If it's done right, making pots is like water flowing down a river. One thing happens after the next. You start with digging the clay, putting it in a wheelbarrow, taking it up, putting it in a cement mixer. Getting the slurry made. Drying the slurry in the clay-drying beds. Wedging the clay up. Putting the clay on the wheel. Throwing the shape that you want. Preparing the wood. Splitting the wood down to the correct size. It has to be the right kind. You can use hard wood, you can use soft wood, but you have to use them at the right times of the firing. If you don't get the jobs done in the right order at the right times, you're going to be pushing the stone uphill, so to speak. You're going to be going against the flow. This is basically what it's all about."

Just as their artistic work does, their spiritual practices impose an order of their own. They require preparation and paying attention to the task at hand. Simpler skills precede more complex ones. Although these practices differ from rational systems of theological or philosophical thought, they have their own form of rationality—a rationality inherent in the discipline that leads to mastery. It is for this reason that most artists emphasize the growth they have experienced as they have endured in their spiritual practices.

Although this growth may be uneven and unpredictable, it is usually nurtured by the places in which artists work, worship, or engage in their daily spiritual practices. Ann Biddle's home altar helps to sanctify the space in which she chants and meditates. She does not worship the altar but understands that it symbolizes the importance of having a sacred dimension in one's life. Willi Singleton is not particularly sentimental about his farm, but he knows his work would be different if he could not

dig clay from his backyard or burn corn husks from his neighbor's field. In her studio Lydia García has an altar that she inherited from her father, and it reminds her of him. Her *retablos* give her studio a religious atmosphere, but she also feels closer to God when she remembers people who have come to her studio and been touched by her work. Greg Wyatt's work space provides him with a metaphor for his spirituality. His studio, a 2,400-square-foot space in the cathedral crypt, is insulated by hand-cut blocks of granite and, being below ground, depends almost entirely on artificial light. Working there, he says, is like lighting a candle. His daily actions help to bring light into the darkness.

Engaging in regular devotional activities helps these artists circumvent any confusion they may have experienced from being exposed to different theological and philosophical traditions. Ann Biddle says her childhood attraction to Christianity has been difficult to sustain because of her exposure to other religions in Thailand and her affinity for her mother's Japanese traditions and her grandmother's Native American heritage, not to mention her exposure to Judaism and Buddhism through her friends. "I'm into application and less into doctrine. I'm a hands-on kind of person. I like to see how I can apply things to my daily life, and that's why I've been attracted to this kind of practice, because it's very accessible to anybody, regardless of education, background, money situation, whatever. Anyone can do it." Willi Singleton is attracted to Buddhism for similar reasons: it emphasizes activity and experience, whereas doctrinal religions become "dogmatic and unbending."

Although Lydia García and Paul Kim are squarely within the Christian tradition, they too have been influenced by diversity within their environment. García's third husband was a Presbyterian, and she went with him to his church for years. She never liked it as well as her own, but it convinced her that Catholicism wasn't the only way to God. Native American religions have been a part of her culture from birth. She feels she has a deeper appreciation of nature and of suffering as a result of living among the Pueblo Indians near Taos. Her devotional practices downplay theological differences among Catholics, Protestants, and

Indians, encouraging her to focus more on simply being faithful to God. Over the years, the Holy Spirit has become increasingly important to her because she is able to imagine that this is God's spirit living inside her.

Greg Wyatt became dissatisfied with Catholicism during college and started attending services with Methodist, Episcopalian, and Jewish friends. The antiwar turmoil at Columbia turned his attention toward politics and sharpened his interest in existential philosophy. His daily practice of meditation has been influenced by friends from Japan. Although he knows Christianity better than other religious traditions, he does not feel it necessary to settle into a particular system of belief. He thinks spirituality needs to involve "prayer and self-education" more than participation in religious organizations.

The Role of Mentors

Many people who express interest in spirituality seem to believe that they can pursue this interest entirely on their own. Perhaps this view stems from our deep distrust as a people of nearly all institutions, or perhaps it arises from an inability to find help from congregations, clergy, or friends. But, according to these artists, the best way to develop a spiritual practice is by cultivating a relationship with a mentor, just as an apprentice does in learning art. Willi Singleton's experience as an apprentice in Japan is emblematic. His mentor insisted that he learn by doing. Singleton remembers struggling to learn wedging (preparing clay for the kickwheel). His mentor refused to explain the process and told him not to read about it. "There's a Japanese saying, 'It takes three years to learn wedging.' I had to figure it out for myself. That was exactly the point. You've got to figure it out for yourself. It's not like figuring out a simple riddle; it's something that you've got to work through."

Several different mentors are often required to learn a personally fulfilling set of spiritual practices. For Paul Kim, his various music mentors contributed to his understanding of spirituality as well. One of the most significant was the French composer Olivier Messiaen. A devout

Catholic, Messiaen was influenced by meditating on the mystery com-
municated by the life and death of Christ. He was also fascinated with
nature, incorporating rhythm and melodies from birdsongs into his
compositions. For Kim, studying Messiaen suggested possibilities for in-
tegrating his faith more explicitly with his music. In recent years, fol-
lowing Messiaen's influence, he has turned more and more of his atten-
tion to performing sacred music. He regards it as a form of "spiritual
confession."

Greg Wyatt believes the apprentice-mentor relationship should be
understood in terms that span several generations. His own develop-
ment was shaped not only by artists with whom he worked but also by
such historical figures as Cézanne and Gauguin. "The central search of
Cézanne was essentially a search for a new language to expand nature's
vocabulary and the understanding of nature's constructions. He in-
vented a language which took into account not so much specific detail,
but a hidden order within all of nature. Whereas in Gauguin, his reli-
giosity is seen in his composition of forms within the work. He is truly
a religious artist, both in terms of his selection of subject matter and also
in the way that he colors, in the way that he appropriates the elements
of art to emphasize a strong religious feeling communicated by his pic-
ture." Wyatt's efforts to incorporate spirituality into his art reflect both
these influences.

At some point in their spiritual growth, just as in their professional
development, these artists found it necessary to move away from their
mentors and cultivate a more personal style. Lydia García recalls one of
her mentors advising her not to imitate his techniques but to cultivate
her own. "It was a long time ago, but it was the best advice he could have
given me." She draws a parallel to her spiritual life. The "desert times"
in her life usually come when she forgets this advice and tries to be like
other people; then she has to be quiet and reestablish her unique rela-
tionship with God.

The shift toward a more personal style of spirituality involves achiev-
ing a balance between competing with others and focusing on one's in-

ward guidance and growth. Ann Biddle says it is extraordinarily difficult to be a dancer because the training process is so competitive and so focused on learning techniques that a person loses self-confidence. She thinks her daily spiritual practice has helped restore her confidence in herself. "When I chant, I get a lot of confidence. My vision, what I want to say, becomes so clear that I know I just have to say it, no matter what and who cares, and screw them." Willi Singleton says the best advice he could give someone is "figure things out for yourself; don't accept doctrine blindly."

If spiritual practice clarifies one's self-identity, including art in one's practice provides a way to offer a part of oneself to God. An example is Lydia García's *retablo* of Saint Francis. The birds hovering above his head and the animals at his feet express her sense of joy. Yet his hands are elongated and enlarged, revealing stigmata as symbols of Christ's crucifixion and her own times of sorrow, which she says are impossible to separate from her times of joy. Near the bottom, she has embedded mirrors to reflect light from a candle that might be placed before the *retablo*. Saint Francis is a reflection of Jesus, she explains, and we are a reflection of each other. Large eyes and dark skin identify the figure with Hispanic culture, while a blue robe symbolizes the sky, which García's father taught her to think of as the sheltering protection of the Blessed Mother. This *retablo* is both an expression of herself and a reminder of the spiritual connections between herself and God.

Of course the practice of art and the practice of spirituality differ in that artists do the former full time to earn a living, whereas spirituality may occupy their conscious attention for only a few minutes a day. Art and spirituality are nevertheless similar in that both are sets of activities that infuse all aspects of a person's life and gradually shape that person's worldview. Ann Biddle insists that prayerful chanting influences every other part of her life. For Willi Singleton, spirituality is separable from life only when he has to answer questions about it. "Making pots and the life of the potter are one thing. It's not very theoretical. There are some potters who write a lot or talk a lot. Most potters don't. You're working

at the wheel, you're working with clay, you're firing the kiln, you're exposed to these elements of nature, and things kind of tighten up in your life. Things come together, the relationship between the work and your spirit." Similarly, Lydia García says her art pervades her entire life and that spirituality subsumes everything. "It's always flowing. It keeps going in and out, in and out, and it's moving all the time, and it's not just the prayer or your thoughts—it's your work, it's everything."

From Practice to Service

The key to how much a spiritual practice influences the rest of a person's life is often most evident in how much that person is committed to serving others. Ann Biddle is increasingly convinced that her work is significant, not when it simply expresses some personal trauma or insight, but when it uplifts and inspires others. "As you practice, you develop a feeling of compassion and empathy in a much stronger way and that affects the kind of work you do." She recalls how a performance she did in Japan as part of the fiftieth-anniversary remembrance of the bombing of Hiroshima moved her beyond viewing dance purely as a personal quest. "It was a transformative experience. I didn't need to be the star anymore. I have come to realize that my dancing needs to be for other people. It needs to take a whole different direction, and I'm still trying to figure out what that is." Her growing interest in choreography that reflects the struggles of women and her emphases on multicultural and international themes are clearly part of this quest.

An example is a piece Biddle choreographed entitled *Women of the Sands*. An abstract performance based loosely on T.S. Eliot's *The Wasteland*, it depicts the enduring struggle of women faced with the ravages of war. In the first section women in gauze shrouds cross a metaphorical desert. The second section dramatizes the effects of war as the dancers wash blood from their shrouds. This section is followed by a more active dance in which the women themselves attempt to engage in combat. The final section uses water and unveiling to represent a new be-

ginning. Biddle remarks that it often brings her to tears to participate in the performance and that many in the audience are deeply moved as well.

Willi Singleton has always thought of his work as a form of service. Lately, though, he has been thinking more about this connection. He hopes that while using his pots, people pause once in a while to reflect on the beauty of nature or its power. He enjoys having people watch while he works so he can tell them about wood-firing and his understanding of the clay. "It's very instructive to know how these pieces fit into people's lives and to know how they understand the pots."

Lydia García has discovered that her *retablos* have become a kind of ministry. This is why she inscribes them with prayers and Bible verses. People write to her about seeing one of her pieces in a gallery or museum and being touched by the experience; they also come asking her to pray for them. "It's scary for me when people come and ask for prayer because I don't have any special powers," she confesses. "I really don't. But I can pray, and usually the prayers that I do are just, 'God, help the people that ask me to pray for them.'" Although she hesitates to talk about it, she also donates money to a shelter for abused women and children, teaches art to disadvantaged children, and regularly visits people in the hospital.

Paul Kim believes that service should start at home but not stay there. He devotes as much time as he can to his two sons and has taken the older boy, also an accomplished pianist, on tours with him. Several of their national and international tours have been charitable efforts to raise money for orphanages. "We want to do this kind of activity for society as much as possible. I've got to be service-oriented, because that's the commandment we find in the Bible, 'Go and serve and preach the Gospel.'"

Greg Wyatt decided more than a decade ago that his art should serve others. He draws inspiration from Wassily Kandinsky, who emphasized both the spiritual aspects of art and the need for artists to recognize the social responsibilities of their work.[5] Much of Wyatt's work is public art, and therefore intended to contribute to the wider community, but he

also tries to serve others by training young people. He has an apprenticeship program at the cathedral and mentors young artists in New York's public schools, often finding that they are at a loss about what to do with their creativity. His dream is to start a national school for young people interested in creating public art.

Spiritual practice reinforces these artists' commitment to serve others by regularly focusing their attention on questions about what matters in life. They become more aware that self-gratification is not the ultimate aim of their work and that they participate through their work in human and even cosmic forces they cannot control. They nevertheless recognize that they play an active part in creating goodness and beauty. Having benefited from the contributions and mentoring of others, they want to pass these benefits on to their audiences and students.

People in many walks of life report difficulties integrating their spirituality with their work. The former gains focus during weekend worship services while the latter consumes them the rest of the week. But there has been a growing interest in recent years in such regular devotional activities as contemplative prayer, meditation, and keeping a spiritual journal. Like these artists, people who have been engaged in such practices report that their understanding of God has deepened and they experience a closer relationship to God. These practices contrast sharply with the casual spiritual dabbling so often encouraged by bookstores and television programs. They require concerted effort over a period of years. Often people rely heavily on a spiritual director, a member of the clergy, or a trusted friend to guide them and to offer encouragement when their commitment falters. The practices eventually yield results but usually not immediately. Although they generally require learning a particular regimen, at the same time they need to be personalized. As artists' stories reveal, creativity can be a valuable aspect of these spiritual practices.

THE CIRCLE OF LIFE

ARTISTS HAVE BEEN DESCRIBED, even by some religious leaders, as the theologians of our time. Few have received conventional training in seminaries, but their stories capture the public's imagination and their songs and images stir the soul in ways that often rival the teachings of religious leaders. If theology is the practice of drawing connections between religious truths and contemporary cultural concerns, then artists may indeed be functioning as theologians. Although their knowledge of religious tradition is often scant, their work sometimes does reflect considerable engagement with tradition, while in other instances it raises profound questions about such issues as the character of God, the reality of evil, and what it means to be a responsible person.

The theology in artists' work is seldom heavy-handed, more often being disclosed in carefully turned phrases and subtly crafted shapes or movements than in authoritative philosophical arguments. It nevertheless emanates from what artists frequently describe as agonized periods spent pondering the distinction between good and evil, the uncertainties of life, the nature of God, and familiar religious teachings on these subjects.

An "Irrational Season"

The deeper meanings of life have always been central to Madeleine L'Engle, the author of more than fifty books, including the widely read *A Wrinkle in Time*, which won the prestigious John Newbery Award in 1963.[1] In addition to the many readers who follow her written work, thousands flock to conferences and retreat centers to hear her in person. A master storyteller whose books for children and teenagers contain rich insights for adults as well, she has written extensively about her own spiritual life and about her reflections on such topics as family life, angels, bereavement, grace, and the theological implications of scientific discoveries.

Sitting at her desk, nearly engulfed by towering walnut bookshelves overflowing with favorite volumes and personal memorabilia, she explains her lifelong interest in spirituality. "My spiritual journey was largely at home," she recalls, mentioning how she (an only child) spent long evenings with her parents reading the Bible and Shakespeare, listening to music, and making up stories. "My parents gave me a God of love, not a God of anger or retribution. Not God looking like Moses in a bad temper, but somebody who loved me the way my dog loves me. Totally. I was very lucky. Because they worked late at night, there was nobody to take me to Sunday school at an early hour. So I just went to eleven o'clock church with them and skipped Sunday school. I feel very blessed. I've met so many people who have spent their lives unlearning the garbage they got in Sunday school. I didn't get it. My journey was often through fiction, through the journeys of fictional characters, and it was always toward being more open, more inclusive. We did not think of heaven as a gated community, but a place for everybody."

Living part of her childhood in England, she was exposed to Anglican theology in school but found it "restrictive, cold, rigid, nothing to live by." By the time she was in college, she had largely abandoned going to church and did not resume until she was married and had a baby. Returning to church, she found herself drawn to the companionship of

other couples with young children who cared deeply for each other. She became active in the church choir and taught Sunday school. But these were not the main reasons she went. "I need sacraments, I need symbols," she asserts. "I need questions that do not have answers."

These needs continue to lie at the core of her religious belief. When asked her religious preference, she chuckles and says, "I don't prefer anything. I am an Episcopalian because it's the least intolerable thing to be." It provides her with sacramental occasions on which to ponder the questions that do not have answers. She is adamant that theologies in today's complex world must be more about questions than answers. Some years ago, when her children were still young, she yanked them from the Sunday school they were attending because "they were being taught questions that had answers."

Her views are heavily influenced by an enduring fascination with biology and physics. Reading in these disciplines convinces her that the world is characterized chiefly by uncertainty. "We're no longer in a deterministic universe. It's indeterministic. Everything affects everything else. You cannot study anything objectively because to look at something is to change it and be changed by it. We're suddenly in what's called the world of chaos, and it's not chaos as we understand the word, it's rational. But it's where we can't predict the weather. They try all the time and very seldom succeed. There are many situations that are unpredictable. We don't know what's going to happen during the course of the day."

She means this quite literally, pointing out that she is about to attend the funeral of a friend who died unexpectedly. Her reflections on the uncertainties of life have always been sparked by such events. When, for example, she adopted a seven-year-old girl whose parents had been killed in an automobile accident, mothering this girl raised hard-to-formulate concerns about evil and injustice, freedom and responsibility. Working through these questions was the principal reason for writing *A Wrinkle in Time*. "I wrote it because I was not satisfied," she remembers. "I could not live with the theology that was the ordinary theology. I read

a biography of Einstein in which I read that anyone who is not lost in rapturous awe at the power and glory of the mind behind the universe is as good as a burned-out candle. I thought, 'I have found my theologian,' so I began to read his theories of relativity, and then I read quantum theory and particle physics, and there I found my theology."

Her outlook has been shaped too by literary figures and artists. One of her heroes is the Scottish writer George MacDonald. "He was excommunicated from his church because he refused to believe that God would regard three-quarters of the people of the planet as unworthy of his attention, or fit for hell. So I thought, 'I agree with George MacDonald.'" Her thoughts are frequently jarred by a line from Shakespeare or Dostoyevsky and by contemporary writers, such as P.D. James and Elizabeth George, whose work is rich with metaphors. She especially appreciates those for whom the "rules don't hold."

This is one reason she is continually attracted to the life of Jesus. "Read the Gospels. Read what this guy was really like. He had a strong personality, he told jokes, his friends were all the wrong people, he liked to go to parties. He didn't start a lepers' rights movement, he just healed lepers in his path. He was far more severe about people who were judgmental than he was about people who committed adultery. Love was always more important than anything else. All of his miracles were done on the Sabbath. God should have said, 'Jesus, tone it down a bit. Be a little more tactful!'"

She believes Jesus' example should encourage people to exercise their own freedom, rather than worrying so much about what is expected of them. She cites some of the negative reactions to *A Wrinkle in Time* as an example: "When it was first published, it was hailed by the evangelical world as a Christian book. Now it is one of the ten most censored books in the United States. Not one word of the book has changed. Something else has changed. We live in a climate of fear and hate. What's happened to us? What are we frightened of? I think we're frightened to accept that the universe has changed, and this free God offering us freedom is very different from Moses, which is what we used to

sort of see as God. We're terrified of freedom and so we slam around in our fear, and if we can hate enough people, maybe our freedom will go away and we'll be safe again."

But her insistence on freedom is based primarily on the conviction that God's ways are ultimately beyond human comprehension. She recites a four-line Christmas poem she wrote several decades ago:

This is the irrational season
When love blooms bright and wild.
Had Mary been filled with reason,
There'd have been no room for the child.[2]

She elaborates: "We try to be too reasonable about what we believe. What I believe is not reasonable at all. In fact, it's hilariously impossible. Possible things aren't worth much. These crazy impossible things keep us going. God loves us that much!" This is why she has faith, even though she has more questions than answers.

Madeleine L'Engle's writings are routinely quoted in sermons and in theological treatises, and they are required reading on many church-related campuses. Although not the cause, the popularity of her work suggests that many Americans have retreated from trying to understand spiritual truths in concise theological formulas. Her insistence that belief is not reasonable has not prevented her from finding rich insights in the Bible and in other religious writings. Yet her idea of an "irrational season" clearly opens the way for artistic approaches to the sacred to gain prominence.

Coming Full Circle

Another writer whose work has attracted a wide audience is San Francisco–based essayist Richard Rodriguez. The son of Mexican immigrants, he graduated from Stanford University and pursued doctoral studies in English Renaissance literature at the University of California at Berkeley before turning his full attention to a career in writing. His

autobiography, *Hunger of Memory*, has gone through more than two dozen printings; his second book, *Days of Obligation*, was a finalist for the Pulitzer Prize in nonfiction. His essays regularly appear in five major newspapers on three continents and on three national television programs in the United States. Whereas Madeleine L'Engle's theology was shaped by growing up with little involvement in a religious community, his was influenced by total immersion in one community.

For Rodriguez, the Catholic church was virtually omnipresent during his childhood. The church itself was a block from his home in Sacramento; a block in the other direction was the Catholic school he attended. From his backyard, the Catholic hospital was visible, and the periodic moaning of ambulance sirens was a constant reminder of death. "Living in a community of shared faith, I enjoyed much more than mere social reinforcement of religious belief. Experienced continuously in public and private, Catholicism shaped my whole day. It framed my experience of eating and sleeping and washing; it named the season and the hour."[3]

His views of God developed almost instinctively in this environment. God was a communal being whose shape and texture came from the Mass and the Irish priests who administered it as well as the nuns who instructed him. "I think I was most deeply spiritual then, enormously interested in religion from a very early age. Was very much moved by the Irish Catholicism of my school and those nuns, some of whom are still alive today and with whom I'm in correspondence. The example of their lives was very interesting to me. Sacred Heart Church was just this extraordinary, Ravenna-like church in the middle of Sacramento where I could go on a summer day and it's cool, dark. There were things that went on the altar. The smell of flowers, the lights, everything was so enchanting there. It beat anything on television, I'll tell you that. I think it was when I was closest to God, those years. I certainly knew how to pray."

But as he matured Rodriguez found himself living outside a Catholic world. "My education may have made it inevitable that I would become

a citizen of the secular city," he has written, "but I have come to *embrace* the city's values: social mobility; pluralism; egalitarianism; self-reliance. By choice I do not confine myself to Catholic society. Most of my friends and nearly all of my intimates are non-Catholics."[4] In college his interest in theology was sparked by Catholic theologian Michael Novak, yet his thinking was increasingly shaped by Miltonic Protestantism, by Buber and Sartre and Freud, and by Zen Buddhism. Both the civil rights and farm workers movements drew him increasingly into wider circles. He moved to New York, studying with Abraham Heschel at the Jewish Theological Seminary and learning more about world religions at Columbia University. After a few years he moved to Los Angeles, where he embarked on what he describes as the "pagan phase" of his life.

"I still don't know how to talk about this, and I've never written about it," he confesses. "I found myself with movie stars and models and an extraordinary drug scene, which I was a witness to. I know a lot of people who had a lot of trouble in those years, and I was the person they called. It was partly that I was so straight that they needed me so much. I listened to a lot of teary conversations late at night. I was interested in celebrity. I was interested in beauty. People who make their living from their bodies. Not whores, but famous celebrities, movie stars. But there was almost no spiritual life in those years."

Since then, his thinking has come almost full circle, as the frailty of life has brought him closer again to his religious roots. "Since I've come back to San Francisco, I have known so many people who have died with AIDS and this has connected me again to something that's very old and ancient within every religious tradition I know of—the experience of mortality and finitude which is at the very center of life. I've become more Mexican in that sense, more Indian in that sense, and more Catholic. I've helped the dying die, and that's something I didn't think I was going to do early in my life. I thought I would be afraid of it, and now I'm not. If your son is dying tonight, I know how to distinguish the noises in his body and what it means. I know how to clean a body. I'm

not afraid of death the way I thought I was. But I'm still living in the enormous sadness of losing people I know. So many people are in trouble right now, I can't tell you."

Coming full circle means he finds solace again in the Catholic Mass of his youth, and his respect for the patient service of the nuns has increased, overshadowing the formal ("Protestant") theology he learned in college and graduate school. Sitting in the pew each Sunday morning, he muses about the gay couple in front of him, the elderly woman with her dog, and his friends who have died, and he thinks that somewhere there must surely be a God who can love everyone.

He nevertheless acknowledges that it has been impossible to return fully to the communal Catholicism of his childhood. "Certainly the church's position on homosexuality is problematic to me; I mean, I'm officially a sinner in the eyes of the church." He admires the church's efforts to speak on behalf of the poor, but admits that he has become more interested in silence than in social activism. He tries to learn from everyone he meets: the Black Muslims he encounters when he visits prisons and the gay friends who have become atheists because they feel rejected by the church. He lives beyond borders, questioning what it means to be labeled Hispanic or Latino and reveling in the growing diversity of California.

Living beyond borders has become a metaphor for his writing as well. "I'm trying to violate borders. I'm very much an admirer of illegal immigrants. I like the idea of not staying put. I like the idea of violation. I like the idea if you're writing nonfiction, of trying to introduce fictional elements to it. I like the idea if you're writing prose to poeticize the prose. I like the idea of people not knowing exactly how to approach you, how to think about you. I like that kind of complication in ideas."

At the same time that he admires complication, he indicates that complexity leads ultimately to the realization that one can do little more than sit in awe at the presence of God: "God, for me, is sort of the envelope of infinity and made manifest to man through an agency, Christ, which allows for that extraordinary abstraction to be realized as a per-

son, to be spoken to, to have a face, to have an emotional life for my benefit. While I'm more and more of the opinion that God is everything that I cannot speak of, I'm more touched by the fact that what Christianity has given me is the ability to speak of God."

Faced with the death of so many friends from AIDS, pondering the void in the eyes of a teenager he recently visited in prison who had shot and killed a fellow teenager, and reflecting on the ways in which his familiar world is becoming more difficult to comprehend, he says his religious belief is increasingly expressed in the simple customs of his childhood. "I've come to the opinion that those nuns in the first grade knew all about it, and that I think exactly the same as they did. More and more I'm reverting to very simple notions of God and prayer and the Blessed Virgin."

Like Madeleine L'Engle, Richard Rodriguez has influence that extends well beyond the kind a local pastor or priest might have. Those who decry the absence of public theologians should recognize that Rodriguez is one, even if he is not ordained. Moreover, he is as concerned about social issues as he is devoted to Christianity. In a complex world filled with death and uncertainty, his reversion to "simple notions of God" contrasts sharply with the elaborate philosophical systems that have attracted some and the heterodox notions of spirituality that appeal to others.

Rediscovering the Path

Like Richard Rodriguez, the New York playwright Tony Kushner has lived in a world that forced him to come to terms with the reality of AIDS. His two-part, seven-hour Broadway production of *Angels in America: A Gay Fantasia on National Themes* (1993–94) won a Pulitzer Prize and two Tony Awards. Reviewers praised it as a call for hope and for greater social responsibility. Other plays, including *A Bright Room Called Day* (1985) and *Slavs!* (1994), emphasize similar moral and theological questions raised by contemporary social and political conditions.[5]

Raised in Louisiana by a mother who had played bassoon with the New York Opera and a father who was a conductor, Kushner developed an early interest in both the arts and spirituality. He was often painfully aware of being Jewish because of the anti-Semitism in his hometown, yet he regarded his experiences at synagogue and in Hebrew school as wholly positive. His defining encounter with spirituality came at age eleven when his mother fell ill and was rushed to the hospital without much hope that she would survive. He prayed in desperation, promising to fast for a full day if God would spare his mother's life, but in his anxiety found himself consuming a box of cereal a few hours later. His mother did not die, but he secretly blamed himself for her ordeal. "It was massively disruptive and guilt-producing and frightening. I know it's the first time it ever occurred to me that people died. The people who were the foundations of my world were mortal."

The theology of his youth, Kushner now thinks, was heavily conditioned by the physical geography of Louisiana. "It's a very haunted place. There's intense decay going on in the bayou all the time, and at the same time there's an outrageous amount of life. The bugs are at least sixteen times bigger than anywhere else and they're very loud. In spring there is this unbelievably erotic explosion that just puts northern springs to shame. And yet everything is so steamy and so hot that everything's always decaying and falling apart. The South is like that. You're really at the crux of a birth-death cycle. And there's vegetative covering over everything, so nothing is really apparent. It's not a place of clear vision. It's a place of mystery. You're in the middle of something that you can't completely understand because it's partially hidden and elusive and slippery."

In this environment it was as easy to believe in the supernatural as it was difficult to find a clear identity of his own. "I was alive and gay and living in a world that was intensely homophobic. Judaism became tremendously important to me as a way of surviving as a person of a difficult identity in a world that was hostile to the person that I basically was. But it wasn't really a religion in a sense. I think I sort of supersti-

tiously imagined that there was a God, and I've always had a metaphysical bent."

His metaphysical interests eventually took him to Columbia University, where he majored in medieval studies, and they have continued to inspire much of his reading and thinking. He regards it as equally impossible to prove the existence or the nonexistence of God. But he acknowledges having a strong emotional attachment to a metaphysical something that he prefers to think of as a deity, and he is convinced that he has a relationship with this deity.

Having long been fascinated with Hegelian Marxism and with socialism, Kushner chooses the language of dialectics to express his understanding of what it means to have a relationship with God. "I've come to believe that there is a dialectical relationship between the search for God and the knowledge of God. One has to invest a certain amount of effort in searching in order to discover anything. And it's paradoxical. To search for something, the existence of which you're uncertain of, is a complicated question. Everything I've ever read about personal revelation of the existence of a deity seems to me highly subjective. I'm nervous about working myself into a religious state in which it suddenly becomes clear that objectively speaking there is a deity. So I'm sort of comfortable with the discomfort of being an agnostic."

His discomfort keeps him sufficiently unsettled to read avidly in search of clearer understanding. Lately he's been reading Kant. "I'm curious as to whether or not there is a way to arrive at moral absolutes that are genuinely moral but flexible enough and subtle enough to incorporate the complexity and unpredictability of human experience. Too much has become up for grabs. But we also need to move forward in figuring out this tangle, rather than going back to things that won't work anymore." Other favorite authors include Walt Whitman, Herman Melville, Adrienne Rich, and Stanley Koonitz.

But Kushner's theological thinking is propelled less by abstract questions than by the challenges he confronts in daily life. "I've begun to learn that each individual human life is inescapably tragic. Only fools

imagine that they will escape tragedy, and only scoundrels come anywhere near escaping it. Eventually your body will betray you, no matter who you are or how much money you have or how many people you've screwed over to preserve your own happiness. If you love anyone, if you care about anyone, if you are a human being, if you have connections to other human beings, loss is unavoidable. And loss is terrible. Unbearable. And it can come in unimaginably awful ways at any time."

He continues: "When you lose somebody as important as a mother or a lover, or when you are confronted with the AIDS epidemic, it is proof on one level. It could be turned into proof that there is no God because the loss is bitter and impossible to bear. But believing that there is no God is abandoning the hope of the resurrection of the dead and of any sort of reunion. That's, I think, more than the heart can bear. I've lost friends whom I miss terribly. There's hope of seeing them again."

His hope and his understanding of God are expressed vividly in a prayer he wrote to commemorate those who have died of AIDS. "I am in the habit of asking small things of you: one of the guilty who hasn't done enough, one of the lucky, the survivors by accident. When I was ten an uncle told me you didn't exist: 'We descend from apes,' he said, 'the universe will end, and there is no God.' I believed the ape part—my uncle had thick black hair on his arms and knuckles, so apes was easy—and the universe become a nulliverse, that too was scary fun. And since his well-meaning instruction I have not known your existence as some friends of mine do; but you have left breadcrumb traces inside of me. Rapacious birds swoop down and the traces are obscured, but the path is recoverable. It can be discovered again."[6] The image, he explains, comes from Hansel and Gretel. "It's a sense of the possibility of finding your way to something through a means that's perishable and easily blown away, which is a frightening thing. The terrible experiences you have in life can take away the traces and leave you without a path. But it ends on a hopeful note: the path is recoverable, it can be discovered again."

Just as he did when he was eleven, he wants to make a deal with God:

"All right, I'll believe in you if you give us a cure for AIDS right now. Doesn't that seem reasonable?" But he now realizes that reason is not the issue. "Believing or not believing in God is simply a choice you make. It's an act of will."

There is a great deal of wisdom here, and it is not difficult to see why Tony Kushner has become one of the nation's important public theologians, even for people who would not use that term to describe what they learn from his work. He has chosen to focus on the difficult questions of life, rather than blinking and avoiding them. In his work, there is no escaping thinking about the tragedies of life and the pervasiveness of evil. Equally, there is no escaping thinking about God.

Tension and Freedom

Madeleine L'Engle, Richard Rodriguez, and Tony Kushner draw heavily from their respective religious traditions. Myra Keen, a New Mexico–based choreographer, dancer, and vocalist, typifies the more eclectic perspectives that many contemporary artists bring to their theological reflections. The daughter of a concert harpist and the granddaughter of Alan Watts, the noted author and interpreter of Zen Buddhism, she was raised to value insights in both Western and Eastern religious traditions. Her creative work also brings together diverse influences, with her choreography combining elements of flamenco, Afro-Caribbean, and Middle Eastern dance, while her 1995 album *Barely* is composed of original and adapted lyrics sung a capella and with dusky embellishments reminiscent of Billie Holiday, Ella Fitzgerald, and Sarah Vaughan.

As a child, she was exposed to a variety of religious beliefs and spiritual practices. "I grew up around a lot of Zen Buddhism and Taoism and Christianity of all different kinds and Hinduism. I remember the Dalai Lama coming to our home to visit one time. My mother followed a guru from India. We were Quakers. We were Unitarians. My grandfather was an Anglican priest as well as being a Zen Buddhist philosopher." She credits him especially with awakening her interest in spirituality.

In California and then in North Carolina, her parents encouraged her to explore the available options. "We would go and hear Gunga Ji or we would go to the Baptist church across the street and listen to the Sunday sermon. I think we were just interested in all of these. I went to Methodist churches. I went to some great gospel churches in the South that were really moving. A lot of my friends are very strong Catholics, so I visited quite a few Masses."

She attended many more Masses while she was a student at a Catholic college, and she became familiar with the Bible and with the theologians Augustine and Thomas Aquinas while she continued to meditate and learned choreography. These experiences contributed to her developing awareness of the sacredness of all life. "I've never been to Bali," she notes, "but I hear that in Bali their whole day is about making offerings, and that everything they do, every movement, every motion that they make is somehow an experience of worship. I think my family felt that way, and I took that on. Somehow every act of my life, every movement that I make is kind of an act toward God."

Since college, she has tried to deepen her understanding and daily practice of spirituality. A reading knowledge of Greek and Sanskrit has made it possible for her to examine the Bible and Hindu and Buddhist texts and to see English translations in a different light. She is an avid reader of Lao-tzu, Nietszche, and Gabriel García Márquez. She prays and meditates every day and quietly attempts to integrate spirituality into her choreography and music. "I have always experienced my performing as sort of a religious act, but I have never spoken about it. I gather that it was no secret to the people who were watching me, though. They would come up to me and say, 'I feel somehow like I'm a part of a holy enactment.'"

Her interest in spirituality has been sharpened by the uncertainties she has experienced, both as a child and in her career. "My life has been extremely uncertain. It has changed so dramatically, up and down, from one thing to another. Not ever living in the same place [she moved twenty times while growing up]. Not ever staying at the same school.

Not having my father around. And then being very, very poor for a really long time. Not knowing where my next meal was coming from." The one constant in her life was her interest in spirituality.

Myra Keen currently finds companionship for her spiritual explorations in a group called the Celebration. Its members meet every Sunday to encourage one another in their various spiritual activities. They often invite a guest lecturer to speak about some aspect of religion or spirituality, but the singing and feeling of community are what she cherishes most. "They really, really just come there with a totally open heart and with the idea that they are there to celebrate their own feeling of God. There are no boundaries about what you have to believe."

With no boundaries, she has had to think seriously about what she truly does believe. "About ten years ago I started to ask myself some very serious questions. What are the underlying ideas I have about how this world works and how spirit moves through it? What is it that I really think, bottom line? It's easier when you are raised in a certain religion. For me, there was so much around that I knew I had to settle on certain things myself." She thought a lot about what happens when people die, and although many of her friends believe in reincarnation, she finds it hard to accept this belief. She thought more about God, weighing what various religious traditions think about God and paying special attention to her own desire to sense the presence of God. "I think God is within us and in everything that you see or touch or feel or are a part of, and yet exists somehow separate from this particular physical manifestation. I feel like everything I do here is a kind of learning for God. Everything I do is a kind of informing or information to God and that then affects everything that exists here. I don't know about other things existing other places. I would imagine that if they do, it affects them as well. It affects the big picture of things, not just where we live here. So when I die I am leaving the work that I do here and just returning to whatever was before and then all of me will be scattered. My ego will be scattered, and I'll come back some other way. I don't know how."

These thoughts arise not just as abstract speculation but from per-

sonal experience. The sudden death of a close friend prompted much of her thinking about what happens when people die. A serious romantic relationship that came to an end generated questions about her own identity and meaning in life. "I had no idea anymore about why I was here or why we are here at all. I lost that sense. I had always felt a connection even though I didn't know a specific reason why I was here. I just knew I was supposed to be here. Then I went through this period where I had no sense of that at all. I couldn't find it in myself. I couldn't touch it. I couldn't feel it."

More than settling on clear answers to theological questions, she found help in close friends who supported her emotionally during her crises and was sustained spiritually by her work and daily prayer. When she prays, she talks to God but also tries to be silent and reflective in God's presence. Doing so, she believes, affects her at several levels, including her subconscious. The images that emerge in her dreams are a result, and she in turn gives expression to these images in her choreography.

After her friend died, Keen experienced a vivid dream. "It started with all these people who were attached to the earth by these things that were elastic, and they were moving against the elastic all the time. It was an image of tension and pulling. All of a sudden the tension would relieve itself and there is this moment of freedom, and then you're back on the plane of the earth again. Then we were on the face of a clock and taking poses, iconographic poses in a way." The dream became a dance performance. It symbolizes the struggle for life that people experience as they go through time, and their connection with reality and desire for freedom.

"It was my way of thinking about time and our experience here on this planet as individuals, living in separateness from one another, which is really an illusion, and the joy of being in the body but also the difficulty of the gravity of it, literally and metaphorically. We go through these things as an embodiment of God so that God can understand what it's like to be in the physical plane. I was just thinking a lot about [my friend] not being on the planet anymore, about how I had known her for

all this time, and the changes I'd seen her go through. Then just as her life was coming together she was gone, just that fast. It made me think a lot about being here and what it means to be here."

Keen doesn't try to express that meaning in words. She isn't convinced she could. But she does feel that she has worked through some of her grief and that she has grown in the process. She remains persuaded of the reality of God and is regaining her feeling of connection with God. The connection is particularly evident when it takes human form. "I know where you are," one of her friends will say, "and I know to tell you that you're going to make it out of this. It's going to be okay."

There is a level of authenticity in Myra Keen that is often overlooked by critics who write about the superficiality of contemporary art and spirituality. Her knowledge of several world religious traditions outstrips that of many clergy and scholars and journalists. And yet her faith includes much more than a set of ideas. She practices it, thinks creatively about it, and tries to include worship as a central part of her life. She shows too that genuine faith cannot be separated from the trauma and pain that are features of everyone's life.

"God Is a Q43 Bus"

The musician Mario Sprouse has experienced bereavement and uncertainty in much the same way as Myra Keen, but his roots and religious beliefs are quite different. In contrast to Keen's diverse spiritual experiences, Sprouse's have taken place almost entirely in a handful of Protestant churches. Whereas Keen seeks spiritual insights from all corners of the world, Sprouse advises people to "find a place where you can express and practice and be nurtured by spirituality; otherwise, you will flounder and die because you will be disconnected; you'll be a hothouse flower without a root."

Sprouse describes himself as an "arranger, composer, piano player, orchestrator, and musical director."[7] His parents immigrated to Spanish Harlem from the Dominican Republic in the late 1920s. His religious

upbringing took place in a theologically conservative Presbyterian church, where his father sang in the choir and his mother "supported every single event, from bazaars to whatever." He grew up reading the Bible, both in church and on his father's knee during family devotional times. He speaks fondly of those years, recalling how he sang in the children's choir, learned to play the piano, went to parties and Cub Scout meetings in the church basement, and met his first girlfriend there. He credits his musical talent to his father, who earned a meager living as a carpenter but had a marvelous tenor voice.

Besides his parents, the most formative influence on his life was Elder Hawkins. One of the first prominent black leaders in the presbytery, Elder Hawkins was both a man of God and a lover of the arts. Sprouse remembers Hawkins inviting actors and musicians to the church, introducing him to these artists, and also regaling him with Hawkins's own sketches, paintings, and sculptures. "I didn't realize it until many years later, but my entire sensibility about spirituality and art came from him."

After college, Sprouse took a job, got married, and pursued his musical interests on the side. At age twenty-six, he and his wife divorced. He was no longer affiliated with a church, but his interest in spirituality was rekindled though a church-related counseling center that helped him recover from his divorce. "My whole level of spirituality bumped up a notch, because that's when I began to put the personal encounter with Jesus in my life. Before, it was something I knew about. Now it was something I was experiencing."

Several years later he remarried and he and his second wife started attending Marble Collegiate Church, where Dr. Norman Vincent Peale was pastor. They were happy there, but a schism emerged among the members and Sprouse's wife became part of a new church that, in his view, behaved like a cult. "I don't want to use the word 'fundamentalist,' but it was real strict. It had real thick boundaries. They were interested in only two things: conversion or condemnation." Refusing to convert, he was condemned. He remembers it as a "horrendous period" of his life.

But the experience forced him to read the Bible more carefully than

ever before and to think through his own beliefs. "It was a very literal, Bible-believing, Bible-thumping church. I had to know my stuff to talk to anybody in that organization. I had to read and think. I read the Bible cover to cover several times and took notes and questioned what they were saying. I said, 'This doesn't make sense to me.' They said, 'Well, does it have to make sense? This is just the way it is.' I said, 'No, but I do have a brain.' I really had to get into that Word, not just about what they were saying, but about my own faith, my own understanding, what I believed. That was a critical point. Hurt like hell, but it really strengthened me."

His encounter with "a Christian army that shoots its wounded" has made him more tolerant. He regards Jesus as his spiritual guide, believes the Bible is divinely inspired, attends church every week, and tries to integrate his faith and his music. But a religion of thick borders distresses him. He says the most compelling aspect of Christianity is its emphasis on unconditional love.

Unconditional love does not imply that all behavior and all beliefs are equally acceptable. But for Mario Sprouse, it means he has to be humble, acknowledging his lack of a monopoly on spiritual truth, and recognizing that love may be easiest to identify when it is broken in small pieces. He illustrates this point with a story. "There's a bus stop and there's a half loaf of Italian bread in the street. There is this little tiny sparrow beaking away at it as I'm waiting for the bus. A starling, just a larger bird, comes over and swoops that bird out of the way, and it starts pecking at this piece of Italian bread in the street. A pigeon comes along, swoops that bird out of the way, and starts pecking at this bread on the street. For whatever reason, we have a lot of seagulls in our area. The seagull comes along, swoops the pigeon out of the way, and starts pecking at this piece of bread. The bus comes along, smashes the bread into a million pieces, and all the birds are eating. I say, 'Sometimes, sometimes God is like the Q43 bus—comes along and smashes everything so everybody can have a piece.'"

Is this good theology? It certainly fits with long-standing Christian

teachings about God disrupting human expectations and about Jesus setting aside ethnic boundaries. There is wisdom too in Mario Sprouse's description of his relationship to the church. Although he was troubled by the human frailty that resulted in a schism, he recognized the valuable training he had received growing up in the church and his continuing need to be part of a Christian community.

Art and Theology

Madeleine L'Engle, Richard Rodriguez, Tony Kushner, Myra Keen, and Mario Sprouse point to the diversity of American society—in faith, tradition, intensity of religious involvement, gender, race or ethnicity, and lifestyle. One of the few traits they share is that (unlike many artists) all five have positive feelings about their religious upbringing and have remained loosely within the traditions in which they were raised. To be sure, they have struggled with personal crises that have required rethinking their spirituality. But their earliest childhood experiences with religion included sufficient reinforcement from parents and other adults that these experiences continue to be an important aspect of their personal identities.

Although they would not describe themselves as theologians, these artists clearly have thought deeply about theological questions. None rejects formal theological teachings out of hand. Four of the five were thoroughly exposed to such teachings while attending religious boarding schools, parochial schools, or colleges, and all five have spent more time than the average college-educated American reading about theology, philosophy, and related subjects.

None of these artists denies the value of thinking rationally about life's deepest questions. Madeleine L'Engle insists that the chaos and complexity of the universe are not irrational; she regards quantum physics as a rational discipline, just as much as Newtonian physics. Tony Kushner's fascination with Kant is driven by a search for moral absolutes, and Richard Rodriguez acknowledges that years of exposure to

Thomist theology have given him a deep yearning for intellectual and spiritual order. Myra Keen believes it is important to think carefully about spiritual questions and to read the writings of thoughtful religious leaders. Mario Sprouse found it necessary to think through the issues he confronted at the church he and his wife attended. Reading theology, he says, "helps me to understand the nature of my own faith, things that I can't easily explain, but I know."

But these artists' thinking about God leaves them uneasy with theological systems that claim to understand God through reason alone. Indeed, reason compels them to believe in a God who ultimately defies rational understanding. Tony Kushner makes this point in explaining why he reads Whitman for theological insights: "I feel very American when I read Whitman. It's so vast and so inexhaustible and so joyous. There's a kind of spirituality in Whitman that I find tremendously appealing. You can find it in Emerson and in Melville as well. It's really cosmic and it seems to incorporate the tragic and the joyful all in one. It's on one level rational and immediate and approachable, and on another level wildly irrational."

He adds, "There's just a sense that the visible, material world is not sufficient, isn't enough, that the story doesn't end there, and that there's something else that is not as apparent that requires seeking after. It's a nagging sense that there's a call being made to you from somewhere else—somewhere very important that you simply can't afford to ignore."

Although Madeleine L'Engle emphasizes the value of rational thinking about God (or any other subject), she believes it equally important to let other factors influence behavior. "When we think, we're using our dominant dictator brain. But spirituality and creativity involve your intuition and your intellect working together. They're making love, and you can't leave one out. Leave the brain out, you get sentimental. Leave intuition out, you can get cold and murderous. So they work together."

Not surprisingly, there is a close connection between these artists' insistence on the limits of rationality in spirituality and their experience of

these limits in their artistic work. Tony Kushner draws the following parallel: "I've learned something about the nature of seeking. You sometimes have to leap into the unknown. You can't wait until the ground is prepared to take the next step. You have to step into a void. You can't know if there will be ground there to receive your foot. You wonder if you will pitch into something terrible. But in that act of stepping you also prepare the ground. You create where you're going." The process is the same in his writing and in his spiritual life. "Looking for God and looking for the next sentence are not dissimilar."

Believing that God defies rational understanding can provide ammunition for rejecting the idea of God entirely. But these artists overwhelmingly draw a different conclusion. They emphasize that life as they experience it is not always rational (meaning that they cannot make sense of it), and religious teachings seem only to compound the difficulty because they raise questions that cannot easily be answered. Thus, the wisdom inscribed in religious teachings is *worth preserving*, they argue, because it is true to the disturbing complexity of their personal experience. This is why Madeleine L'Engle goes to church: the liturgy raises questions for which she does not have answers. Similarly, Tony Kushner complains that he has never been able to understand the alleged goodness of God in view of the fact that life is so awful for so many people ("Why is there poverty and why is there AIDS and why is there Jesse Helms and Jerry Falwell and Ronald Reagan?"). But it is this inability to comprehend goodness and evil that keeps him interested in the possibility of God's existence.

Acknowledging the limits of reason has not impelled these artists to be disinterested in religion; rather, they appreciate how their spirituality is enriched by sensory experiences that cannot be reduced to intellectual formulas. "I can know the *Encyclopedia Britannica* and everything in it," Madeleine L'Engle observes, "but if I'm walking my dog back up 105th Street and I don't notice the shadow of the trees moving against the wall, I've lost something. It's an awareness. Knowledge is something I learn and I can dig for when I need it, but awareness is seeing something

maybe not everybody sees, or noticing something, sometimes with some-body who sees more than I see and points it out, and I say, 'Oh, yes.'" This is part of the reason she knows that, by attending the funeral of her friend, she will learn something about spirituality that she cannot learn any other way, and why she takes walks and reads murder mysteries.

Myra Keen often finds that her spirituality is enriched in the process of some creative activity. When she was recovering from the breakup of her romantic relationship, she worked with two other women on a dance performance called *Drinking the Rain*. It drew the women closer as each was able to see her own life reflected in the others. For Keen, it also re-sulted in spiritual healing. "It helped me to rebuild my tethers to my own spiritual faith, and to lace those things back together and to under-stand what had happened to me. Just being with it in an artistic sense helped me to release it and let it go."

These artists' prayers provide vivid evidence of relating to God in other than strictly rational terms. Madeleine L'Engle admits she likes to approach God the way she did when she was a child. She asks for un-reasonable things and then tries to be patient. Mario Sprouse talks about the "F train prayers" he utters on his way to work. "If I'm merely think-ing, it's processual, but if I'm praying, it's God-oriented, and I may just do a lot of listening." Richard Rodriguez says it is harder to pray now than when he was a child because the ambiance of the church is missing. But the blue sofa in his living room has started to play a similar role. "I sit on that blue sofa and some part of my day is merely spent not think-ing. That's an enormously rich moment, being open and not directing the ideas I'm having. That's very important for my life right now, both my writing life and my spiritual life."

Tony Kushner sometimes prays in language drawn almost literally from the Bible. He especially loves the biblical psalms, not only because they are beautiful but also because they express the raw emotion he sometimes needs to direct toward God. His prayer about AIDS is an ex-ample: "Must grace fall so unevenly on the earth? Must goodness pre-cipitate from sky to ground so infrequently? We are parched for good-

ness, we perish for lack of lively rain; there's a drought for want of grace, everywhere. Surely this has not escaped your notice? All life hesitates now, wondering: in the night which has descended, in the dry endless night that's fallen instead of the expected rain: Where are you?"[8]

The Place of the Bible

Recognizing that spirituality is more than a system of knowledge has a profound effect on how these artists regard the Bible. They read and re-read it, regarding it as a source of great truth as well as inspiration and comfort. But its value lies less in its theological propositions than in its accurate description of human experience. Mario Sprouse picks the story of Gideon to illustrate why he likes to read the Bible: "I love that guy. He says, 'Prove it to me, Lord. Okay, prove it again.' That's it, that's his story. It isn't this blind faith, 'Follow me to the ends of the earth.' 'No, I can't do that. You've got to prove it to me.' That has helped me a lot."

Tony Kushner is drawn to the biblical narratives because they are messy, showing the raw edges of people's relationships with God. *Angels in America*, he explains, "began with an image of an angel crashing through the bedroom of a man who had AIDS. The angel is a Benjaminian kind of angel. You know, Walter Benjamin and his famous angel of history, his being blown backwards into the future. It's a profoundly ambivalent angel. My angels in the play are caught up in the same kind of historical catastrophe that human beings are caught up in. It's very Jewish. It's a sense of the deity as being part of the drama of history that really comes right out of the Holy Scriptures. It's really right out of Genesis. When you're looking at Genesis, which is so raw, you have this God that basically walks around in the garden and talks to people and says to Moses, 'Well, yes, I could soften Pharaoh's heart, but I don't want to do that because I want everybody to hear about this story. So I'm going to keep his heart hard so that I can kill all the children of Egypt so that everybody will know that I'm the biggest God of all the gods.' It's really repulsive. Then on the other hand, it's basically saying

God is not all that different from us. God is a being with a psychology and a vanity and a bloodthirstiness and a cruelty and a sense of horror. That's the spirituality, I think, that's primarily governing the play."

The Bible is but one source of truth, in these artists' view. The wisdom it reveals about God is filtered through cultural interpretations that depend on accidents of birth. Other ways of knowing God are conceivable, even for those who continue to seek inspiration primarily from the Bible. Tony Kushner remarks, "Any claims of exclusivity have always seemed slightly dicey to me. The zealots I encountered in school who were Baptist fundamentalists or Catholics were that way because they were born to a certain set of parents, and I was Jewish because I was born to a certain set of parents. Therefore, the fact that each of these groups claimed absolute exclusivity seemed deeply suspect."

Myra Keen likes the "flavor of mysticism" she finds in the Bible, but she is equally attracted to the Tao because it offers simple guidance for daily living. Richard Rodriguez emphasizes the metaphoric quality of the Bible and says he was raised to find truth in the church and through the Catholic tradition more than in the Bible itself. "The Bible is the whisper that the church in its life becomes the voice for. There is in Catholicism the notion of tradition as being the Bible or the way religion manifests itself over time; that is, the accumulation of wisdom that a society has. I see the Bible in relationship to that tradition." Mario Sprouse holds a similar view. He approvingly quotes one of his Bible teachers who told him, "If every known record of the Bible were destroyed and it had to be rewritten, it could be rewritten through the lives of people today."

In their various ways, these artists find images of God in the Bible that can be reconciled with images from other sources, such as scientific theories, literature, and even other religions. God is pictured as a being who can be related to by individuals, but also as an amorphous force or reality that defies easy description. Richard Rodriguez mostly thinks of God as an incarnate being to whom he can relate personally. He likes the way Flannery O'Connor pictures God. "God appears in the guise of

a redneck Bible salesman coming to the door. The proud are vanquished in her world. She has a sense of the penetration of the holy in the middle of the most mundane Tuesday in a Mississippi small town. That's when God appears. He appears in the raiment of peacock feathers."

Richard Rodriguez has his own ways of picturing God: "I had a stalker outside my house a few years ago. It was a kid who came by and was convinced that I was the son that his mother wanted and would stuff these big, big envelopes into the mailbox all day. It turned out that he had been a professional boxer and could have beaten the hell out of me if he wanted to. Sometimes I think that God is a stalker. I really do. Sometimes I think I'm haunted, that God wants me." He is particularly attracted to the idea that God took on human form in the person of Jesus and can be known in that way. "I love that God became man, became flesh. I love that. That's what interests me about Christianity, unlike most of the other religions, where God becomes spirit and disappears into a sort of vapor. Here he ends up a little baby squalling on a winter night. It's really quite interesting."

An amorphous image of God is most apparent in Myra Keen's remarks, especially when she speaks of "spirit" in the abstract or likens God to a river or an energy flow. Tony Kushner emphasizes this amorphousness as well. Although he is attracted to the biblical personifications of God, he thinks the unknown writer of the medieval text *The Cloud of Unknowing* was probably more on target. "This is not the God of fundamentalist literalism. Everything that God has done in the world has created an enormous amount of confusion, including creating the world. There seems to be something generative about this confusion and about contradiction. So one thing I know is that God is not simple. The only simple thing about God may be that God is not simple."

Mario Sprouse's view of God also goes beyond easy categorization, and he admits this in talking about Jesus: "My understanding of Jesus is theological, but it involves the mystery, so I can't explain it." He thinks his West Indian heritage influences his views. "The cycle of nature is still in my blood. I gravitate to the power of God's spirit in nature. My

theory is that if God created everything, then there's a little bit of God in everything and, therefore, there are lessons of God in everything." These lessons, he says, remain silent within him, existing more in his memory of stories told by his Dominican father than in ideas he can put into words.

For each of these artists, there is an emphasis on reciprocity between humans and God. In partnership, they complete the circle of life. "There's a way of conceiving of God in partnership with the world," Tony Kushner asserts, "not plainly and simply the author and puppet master of the world, but a God who in a certain sense is created by human action and who creates human action—a dialectically inflected being." Madeleine L'Engle says particle physics convinces her that just looking at something changes it. So she believes human actions in some way change God, at the same time that God affects them. Myra Keen's remark about humans providing God with information about what it is like to live on a physical plane suggests a similar complementarity.

Inwardness

When ideas about God and about spirituality are not regarded as elements of doctrine that are fully revealed in a sacred text, they inevitably become more subjective. Subjectivity implies interpretations of truth that are likely to differ from person to person. There is a tentativeness about these interpretations, suggested by the use of such phrases as "I think" or "I feel," and there is a formlessness about them that some artists find worrisome ("each of us concocting our little smokey cloud for ourselves," Richard Rodriguez complains). On occasion, subjectivity privileges the emotional gratification that comes from relating to God, as when Myra Keen admits she "likes being there in myself, feeling that sensation of being close to God." Subjectivity also implies that thoughts and feelings about spirituality cannot be expressed adequately in ordinary conversation or in scholarly writing—an implication that reinforces artists' conviction that the sacred is ultimately a mystery.

But "subjectivity" is not a word that many artists use to describe their spirituality. Words such as "personal," "emotionally rich," and "inward" more aptly capture their experience of spirituality. These words do not imply that individuals are concerned only with gratifying their own needs or that they can think whatever they want to without benefit of interaction with others. Personal spirituality means that the sacred is fully entwined with individual human experience, so fully that it cannot be expressed apart from this experience. In the same way that biblical stories reveal divine purposes through the lives of historical individuals (and groups), contemporary artists communicate their own experiences of the sacred through self-disclosure.

As a member of the Arts Fellowship in New York, Mario Sprouse has an opportunity to help others by disclosing insights from his own experiences. "They look at me and I tell them my story, and they go, 'How did you do that?' I say, 'I didn't. I just participated in it. I did not engineer this at all, but I can tell you that I had some faith to do it.'" The comments Myra Keen receives from people who sense the sacred in her choreography suggest that she is disclosing something of herself in this way. Madeleine L'Engle, Richard Rodriguez, and Tony Kushner have all written candidly about their identities and struggles.

These artists' emphasis on personal experience with the sacred implies taking responsibility for their own spirituality. As Tony Kushner says, gaining knowledge of God depends on taking responsibility to search for God. And searching for God means being guided by what one finds. Mario Sprouse observes, "If I am human, I have evil inside me as well as good. I could choose to strangle someone. But I don't have to succumb to those impulses." He continues, "I am created to be me. My life is not filled with 'thou shalt nots,' it's filled with 'thou shall.' It is more active, more free. It doesn't have anything to do with rules and regulations. The lines between the sacred and the profane are not thick for me. It's what's in my own heart, what I am doing that makes sense to me."

Tony Kushner insists that responsibility involves choosing to live in

hope, rather than succumbing to despair. "Despair is basically a form of laziness, an abrogation of responsibility. I think that you create reasons for hope by hoping, not stupidly, not naively, not by being a cock-eyed optimist and singing songs and whistling while you work, which is simply a way of accepting misery and becoming indifferent to it, but by saying, 'Well, I must not despair because it's immoral to despair. Therefore, I must have hope and I must find the occasions and opportunities for hope.'"

Taking responsibility for oneself, perhaps ironically, goes hand in hand with doing what one can to help others. Kushner suggests this connection as well. In his political views he is a socialist. But he believes Marxist-Leninist socialism failed because it focused so much on the inevitable forces of history and on large-scale social conditions that individuals saw no reason to take responsibility for themselves. Spirituality gives people the resolve to do what they can, to make a difference, and to resist the kind of dogmatism that can result in a Stalinist form of government. On a smaller scale, it is the same resolve that draws Richard Rodriguez to the bedsides of young men dying with AIDS and to organizations that take them meals and to visiting teenagers in prisons.

This is where the circle of life becomes most evident. Responsibility implies that a person is an agent—someone who plays an active role in shaping events—and agency implies mutual effects. God is not unmoved by the behavior of mortal men and women. Nor are individuals unaffected by the behavior of other individuals. Being part of the circle of life means sharing and contributing to making a better world.

Critics of American spirituality say it is entirely too focused on the individual. They would rather see more emphasis on congregations and communities. The diverse views that artists exhibit toward God and the Bible are, in some ways, symptomatic of the individualism that pervades our culture. Every person feels authorized to make up his or her own understanding of religious teachings instead of looking to the wisdom of church leaders. Yet there is a positive side to individualism as well. If

people cannot agree on fine points of doctrinal interpretation, their in-dividualism nevertheless requires them to accept responsibility for working out the implications of their faith.

In the end, seeking to be a responsible link in the circle of life leads people not only to action but also to prayer, especially when action fails to yield results and when it raises unanswerable questions. "I think you are our home," Tony Kushner prays. "At present we are homeless, or imagine ourselves to be. Bleeding life in the universe of wounds. Be thou more sheltering, God. Pay more attention."[9]

6

BODY AND SPIRIT

ON OCTOBER 12, 1997, a sixteen-year-old boy used a hammer to smash the controversial photograph *Piss Christ* at the National Gallery of Victoria in Melbourne, Australia. The photograph by New York artist Andres Serrano featured a plastic crucifix immersed in a golden glow, created by Serrano's urine. The boy told police he attacked the photograph because "it mocked my God."[1]

The incident, occurring only a day after another man damaged the photograph's frame by yanking it from the gallery's wall, was only the latest example of the work's capacity to generate controversy. In 1989, on the Senate floor, New York senator Alfonse D'Amato tore up a catalog of an exhibit that included the photograph. Later, thirty-five senators signed a letter of protest by D'Amato in which Serrano's work was called "shocking, abhorrent, and completely undeserving of any recognition whatsoever."[2] Over the next decade, the work (which had been in an exhibit partially funded by the National Endowment for the Arts at the Southeastern Center for Contemporary Art in Winston-Salem, North Carolina) was cited frequently in debates about congressional appropriations for the arts.

Critics of *Piss Christ* disliked it for many reasons: Catholic church leaders insisted that it was blasphemous; others said it offended their sense of moral decency (calling it "lewd" or "obscene"); still others argued that it was simply in poor taste or lacked technical mastery. Its supporters defended it on equally diverse grounds, ranging from seeing it as a statement about the trivialization of the sacred to defending the artist's right to freedom of expression or the value of government support for the arts.[3]

But *Piss Christ* illustrates deeper questions about the relationship between contemporary art and spirituality. Both in painting and in other art forms, such as dance and music, the body and its movements and functions have been a recurring theme. Yet the relationship between the body and spirituality has been the focus of much debate and rethinking in the past three or four decades. Eastern religions that include ideas about breath and energy centers, along with new insights from alternative and complementary medical approaches, holistic perspectives on health, scientific studies of the effects of meditation and prayer, feminist spirituality, and the incorporation of dance and visualization into traditional liturgical practices, have influenced how the body is understood in relation to spirituality. In this process, boundaries between the sacred and profane that are symbolized by the body become blurred, and works of art that challenge these boundaries sometimes become charged with special significance.

The Body of Christ

At his home in New York City, Andres Serrano continues to be puzzled by the violent reactions to his work. The son of a Cuban mother and a Honduran father, he was raised as a Catholic, and although he did not go to parochial school, he received religious instruction when he was eleven and took his first communion shortly thereafter. His continuing fascination with religion is evident in the religious artifacts, candelabra, wood and stone statues, and frescos that fill his apartment.

His rise to prominence could not have easily been foreseen. At fifteen he dropped out of high school and two years later enrolled at the Brooklyn Museum Art School, where he studied for two years. "Aside from art school," he explains, "I have no art training. Even though I use photographs and somebody refers to me as a photographer, I've never studied photography and I have no interest in the medium except as a means to an end. I've always regarded myself more as an artist using a camera."

Upon graduation, he was unable to pursue his personal interests in art, and for ten years took odd jobs to support himself and his wife (a painter), while participating in a group of artists attempting to address social and political issues, such as urban poverty and U.S. policies in Central America. His first show was in 1984 and was part of an exhibition by several dozen artists called "Open Call Against U.S. Intervention in Central America." One of his entries presaged the work that was to gain him national attention. It was a picture of two robed women looking up at a cross composed of raw meat.

In retrospect, he thinks he was probably "addressing my unresolved feelings about my own Catholic upbringing." But he was not consciously attempting to make a statement. "Even to this day, I think I've done a lot of images that for me are basically unexplainable as to where they came from, and I've never really probed. It's only when I'm asked by journalists and writers to explain certain images that I have to come up with a rationale for them, but normally I don't."

This was the case with *Piss Christ*. "It was made at a time [1987] when I was doing an investigation of bodily fluids—milk, blood, piss—and dealing with them in a very abstract way. In fact, I was trying to mimic painting, abstract painting, action painting. At some point in the middle of the series, I decided to refer to some sort of representation, and because I had been working with religious images, I decided to combine two directions in my work in one image. *Piss Christ* is an attempt to bring two different directions in my work together in one image, the religious along with the bodily fluids."

"In hindsight now," he reflects, "people want me to explain what is meant by *Piss Christ*. *Piss Christ* has been singled out because of the controversy, because of the fact that the American Family Association, which is a very right-wing, fundamentalist group, targeted *Piss Christ* and sent about 178,000 letters to their constituents, mostly churches, asking them to write to Congress, to the Senate, to the NEA, protesting the taxpayers' use of funding of controversial art. What I'm trying to say is that because of the campaign against *Piss Christ*, I feel that it became a bigger issue than it would have been had not the American Family Association intervened."

"For instance," Serrano explains, "when this first happened, the Southeastern Center for Contemporary Art called me up, and they had given me this award in the visual arts, which had been so controversial because a third of the money had indirectly come from the NEA. Not directly, but indirectly, because the NEA had funded the program. So you could say that $5,000 of the $15,000 grant had come from the NEA. The other two-thirds had come from the Rockefeller Foundation and Equitable Life Insurance. They were the other funders of the program at the time. But when the controversy first erupted, Ted Potter, who was the director of the Southeastern Center for Contemporary Art, called me from North Carolina, saying, 'You know, the NEA is breathing down our necks. They want a rationale for the image. They're getting a lot of heat. They want to know what it means.' He said, 'Why don't we say it's a protest against the commercialization of religious or spiritual values.' I said, 'Well, you know, Ted, it's not language that I would use, but if you want to say that, it's fine, go right ahead.' And I've seen that printed over the years as a rationale for it, but I've never felt the need to create a rationale for the image. In fact, I've always believed that art should not be rationalized. What I'm trying to say is that *Piss Christ* for me is just one image in a series of images that were made at a time when, like I've said before, one image led to another, and it was an instinctive process really."

Although he resists rationalizing the image, he does acknowledge that he has been able to think of reasons why it has sparked interest. One is

simply that he has always tried to do art to which ordinary people can re-
late, whether positively or negatively. His subjects are generally familiar
(bodies, crosses, church doors) and, since *Piss Christ*, they have more
often been depicted representationally than abstractly. Another is that
his work is deliberately evocative (including photographs of aborted fe-
tuses, slashed and mutilated corpses, nude bodies, and hooded members
of the Ku Klux Klan). "I go in there and identify with the audience.
They're outsiders, they don't know much about the Klan. They don't
know much about death, but they want to see, there's the natural desire
to see, to see where it could take you. That exploration. I'm an explorer.
That's all I am, an explorer."[4]

Serrano thinks the work may be of interest to people who, like him-
self, are struggling with unresolved issues about their spirituality. In his
own case, he largely abandoned Catholicism soon after he was
confirmed and spent little time thinking about spirituality for the next
twenty years. It was his artistic work that rekindled his interest in spiri-
tuality. "I think I'm a Christian in search of God, still searching." Yet his
searching has remained almost at the level of intuition. His education
has not exposed him to philosophy or to theology, and he has felt too
uncomfortable with church rules and doctrines to seek there. Capturing
color images in Cibachrome prints has thus been central to his explo-
rations. "A lot of my work is meditative. I do it intentionally in the sense
that I like to create work in which you can hear a pin drop. There's a
sense of stillness, a quietude, which is something I'm looking for. That,
to me, is part of the spiritual process. I haven't been able to solve any of
life's mysteries. I guess my work just makes me realize that life is an on-
going mystery."

He also recognizes the symbolic aspects of *Piss Christ*. "I've always
seen the bodily fluids as basically a very human component of life. When
I started using the fluids, I used them much like an artist using paint. I
didn't place a moral judgment on the fluid saying, 'Well, the blood,
that's a good one; the milk is a good one. Piss, it has negative connota-
tions.' I don't see it that way. For me, it was just paint. But the fact that

they are bodily fluids means that they're pregnant with symbolism, that they have more far-reaching implications than if it was just paint. I'm comfortable with that, with the fact that it's loaded imagery."

A crucifix immersed in urine is a juxtaposition of body (humanity) and spirit (deity). "Piss is as human as you can get, it's a necessary bodily function." Although it is human waste, the fact that it is *human* is what attracts Serrano most. The crucifix, while depicting the body of Christ, is in his view richer with symbolic spiritual content. Indeed, in one published statement Serrano observes that the photograph is meant to humanize Christ because Christ has become too much of an unattainable deity in the wider culture.[5] He believes the work's title helps draw attention to the juxtaposition of the sacred and the profane. "Without the title, it would have been taken as a spiritual rendering. It wouldn't have been taken as anything other than a seductive treatment of an age-old subject. *Piss Christ* in itself is not offensive or threatening to anyone. It's the title and the knowledge of what has gone into the making of the image that's threatening."[6]

But Serrano refuses to read much more into the image. "I allow myself the freedom to explore whatever pops into my head, and that means photographing the imaginable and unimaginable. So when I do work, when I'm in the studio doing work, I don't think about, 'What does it mean? Why am I doing this?' On the contrary. I've learned from dream analysis that when you're having a dream, you have absolutely no control over what the dream is doing, where it takes you. You don't even know what it means. Afterwards, after you have the dream, you can sit back on the couch, free-associate, put things together, remember more, and figure it out better. But you never quite figure it out completely, and it's not necessary to do so. It's the same thing with my work."

An Intricate Machine

To understand the larger questions about body and spirit raised by Serrano's and other artists' work, we must consider the sharp distinction

between body and spirit in much of Western culture. In this view, the body is mortal flesh, an organism or machine, and the source of temptation or evil, whereas the spirit connotes eternity and all that is godly, pure, and uplifting. This dualism is implicit in the concerns voiced by Serrano's critics as well as in the work of some contemporary artists.

An instructive example comes from the composer and musician Robert Tosh. A former air force technician with a degree in medicine, he devotes much of his time to the evangelical church he attends and to the Christian music group he travels with as a singer and guitarist. His music is a way of both expressing his spirituality and encouraging others to think more seriously about their relationship with God. His medical training, along with years of participating in Baptist, Presbyterian, and Mennonite churches, has given him ample opportunity to think about the relationship between body and spirit. "I view the body as a machine primarily, a very intricate machine that was devised by God," he explains. "I think of it as a housing for the soul or the spirit. And there is also the mind. I see a distinction among all three, but even the mind is more of a machine, in a way. To me, certainly the body is a machine, and that's the machine that's designed to take the soul and the mind around, to make them mobile, and to manipulate our environment with our hands."

Whereas body and mind are machines, he equates spirit with the idea of a soul. "The soul is separate. The soul is who you are and what you are." He says some people believe that the brain and the soul are one, but he disagrees with this view. The brain can have a disease, but that is different from something that troubles the soul. In his view, the brain is part of the bodily machine, and when it doesn't function properly, the person is likely to die. When that happens, the soul is released from the body. What lives on is the "person you are, your soul."

While insisting that body and soul are separate, he acknowledges that the two influence each other. When he sings, for instance, it is his body that permits him to make sound, but the words he chooses are an indication of what is happening in his soul. Similarly, he recognizes that the

body may require healing that goes beyond medical science. If this heal-
ing comes from God, it somehow may affect the soul first and then be
transmitted to the body. But he is unsure how to think about it.

What troubles him are what he calls "New Age" ideas about body and
spirit. New Age beliefs, he feels, transgress what can be known about the
body to the point of bordering on the satanic. He is only comfortable
with ways of thinking about bodily processes that essentially conform to
his view of the body as an intricate machine. For instance, he sees
biofeedback as unobjectionable because it is simply a way of focusing the
brain's attention on a malfunctioning part of the body. Although he ac-
cepts that people may experience healing that physicians cannot explain,
he feels this will eventually be understood by science. He cites herbal
remedies as a kind of medicine that God has provided for human
benefit—one that works through ordinary physiological processes. New
Age beliefs, in contrast, seem to imply that there are supernatural pow-
ers ("spooky things") associated with crystals, pyramids, and the like.
"They may get their power, if you will, from demonic forces." He adds,
"My big concern is to make sure Satan stays away, because I know that
he's very powerful and real tricky."

The negative contrast between body and spirit suggested by these re-
marks ("one is carnal, the other spiritual") is evident in other artists'
comments. Another Christian singer describes the body as the "fleshly
cage" for the spirit or soul. "One is perishing, while the other will be
going on forever." He does not believe there is much of a relationship
between his understanding of the body and what he tries to convey in his
music. Nor does he think spirituality plays a role in healing, other than
providing comfort for someone who may be dying.

The pervasiveness of ideas that separate the body from the spirit is il-
lustrated by another artist with quite different religious views (she de-
scribes herself as a devotee of New Age practices). In her words: "We are
an animal body, but the spirit also lives inside us. The spirit doesn't run
the show most of the time; the animalistic part does." She maps other
terms onto this distinction: light and dark, good and evil, yin and yang.

In her view, the solution to disease (and most other problems) is to move away from the body into the spirit. Yet another artist says the spirit is the essence of the person, whereas the body is merely like an actor's costume.

When body and spirit are regarded as fundamentally different, artists can more easily associate their work with one category or the other. Richard Rodriguez (who does see a connection between the two) complains that many artists he knows live entirely in their heads ("most writers don't have bodies") or in some other ethereal realm. Many more, he believes, live strictly to gratify their bodies: "They live only in their bodies. At the age of twenty-eight, they talk about themselves as past their prime. Really quite extraordinary. I think the body is almost the only transcendence they can have."

The Body in Worship

In contrast to envisioning either/or boundaries between body and spirit, many contemporary artists are experimenting with ideas and practices that blur the distinction. For example, Carla DeSola, one of the most prominent national figures in liturgical dance, emphasizes the considerable overlap between body and spirit. Entering college at age fifteen, she decided to study dance and two years later transferred to Juilliard, where she specialized in modern dance. After college she did additional work with the actress and dancer Valerie Bettis and performed in a modern dance repertory company in New York City. Increasingly her interests turned to social issues, at first through street performances, and eventually she abandoned dance entirely to work with the poor. When she began dancing again (about five years later), she discovered that churches were where she could do what interested her most. She spent the next twenty years developing liturgical dance: performing, teaching, doing choreography, writing, and leading workshops. Since 1990 she has taught liturgical dance at the Graduate Theological Union and headed the Omega West Dance Company in Berkeley.

Although she thinks she had a "natural sense of spirituality" as a child, her first exposure to religion did not come from her parents (who were atheists) but from José Limón, with whom she studied at Juilliard. He created a Missa Brevis, which was the first time a Mass was put to dance in concert form. It was a "liturgical structure," performed to the music of Zoltan Kodaly. DeSola remembers "pondering questions about the existence of God and who Christ was and all that, looking at this man [Limón], working in a form that meant so much to me, and just seeing his soul coming out, and at the same time being introduced to friends, other people who had me sit down and listen to beautiful music like Mozart and Verdi's *Requiem* and religious music and say, 'Where does this come from, this depth?'" Shortly after college, her twin sister became a Catholic and encouraged her to become more interested in spirituality as well.

DeSola tried going to church but persistently felt that "something was missing." Then, while working with the poor, she became acquainted with Franciscans and members of the Catholic Worker movement. "I moved down to the Lower East Side, gave away all my jobs, quit all the companies, did embarrassing things. Most of the people around me didn't have [dance] training. Yet, it was like the gospel becoming alive. It was a training time for me." She realized that dance had always been an important way for people to express themselves religiously. As she talked with priests and members of Catholic churches, she also realized that the Second Vatican Council had opened the door for greater freedom of expression during the liturgy. She wondered if dance might be a possibility.

A priest in New York City invited DeSola to do a processional dance for the Feast of Christ the King. "That was to be my first liturgical dance. As I stepped down the aisle in procession, from deep within, a smile emerged. 'Oh, this is it, this is my work.' It was like touching some deep chord. It's interesting. Usually people think, 'How do you move from within the church out to the streets, for the church isn't only for it-

self, it's to be a leaven in the world.' So there's always a step outward. But for me, I moved from the streets into the church."

From the start, DeSola has considered the body her way to speak. She became interested in dance as a teenager because she was a quiet ("nonverbal") person who found it difficult to express herself in other ways. In teaching she encourages students to regard dance as a form of "movement meditation" through which they can gain clarity about their spirituality. Many of her students will never become professional dancers, but are planning careers as clergy or lay leaders in churches, or they are simply trying to grow spiritually. She especially enjoys "helping the average nondancer to be deeply accepting of their body and finding another way of prayer when they have no more words with which to speak—a way through the body of scriptural study, of entering into a passage and knowing it with your bones. You can learn many things that you can't learn through what's called an exogenical approach, just going and reading about it."

Her creative work ranges from sacred or liturgical dance, which generally follows the format of a Catholic liturgy and pays special attention to the seasons or church calendar, to less formal ways of expressing individual spirituality, such as modern dance, ballet, yoga, or African dance.[7] She strives for a balance between structure that adds to the aesthetic experience of the dance and improvisation that lets individuals express themselves. "I'm treading a thin line, having people value what makes the beauty of dance as dance as well as finding a simple way of doing it themselves. So that when they're constructing something for a liturgy, and let's say they have very little background, they won't try to do something above their technical level, and look like just bad ballet. I'm concerned about the aesthetics of it as well as dance as therapeutic. My soul needs beauty and I stand for and work for it. Beauty has many forms, however."

She often draws inspiration from paintings and sculptures, from working with artists and musicians, and from the people she meets at

classes and workshops. For example, a performance at the Pacific School of Religion was based on a bronze sculpture of a winged figure with only one arm. "It has a beautiful torqued body and an almost nonexistent head. It interests a dancer because of the lines, but it has to do with incompleteness and wholeness. I didn't want to just copy the characteristics, but use it for inspiration. I had been giving a dance retreat and a woman came into the workshop and said, 'Can I work a bit with you?' There were about forty people or so in the room and she started moving with us. Then when we were processing at the end, she burst into tears and told us about having a mastectomy. This was the first time she felt whole. I decided this is what the dance should be about. I had one dancer come down the aisle as a woman that way, and then these three winged figures rise and become her teachers in freedom and acceptance. I see it as a healing dance, which to me is spiritual—a healing dance with people going through being broken to get to a different, more luminous understanding of wholeness."

This example suggests the integration between body and spirit DeSola tries to achieve in dance. She understands spirituality as "connecting yourself with God." It is an inward centeredness that happens on many levels and involves her body as much as her mind. Any activity that helps her achieve this centeredness contributes to her spirituality. "It can be breathing, walking, movement, as well as saying words, saying a name, Jesus, a holy name. A lot has to do with an attitude of posture, bowing, openness. It doesn't have to be a verbal thing at all."

In this view, knowledge can be obtained through the body as well as through the mind. "I have knowledge through my own body in a felt, kinesthetic way." Similarly, she believes there is spiritual wisdom in the body. "If you cannot honor your body and learn from the body's wisdom, it seems to me something is missing in your spirituality. We are incarnate. It is the central part of Christianity, incarnation, resurrection. It's a schizophrenic split if people cannot connect that with the body."

She sees a parallel between the effect of dance on a person's spirit and the way Bible reading has traditionally been understood. Both are vehi-

cles through which God's spirit brings some realization to a person's attention. "When you're moving, things come to you. Moving frees the mind. You find things with your body. You find the input that matches your inner needs. That input is rich when it is both liturgical and scriptural." As an example she refers to her class in community dance. "I say, 'Tell me a [biblical] line that's meant something to you during the week.' Someone says, 'I will write my words upon your heart.' Well, whoom. I have people dance with or without music maybe for ten minutes and just playing with that line. Then we share. The ideas come out. 'What does it mean on your heart? What do I have to erase in order to get to what God's words would be? Oh, I think I heard God.' People get all kinds of ideas." It pleases her when they do.

The Voice of the Body

Carla DeSola's understandings of body and spirit come primarily from thinking creatively about Christianity, but many contemporary artists draw from a wider variety of traditions. Meredith Monk, a New York–based composer, singer, filmmaker, choreographer, and director, is an example. Evaluating her contribution, the critic Alan Kriegsman has written in the *Washington Post*, "When the time comes, perhaps a hundred years from now, to tally up achievements in the performing arts during the last third of the present [twentieth] century, one name that seems sure to loom large is that of Meredith Monk. In originality, in scope, in depth, there are few to rival her."[8] Her ideas come from the Judaism in which she was raised, the Christianity to which she was exposed at a Quaker high school, and the Shambala practices she now follows.

Meredith Monk came naturally to her career. Her mother was a professional singer on radio, her grandmother was a concert pianist, and her grandfather was a concert bass baritone who emigrated from Russia in the late 1800s. His father had been a cantor in Moscow. "I was reading music before I read words and I was singing melodies before I spoke," she recalls. From ages three to seven she studied eurythmics and after that the

Doris Humphrey–Charles Weidman dance technique as well as piano, music theory, and theater. She continued her studies in the arts at Sarah Lawrence and after graduation started performing in New York City.

About a year later she started developing a new style of vocalization. "I suddenly realized that I had developed a movement style that was built on my personal idiosyncrasies, and I realized that I could do the same thing with my voice. I could find a vocabulary built on my own instrument. I found that I had a limitless palette to work with, and at that moment, that moment of revelation, I realized that the voice could be an instrument. The voice could have the flexibility of the spine or of a foot or a hand. Within the voice were landscapes, characters, limitless colors, and textures, and I could work with that as the basis of a musical vocabulary. From that point on, I started exploring the voice in a very deep way and that became, in a sense, the heart of my work."

Monk's style, which has become known as "extended vocal technique" and "interdisciplinary performance," emphasizes the weaving together of voice and movement. "I think of my work as a kind of tree with two main branches. One main branch is the exploration of the human voice and the depth of that. I think sometimes what I do is vocal archaeology in that I'm digging down into my body and there are sounds that I find in the human voice that have a sense of the world vocal family within them. When you start working with your own instrument, as long as you're not just following the Western European model of the pear-shaped tone, I think that you're finding certain cross-cultural kinds of sounds that have existed in human beings throughout the ages. I'm very interested in getting back to basic human utterance, nonverbal human utterance. Rarely do I use text in my pieces. I always am working with the voice as a language. The other main branch would be what I call the composite pieces or films, which are the combined forms of either large musical theater works like the opera or even smaller chamber theatrical pieces, musical theatrical pieces, that combine these different elements. You can think of them as collage or a mosaic. I made a feature-length film called *Book of Days* that was a way of weaving my music with

imagery. It was a fairly nonverbal film. There's a little bit of text, but it's not dependent on text as the organizing factor."

As a vocalist and dancer, she naturally emphasizes the role of the body in her artistic work. Its connection with her spirituality has evolved gradually. She was scarcely aware of her Jewishness as a child, even though she knows in retrospect that it influenced her outlook. The more conscious influence was her mother, whom she describes as a searcher. They attended Quaker meetings, Christian Science and Methodist services, and eventually a Reform synagogue, where she had her bas mitzvah when she was fourteen. During college she familiarized herself with Israeli culture, but it was another decade before her present interests in spirituality began to take shape. Between 1975 and 1978 she taught several courses at the Naropa Institute in Boulder, Colorado, where she was exposed to Tibetan Buddhism. She remembers being struck by the "quiet and depth" of the audiences, but was skeptical ("I was kind of hovering about but wasn't ready to commit myself"). Still, she developed a course called "Dancing Voice, Singing Body," which became a means of exploring her spirituality through art. Several years later, during a low point in her life, she started reading and taking courses to gain a clearer sense of spirituality.

She studied Tibetan Buddhism, took yoga and Tai Chi classes, and read the writings of Carl Jung, Krishnamurti, the Dalai Lama, Thomas Merton, and other contributors to contemporary spirituality, but says she "wasn't trying to find a school that would be the center of my life." Art continued to provide her with a spiritual core, and these teachings and practices added to her ways of experiencing it. Through them she has learned about meditation and about concentrating on the experiences of the moment.

She currently meditates about forty minutes a day, following a simple pattern of breathing and detaching from the thoughts that may enter her mind. Prayer remains largely unverbalized, except in crisis situations, but she regards it as an important aspect of her spiritual life. "I think prayer is connection and contact with a larger being. It's not necessarily

to ask for something particular, but it has the same kind of centering aspect that meditation has. It's literally getting in touch with something that's larger than you are."

Because her art is the central expression of her spirituality, she necessarily draws a close connection between body and spirit. "I don't separate the body from the spirit. I think that synchronizing body and mind is working on a spiritual path. It's a synchronization. It means a kind of alertness and awareness. It's not separate. It's not like my spirit is here and then my body is there. It's literally 'being in.' I mean, this is the house that you have to live in for this lifetime, so you want to be home. When you're not home is when there's so much lack of awareness, and I think this culture perpetuates that."

Sometimes her attempts at synchronization succeed beyond her expectations. "In the most privileged moments in the life of the theater," a reviewer wrote of one of her performances, "the stage becomes a place that's holy, and the performance seems to return to its roots in ancient ritual. What transpires there is like an interlocution with the gods, a seeking after humanity's place in the divine scheme of things."[9]

This is a case of someone whose emphasis on the body stems both from considerable talent as an artist and from the kind of religious pluralism to which a growing number of people are exposed. Compared with Western religions, Eastern traditions have typically drawn a closer relationship between body and spirit and have thus emphasized the role of bodily movement and the senses in meditation and worship. At the same time, bodily spirituality provides an attractive alternative to intellectual spirituality, particularly when one is exposed to competing religious traditions and concludes that intellectual arguments alone are insufficient to guide one's spiritual formation.

The Body in Sculpture

Barry Johnston is another artist who has devoted much thought to the relationship between spirituality and the body. He is a metal sculptor

who specializes in figurative work from small models to public art up to twenty feet high.[10] Raised in Alabama, he received an undergraduate degree in architecture from Georgia Tech, spent a two-year stint in the army in Vietnam, studied sculpture for two years at the Pennsylvania Academy of Fine Arts in Philadelphia, and received additional training at the National Academy in New York before spending two years studying in Italy. After returning to the United States, he lived in Washington, D.C., for more than a decade doing commission work, returned to Italy for several years, did gallery work in Baltimore for nearly a decade, and eventually settled in Brooklyn.

His understanding of the relationships between art, spirituality, and the body is an amalgam of ideas from his professional training and his religious explorations. During his training at the Pennsylvania Academy, he devoted at least 3,000 hours to learning the mechanics of the human body. This training included basic anatomy and physiology, as well as practice in sculpting, and was grounded philosophically in an Aristotelian concept of the tripartite division of body, mind, and soul. This concept corresponded easily to the thinking he had assimilated from his religious upbringing (his parents were Episcopalians). He observes, for example, that the Christian doctrine of the trinity is similar to Aristotelian philosophy in that God the father is like the mind; Jesus, like the body; and the Holy Spirit, like the soul. The influence of these ideas is still evident in his belief that an ideal worth striving for in art and in life is balance between mind, body, and spirit.

But Johnston's thinking has also been shaped by exposure to other religions, by trying to piece together a workable approach to spirituality, and by his experiences in art. Growing up, he found his life naturally dividing into categories of three ("three pockets"), just as he was later to divide God into three persons and humans into three parts. There was the threefold division within his family: his mother, father, and himself. Each represented a different stance toward religion: his mother was an aggressive conservative who eventually left the Episcopal church and became a born-again Christian in another denomination; his father reacted

against this orientation and took a more laissez-faire attitude toward religion; and he himself was trying to figure out what he really believed. In their own way, they were each struggling with distinct personal issues: his mother, coping with her father's suicide by championing a rigid code of moral behavior; his father, struggling with alcoholism; and himself, searching for a way to express his creativity. At another level, his own life was also defined in three categories: attending school in a community dominated by scientists associated with the space program (Wernher von Braun was a neighbor) exposed him to the life of the mind; the Episcopal church, where he served as an acolyte and participated in the youth group, defined him as a member of the corporal body of Christ; and his budding interests in art seemed to express his soul. The neat compartments of Johnston's life, however, dissolved in confusion as he grew older and was eventually forced to rethink the relationships between body, mind, and spirit.

Vietnam was an important source of his confusion. Like many veterans, Johnston came home feeling disillusioned and rootless. He was fortunate, he reflects, because he was able to work as an artist in the army, rather than serving as an ordinary foot soldier. Nevertheless, he found himself in the thick of combat because the army wanted him to portray battlefield scenes. Once the photographer standing next to him took a bullet in the mouth.

Doubts about what he had learned in church also helped undermine his neat separation of mind, body, and spirit. Although he generally enjoyed being part of the church, it was often more like an organization and a set of rituals than something that was personally meaningful. In retrospect, he thinks he became an agnostic because that was essential to becoming a person whose spirituality was rooted in faith instead of dogma. Studying music (he is also a concert pianist) and art became a way to find spirituality in a more personally meaningful way. "It's taken a lot of time to try to integrate it, and yet I somehow try not to integrate it completely. My life just keeps trying to find a balance between the re-

ality of physical things and the reality of the human soul and how all of that takes shape."

Searching for a broader understanding of spirituality than the one he was raised with has led Johnston to read widely about early Christianity and the life of Jesus, to explore the Roman and Greek influences on Christianity, and to learn about Hinduism and Buddhism. He thinks some of the miracles attributed to Jesus may not have happened, but he believes Jesus had creative powers worth emulating. "He's a very basic model for what it's like to be an artist. He was an artist in his interaction with people and he created metaphors. His words, his language, everything that he did was to bridge the chasm between the realm of God and the realm of the real. To bring those two together he used metaphor, and his metaphors are highly potent. They reveal something profoundly fundamental: everything goes back to the realm of the soul. 'Don't try to flesh out glory for yourself, but put your house in order.' They are trying to make the spiritual dimension, the realm of God, a reality in the world."

Johnston has thought a lot about the meaning of Jesus being God incarnate. He believes that Jesus was fully God and fully man, and therefore both spirit and flesh, but he is also intrigued by aspects of this unity that were not sufficiently emphasized in his religious upbringing. For instance, he is curious about the part of Jesus' life that receives no treatment in the Bible, wondering what Jesus may have done in those years to cultivate his relationship to God. He thinks Jesus' *choice* to be in a relationship with God has been underemphasized, and this concern leads him to believe that ordinary people may also have rich and complex ways of being spiritual and human at the same time.

He summarizes his views of the relationship between the body and spirituality this way: "The body is connected with spirituality just like the mind and emotions are. They are all interconnected. So I would say the spiritual is the fulcrum on which all things hinge. You're able to integrate the body and the mind better with the spiritual base." He adds

that the spirit becomes kinesthetic or movable because of the body, and through the senses the body provides focus to the spirit. He is especially drawn to the idea that close interaction between the body and spirituality enriches both.

Because Christianity is the majority religion in the United States, it is especially important to see the wisdom in Barry Johnston's understanding of the relationships between body and spirit. Although Christianity during the past two centuries has been heavily influenced by the rationalistic emphasis of the Enlightenment and science, its teachings have had much to offer for people interested in the body, the senses, and the emotions. Part of what Johnston emphasizes is the long-recognized argument that the Christian life must be one of *balance* and, for this reason, capable of including the bodily reality of human life rather than denying it.

The Impact of World Religions

Artists' interest in how the body connects with spirituality is generally influenced by their training in the arts (something especially evident in Carla DeSola's case) and by the practices they have encountered in their spiritual explorations, which often include journeys outside of Christianity or Judaism. For instance, DeSola was drawn to a form of Catholicism that paid relatively little attention to catechism and church doctrine, instead emphasizing liturgy and the mystery of God. She came to regard spirituality as a kind of divine energy as a result of learning yoga from Swami Satchidananda and having a godmother who was a practitioner of Vedanta. In addition, DeSola has been influenced by acquaintances who were American Buddhists or Native Americans. "God is everywhere, deeply in every body, and there are ways through the different religions of understanding God."

For some artists, the Hindu idea of chakras has shaped how they understand the relationship of the body to the spirit. A woman in New Mexico explains that the spiritual energy within her body (which she

likens to a pool of energy that exists within the entire universe) is con-
centrated in her seven chakras and, through meditation, she is able to
become more aware of this energy or release it to enhance her creativ-
ity. "I feel the body is the vehicle for our soul at this time, and that we
choose to incarnate on this earth for a reason. Through fully experienc-
ing the body, and life on earth in a conscious way, we can attain our pur-
pose. Life and spirituality are to be experienced in great ecstasy and joy
in the body, and that's not denying the body or being an ascetic, so much
as fully experiencing life in the body." An artist in Pennsylvania ex-
presses a similar understanding of the body: "It is the container for spir-
itual energy. We must keep the body well. We must feed it well with
good nutrients. But the main purpose is that it houses the seven chakras,
the seven energy centers, and once these are opened up and connected,
then you can move on to the chakras above, which are very important."

The relationships between art, spirituality, and teachings about
chakras are particularly evident in the work of the New York wood
sculptor Nancy Azara, a leading contributor to the artistic representa-
tion of feminist spirituality. Her work includes large carvings covered
with handmade paint and gold leaf, which dresses the wood to reveal the
life held in stasis within it. One reviewer has written that these pieces es-
tablish "a commanding, otherworldly air that feels ancient and contem-
porary, Christian and pagan [and] turn the gallery into something of a
sacred precinct."[11]

When she was little, Azara enjoyed the religious services she attended
with her family at a Catholic church, feeling that silences and gestures
did more to convey the existence of God than the homilies. In college
she explored other religions, was influenced by the turmoil of the 1960s
and 1970s, and discovered that art was a way to express her continuing
interests in spirituality. Living in Italy for several years, becoming in-
volved in feminist groups, giving birth to a daughter, and having her
marriage fail shaped the direction of her artistic interests.

Her interest in chakras emerged from meditating, participating in
workshops on spirituality, and working on carvings that sought connec-

tions between bodily shapes and what she was feeling inside. A carving called *Hand Wall* illustrates these connections. It consists of four carved pieces of wood, each six feet high, which serve as a background for a central figure made from a one-hundred-year-old Douglas fir log. "It has a newness in the background and an ancientness in the front. Now it becomes a figure which has all these hands pressed into it. The fingers open out like a flower, almost as if it's wearing something, like a cape that's opened out, which says, 'See me. Look at my heart. I have this bloody hand at my heart chakra,' which is right here. Then there are these other hands, too, and they're reaching up. They are all painted red, but the most red one is at the heart. It's the lifeblood hand, but it's also the hand of violence and brutality. There are many other hands carved into it that are still gold, and then there's this little brown hand at the bottom. It's as if it goes into the earth in the shamanic way."

Azara explains: "In the shamanic tradition, the shaman beats the drums and brings the energy of the world from deep down in the center, from inside the earth, up into the heavens, into the universe. The hand comes from deep down in the center; it's drawing energy from the center of the earth—all the energy. When you look at [the carving], it has the feeling of this animate body that has its hands open with lifeblood but also the violence in the universe. It's reaching up to the heavens, and there's this battering ram, an old piece of cedar—and that's red and bloody—and it's battering its way into another kind of understanding. It's working on transforming itself in a way that's battered and brutal and beautiful and exquisite and sexy and sultry."

Hand Wall expresses her understanding of spirituality's relation to the body. "It comes out of my experience of working with the chakras, of looking deep inside, the journey within. I go deep in myself. I look for an expression, an understanding of what I want to put out into the wood. Spiritual life is looking into the unseen, the unknown, working with the psychic force in the universe, communing with silence, seeing what's between the unseen and yourself. The body is like the heart, like the mind,

like science, like all these things that are available to us. It's another way for us to find an awareness about the universe, about spirituality."

Like Nancy Azara, Meredith Monk has come to think of spirituality as "a flow of energy," although she does not talk about chakras. This flow of energy envelops her but is also so much a part of her body and mind that she cannot separate it from her art. The discipline of creating and putting on a performance, she says, is very similar to the experience of meditating. Both teach her patience and humility. Both require her to go into the depth of her inner being and discover whatever is there. Both are most fulfilling when she has been able to reach a "pinpoint focus of intensity," and they are similar in forcing her to realize her limitations.

Barry Johnston's thinking about spirituality has been shaped by an early realization that the creative power ascribed to God in Christianity and Judaism implies a kind of spiritual energy that pervades everything, and that it can in a small way be reproduced in the creative acts of humans. Although he understands this energy to be the Holy Spirit in Trinitarian theology, he has found it helpful to read about Greek mythology, where he finds the idea of energy personified in demigods, or Hinduism, where there is a complex portrayal of spiritual energies.

All these artists' views of the body's role are greatly influenced by their broader understandings of spirituality. If spirituality is universal (in the sense that the spirit is always present in everything), these artists nevertheless regard it as more apparent at some times than at others (or more readily found in some parts of the body than in others). Carla DeSola says she has a "Teilhardian sense of spirituality in all matter," but she emphasizes that a person whose mind is filled with other things is unlikely to be sensitive to the spirit. "I try to be empty. Where there's emptiness, things flow. It has to flow into an emptiness, not into something all full. Otherwise you're just playing with the same stuff, almost in a compulsive way. But if you can clear your mind, and I don't practice in a Buddhist way, but I have enough sense of how to breathe and be quiet to go for that." Dance itself is often a way to empty herself.

To refresh herself spiritually, DeSola generally prays, doing this almost every day, and her prayers often involve dancing. She sees this as a "return to your soul. Something like that. I know I have to find a way of moving. Moving will return me. If I can just remember to move. It doesn't have to be a whole dance. If I just remember to do a movement prayer. But sometimes I have to move more. When I've not been moving, I'm off-centered, and then I've got to remember to give myself time to dance. I mean more improvisation, just anywhere. I can't have a whole spirituality if my body isn't involved with my spirit. It's the integration of body, soul, spirit."

Likening spirituality to breath or energy is an additional way to grasp its relationship to the body: it enlivens and enriches what one does with one's body, just as oxygen does. Carla DeSola says she "breathes prayer" into her dance performances, so that "the movement comes out of a center." She does so by asking herself what she is trying to express. "Are people being gathered together? Are people being challenged in a prophetic way? All of that has to do with spiritual choices. In terms of the body and spirituality and theology, every gesture you make says something, it has a theology. You raise your arms upward. Is that telling people God is up there? You move your arms downward. Is it telling people God is in the earth? You can't make a gesture without it having a theology behind it."

She elaborates: "In an academic way you would talk about 'ruah,' the breath of God. Breathing and breath, the spirit of God creating the earth. They are really entwined. A dance can be dead. Perhaps you've not bothered to allow room for the spirit to fill it and have worked from the head too much, so it's too intellectual an approach, or just pieced together things from the past. Creativity has a sense of life and the unexpected and maybe even the chaotic, or whatever, when the spirit's there."

Barry Johnston does not talk about the breath of God, but he enunciates a similar idea when he equates spirituality with the animating force that sustains life. "Spirituality is the essence of who we are. A person, if they're going to have any sense of individuality, they have to have

a spiritual life. Ultimately, you choose what's going to direct you, who or what is going to direct you. It can be the things around your life. It can be the people around your life, or it can be higher values. If you go for higher values, I don't think you can find a higher value than the source of all existence, which is what the idea is about of faith in a God. 'God' is a word that describes that ultimate source behind all existence."

In Western thought, energy has been conceptualized mainly as a physical force, such as the energy generated by engines and measured in horsepower. Bodily energy is often understood as the movement measured in time-and-motion studies or as a function of muscle development and lung capacity. But when used in reference to spirituality, energy has different connotations. It is more metaphoric and located more in an alternative plane of existence than in the natural or physical. It suggests a holistic, animating force that either comes from God or is an attribute of God. And it emphasizes the interconnections of body, mind, and emotions.

Spirituality and Healing

Given their vision of a close relationship between body and spirit, it is no surprise that these artists believe that spirituality can play an important role in healing. Carla DeSola points to the healing power of music, for example. "If you are in an agitated state, beautiful music can calm you. The delightful, humorous aspects of the arts are helpful when you're feeling down. Gentle movements of the body can also heal. I encourage women at the homeless shelter [where she volunteers] to move."

Barry Johnston emphasizes *balance* as the key to healing, just as he does in his more general views of spirituality. People are more likely to be healed if they can align ("attune") themselves to the spiritual and physical energy in their bodies and in their environment. "A wound will heal through natural processes sometimes, but a body that's well balanced tends to nurture all of these aspects of healing and finds equilibrium a lot better. If you have a spiritual life, you can bring more to the

process. Also, spirituality helps your mind to know with greater clarity the consequences of certain actions."

An artist who identifies herself as a Catholic says, "We separate body, mind, and spirit only for purposes of discussion; in actuality, one dimension is always affecting another. There's no way you can have a healing without the human spirit being involved." Several artists mention "therapeutic touch" as an example: they regard it as a result of people "channeling their spiritual energy" through their hands. A wood carver elaborates: "When you work with psychic healing, you bring the energy from the top of your head down through your body, down to the earth and back out through your hands." In her artistic work, she tries both to use this process and to depict it so that others may be encouraged to use it in healing themselves.

According to these artists, bringing spirituality to the body through the arts can effect healing. Carla DeSola, who teaches a course called "Sacred Dance for Healing," explains, "I approach it in three ways: one, the inner transformative healing that comes through prayer and meditation. Then the healing that comes through dance, almost like dance therapy, which would be exploring and increasing the ranges of movement. Then in terms of my own work at the seminaries here, taking healing stories of Scripture and embodying them—for instance, the story of Jairus's daughter, a little girl who is believed dead.[12] Working on this, one woman exclaimed at the end of the session, 'I'm not dead, I'm only asleep.' She had thought a part of herself was dead through overwork. She lived through that story."

Meredith Monk's view of the healing potential in art is similar: "I think it offers an affirmation of life. It gives people ways to slow down and to become more in touch with themselves and with the deepest aspects of themselves and the mysteries of their life and the memories of the human race and the sacred space that we are in danger of losing. I think that's what art can actually provide, and it's not being covered in the media."

A woman trained in dance who works as a nurse says the arts have

been instrumental to the healing process in several ways. Through workshops for nurses that have involved training from music and movement therapists, she has gained greater clarity about her own spiritual core and thus been able to relate better to her patients. She sometimes leads workshops herself that use liturgical dance to help sick people get in touch with their "essential being"; doing so helps them gain perspective on their illness. Like Carla DeSola, she believes that people can reach a kind of spiritual oneness with themselves and with others through what she calls "contemplative dance." The bond people establish with others by participating in group artistic activities may also be instrumental to the healing process.

In these examples healing may be understood to happen in miraculous ways, involving direct supernatural intervention, but it is more likely to be regarded as a result of someone becoming more aware of the spirituality that already exists within the body, or of coming to a different awareness of connections among the various aspects of his or her physical being. Carla DeSola is a firm believer in the power of prayer because she regards prayer as operating at all these levels. It can focus people's attention, helping them to become more centered and thus better able to draw on the resources of their bodies. It can also help others because of the inevitable connections among all living things. "I believe the monk sitting in his cell, if he is centered, is part of the centering of the world," DeSola asserts. "There is an invisible reality that is very strong, that is probably stronger than the outward reality."

A visual artist who leads retreats for people interested in spirituality and healing explains her understanding of what happens this way: "The image is what heals because the image gets a person to speak. They use the image like a dream and they begin to dialogue with the image. In that dialogue, what they're doing is bringing their own psyche and spirit to that image, and then they're sharing with me or with others in the retreat group. It's something that they can use as a source of reflection for the next year or two. It reveals a depth that they never knew they had." This artist believes in God and prays regularly, but she considers it un-

necessary to speak about the supernatural in describing how a painting may contribute to personal healing. "When a person has the courage to reveal their spirituality through painting [or any other art], it is a form of healing. It certainly was for Hildegard von Bingen. The spiritual release is essential. It's necessary for us if we think of ourselves as artists, to get rid of that energy, what builds up within us, in order to stay healthy. The release is essential. It's healing."

The healing that comes from an integration of body and spirit is sometimes extended beyond the body itself. Carla DeSola periodically stages dance performances designed to heal the rift between humans and the natural environment. One is called *Wisdom's Way: A Passion Dance for the Earth*. "The dance has to do with weeping for the conditions of the earth, as Hildegard von Bingen might have talked about it. It evolves around the biblical figure of Wisdom, seen weeping for the suffering of the earth. It asks, 'Can we shed tears of repentance for the condition of the earth?' Wisdom as a figure comes with celestial beings and sees the condition of the earth. She is a wandering figure. As in every generation, she seeks holy souls to make them friends and prophets. I see her as a prophet, asking how we feel about the elements of the earth, why there is destruction, and why are we cutting down the rain forests." The dance is performed in a space marked by a labyrinth, and part of it follows the story of Theseus and the Minotaur. "There's a wild dance with the Minotaur, and then a blessed dance with Icarus's wings. Then Wisdom with her light invites the audience to walk through the labyrinth."

DeSola entertains no illusion that the dance somehow effects a direct healing of the earth. Instead, she sees it as a visual-kinesthetic statement with the potential to heighten the audience's awareness more than simply reading or thinking about environmental problems would. Her goal is for people then to take individual responsibility for protecting the environment, much as they might for maintaining their own health. The spiritual aspect remains elusive. It is present, in her view, because God's spirit pervades every part of life, and it is especially apparent when people work for the redemption of God's created order.

One of Meredith Monk's most notable works, *Quarry*, combines movement and music in a similar effort of spiritual healing. It is an opera for thirty-eight voices that opens with a young girl waking and crying that she is sick: "I don't feel well. I don't feel well. It's my hand. It's my hands. It's my eyes. It's my eyes. It's my skin. It's my skin." And then the audience realizes that the sickness of the girl's body is a metaphor for a pervasive illness in the body politic. The story unfolds through the horror of Nazi Germany, including destruction ending in silence, and a vocal requiem. "It's kind of a cleansing of the space," Monk remarks. Or, as one reviewer has observed, "Monk purges the grief without assuaging the guilt. She dreams our collective nightmares for us in public, leaving us to answer the questions they raise in that shocked moment after we wake up."[13]

Nancy Azara's carving *Spirit House of the Mother* has been an act of healing for herself and for many who have experienced it. This eleven-foot structure (which viewers can enter) is painted red on the inside and covered with gold leaf on the outside. "Outside is this structure like a house and yet it's open to the sky, so that the energy of the light comes from inside down. It sort of cascades, and is very pearlescent, almost like the inside of a body, and it has all these forms, like seeds were there. It feels like a very motherly, female structure. People have told me about feeling at home, feeling as if they were in the womb, feeling an experience of birth or of giving birth." It has helped her express her understanding of "female power" and to remember giving birth to her daughter. But it serves mostly to help people discover the faith that is inside them. "If you have faith that you can heal yourself and you have faith in the inner nature of the spirit self, you can heal yourself in amazing ways."

Believing in spiritual healing does not mean that these artists deny the value of scientific medicine or regard all ideas of healing or spirituality as equally valid. They all voice concern about following ideas that promise too much too easily. Carla DeSola explains, "I tend to trust practices that have deeper roots." Meredith Monk echoes this sentiment in criticizing a workshop she once attended that was like a "spiritual su-

permarket." Although she decided it was probably helpful for people to get five minutes of one thing and ten minutes of another, she worries about the superficiality of such approaches. Barry Johnston warns that the trick is to investigate many different ideas about spirituality without "getting caught up in your own idea about it too much." He thinks it is important to focus on the "wisdom sources" that lie at the core of one's own religious tradition. "If you're going to understand anything, you have to go back to the fundamental source. You have to go back to its roots." He emphasizes the balance between learning one's roots and letting others explore theirs. "Develop a spiritual life that's solid and based on good solid principles. Don't let it be a hammer to straighten out other people, but a resource for personal growth."

Although they believe in possibilities of spiritual healing, these artists also recognize a fundamental difference between body and spirit with respect to death—whereas the spirit lives on, the body dies—and this difference is a reminder that spirituality is never fully expressed in bodily experience. Carla DeSola thinks of death as a separation of the body from its spirit, and for this reason she acknowledges fearing it. "I know graces will come, but I identify so deeply with my body and being able to dance that every time there is another ache or pain it's very painful to me. I fear the diminishment of accessing my best self if there comes a time when I am not dancing. I will have to find other ways of finding that integration of spirit that comes through dance."

Meredith Monk says that meditation (and by implication, art) is a way of "practicing death," of gaining an understanding of what it means to detach, to give up oneself. Meditation reminds her that death is a natural process and gives her hope that spiritual energy somehow is recycled. Beyond this, she is unsure what to think about death. Barry Johnston echoes this sentiment. He believes there is life after death, but thinks it is unhelpful to speculate very much about it. For him, it has been formative to see close friends die and to face death himself in Vietnam. These experiences have encouraged him to focus more attention on the spiri-

tual meaning of his life and to recognize that his physical existence will come to an end.

The months Andres Serrano spent photographing violently slain bodies in New York City morgues persuaded him, beyond any doubt, of the reality of death. He remembers the body of a girl who in death struck him as still revealing something of her personality, but at the medical examiner's hands her body was reduced to a pile of flesh and bones in less than an hour. Since then, he has been thinking more seriously about the meaning of death.

His earlier piece *Piss Christ*, though graphic in its own way, is a more subtle reminder of the limits of conflating body and spirit. When the body is symbolized as human waste, it is hard to acknowledge its spirituality, especially when spirituality is symbolized by the long-venerated image of the Christ. The emotional reactions to this work show the symbolic power—and danger—of trying to bring together categories of thought that have long been kept apart.

These limits notwithstanding, it is evident that contemporary art, music, and dance are at the cusp of widespread rethinking about the relationship between body and spirit. Spirituality increasingly transcends images sanctified by religious institutions as well as teachings that require the body to be denied for faith to be accomplished. Spirituality infuses bodies with new power to evoke controversy and wonder.

Religious traditions have always struggled with understanding the relationship between the body and spirit. In the United States, spiritual forms of healing as well as ideas about God becoming real through visions, voices, and other tangible manifestations have been an important part of the nation's religious history. The central doctrine in Christianity of Jesus being the human incarnation of God has made room for teachings about the ways in which spirit and flesh intermingle. Yet there has been an even stronger tendency to keep the two separate. The body has often been regarded as a source of fleshly temptation, while the spirit has been thought of as something other than the body.

It is not surprising that the relationship between body and spirit is currently being rethought. A more positive image of the body has been encouraged by the sports and fashion industries. Religious teachings currently emphasize the present life, as opposed to the afterlife, to a greater extent than in the past. Growing numbers of Americans have been exposed to Hinduism, Buddhism, and other religious traditions in which ideas about energy provide a way of conceptualizing a more complex relationship between the body and spirituality.

Contemporary artists are among the leaders engaged in popularizing new ideas about the body's role in spirituality. Working with images or using their own bodies in performances, they are unable to ignore the body in the way that people in more purely intellectual professions may be able to. Many of them have been drawn to reflect on the body through their own efforts to pray and meditate.

It is too soon to tell whether the current interest in rethinking the body's relationship to spirituality will result in fundamentally new ideas or whether this interest will prove short-lived. Few artists think they have come up with ideas that represent scientific discoveries or that necessarily challenge the wisdom of religious tradition. They are interested mainly in encouraging the wider public to recognize that spiritual journeys are likely to be richer if the body is included.

7

THE ONE EARTH

WORKING AT THE INTERSECTION of body and spirit, artists' interests frequently turn to our precarious relationship with the earth we inhabit. Nature provides them with metaphors to express their ideas about spirituality. The power of God is envisioned in the energy of a storm or divine love in the intricacy of a flower. Beyond its metaphoric uses, nature's rhythms, sounds, colors, and textures, as well as its harmony, balance, and the perils that threaten it, sometimes become manifestations of spirituality itself.

Although the relationship between spirituality and nature has often sparked the imagination of artists throughout history, contemporary artists' views seem particularly influenced by an awareness of the natural environment's fragility and by diverse religious experiences. Some artists are leading the search for a new understanding that regards nature and spirituality as virtually interchangeable dimensions of reality.

Combining Nature and Art

David Dunn is a composer and experimental electronic sound artist whose albums have ranged from *The Lion in Which the Spirits of the Royal*

Ancestors Make Their Home (1995), which uses vernacular sounds to document life in a Zimbabwe village, to the innovative *Angels and Insects* (1992), a scientifically accomplished rendering of the bio-acoustics of underwater life. A bearded man in his forties, he spends much of his time collecting unusual sounds in out-of-the-way places. One expedition took him and three trumpet players on a three-day backpacking trip to a remote part of the Grand Canyon in search of echoes; another required days of slogging through Mississippi and Tennessee river basins.[1]

At his home in Chimayo, New Mexico, he describes becoming interested in music while still in elementary school: "I always knew what I wanted to do, and I even had a pretty clear idea when I was a kid what I wanted to do musically, which had to do with two major interests. One is technology and the kinds of technologies that were unfolding, beginning to really be available at that time—electronic technologies, computer technologies. The other had to do with environmental sounds, sounds of nature and the relationship of music and the relationship of language—linguistic structures—to music."

After finishing high school in three years, he terminated his formal education to work as an assistant to the composer Harry Partch on projects exploring the relationships between music and outdoor acoustical spaces (such as the Grand Canyon). These projects and later ones he initiated led him to theoretical questions about the nature of music— "looking at what music actually is, and questioning it as a historical phenomena, as a human activity, with regard to the sounds of the environment." He points to his projects involving bird and insect sounds as examples of ways to explore "the nature of intelligence within nonhuman living systems and the idea of music as a modality to enter into interaction with those systems of mind." He has recorded the sounds of mockingbirds, analyzed them by computer, and then experimented with evoking different responses from the birds by modifying the recorded sounds and playing these modified songs to them.

Although much of this work is technical and scientific, he remains primarily interested in the artistic and aesthetic aspects of music itself.

His writing focuses on music theory, and his albums combine sounds from nature and from musicians to evoke meditative and variously somber and joyful moods. These moods, he believes, are the result of some fundamental capacity in music to preserve and process information. "Music is a way of thinking, a way of actually processing information, and a way of communicating in the world which has more to do with the way other forms of life do it. Music, I think, has been our principal holding action, a kind of conserving action, what [anthropologist] Claude Lévi-Strauss alluded to when he called artists the national park of the savage mind." Dunn believes there is an inevitable relationship between the complexity of the environment and the kind of music people prefer. At present, he thinks there may be a relationship between the "increasing amplitude of music" and our destruction of some of the natural environment's complexity.

Music is thus the means by which he feels it possible to reconcile human technology with nature. Although he recognizes that technical developments have often harmed the natural environment, he does not believe the two must always be at odds. Instead, he uses computers and electronic synthesizers (technology) to produce music that reflects the natural world and to which that world can sometimes respond. He imagines sound sculptures, for example, that would operate by solar power and make music compatible with the sounds of birds and insects and animals in a particular habitat.

The relationship between these interests and spirituality is so close that he has difficulty separating the two. He remembers going to church only once as a child, simply because his parents (who were nonreligious) thought he should know what a church was. During his childhood, his conviction that something existed beyond ordinary reality was reinforced mostly by his mother, an artist who claimed to have psychic experiences involving clairvoyance or extrasensory perception. Later, various mentors helped shape his emerging awareness of spirituality. In particular, Harry Partch, the son of missionary parents, impressed Dunn with his appreciation of the spirituality of the cultures to which

he had been exposed as a child. Other influences from early in his ca-
reer included the historian William Irwin Thompson and the mathe-
matician Ralph Abraham, who both spoke of their interests in cosmol-
ogy and other aspects of spirituality at an American Film Institute
seminar series Dunn organized. Dunn's thinking was also profoundly
affected by reading Buddhist philosophy and by the spiritual interests of
such musicians and composers as John Cage, Kenneth Gaburro, and
Pauline Oliveros.

These influences encouraged him to think of spirituality as a dimen-
sion of life that is always present but generally ignored because people
are too busy thinking about other things. He regards music as being fun-
damentally derived from listening—from being quiet and paying atten-
tion to one's inner life and one's perceptions. "Musical notations are
ways of listening. The emphasis is on listening rather than upon an ex-
ternal manipulation, and that becomes the music." He appreciates John
Cage's *Four Minutes 33 Seconds* (a piece that consists of that much si-
lence) because it creates a space in which people are forced to pay atten-
tion to what is happening inside them. In his own work, "these little ges-
tures of how one goes about organizing perception and listening, it's
very much like a meditative practice. Over a period of time doing this
constantly and practicing it as if it were a piece of music does increase
levels of sensitivity and the ability to focus in ways that one may not have
had prior to the experience."

Dunn's understanding of the relationship between nature and spiri-
tuality emphasizes the same quest for sensitivity. "I don't understand a
separation of spirituality from the life and from the work that I do. It's
so integrated that when I talk about things like these domains of nonor-
dinary reality or the aspects of nonhuman living systems and communi-
cation with those things, that is no different than what a lot of people
have referred to traditionally as forces of nature, forces of spirit. So a lot
of my work has been directly looking and trying to ask questions or to
provide evidence of the nature of spirit in the world. That is the journey.

The journey is all these things that I've been doing. These things are as much a spiritual quest as they are an intellectual one or a career one. They're so interwoven and so inseparable."

Deep Listening

David Dunn singles out Pauline Oliveros as having been particularly influential in shaping his work. "Her thinking with regard to music, deep listening, and before that, starting clear back in the '60s doing what she called sonic meditation, just the whole manner of Pauline's thinking and work is extremely profound. She's just one of the real major figures of our time. She's great. She's a really very powerful person."

Pauline Oliveros grew up in Houston, Texas, where she was exposed at an early age to music and composition by her mother and grandmother, both of whom taught piano. She studied violin, learned the accordion, and played in the high school band. "When I was about sixteen," she recalls, "I began to hear inwardly all kinds of sounds, wild sounds, very interesting sounds and orchestra sounds and all sorts of things. So I announced that I was going to be a composer. Then it took quite a while because there was no way to translate what I was hearing into any form that would be communicable to other people!"

She majored in music composition at the University of Houston, but felt she was making little progress until she moved to San Francisco, where she was able to study for five years with Robert Erickson and interact with other students interested in innovative forms of composition. In 1960, with fellow student Ramon Sender, she founded the first electronic music studio and two years later initiated the nonprofit San Francisco Tape Music Center. Following a successful concert season in 1964, she received foundation support that made it possible to initiate the Center for Contemporary Music, which began in 1966 at Mills College in Oakland. A year later, she took a position at the University of California in San Diego. It was there that she started composing *Sonic Meditations*, a

work designed to help musicians learn how to focus on, listen to, and produce sound naturally.

Her sonic meditations were a series of twenty-five "recipes or instructions for directing one's attention and making sound or listening in particular ways." Oliveros developed them with a group of women who met one evening a week at her home to talk about writing in their journals, share insights from their dreams, spend time together in silence, and experiment with her sonic meditations. The idea was to "listen inwardly," just as she had done as a child, to the effect of a particular sound or tone on her body, mind, and emotions.

After nearly a decade in southern California, she left her tenured teaching position and moved to upstate New York, where she served briefly as artist-in-residence at the Zen Mountain Center, and then relocated in New York City as a freelance composer and performer. During the next decade and a half, she traveled widely in the United States, Europe, and Asia; gave workshops and lectures; and established an organization to promote new forms of composition and improvisation in music, theater, and literature. In 1996 she returned to Mills College, continuing the work in creative music she had begun three decades earlier.[2]

The connection between her musical work, nature, and spirituality was evident in the 1970s as she pursued her interest in sonic meditation, but its origins lay in her childhood. "Spirituality has to do with nature," she reflects. "The feeling of just being in nature [as a child] was very important to me as a spiritual practice. I didn't know to call it a spiritual practice until later, but nature is where I can center and feel at home. I didn't have that much church in my life. When I was about nine, my mother had my brother and me baptized as Episcopalians and for a couple of years we went to the Episcopal church, but after that we didn't. As a teenager I went around to a few different churches to check them out, but I really wasn't too interested. I don't know what I was looking for. People went to church because Texas was churchy, but I didn't like it very much. I didn't like the things that were said. I just didn't feel comfortable in that environment. I remember at seventeen my teacher, who

was a Lutheran, was trying to convince me to go to church, and I said, 'Well, I'd rather go sit under a tree.'"

As she matured, she came to regard music as her primary spiritual practice, but also learned more about religion. "My religion was music: practicing and learning, playing and composing. That was religious to me. It was discipline. The main thing was my work with sonic meditations at the end of the '60s. I started to read about Tibetan Buddhism at that time too. I was fascinated with the mind practices and the consciousness. Then during the '70s more and more things became visible, like yoga and Zen practice."

The role of nature in her work has been closely linked with her interest in spirituality. Like David Dunn (who studied with her in southern California), Pauline Oliveros has been increasingly interested in ecological acoustics as a medium for uniting spirituality and nature through music. In 1988, near Port Townsend, Washington, she recorded *Deep Listening* in a fourteen-by-sixty-foot cistern that had been used as a water supply for soldiers at Fort Warden. The cistern attracted her because sound reverberated for a full forty-five seconds, and the reverberation was nearly indistinguishable from the original sound. The recording was reminiscent of her earlier sonic meditation (or inner listening), and it was in her view spiritual, but she was drawn to the idea of doing something that was even less obviously related to organized religion than meditating. The words "deep" and "listening" attracted her because they were common ideas that suggested a relationship between the spiritual dimension and nature.

"Deep listening," she explains, "is similar to the idea of deep ecology, although I hadn't heard of that idea at the time. It means going below the surface of ecology and understanding what ecology is and what it means to all of us and for the life of the planet. I feel the same way about deep listening. Hearing is different from listening. We all hear if our ears are healthy. If they're not healthy, then there are problems. But hearing is part of the natural order. It happens to us whether we want to have it happen or not. It's a primary sense. It develops first in the womb.

The ear is complete by four and a half months. It's the last sense to shut down after death. So hearing is there as sound waves impinge on the eardrum. Then we have listening. Listening is cultivated and developed and is a lifetime art and practice. We don't stop learning about listening. There are levels and levels and levels of it. If you put 'deep' beside 'listening,' then it means going below the surface in terms of listening so that you get meaning, you direct action, you gain understanding, knowledge and, hopefully, wisdom through this practice of listening."

Since 1991 she has devoted much of her time to what she calls "Deep Listening Retreats." Held each summer in the Sangre de Cristo Mountains outside of Las Vegas, New Mexico, these are week-long events for people (many of whom are artists) who want to combine an experience of being in nature with spirituality and personal reflection. Each day begins with a ritual of bowing to the four corners of the earth and engaging in a "meditation walk." After breakfast, participants spend the day in guided listening exercises, writing and drawing, sitting in silence, and doing outdoor meditations. Specialists in Tai Chi, Taoism, dream work, and poetry assist Oliveros with these events.

"If you want to listen," she explains, "it's important to become quiet inside and to be able to let go of all sorts of motivations for listening and become receptive to what is. Every sound has intelligence and information. So consider that you are at the center of everything that can be heard and try to open to the whole field of sound and not being committed to any particular one, not being committed to any sound, not worrying about identifying and locating, but simply listening to the whole web of sound."

This kind of perspective stems in part from an attempt to appreciate the richness of nature, rather than viewing it only as an exploitable resource. Spirituality may not be discussed per se, yet the very emphasis on a diffuse, holistic sense of the sacred suggests that nature can be regarded as a spiritual entity or manifestation, just as the body can. Of course this view differs markedly from Christian and Jewish teachings that draw a sharp distinction between the creator and the natural order.

Expressing God's Handiwork

A decidedly different way of linking nature and spirituality is evident in the work of Derek Fell, a garden writer and photographer who specializes in portraying the romantic qualities of garden design. He lives in Bucks County, Pennsylvania, at historic Cedaridge Farm, where he cultivates award-winning flower and vegetable gardens, and he has published more than fifty books, including several volumes on Impressionist gardens.[3]

Derek Fell's awareness of natural beauty emerged in Lancashire, England, where he spent the first decade of his life. He remembers the seaside resort in which he lived as a place of incomparable beauty. From there, his family moved to Findhorn, Scotland, and the three years he spent there were to have a decisive influence on him. Findhorn was later to become the site of an experimental religious community that drew seekers from all over the world. He remembers it as a magical place. "It's one of those places that when you live there, you feel it's different from anywhere else. All I can ever remember of Findhorn is the sun shining every day, and the warmth. You wouldn't think that of Scotland. You'd think it was snow and sleet and cold. It was an amazing place, very beautiful. I had my own boat. I would watch the whales mating from the beaches. It was just a glorious time."

After completing his secondary education in Germany, where his father was stationed with the Royal Air Force, he quit school to become a journalist. For the next six years he worked in London as an assistant to the renowned war correspondent O'Dowd Gallagher, who was known for acquiring exclusive stories and for his unremitting impatience with errors. In the course of this work, Fell learned horticultural photography as a hobby and did some work for the Burpee Seed Company. When David Burpee invited him to come to the United States to serve as catalog manager, Fell accepted.

This position lasted for six years, ending when the Burpee company was purchased by General Foods. Fell, then barely thirty years old, de-

cided to strike out on his own, doing freelance photography, writing, and establishing what was to become one of the largest collections of original horticultural photographs in the world. His first book was on vegetable gardening, a topic that had become popular in the aftermath of the energy shortages created by the oil boycott of the early 1970s. With a contract from *Architectural Digest,* he was then able to travel the world in search of gardens and natural scenery.

"With photography, the key is spirituality," he says. "I could be in the middle of a slum or I could be on the edges of Antarctica and something will click and I will recognize an uplifting, almost religious scene. It makes me feel good to see it, and it challenges me to capture it and expose it to people. That's really the kick that I get from it, photographing a fleeting moment, something that's only there for a split second. A lot of people don't realize that about gardens. 'Oh, they just sit there. It's not like photographing wildlife.' You can be there at a special time when perhaps a shaft of light comes in, and it's like the dawn of creation. A shaft of light comes through and it just hits a clump of flowers and immediately, you're saying, 'Oh, God, that's great, and thank God, I'm alive to see this.'"

Being grateful for natural beauty is something Fell learned as a child, not just from growing up in beautiful places, but from being taken on nature walks by his father and to Anglican church services by his mother. Although he participated in church regularly until he left home, he gradually became disillusioned with organized religion because of its rigidity. "My skepticism is against any hard religion or any religious zealotry. I think spirituality has to be calm. I have never studied Buddhism, but it probably comes closer to the real meaning of religion than anything else, because of its tranquillity and serenity and peacefulness and not speaking loud and seeing beauty in nature. If you create a garden, you symbolize everything in nature in the garden. You don't see Buddhists thrusting their ideals on anybody. It's a very peaceful, quiet, serene existence, and to me, that's what spirituality is. It's peacefulness, it's serenity, it's seeing the beauty in everything that's in nature."

Despite the fact that artistic renderings of natural beauty have been common throughout American history, some people still chafe at the suggestion that photographs of beautiful gardens have anything to do with spirituality. They say it is misguided or idolatrous to see the sacred anywhere besides church or in the Bible. But this view appears to be that of a minority. Beauty and serenity are not all that we understand spirituality to be, but for most people there is a meditative quality about nature that makes them feel closer to God.

Spiritual Gardens

Although Derek Fell is particularly attracted by the beauty in nature, the beauty he observes is enriched by the camera's eye and in many instances is the result of painstaking horticultural design; it is truly an integration of the physical world and the human spirit, rather than deriving only from nature. Another artist who works actively to achieve the effect she desires from nature is Bay Area installation artist Dawn E. Nakanishi.[4] Her installations are room-sized, creative interpretations of nature, constructed of rocks, water, leaves, and other natural elements. Referring to them as "spiritual gardens," she says she wants them to be a place where people, through free association and personal reflection, achieve a "transformative experience." One installation (at the University of the South in Sewanee, Tennessee), called *Poetics of Time*, featured a 400-pound block of native sandstone suspended over a pond, surrounded by rock formations through which water was pumped to produce reflections on the walls and ceiling. Another installation (for a "Dia de Los Muertos" exhibition in Oakland) was a quiet fountain surrounded by rocks, leaves, and leafless tree branches. She placed tangerines and a small bowl of rice by the water as a symbolic offering to the spirits of the dead and near the pond inscribed four pairs of words: water/blood, wind/breath, earth/bone, fire/soul.

These installations represent a return to her childhood experiences of the sacred. A third-generation Californian of Japanese ancestry, she at-

tended a Presbyterian church with her parents and two older sisters. She does not remember any bad experiences at the church, but seldom felt as close to the sacred there as she did in other places. She particularly enjoyed the natural beauty of the Bay Area and, from age six, liked swimming. By fifth grade, she was feeling uncomfortable at church because she didn't know many of the other children, and because she found it hard to imagine the pastor having special powers to interpret God or pronounce forgiveness. Swimming was becoming the central aspect of her life, and by age seventeen she had earned eleven national titles and qualified for the Junior Olympics. She was also discovering her talents as an artist.

But the path to becoming an installation artist was circuitous. Although she was skilled enough in watercolor to sell some of her work when she was still in elementary school, she grew interested in making jewelry in high school, and in college and graduate school she specialized in metalsmithing with an emphasis on jewelry. She then held several positions as an art instructor, worked at the Richmond Art Center and the DeYoung Museum, and devoted her artistic efforts to creating jewelry. With budget cuts for education and the arts during the 1980s, it was difficult to obtain steady work, and she even seriously considered taking a job as an industrial artist. In 1990 she returned to graduate school, this time with an interest in spatial art.

Her jewelry making (which she continues) has given her a unique perspective on installation art. She wants her installations to be personal, just as a piece of jewelry is, and she uses natural elements in both to encourage people to ponder their relationship with the earth. "I am very interested in working with natural materials, water, rocks. Some are water washed, so they're rounded pebbles. The boulders that I use are usually water washed, because the trace or the etching of water on the stones is important for me. The water is very connective. I use it as a metaphor for the lifeblood. The spaces are meant to be metaphysical, in that the viewer comes in, spends time, and is hopefully transformed or goes into a transformative state. The spaces are meant to be very private."

To encourage people to spend time in these spaces, Nakanishi often requires them to remove their shoes. "Part of me is trying to educate people to realize that art deserves your time. If people look at a painting or sculpture for two to five seconds and don't 'get it,' they move on. I was noticing that. They would say, 'Oh, this is just a garden inside a room.' So I decided I would incorporate the Japanese idea of honoring a space by asking people to take their shoes off. That was a deciding factor for a lot of people. They didn't want to take the time to take their shoes off to go into a space, because they just wanted to zip in and zip out. This required them to make a commitment. But if they finally did go in, they would stay and then come out and say, 'Wow! I'm glad I did that.' In the Japanese culture, to take your shoes off before you enter a house also means that you are crossing the threshold into a sacred space. That was also a thought of mine."

For *Poetics of Time*, she heightened the sense of moving into a sacred space by constructing a stone path leading into the installation. Viewers "took their shoes off and if they had bare feet they could feel the stone on their feet and one of the stones was etched. It said, 'Life is a river, a journey of the soul.' They would walk down this path and then come into the room with the pond of water and the sandstone pendant suspended over it." She recalls one visitor remarking that the experience reminded him of the biblical story of Bethesda, in which an angel touches the water and causes it to heal those who come to it.

She is pleased when people draw spiritual connections like this. Her own connections are quite personal. Working on installations often reminds her of her Japanese American grandmother whose Shinto practices included talking to the spirits in plants and animals. "I'd be in the backyard and my grandmother would be trimming the hedges, and as she cut the branches, she would be saying a prayer to the plant that she was sorry that she had to do this and she was apologizing. To me that was probably the seed that made me understand that every living thing, even a rock, has a spirit." Her installations have been a way to express gratitude to her grandmother and to others from who she has learned.

Her *Gift of Spirit* series, for instance, used rocks she had selected from the San Juan Islands to commemorate these people. "I chose a rock with specific qualities for each individual and added copper, brass, or other elements to emulate that person. They became the individual."[5] The installation was personally powerful because it symbolized the fire, mineral, and water that are in every person.

Sometimes Nakanishi composes a statement to accompany an installation. One poetically expresses her understanding of the relationship between spirituality and nature: "Each rock has a strength, a soul, a timeless permanence. Gazing across the many miles of pebbled beach reminds me of a sea of humanity. Each rock, an individual soul, one for each being who has ever lived or is living on this earth."[6]

I have included Dawn Nakanishi's work because the attraction of nature for many people is that it is presumably pure, pristine, unsullied by human intervention. It clearly does not have to be. Indeed, artistic renderings of nature are always interpretations. Even the experiences people describe from being "in the wilderness" are filtered through their previous perceptions and worldviews. This is another reason why nature and the spiritual life are difficult to separate. Religious convictions influence how one experiences nature. And, as in the case of spiritual gardens, an experience of nature (even a skillfully crafted one) can put one in a reflective mood that results in spiritual insight.

My Work Is a Prayer

Another artist who focuses on the intersection of spirituality and nature is Sara Novenson, a pastel artist who has spent most of her life in New York City and Santa Fe. Her art represents the influences of both places. She paints Jewish folk art inspired by her religious upbringing in New York, and she paints landscapes of scenes around Abiquiu, Black Mesa, and the Chama River. Increasingly, she has been combining the two subjects, for instance, by painting landscapes with ancient Hebrew prayers inscribed around the edges.[7]

Her interest in the natural beauty of New Mexico dates to a family vacation when she was five. She recalls, "The country opened up wide and the landscape was so open and free of human beings. I loved it. We were in our '59 Chevrolet station wagon, and golf-ball-sized hail came out of the sky. It happens here. They're this big, and we put them in a little glass. Then we drove. We came through Albuquerque, and I remember the Indians. We went to a pow-wow that night. We were sitting right in front of this huge fire. They were dancing, and this Indian came next to me, and he had his feathers on. He was sweating and was all painted and had no shirt on. He was sitting next to me breathing really hard because he had just stopped dancing, and I was sitting there like this, 'Oh, my God!' I'll never forget the light of the fire reflecting on his face and the paint on his face and the feathers, and the way he was breathing. That was one of the main things that left an impression on me, the whole Indian culture. I just loved it from then on. It was so mysterious to me."

Novenson returned to New Mexico on several occasions, including one of her college years, and worked in Santa Fe for five years early in her career before an illness forced her to return to New York. After working several years as a graphic artist she married and moved with her husband (a musician) to Germany. This experience played a large role in shaping her interest in spirituality. Although she had been raised in a Conservative synagogue and had been interested in psychic phenomena and metaphysics as a teenager, she had little personal interest in Judaism until living in Germany forced her to think seriously about the Holocaust. Not only did she gain a stronger appreciation of her own religious heritage, but she also became more interested in alternative forms of spirituality. "I was drawn to Eastern religions like Buddhism and Hinduism, but also to the mystical part of Judaism in the kabala."

The link between Novenson's budding interest in mysticism and her art was Isaac Bashevis Singer, whose work she began reading in Germany and later was exposed to more directly in New York while working with one of his editors. "It's very mystical and it's very visual.

When I'm reading it, I feel like he's painting a canvas. It's full of color."
She uses almost the same phrases to describe her own work, emphasiz-
ing the soft, mystical quality she seeks to convey by using pastels and the
strong colors that have personal significance for her. "My art is full of
color. It's very strong. I use pastels, and pastels are a soft medium, but
the colors I use are vivid and strong. So there's a soft, mystical quality,
but yet I use strong colors. I think that's kind of how I am. I think I'm
strong, but soft. I'm a survivor, yet I'm really sensitive and I feel the
transcendent quality of life and of myself."

In 1991 she returned to New Mexico, where she has been able to de-
velop a closer sense of the connection between spirituality and nature
through her painting. "When I'm working, I feel like I'm really part of
the earth. I feel like I'm giving gratitude to God for letting us be in this
beauty and for him creating it. I also feel I completely lose a sense of
who I am. I feel like there's spirit. See, this is what I think the Indians
probably feel. I've always felt that everything on the earth had a spirit.
Everything is alive. The mountain has its own spirit and strength and
power. The trees, the leaves, everything to me has always seemed alive,
and when I work, that's my acknowledgment of it and it goes through
me as I work."

Although she sets aside time each day to pray and meditate,
Novenson's work is her most serious form of prayer and meditation.
"My work is a prayer. I want to think that everything I do in life is a
prayer. It's being aware of the spirit, whatever it is. I don't know what
God is, but I believe there's something going on. There's something
more than us, and I think it's basically from love. I think by expressing
your gratitude you fill yourself up with that and you fill the people
around you up with that. That's the way I pray." She adds, "When I'm
in nature, I feel most connected to God. I think maybe that connection
is what drove me into painting. I had to do something. I had to express
my gratitude. It had to go through me somehow."

At one time, artists would have been more likely to express their feel-
ings about God by creating objects for the temple or painting pictures of

biblical scenes. That so many artists now say they feel closer to God in nature and choose to paint naturalistic scenes is probably revealing. Among other things, it suggests the level of alienation that many artists feel toward organized religion. And that so many people who are not artists feel closer to God in nature than in religious buildings suggests that this alienation is not limited to artists.

A Way to Praise

A few miles from Sara Novenson's studio another artist devotes himself to exploring the subtle connections between spirituality and the earth. The poet Greg Glazner, who won the 1991 Walt Whitman Award for his collection of poems *From the Iron Chair*, observes: "My work is about themes: living in the face of death, of violence, of bitterness, and finding a way to praise that living without looking away from its real terms."

At his studio, a rustic stone structure nestled near a stream in the foothills north of Santa Fe, he speaks in soft, twangy tones that betray his Texas roots. "When I was a little kid," he recalls, "I had a fourth-grade teacher who taught us Robert Frost poems. She didn't patronize us, she taught us real poems. I think that had an effect. I wrote when I was in high school, but that was pretty much discouraged in Graham, Texas. Then I forgot about it. But in college I took some literature classes and remembered how much I had always loved it." After college he earned a master's degree in creative writing and one in literature, and has been writing ever since.

But the real story of why he became a writer is that he experienced a crisis of faith. He attended a fundamentalist Baptist church throughout his youth, was baptized by immersion once at age six and again at fourteen, and attended a Baptist college, where fellow students sought eagerly to make him a born-again Christian yet another time ("fun-filled years of people witnessing to me constantly to bring me back into the fold"). Their black-and-white thinking left him increasingly skeptical. In

one of his poems he remembers: "Sweltering one summer in the Texas heat, I gnashed my Baptist faith until it snapped like a tether; and walked the flat streets emptied."[9] He elaborates: "I was in a serious crisis. It was terrifying. The whole substructure of existence was completely torn away. All the strategies for saying what meaning was were just completely removed. It seemed to me that in literature and art all the worst stuff is saved somehow, all the darkest material is still useful, is still helpful. It was clear to me that making art was a way of acknowledging all experience without looking away from it. So I guess it was in a way a more mature kind of religion."

He turned to art and literature for answers rather than to science, as many skeptics do, because he had already become conversant with science as an undergraduate chemistry major and knew he wanted something more satisfying. He wanted to preserve the rigor of science in his writing, but he also wanted the freedom to think about large philosophical questions that went beyond science. He cites his consideration of the big bang theory as an example. "As a culture we've invested thousands of lifetimes of the most brilliant people of five centuries to create that story, and most people disregard it, actively disregard it. 'I think something else is true.' Why is that? Fascinating. I don't want to disregard it, but I also think it's very limited in important ways. I think literature and art fill in and approach aspects that can't be touched by that story. In the *Tractatus* Wittgenstein has a little section on the mysterious. It's wonderful because everybody thinks of Wittgenstein as this hard-nosed logical positivist. But he was definitely a mystic, too. Wittgenstein says it's not how things are in the world that is mysterious, but that it exists at all. That's a wonderful point. 'How is it that there's something instead of nothing?' is a fabulous question that can't be touched by the big bang story. He also wrote that what can be said can be said clearly, and what cannot be said may yet be shown. Art shows things through textures and intuitive moves and a sense of color that simply can't be said directly."[10]

Besides Wittgenstein, Glazner admires metaphysical poets such as John Milton, Rainer Maria Rilke, and Galway Kinnell, although he

laments that it has become unfashionable for young contemporary writers to speculate about the large philosophical questions tackled by these poets. Whereas "spontaneity, thinness, and the conversational voice" are in his view popular, he strives for greater density, thickness, and texture in his work. He recites these lines of his to illustrate what he means by density: "A wasp drifts against the high window, its flight a loose scroll work, the wing hum hovering over me in the dark yard, filling the pane as if glass rinsing with praise would melt, or enough singing transfigure an ordinary room, its nightstand and closed book, the small lamp that blinds each segment of the eyes."

Lines like these emerge slowly. "I'll walk down here to the studio about 7:30 in the morning. I'll re-read what I've written recently, maybe scratch through a few things, make some revisions. Then I'll pace around in the studio for a while, usually with a cup of coffee or at least a glass of water, and try not to think about anything. Just walk back and forth. I write all my drafts out longhand, so I'll start to write out a longhand draft. If it goes well, I might get a couple of paragraphs down before it starts going badly. If it goes badly, I'll get one sentence down and it's scratched out. Or a few lines, if I'm writing in lines. Then, without trying to slip into an analytical mode, I keep writing and rewriting, coming up with new lines and a lot of times crossing those out. It's very comforting to me that Yeats said a good day's work is four lines. I love that because that's about the pace I work at. Dylan Thomas used to write one line at a time. He would write the first line and work on it and work on it and work on it until it was correct, and then write one more. That's kind of how I work."

Glazner writes more energetically when inspired by some conflict, and the conflict that inspires him most is that between the human propensity for consumption and the natural world. "I call it brainwashing, which is an overstatement, but it's the successful effort at turning people into consumers almost all the way down to their core—it's that four hours a day of television watching, the billboards we drive past, the stuff we're irradiated with when we turn on the radio. It's really an in-

credibly destructive force, just amazingly destructive. Whereas the natural world, in contrast, never tries to schmaltz you, never has any particular designs on you, but just sits there."

The conflict between consumerism and nature is not ultimately resolvable, in his view, but it does suggest the value of being immersed in nature to the point of realizing that there is more to life than consumption. He suggests fly-fishing as an example. "When you are fly-fishing, you're immersed in the natural world. You come to a point where you're not thinking thoughts anymore. You're moving, you're acting, you're even acting with purpose, but you're not thinking words, you're not even thinking concepts. You're simply experiencing things and acting. There's not a division between your thoughts and your actions. Living in the natural world encourages that unbroken quality I think of as spiritual."

Nature and Spirit

In their own ways, each of the artists described in this chapter is attempting to capture something in nature that goes beyond the mere surface experiences of sight and sound. For David Dunn, nature is alive with potential for instructing the human listener; it is a spiritual experience for him to compose music that incorporates the sounds of insects or the reverberation of the Grand Canyon. Pauline Oliveros regards deep listening as a way to move through deeper and deeper layers of understanding to the point of achieving a kind of harmony between her inner being and the outside world. With his camera, Derek Fell tries to capture the fleeting moment, the epiphany, that is spiritually uplifting. Dawn Nakanishi thinks there is a universal "life force" in all of nature; spirituality is "the point where you cross your personal boundaries" and become aware of that life force. Sara Novenson is almost animistic in her belief that all of nature—including rocks, trees, plants, and animals— contains a spirit that somehow manifests a unifying spiritual realm. Although Greg Glazner believes the idea of spirituality is often overused, he emphasizes a state of being that exists more clearly in nature

than anywhere else and that posits unanswerable questions about the very being of the universe.

The unity of nature and spirit is an idea that David Dunn, Sara Novenson, and Greg Glazner, in particular, have come to appreciate as a result of living in close proximity with American Indians. David Dunn says he is "particularly interested in Native American ideas about nature and spirit and the relationship of humanity as part of an integrated view of nature," even though he is reluctant to disturb the veil of secrecy that he feels American Indians have rightly put up to protect their religious practices. Sara Novenson says people are sometimes surprised that she is Jewish because her landscapes resemble those of some Native American artists. "I feel very similar to the way the Indians probably feel about the landscape, but it's in Judaism too, because the people lived on the land. The holidays are all based on the lunar calendar, the harvest, and the seasons, and there's gratefulness to God for the earth and the food and the beauty. That's the root of everything. It's kind of a gratitudinal love that I feel." Still, she feels her appreciation of nature has been enriched by living near Indians: "What I love about them most is their respect for the earth. They have an awe for nature, and they feel that they're part of it, and they feel like what they take they have to give back." Along similar lines, Greg Glazner remarks, "I'm really impressed by Native traditions, the traditions of the Earth Mother, the traditions of storytelling, and the traditions of chant," but he also respects the integrity of these traditions.

Pauline Oliveros has been more influenced by Tibetan Buddhism than any other religious tradition, although she gained some familiarity with American Indian practices during a fellowship year in New Mexico. Buddhism attracts her because she has difficulty with the idea of God as a distinct being; for her, the Buddhist idea of an all-pervasive spirit is more appealing. Greg Glazner attributes much of his thinking to Buddhist influences as well. "I've found that what they say is just correct, that the separation between one's self and the external world begins to fall away, and that kind of immersion in the universe is what I would call

spiritual." Although Derek Fell admits that his familiarity with Buddhism is minimal, he is attracted to its veneration of beauty in nature. He also views some American Indian traditions and Christian traditions, such as Quakerism, favorably because of their emphasis on simplicity.

It is not only American Indian or Buddhist practices that turn artists' attention to spiritual aspects of nature. A Christian painter says, "The power of the ocean is really the power of God, and you see yourself in relationship to that power. It makes the spiritual life much easier to understand when you go from the natural elements. This is why they were created, this is word made flesh. The earth." A musician holds a similar view: "God doesn't typically speak directly to us. The spirit world speaks to us through the material world." The poet Sharon Thomson reflects, "God is imminent in all of life, and nature is one of the major points at which we can touch the divine, if we're willing to go and just be there and be present to what's there."

These artists follow a long tradition of writers, painters, and musicians for whom the natural world has been a church. David Dunn says he is a direct descendant of Martin Luther, so he has some appreciation of Protestantism, despite not attending church as a youngster. Nevertheless, he deepens his spirituality mainly by being in nature and incorporating nature into his work. Derek Fell describes himself as a Unitarian, but attends a local church of another denomination a few times a year. He laughs, "We have a lot of religion in the garden, and we'd rather be in the garden than at church, quite frankly, so we don't go to church much." Although Pauline Oliveros feels she is part of a religious community because of her contact with others through her listening retreats and other workshops, she is most enriched spiritually by being in nature, where she can listen deeply. Dawn Nakanishi no longer attends church, choosing instead to pray when she is walking her dog or working in her studio. She has found community with a group of Asian American artists who support each other spiritually and emotionally, but she is more often strengthened and inspired by swimming and spending time outdoors. Sara Novenson acknowledges the centrality of congre-

gational life and community in Judaism, but she believes the spiritual realm pervades all of life and is too often restricted by organized religion. Greg Glazner's religious reference point is still the fundamentalism of his youth; he contrasts its having answers with his own view that it is legitimate to have questions: "It's not unspiritual to question things. If one isn't careful, knowing is a barrier between one's self and the rest of the universe. Knowing's a way of constructing a separation, and that's fine, that's useful. But I don't think it's very rich to be there all the time." Instead of knowing, he emphasizes being: "It's somehow mysteriously provided. We can't say how there's something here; the ground of everything is this big mystery. How could it be that we exist? Not only do we not have an answer, we can't even think of a framework that would provide an answer for that. So instead of trying to know the unknowable answer to it, you recognize the mystery of it and are aware of being."

The appeal of nature for these artists, compared to that of organized religion, is that nature is different from ordinary human experience and thus unsullied (at least in principle) by human frailties or misbehavior. David Dunn believes he inherited this understanding of nature from his mother, who, besides being an artist, was an avid gardener and turned her arid southern California yard into a lush subtropical hideaway. "That was her retreat, it was a place of going away, of hiding from the world to some extent. But it was also a place of integration. So nature, for me, is that kind of phenomenon. It isn't just stuff, it is something that activates very deep levels of reality." In comparison, his experience of organized religion was through "family reunions, where it would just turn into these harangues about religious this and that—theological arguments, silly ones, not serious ones."

Pauline Oliveros is uncomfortable with organized religion because of its emphasis on "codification." She has experienced minor conflicts with religious leaders often enough to persuade her that they are more interested in rules than in spirituality; she feels more at home in nature. For Derek Fell, even occasional glimpses of nature's beauty are uplifting,

and they strengthen him to withstand life's more difficult challenges. His first wife joined the Rajneesh religious community in Oregon, leaving him to care for their children. As he recalls the pain of this experience, he reflects, "It was devastating. I was very close to her. We'd had a lot of good times together. But I can take a lot of licks. Some of us have that ability. No matter how hard life is, we just have an ability to see the beauty of the sky and the beauty of the leaves turning green in the spring, and that's enough to get by."

Sara Novenson says it was difficult as a child to believe what she learned at synagogue because God always seemed to be an angry old man, whereas her experiences in nature gave her a clearer sense of divine love. She did not feel accepted by the people at her synagogue either. "I used to feel that people were looking at what I was wearing, and it was very materialistic and hypocritical. I would go wanting to feel God and the spirit, and that stuff was just screwing it all up. And our rabbi! I remember one day he was going around in class asking each of us what our fathers did for a living. I was outraged. I just wanted to get away from there. The other people, their fathers were lawyers and doctors. My father had a business, so I felt intimidated. A lot of them lived in mansions. They were looked at as being better than me, because of how much they had. I said, 'This isn't religion. Get me out of here!'"

Of course she turns to loved ones in times of need, and she participates at least once a month at her synagogue because she values the Jewish tradition. Yet her awareness of the uncertainty of life, and its frailty, inspires her to have faith in the ultimate, spiritual source of strength, which she happens to see most clearly when she considers the beauty of nature. She emphasizes, "I live in the uncertainty of life. My life is uncertainty. I feel that everybody's life is uncertain. The nature of life is uncertain. As artists we live in that reality more than a lot of other people, because we live on the edge career-wise. I mean, some people have the illusion that they're going to be fine. Their career is fine and then all of a sudden they get fired or technology changes or they have an illness. I feel that everybody's life is fleeting and uncertain, but I'm very aware of

it every single day." She adds, "It may sound weird, but sometimes I just have to say, 'Oh, thank you God for doing these things to me.'"

Saying thank-you is a healing process that Sara Novenson engages by focusing on a particularly meaningful landscape. As she paints, its meaning becomes clearer to her, effecting an emotional release. Her painting of the Rio Grande Gorge, *Dawn's Witness*, is an example. "The Rio Grande Gorge is a gash in the earth, a deep gash, and I went there after my mother died. I got up before the sunrise and went there. The gash in the earth was all my sorrow and grief. I felt as though I was cut. A knife cut through my heart. Yet the gorge is very beautiful. It has the deep part, and then it has the part where the earth is flat. These giant plains and then it has the mountains. So it's like all different levels of the psyche, and the time of day was dawn, which is a very contemplative time, a restful and reflective time. There was this one tree standing there, and I did this tree facing the gorge and the sunrise, the very soft light of dawn over the gorge, and the tree was me witnessing life and my pain. It was like I was witnessing everything that was happening, and it brought me a lot of comfort. The gorge is also like the heart, the deep red heart that's inside of us, and then it rises into different dimensions of life physically and psychically. Then the mountains are in the background, and they're the high point. The sky—of course, my work is full of these huge skies—and the sky is the ethereal, the possibilities, the creating shapes, the openness, and the light."

Greg Glazner contrasts nature to not only organized religion but also the alienation of structured social life in general. "The experience of nature is the opposite of the experience of turning on the television set. The experience of nature has no designs on you, it simply sits there and is what it is. The sense of being on a trout stream, throwing a Royal Wolf upstream and watching it work the riffles when there's nothing there. You can see all the way to the bottom and there are obviously no fish in that stretch of water, but a trout materializes somehow, and you see the gold mouth of the brown trout where the fly had been, the fly disappears and your rod's tight. That experience of spontaneity in the

natural world—that it just shows up, that it's there—is really important to me. There's a sense of flow. Being in town is all about having a firm sense of ego, of separateness, of strength and idiosyncrasies that make us not like anything else around us so that we can survive, whereas being in the natural world seems to be the opposite of that."

He nevertheless resists romanticizing nature. "I see the natural world as a set of balances and counterbalances. I always try to color nature red. What is Browning's line, 'Nature red with tooth and claw'? I try to keep that in mind, too. It's not all Steller's jays sitting on the branch and sunlight pouring down. It's also bobcats falling on the backs of deer—how bobcats hunt deer—as they wait in a tree, if they're really hungry, for a deer to graze its way under the tree, then they drop down and claw the jugular veins of the deer, which runs and bleeds itself to death. There is a nasty, violent aspect to the natural world, too, and I try to keep that in mind as a counterbalance to the lyrical qualities of it."

Nature's Voice

Each of these artists has experienced times when nature spoke almost audibly about some other, perhaps spiritual plane of existence. David Dunn remembers his excursion into the Grand Canyon with three trumpet players. "The initial intention was to use the space as a beautiful acoustic resonance. We were down there for days, setting up and getting ready for the recording. As soon as the trumpets starting playing, three ravens appeared and came right in front of where the trumpet players were. They were matching the trumpet sounds and just having a great time. It went on for about twenty minutes. The trumpets stopped, and they flew off—never saw them again. It was totally unexpected. But the recording is just spectacular because of the interaction between the trumpet players and the ravens. It changed my view of the meaning of this stuff. That's when I began to question, 'Well, maybe there's something else going on here.'"

On another occasion he recorded some people's remarks while they

were in a wilderness area, then took them to another spot a week later and broadcast their remarks while recording the sounds of insects and birds in the area. "All sorts of things happened, the most interesting being these interpenetrations where you'd hear this voice that was recorded a week before talking, describing things in their environment and being played back into a different environment. As they'd be describing it, the event would start happening again in reality. They'd be saying, 'Oh, look at that crow; it just landed on that branch,' and in the middle of the space, while this voice that's prerecorded is saying this, this crow comes flying into the space and lands on the branch. That happened several times, and I have no explanation for it. I don't even know if I want to have an explanation for it!"

Pauline Oliveros is less inclined than David Dunn to emphasize unexplained or mysterious events, but her experience of recording reverberations inside the Fort Warden cistern came close to being an epiphany. More generally, she insists that spirituality comes to those who are aware and who consciously make themselves receptive. It requires patience and self-discipline, as well as sincere effort to understand others. Deep listening helps her "to accept differences and to understand that your way may not be someone else's way."

Derek Fell has experienced something spiritual in nature on many occasions, but his most vivid memories are still of Findhorn as a teenager. "You looked across a beautiful, glittering blue bay and on the other side was this huge mountain of sand dunes. You would take a boat over there, and the minute you stepped ashore, you would be surrounded by these incredible sights and sounds of nature. Thousands and thousands of terns nesting in the sand dunes. Oystercatchers, seagulls. Eggs everywhere. You'd walk behind the sand dunes and there'd be a swamp with these incredible grasses in bloom. The blooms were like heads of cotton, as far as you could see. You'd shift the sand and find a little flint arrowhead from prehistoric times, perfect in every detail. One of my pastimes was opening mussels and finding these beautiful pea-sized pearls. It was a place crammed with visual sensations." All this, he

says, made it spiritual. "It was all of those godly things concentrated in a small area."

Dawn Nakanishi has spiritual insights at unexpected moments while working on her installations—for instance, collecting ginkgo or bay leaves and being overcome by their beauty and smell. "The memories that the leaves evoke from the smell of them are just magical. It's almost like an epiphany." Sara Novenson, who has experienced clairvoyance and other inexplicable psychic phenomena all her life, mentions special times when she has felt "very connected to nature." She explains, "I read in books that they call it a peak experience, when all your senses are heightened and you feel all this love and oneness. That's how I would feel."

Greg Glazner uses similar language to describe the "aha" experiences when he feels particularly in touch with the sacred. These experiences occur most often when he "catches some sort of glimpse in the natural world" and realizes that "I am contributing nothing and the world is contributing everything." He returns to fly-fishing as an example of how being in nature has given him special moments of closeness to the sacred. "When you first show up, your head is full of thoughts and full of worries about how to catch them. Then there comes a point at which you're just fishing, you're just acting in the same way the fish are. Something happens and you respond. If you have thoughts, well, they're thoughts, but they're at the same level as the rest of the world, they pass by, they go on through, they're useful or not." Fly-fishing is a metaphor for other times when he sets aside "empty space" in his life. "The spiritual is already in things," he explains. "The world is already made of those things, and what's required of a person is less, not more. Leaving space for the universe to say things is all that's required."

The sense that something intensely spiritual may exist in nature gives these artists an incentive to use their talents to protect and preserve nature, albeit in their own ways. David Dunn believes the possibility of communicating with other life forms suggests a way of overcoming the separation between humans and nature that, in his view, discourages humans from taking greater responsibility for nature. Human language, he

thinks, is uniquely suited for communication with other humans; thus, the way to bridge the gap with nature is to break language into its component sounds. "We need to learn how to talk to the world, not to each other, and our language is constructed to allow us to speak to other humans, not to birds, not to insects. We may use language to appreciate or become closer to these things, but when we're really close to the world, to living things other than humans, it's not language which brings us closer, it's other means of communication. It's things in our body, other sound-making, other kinds of things which are outside the constraints of what we define as human language." This is why he records sounds in nature and experiments with ways of mixing them with human sounds.

"I'm trying to create experimental situations in which we find new modalities for communication directly with the nonhuman world," he says, comparing his work to that of dolphin researchers. "The successful attempts have not been trying to teach dolphins how to speak English, and it hasn't been successful for us to learn dolphin. What has to occur is something that arises through the interaction between the two species, and that's not in the form of language. It's in the form of something else that's an emergent property of what we are as two entirely different forms of life. I see music as providing models for that."

Pauline Oliveros regards deep listening as a way of making people more aware of their relationship with the natural world. Besides her retreats and workshops, she takes on projects concerned with specific forms of environmental preservation. For example, she did a project called "River Soundings" that brought people to seven sites along the Delaware River in Pennsylvania to listen to the river for several hours and then to "process the experience."

Derek Fell remembers a trip to the Antarctic. "One of the most spiritual things I saw was these huge swells with an albatross, a lonely albatross following the ship, with a wingspan of ten feet. I stood at the rail of the ship almost transfixed. The ship was bobbing up and down, and the waves were three times higher than the ship, but I wasn't the least bit afraid. It was beautiful to see it, even though it was just water and a bird.

I said to myself, 'Oh, don't let anything ever spoil this. Don't ever make the albatross extinct. For God's sake, let's preserve these nature spirits.'" His photography, while preserving an image of nature, is his way of encouraging others to spend more time in nature and thus to take more responsibility for protecting it. "The more you get in touch with nature, the less materialistic things become."

Dawn Nakanishi regards her installation work as a way to preserve nature. "It's bringing attention to the importance of nature." Some of her installations are outdoors, where people can easily associate them with problems raised by an excavation or a construction site, while others try to forge a more intimate bond between nature and an individual's inner spirit. She tries to make people think of nature as something to be preserved not only because of its historical or aesthetic value, but also because it is meaningful as a way to heal or enrich themselves. An installation "can wake up people to the importance of having nature in their lives, especially the healing and meditative aspects of it."

Sara Novenson devotes about three months each year to putting on workshops in drawing and painting at Jewish community centers and synagogues. She tries to communicate her enthusiasm about the way art can preserve nature as well as the Jewish traditions. In addition to contributing her work to UNICEF for use on greeting cards, she tries to bring her landscapes into a clearer relationship with biblical texts that have been inspirational throughout the centuries and in this way draw connections between God and the created order that may otherwise escape people's attention. In her *Sabbath Prayer* series, for example, she includes a landscape painting inscribed with the words, "Let the rivers clap hands. Let the mountains sing for joy." In a small way, she hopes her work is part of a growing awareness regarding nature. "Ecologically, something has got to change, because we are connected to the earth, and we won't survive unless the earth does."

Greg Glazner cautions, "Art is so undervalued that we have to be realistic about the effect it can have." Yet "having said that," he adds, "art

creates an awareness that makes it pretty hard to go out in the natural world, appreciate it, and then buy stock in a mining company that destroys the whole tops of mountain ranges. If it's true that art makes you more sensitive to the way you are and the way things are, it can't help but help. But I'm not going to go into a fantasy about how many people are going to be willing to do that. To pay serious attention to art means you have to change the way your consciousness is from watching four hours of TV a day. It calls into question the way that we live every day if you pay close attention to art, and I don't think very many people are going to be terribly invested in that because it makes life unmanageable in important ways."

Despite their differing approaches to the preservation of nature, these artists are united in their view that preservation is key. In a sense, they see humans' need to care for nature in the same way they seek to be in tune with their spirituality. David Dunn says it most clearly: "It's impossible to return to some Edenic state of bliss. There's no going home. We're in the position of being nature's caretaker whether we like it or not."

There is clearly a temptation in contemporary culture to romanticize nature. When humans continue to slaughter each other in ethnic wars and in high school shoot-outs, it is easy to think of nature as a refuge, perhaps even as the only place in which God is still present. Artists more often depict nature as a place of beauty and tranquillity than as a struggle for existence. The fact that natural disasters are the source of much human misery is seldom mentioned.

Artists' pitting of nature against organized religion is in need of criticism as well. If religion has too often encouraged the despoliation of nature, it has nevertheless insisted that the creator is always greater than the creation and that divine and human love need to transcend both the difficulties and the joys that nature may provide.

There is nevertheless room for the religious imagination to be sparked by contemporary artists' incorporation of nature into their

work. The sheer beauty of nature calls for artistic rendering. Paying special attention to such esoteric aspects of nature as the night sounds of insects on a lake can be a way of celebrating the sacred. And it is no accident that those who recognize the spiritual dimension of nature are also encouraged to take steps toward the preservation of nature.

MILLENNIAL VISIONS

IF SPIRITUALITY MATTERS, it orients people more conscientiously to the times in which they live, and not just to what is happening inside themselves or at the edges of the universe. The start of a new millennium is a propitious moment to reflect on the serious challenges the world confronts. But what insights do artists, writers, and musicians have to offer? And how are these insights reflected in their work?

For most artists, the passing of one millennium and the start of another provides opportunities to evaluate the past and consider ways of bettering the future: it interests them to think about current social issues, the contributions of spirituality and art, and whether religious organizations will play an increased or diminished role in the future. They emphasize the limitations of conventional thought patterns and the need for greater imagination. Spirituality is nearly always a dimension of such reflections. Yet artists take different approaches to effecting social change through their work.

Freedom from the Herd

Richard Foreman, a playwright in his early sixties, is the founder, owner, and director of the Ontological-Hysteric Theater in New York City's

East Village.[1] His way of addressing social issues is perhaps best sum-
marized in his description of the central "spiritual task" of the theater as
"trying to free each person from belonging to the herd." To accomplish
this, he employs experimental devices in many of his plays, challenging
his audience to see actors in new ways by positioning them awkwardly
on stage or mixing spoken and taped dialogue. Some scripts are com-
posed almost randomly from fragments that bear little internal coher-
ence, and some are improvised to convey greater spontaneity. He intro-
duces barriers between the audience and the stage, uses strings and
movable lights to alter perceptions, and shifts dialogue from character to
character to keep the audience from identifying too much with one pro-
tagonist. Many of his early plays were so unusual that most of the audi-
ence walked out.

Although his interest in experimental theater dates to the under-
ground film movement in the mid-1960s, his questioning of conven-
tional assumptions was evident much earlier. The adopted son of upper-
middle-class Jewish parents, he grew up in Scarsdale, where he attended
public school. As a teenager he wanted to be an artist and was attracted
to surrealism. At the time, he remembers, he questioned many of his
parents' assumptions and the religious teachings he learned at Hebrew
school. In retrospect he thinks he was interested in philosophical ques-
tions that his parents and teachers weren't willing to address. "I remem-
ber saying something to my father, asking a philosophical question, like
'Why are human beings here?' and my father would get very irritated
and say, 'Don't waste your time on questions like that. You're here,
you've got to live your life. Questions like that will just get you confused
and cause trouble.'"

At school he felt the teachers were skirting the important issues. "I
was not being told the truth about anything. I had the feeling that some-
thing was being hidden. I was being taught the surface of things. I did
not think of it originally in spiritual terms, but in high school I con-
cluded that the best way to teach would be to pass a law that teachers had
to teach from a text with which they violently disagreed, and at least that

would introduce the students to realizing there were life and death issues in every subject."

Art interested him because it violated surface appearances. "I was always interested in art that seemed strange to me. I think its strangeness suggested that there was another world hidden behind the world that we were living in. I remember being interested in the surrealists, and my high school art teacher said, 'Well, you've got to be careful, Richard, because even though that painting may seem interesting, those surrealists were very disturbed people and you don't want to get involved with something like that because it's dangerous.' I remember reading John Dos Passos's *USA* when I was in ninth grade and one of my teachers said, 'Oh, a young man like you shouldn't be reading things like that. That's too depressing.' But that hunger that I could only look to art to fulfill was, I'm sure, the beginning of whatever spiritual stirrings were there."

In college, at Brown University and during three years of graduate study at Yale Drama School, most of his classes seemed "bloodless," so he pursued his philosophical interests on the side, reading Henry Miller and the works of Jewish, Christian, and Eastern mystics. The underground film movement fed these interests when he moved to New York. "I got friendly with a lot of people making the films. This was the mid-'60s in New York, so of course with the drug culture there was a lot interest in Eastern religion and I knew people who were very involved with different esoteric religious practices. I think that fed me. Indeed, at that point I even rediscovered my Jewish heritage through the mystical aspects of Judaism. It all became integrated into my art."

Foreman's reading left him conflicted about the relative merits of mysticism or a more existentialist view of life. "My whole life I've been concerned with: What really is a human being? How is a human being constituted, and what is a human being supposed to be doing in order to justify being alive? I would flip-flop a lot. Eastern mysticism essentially says that if you lead this kind of life, if you have a guru, problems will fall away and you will be happy and you will join the light. Now that seemed

very seductive. But then, on the other hand, it seemed perhaps that was a kind of infantilism. Kierkegaard and a lot of other people would say, 'Well, there's always going to be a fight, there's an internal struggle between these dreams of transcendence and the very real fact that you are placed in life as a human being in a very different way, and a human being's destiny is to live out that penchant.'"

Although the Kierkegaardian view is more evident in Foreman's plays, the mystical view is an important reason for his interest in challenging prevailing cultural assumptions: he has been tantalized by the alternative realities that mystical experiences reveal. One such experience occurred early in his career. "I flopped down face forward on the bed and my head exploded. It was as if my head became a giant glass globe and all of my thoughts and everything outside in the world, everything, was projected equally on this globe. Accompanying that was one of those feelings of total glory and happiness. How could there be any problems? I mean, I could see all my problems, I could see the inside of me and the outside and all my problems there on this surface, and it was all perfect and I didn't have to worry about it. This lasted between five and ten minutes, this intense feeling. Then it started to fade. I concluded it was one of those experiences that so many people have and for better or for worse one calls it a moment of cosmic consciousness."

Experiences like this (he's had several) leave him concerned about the blinders that ordinary speech and action impose on our ability to see ourselves. "I've always had the feeling that something is wrong, something is being left out. I've always had the feeling that the discourse that I engage in with other people somehow is irrelevant and is leaving out the important subject. Does that mean I'd like to be in the seventeenth century and be a Jesuit or a Hasidic Jew? I doubt it. I think I probably would have felt suffocated in those environments. But I've always had that feeling, a feeling of being terribly parched, of being thirsty for something else."

He thinks the truth is generally hidden because it would be "terribly disruptive" if it were revealed: people would ask too many questions for

the ordinary work of the world to proceed smoothly. Artists, he believes, have a "moral obligation" to stand outside the culture, insofar as this is possible, where they can raise questions about the underlying assumptions that prevent things from being different. His own plays aim to effect social change less by focusing attention on particular problems than by creating times when people can escape normal ways of thinking and thus become more aware of possibilities for change. He regards culture essentially as a constraint that condenses a "wide field of impulses into a few nameable categories" and "suppresses our awareness of the infinity of tones and feeling gradations that are part of the original impulse." His plays attempt to show "that you can break open the interpretations of life that simplify and suppress the infinite range of inner human energies; that life can be lived according to a different rhythm, seen through changed eyes."[2]

Foreman places little stock in the idea that the new millennium will bring about major improvements in social conditions, let alone in the assumptions guiding ordinary life. He has read enough history to know there will always be problems. Yet part of him is convinced that the new ideas that began in the 1960s have already opened possibilities that may not have been there before. "The '60s for me were the one time when the spirit was abroad in the land. There was an energy there, a hunger that I thought was terribly healthy. Walls were knocked down in the American psyche, just like the Berlin Wall was torn down a couple of decades later."

He has dabbled with so-called New Age ideas that grew out of the 1960s, attending talks by people who believe in channeling or engaging in guided meditation, but he is cautious about taking these pursuits too seriously. Alternative spiritual practices are most helpful, he contends, when used lightly, like spice, rather than becoming so overpowering that one forgets the core flavor of one's spirituality. The key is to remain open to new possibilities. He mentions reading about how people in later life either become "dry and pedantic" or rediscover "some river flowing deeply inside of them that puts them in connection with the

spiritual life." He resolves, "I don't want to be an old man who is just dried up and not creative anymore and not open to possibilities."

That resolution keeps him interested in bringing spirituality to bear on his work even when there seems to be little evidence of the world getting better. "About ten years ago, I started saying to people, 'I'm a closet religious writer.' Up to that point, I'd always been afraid to say that because I wanted people to come see my plays and I thought that might turn people off. But what I do to deepen my spirituality as I define it is just try to refine my art and the surrounding activity of my life that feeds that art. I spend most of my time reading and then occasionally I do a play. People think I'm very productive. I think I'm very lazy. I manage to turn out a lot of stuff, but I turn it out with a tremendous amount of preparatory work. I've often thought that my ideal would be the Zen master who does his form of meditation—in my case it might be reading or something else—and then when it comes time to make a masterpiece, it's like zip, zip, zip. When I do it, it isn't zip, zip, zip. I agonize over everything."

His play *Permanent Brain Damage* attempts to communicate this need to keep going despite the difficulties one may face. "It is essentially about a man who has grown weary of life, doesn't find anything in life interesting, and yet he knows that he's still interested. But the thing that he can apply that interest to hasn't appeared. At the beginning, my plays were extremely disassociated and impressionistic; they still are, but there's been a conscious effort to make them a bit more parable-like and to make them reflect the autumn of one's life when one realizes that it's never going to be any better and that you have to come to terms with the fact that human beings never achieve what they hope they're going to achieve. This mechanism of the universe, whatever it is, is using us for its own purposes. So a definition of spirituality would be knowing that the universe is using us and therefore trying to shape yourself into a tool that will be most useful to that universe in ways you don't know how."

Dramatic productions like these can be a powerful way of encouraging people to think about large questions in new ways. As Foreman ob-

serves, "Many people find it difficult to believe that my plays are spiri-
tual or religious. There's something scary about them. They seem very
aggressive and there are a lot of hostile people in them. The attitude of
the actors doesn't seem to be very giving to the audience. Everybody
seems very reserved. But I've always believed my plays are about
Paradise and about the worshipping of Paradise, yet not creating a beau-
tiful scene in the country with lambs and beautiful, loving people hug-
ging each other. The task is to take everything in life that is the most
difficult, that is the most problematic, and find a way to redeem it. I'm
constantly trying to adjust all the elements so finally the aestheticism of
the piece says, 'Ah, life is terrible, but you can learn to be lucid and
dance and be joyful using the very degraded material of your life.' To
me, that is the spiritual task. Not to say, 'Oh, I'm going to rebuild the
city,' but to change your own being—to change it even to where you
could be like Mother Teresa was in horrible Calcutta."

"We're All Brothers and Sisters"

Richard Foreman challenges his audiences to question the cultural as-
sumptions that may prevent them from creating a better world. Another
artist, Dorothy Rudolph, reveals how a similar transformation may be
pursued at a more personal level. She is a studio artist in her early fifties
who specializes in colored pencil drawings, often bringing together im-
ages from nature with pictures she remembers from her dreams.[3] Her
exhibitions have mostly been at galleries near her home in Pennsyl-
vania's Lehigh Valley. One of her exhibitions, "Languages of Soul—Art
of a Spiritual Journey," chronicled nearly a quarter century of her search
for self-knowledge through the creation and contemplation of images.

In the mid-1990s the pastoral council at a nearby Catholic church
commissioned Rudolph to create a series of nine banners for a diocesan
initiative called Catholic Life 2000. Its purpose was to encourage parish-
ioners to prepare spiritually for the challenges of the new millennium.
While working on these banners, she came to a greater appreciation of

the passage of one millennium into another: "I think numbers are very powerful. It's like anniversaries, birthdays—they're significant. We celebrate them and they mean a lot. We prepare for them. Our preparing for them gives them energy and carries them further." She thinks it was wise for the church to encourage its members to think about the spiritual meanings of the year 2000.

But Rudolph's reflections on the future differ from what the church's leaders had in mind. She believes the culture is shifting away from religious practices that came to be institutionalized in the church. "Thank God, we're getting to the other side, away from the hierarchical, the dominant, the striving. We're embracing parts of the human being that had been overlooked." She hopes the future will emphasize more positive views of nature, the body, sexuality, and spirituality.

These hopes reflect a lifelong struggle to gain a clearer understanding of her identity as a woman, an artist, and a Christian. Although "church" and "art" are the principal values she learned in childhood, they have always been difficult to reconcile. Her father was a mechanical design engineer but would have preferred a career in landscape design or photography; her mother, a homemaker who consumed art books and directed three church choirs. Both parents were active members of a local Methodist church, where they attended services twice on Sundays and several evenings each week. But both were sufficiently interested in the arts to take their spiritual cues from paintings, music, literature, and philosophy as much as from church.

Dorothy Rudolph traces her search for identity to an early realization that she was responsible for developing her own spiritual path. She kept a journal chronicling her doubts and insights and in high school was drawn to others "seeking their own path." An incident in the church's youth group when she was sixteen became a turning point. "The youth fellowship in our church was having a kind of a rap session with the pastor. I was never a question-asker. I was pretty withdrawn and inside myself. But I had this burning question, and I asked him to tell me something about the Holy Spirit—what the Holy Spirit is, what this is all

about, how it happens. The pastor said, 'I don't know. I don't have an answer for you. I do not know if there is an answer.' In my adolescent way I guess I needed a ticket out the door, and in my mind I just said, 'Well, then I'm out of here.' That was the beginning of my spiritual journey."

She started attending a different church with one of her friends, participated sporadically in a Methodist church at college, and married a Catholic. She was drawn to the Catholic church's liturgy and sense of mystery but missed feeling she was part of a community. To please her husband, she continued attending but participated in small groups at other churches to find fellowship and searched elsewhere for people who shared her interests in art. "I tried every way I could to be a part of the [church] community, but always felt somehow I was not being true to myself. Gradually, I started to just sit in the pew next to my husband and be there. I watched him be dull and bored and frustrated and irritated, and I decided, well, I don't need to be loyal to him in my being here."

As her loyalty to the church diminished, Rudolph pursued her spiritual interests by taking art classes, painting, and studying Jungian therapy. She became interested in feminist thinking, grew alienated from the paternalism and hierarchy of the church, and explored the possibility that she had been sexually abused as a child. "Those issues are all mixed together: my spirituality and my relationship to church, my upbringing, masculine authority, and finally reaching a point where I can own myself as a woman. My spirituality is much more involved with women now." She worships at an Episcopal church, but says, "I'm not getting on any bandwagons, I'm not grabbing for any labels. I have a hard time saying I'm an Episcopalian. My spirituality is stronger in my art, in silence, in journaling, and with women."

Painting has enabled Rudolph to express aspects of herself that were too deeply buried to be retrieved in other ways. "When I was twenty-eight years old and had three children, I remember just getting up from the table, not washing the dishes, and going out to my studio. My son cried out, 'Mommy, Mommy,' and I shouted, 'You've got another par-

ent, ask him.' I just knelt on the floor and started to scribble. Then I did it again. I did these six paintings. I had incredible headaches; it was all very moving. I did the paintings that were such a breakthrough and that contained my first memories of sexual abuse."

Wondering about the meaning of these paintings drew her to the library, where she read books by Thomas Merton, Teilhard de Chardin, and Carl Jung. She remembers reading about two ways of creating art. One was to represent something in the outside world. The other was encountering something "within, rising, and making itself known." She realized, "My God, that's it! Something's coming. Something's got form and direction. There's purpose here." She arranged the six paintings where she could ponder their meaning. At first they seemed to move from darkness to light, but then the dominant pattern shifted. "I went down into myself and asked, 'Okay, how did they come out?' When I looked at them again, I thought, 'Oh my God,' they went from light to dark. They went from this big sun, which consumed the whole painting, to nighttime on a mountain with this mysterious glowing light. I thought, 'Yeah, I've spent twenty years trying to reconcile myself with paternalism and hierarchy, and what I've come to is woman, earth, nature, mother.'"

This discovery nurtured her self-worth. "The spiritual part had to do with believing in myself and believing in who I am. Not the 'who I am' that I thought I was, but the 'who I am' that someplace deeper inside of me was telling me, 'This is your reality.' As painful as it was, it was my story. It was mine to embrace. It was mine to reconcile and integrate. That's been my journey. I have done very few things artistically that were not just spilled out of my soul, and I'm not comfortable when I do something just to earn a couple of dollars. It's not as important to me to meet the standards of society as it is to follow this path."

Although her journey has focused on discovering and healing herself, it has enabled her to be more available to others. Rudolph has spent several years working with a mental health agency that places children in foster homes; she also participates in a women's group that addresses gender issues and environmental concerns. The women's group has be-

come a vehicle for uniting her artistic gifts with her interests in helping others. "I contribute an art experience each year as a time of reflection. We gather in a circle, have a candle and symbols on the table, music and Scripture, and sometimes dance. It incorporates a whole body experience, not just a mind experience. Because I'm an artist and the people have a lot of enthusiasm for my work, I've used themes that are in my work, like a woman theme or a mountain as a metaphor. I did one called *Living the Symbolic Life*, where there were artworks all around and people were free to explore the artwork and contemplate it and meditate and see what resonated and then write or use a choice of art materials to express themselves. It was well received."

Contributing to the group has in turn furthered her healing. "It just feels right. It quiets me. There's something in me that lets go of striving. I may have other agendas that I bring, but I leave them, or they're transformed in the process of sharing them so that they become something lifted up by everybody or embraced and nurtured in everybody rather than me having something to tell or show or give. We all have something to give, but it's more of that entering into the soil somehow than being the sunflower that stands tall. It's a kind of groundedness, a kind of rootedness in community that embraces both the equanimity and the uniqueness of each individual."

Rudolph is convinced that the future will be better if people confront the pain in themselves, rather than denying their troubles. "Sometimes it just seems as if my whole life purpose is to survive. But it really joins me with the human race. Everybody has a history and everybody has screwed-up motives. I started out thinking that my family was perfect and everything was fine. I was naive. But the great thing is that I'm beginning to connect with other people as I never had before. I'm acknowledging that everything gets passed on. The good gets passed on and the crap gets passed on. That's why we're all brothers and sisters. That's the discovery of my life right now, is that we're all brothers and sisters."

The criticism that Americans focus too much on their own pain and

not enough on helping others may be reinforced by a story like this. Yet there is wisdom in the discovery that people are unlikely to help others until they gain a stronger and more efficacious understanding of themselves. Too often, the solution to personal-identity problems offered by people who are busy in service occupations is simply to say "snap out of it" or "get some medication." As this story suggests, however, a better approach may be to focus on some activity that helps to express emotions and build self-esteem *and* to stay involved in some community, religious or otherwise, that keeps one attentive to needs outside oneself.

An Open Channel

Dorothy Rudolph's emphasis on personal discovery is shared by many artists, most of whom reach out only in personal ways to make a difference in their communities. But in some cases this emphasis is linked with organized efforts to promote new outlooks as part of the new millennium. JoAnn Jones's story provides an example. Trained in theater, music, and the creative arts, with a graduate degree in human development and learning, she operates the Morning Star Center for Human Development and Spiritual Awakening near Hellertown, Pennsylvania. Founded in 1993, it "encourages people to express who they are creatively and come together and create a whole new world." It hosts an annual fair that draws several hundred people to view exhibits and participate in arts and crafts; helps sponsor an annual Earth Day, which has attracted as many as 40,000 participants; and puts on workshops and seminars on such topics as yoga, pottery, weaving, and healing touch.

JoAnn Jones is an African American woman who grew up in North Carolina. Her father was an itinerant preacher whose ministry was mostly among poor farmers in the South. She shares his interests in promoting spirituality (although her beliefs differ from his), in music and art, and in working for social change. At fifteen she was jailed for participating in a civil rights demonstration, and as the movement for racial equality progressed she became increasingly militant. "At first I could

see that love could change anything. I sat in on workshops where they trained us to go into a situation where people were adversarial to the point where we might be killed and not fight back. But I had a reaction to that, see, because any teenager's going to rebel. My rebellion was to be a revolutionary. Martin Luther King was blah. I wanted Malcolm X and Stokely Carmichael. I went toward the more radical."

At age twenty, she married and moved with her husband to the Virgin Islands. She remained politically active, organizing rallies to raise awareness of racial discrimination and to encourage the islanders to be economically self-sufficient. But she eventually became discouraged, as much from failing to be accepted by the local residents as by the lack of political change, so she left her husband and returned to North Carolina. Going back to school, she found herself focusing less on politics and more on who she was. "After a while I woke up and it's like, 'I'm not rebelling anymore. It's time for me to be who I am, not rebelling against anything, but finding what is really me and starting to develop that.'"

To find herself she majored in theater. "It was for therapy. I never expected to go on stage, but I knew I needed to find out who I was, to really get inside myself. I had read about therapies where you dealt with the different voices in you and I knew that there was a part of me that was political. But there were so many other parts of me. I wanted to be able to be myself. I was also a VISTA volunteer, which was great, because I was doing community projects and doing my art at the same time. It was an experimental program in the Creative Arts Department."

Through VISTA and working in legal services and as a community organizer, she realized that art could spark people's creativity in these areas as well as in the arts themselves. "You're being creative. You're looking at the situation and you're strategizing, which is so important, and there's so few people who can do that. To really be a creative person, you have to be able to open up and be a vessel for something else, what they call a muse or whatever. Anybody who is truly creative will tell you they do not know how they do it, they do not know where it came from. They're just a channel; the next thing they know they're doing it."

Although she had been exposed to Afro-Caribbean spiritual traditions in the Virgin Islands (as well as to Christianity at home), her personal interest in spirituality emerged several years later in response to the pain of being separated from her husband and searching for her own identity. She participated for three years in a spiritualist circle led by a woman who did "readings" and passed on psychic messages to members of the group. "A part of me was fascinated with it and another part of me was saying, 'This is a bunch of crap,' and I'm trying to figure out what the deal is." One of the readings advised her to return to the Virgin Islands and start a business there. Following this advice, she had no sooner established her business than it was destroyed by a hurricane. She decided not only to leave the islands for good but also to find a spiritual path that was more reliable.

It took more than a decade to find stability. She worked at odd jobs, went to graduate school, pursued many spiritual practices, painted, and wrote in her journal. Marrying a second time and getting regular jobs writing for newspapers and magazines provided economic stability. Spiritual stability has come through the Morning Star Center and the groups and workshops that preceded it. She describes herself as a "second waver." First wavers were the spiritual leaders she learned from in the 1970s and 1980s. They provided a dizzying assortment of options, many of which were dead ends. The task of second wavers is to sort critically through these options and to gain a greater awareness of God. She quotes from her journal: "I've lived a 'normal' and an 'abnormal' life. I've made rules, followed rules, broken rules, most of the time haven't even known what the rules were nor did I care. Didn't know universal laws work whether you know them or not, and even if nobody else knows them, and even if you didn't get caught (which you always do), even if you didn't know it. But when will my light shine? When I stop being anything except an open channel for the higher energies of universal, unconditional love to flow through. When I know that I am the spirit of God and my physical self is simply a vessel of love and expressing love is all that matters."

Art increases her awareness of these higher possibilities. "Spiritual experience or spiritual awakening, the creative process, is more than just feelings. That's why the art itself is so important, because art allows the person to experience and to go beyond feelings and beyond intellectualizing about it." She says poetry crystallizes spiritual insights that emerge over a period of years, permitting them to be revisited and learned from again. She also hopes her poetry and theater performances will make her inner spiritual life more visible so her daughter can learn from it.

She is no longer confident that society can be improved by engaging in political movements, but she believes much can be gained by altering one's own outlook on life. "The first thing we did in the '60s—against the Vietnam War, flower power, the civil rights movement—the very first thing we did was to immediately draw consciousness to the conditions, to the beliefs and the assumptions, and that they had to be changed. So immediately we found that some things were changed and some things were not. We stopped the war, but we didn't stop the mentality. We realized that we would have to do the changing within ourselves. We would have to do the healing within ourselves."

She knows people who regard this inward focus as selfish, but she sees it as a worthy endeavor: "To do that healing, you really are making a sacrifice, because while you're focusing and concentrating on it, you're not out there making money or doing all the things that I was trained to do in order to be successful. I mean, it's a choice and it's not an easy one. I mean, there's only so many things you can do. You focus your energy on the healing."

Because she is confident that more and more people are "waking up" to the value of personal discovery and spiritual healing, she believes evolution to a higher state of human consciousness is possible in the new millennium. "It's a gradual process. It's not one minute that it's going to happen. It's like the caterpillar evolving into the butterfly. You do quantity, quantity, quantity and then there's a quality. My belief is that we have opened the doorway and that we are moving. It just takes time."

Is JoAnn Jones simply rationalizing her withdrawal from political in-

volvement or offering an inflated view of her work at Morning Star? Perhaps. It has been easy for observers to criticize the spirituality that is often purveyed at retreat centers like hers. But it is also valuable to understand the reasons why someone like this shifted from one form of "ministry" to another, as well as the seriousness with which she has pursued a way to combine self-understanding with service. It is especially worthy of note that she sharply distinguishes spirituality from feelings, emphasizing that spiritual insight involves a genuine personal awakening that is itself a sacrifice of one's past and an avenue to sacrificial effort in the future.

"My Chaco Canyon"

Like JoAnn Jones, other artists attempt to raise awareness of human problems and possibilities by rediscovering insights from the past or from their own traditions. Robert Mirabal is a member of the thousand-year-old Taos Pueblo north of Santa Fe. He plays traditional Native American flute melodies intertwined with percussion, didjeridoo, ambient keyboards, and guitar, as well as contemporary music with English lyrics. Also a celebrated painter, poet, and playwright, Mirabal is the author of *A Skeleton of a Bridge*, a book of poetry, prose, and short stories.[4]

Living in the pueblo, it seemed natural as a child to learn the arts and crafts of his people. "I think in America we tend to define artists for what they do—painting, music, whatever it may be. But in my culture, musicians as well as artists and craftsmen are fused into one. So there's really not a definition as artist or artisan. In my understanding of art, I grew up singing with my grandpa, dancing with my grandma, drawing and painting with them, and creating things continuously—moccasins, leggings. All that stuff is part of our tribal tradition. Making drums and flutes is all based on things that make us feel good, things that make us happy for our culture."

He spent more time with his grandparents than many children do because his mother was busy finishing her education. "I was left with my

grandparents. My grandparents spoke English, but they weren't very good at it, and when it came to going to the doctor's or something like that, they couldn't communicate their feelings to a doctor sitting there with his stethoscope telling an Indian man what's wrong with him. So I would ditch school basically and take care of them." He looks back fondly on these times, but he also acknowledges that Anglo and Hispanic schoolmates shunned him ("like the person across the cattle guard").

Besides fistfights, drama was the best way to act out his feelings, so he participated in school plays and after graduation did summer stock. He started making flutes to earn money. "That was just at the beginning of New Age music. I started playing my music and I produced my own tape. I borrowed some money from my grandma and rented some studio time. I didn't know what I was getting involved in. People felt like they needed this type of music to meditate to and for massage therapy."

Soon Mirabal was in demand. "I started performing in Santa Fe, Taos, Albuquerque, everything from weddings to art openings to collaborations with classical musicians. I was young, I was meeting a lot of beautiful people. When I went home, I didn't have time to deal with my peers. They were flunking out of college, coming back home and not knowing what to do. I was nineteen years old and had already started a business. I was in demand for what I look like. I guess I became the art piece, physically became the art, meaning that I created an art form inside my body. My hair, my earrings, the way I dressed at concerts, my flutes, my movements of my compositions with my body—all were part of what I became, and people liked it. I was young and they wanted to be in touch with a Native body and mindset. It became overwhelming at times, but it was what I chose to do."

His grandfather's death in 1987 precipitated a personal crisis. "That was the first time somebody so close to me died. One day you're with him and laughing and feeding him, and then the next day he's gone and you're never going to see him again. I really got destructive with my body. I gained a lot of weight. My compositions became angry. I became really prejudiced towards mainstream America. I became really angry at

white people, white men, white women. You could see it in my body—
there was dark energy. For about a year I performed but became a kind
of evil entity, womanizing, and the artist and the art that was me wasn't
as beautiful, it became very dark. I literally became the dark side of art
inside of myself."

The darkness he was feeling made it impossible to continue per-
forming upbeat New Age music. "I began to create more radical music.
They called me the heavy metal flute player because I studied Charlie
Parker, Thelonious Monk, and Miles Davis. I went to the extreme of
jazz. I realized the chaos and the drug abuse that they were going
through and tried to create my ideology based on that destructive be-
havior." The death of a cousin in an alcohol-related automobile accident
showed him the danger of following this path, however, and he began to
feel a need for healing.

Working with the avant-garde Japanese dancers Eiko and Koma in
preparation for a concert tour gave Mirabal an opportunity to seek heal-
ing. They were interested in his relationship to the land and his people.
One album of concert music stretched to two and then three albums,
and he toured with them on and off for five years, visiting Japan,
Germany, England, and the United States. Exposure to other cultures
made him think more about the richness of his own. "I began to realize
that we were creating a spiritual place, that we had created through mil-
lenniums as a Native tribe through our oral traditional stories and our
oral traditional religion and our dance and our movement and our art,
we were creating a movement and a friction and an axis for the planets,
the stars, the heavens, the rain, the animals, the water, the magnetic
force of people who come to try to feel the healing. I realized that
through studying other cultures, other masters. Here I was in Taos
Pueblo, an initiated man who began to study medicine more deeply, and
Taos Pueblo became more of a mecca for me. It became my North
Africa, it became my Hokaido, it became my Etruscan ruins. It became
my Chaco Canyon."

Identifying more closely with his people added a new dimension to

Mirabal's music. "I started creating my body so that when I moved with my flute playing, I became the sound, my body became an extension to the sound, and I began to see colors when I played flute. Like a gel or a color—oranges, yellows. When my finger would lift up, it would be heavy, and then I would begin to throw the energy out to the people. My compositions became more profound, more elevated, more structured in a simple way that created complexity, a more tribal way. When I started to play, I began to think of Native words, Native chants. Then, all of a sudden, I was in an altered space. All of a sudden I would play a ten-minute composition feeling like I just walked a little trail in the valley of my ancestors." These experiences not only altered his music but also awakened a desire to help his people, which he has realized by starting a healing center for Indian children and a shelter for abused women.

Ironically, "coming back" home became the avenue by which Mirabal was able to relate to a wider audience as well. Earlier in his career he had sought a contract with Warner Brothers, but its representatives expressed doubt that his music could attract people in Arkansas or Nashville or New York. His working through his personal issues enough to gain some authenticity persuaded them that he was worth signing. Thinking about the healing he received from the land convinced him he wanted to turn the music from his performance piece *Land* into an album. "I realized that we're all in America together and it doesn't make any difference if you're an Indian or a farmer, your land is still being taken away by the same people. I wanted to do *Land* because so many people wanted to hear it because it created a structure that was different from a lot of Native albums. It's also a score structure that wasn't American or European. It was based on those formats, but I used traditional instruments. What I was trying to express to people, to that man in Arkansas, was how important his life is and how it is connected to the earth. I'm not trying to sound New Agey with it. It's just that a man who has lost his land craves the same thing I crave. I wanted people to feel for themselves what land was."

The music asks, "How do you walk on land? How do you sing on

land? How do you dance on land? What is the spirit of land? What is the religion of the land? What is the hatred, the love?" When people come to the Southwest, he says, they experience what his music tries to convey. "The trickling of rain, the flash floods, the shamanistic smells of the piñon wood and cedar. There's something about it that evokes the senses and the meditative forces. Native music is really based on a simple process, but it's the simplicity that creates the artistic spiritual expression, the connection to the higher source."

Artists like Robert Mirabal stand in two worlds, sometimes reaping the derision of both. European Americans have not only borrowed from American Indians throughout their history together but also, in recent years, criticized tribal members who appear too eager to export Native practices. Especially when commercial gain is involved, it is easy to register concern about how much the Native practices are being diluted or subverted through exportation. Yet in this case, it is evident that living in two worlds can provide a creative tension that encourages performers to struggle with their own identities and, in the process, challenge their spirituality. Sometimes the result is a message that is both authentic and valuable for a wider audience to hear.

The Dawn of a New Age?

Many artists criticize dominant values and institutions, and their personal crises encourage them to ponder the uncertainties of life. Richard Foreman, Dorothy Rudolph, JoAnn Jones, and Robert Mirabal represent some of the ways in which the arts are engaging contemporary problems—by, respectively, challenging people to strive for hidden truths, helping people overcome personal problems, connecting with change-oriented organizations, and strengthening loyalties to ethnic groups and local communities.

How does the dawn of a new millennium affect this engagement? The sheer fact of living in a new millennium inspires only modest interest. Although Richard Foreman says he is gullible enough to believe in

scenarios that include time travel and new discoveries about the universe, he doubts that human nature changes very much from one period to the next. Dorothy Rudolph knows it will be a continuing struggle to overcome hierarchy and exploitation, while JoAnn Jones abandoned thinking about revolutionary change decades ago. Robert Mirabal quotes his grandfather: "The world goes ninety miles an hour. If you just stand still, it'll come back again." He thinks of history in terms of cycles; the present involves a return of the "water clans," which counsel us to care for the earth.

Some artists do express optimism, suggesting that a new millennium may be an opportunity for change. Willi Singleton thinks "people have a kind of trepidation going into the new millennium and a feeling that it's a good time to turn over a new leaf." Jay Albrecht, a New York poet, notes that ancient prophecies often do not extend much beyond the year 2000. "I believe that the earth will continue to exist and people too," he muses, "but it does seem that these predictions suggest a qualitative change occurring in people and in the earth." Ann Biddle's view, though unrelated to ancient prophecies, is similar: "I hope it will give us an opportunity to break from the past and from old models of male-dominated capitalism. I'm just hoping it will open up a new way. It's a turning point."

Other artists, however, do not share this optimism. Jon Davis regards the specific date marking the end of one millennium and the beginning of another as meaningless, although he admits that "it does affect the way people think and it tends to turn us towards spiritual matters." Like Davis, Madeleine L'Engle attributes no significance to entering a new millennium, noting that specific dates are meaningless because even the Christian calendar does not correspond exactly with Jesus' birth. Similarly, Myra Keen says she has been "mystified" by all the interest in the new millennium because she doesn't think it has any significance at all. Richard Rodriguez thinks it is more important to focus on ordinary life than big events such as the birth of a century or a millennium. "I'm more interested in history the way everything goes on," he indicates.

"W. H. Auden has a wonderful poem about the 26th of December, the day after Christmas, the way life goes on, and the day after New Year's when everyone goes back to work."

A more cynical view is expressed by Greg Glazner, who thinks major turning points in history are marked by "fringe groups doing things like castrating themselves and committing suicide or sitting on mountaintops," but beyond this he thinks the start of a new era has no lasting importance. Skepticism is also voiced by Cynthia West, who says it is natural to be interested in the beginning of a new millennium, just as it is to celebrate one's birthday or Christmas, but who disavows "twinkly" ideas about it as "New Age sewage." Her disdain for New Age ideas (despite having been influenced by some of them) is a reaction to the fact that artists with serious interests in spirituality are sometimes regarded as dabblers in the latest spiritual fads. Along these lines, Glazner likens "weekend Buddhism" to "the visionary buzz of brain-damaging substances" and worries that Santa Fe is becoming a Disneyland for spiritual seekers.[5]

Of course some artists hold views that clearly reflect New Age ideas. JoAnn Jones is one example, and the New York dancer and choreographer Robert Garland is another.[6] He sees the new millennium as "the Aquarian age," commenting, "The song was absolutely right about harmony and understanding, love and peace, and all that. There are major planets that are moving into other signs, planets that have been in different signs for the past twenty-some years. Which is sort of signaling, on a technical level, the Aquarian age. I think this carries with it the portent of another type of understanding, and it's very hard to put your finger on what exactly it's going to be. But I think that it's going to be a lot better than the way it is now because the mindset of the people that are moving in is different from the people that are moving out."

Another artist whose views of society suggest the influence of New Age ideas is Robyn Waters, a Sacramento-based commercial illustrator who for the past several years has been turning toward what she describes as "visionary art" and emphasizing metaphysical themes in her paintings. She says the earth has energy zones or chakras, just like the

body. "The earth's focus has been on the third chakra up until a while ago—the power chakra. We're all affected by the energy that comes up from the planet, so we have focused on the idea that might makes right and have been very competitive. Now the focus is on the heart chakra, which is the chakra of balance. We're always going to have the same needs for experience, but the energy from the planet is changing so that puts the focus at a different place."

But these views are the exception. Although their ideas about spirituality are often unconventional, few artists regard the new millennium as a New Age in which life will automatically improve because of a realignment of the planets. More typical is the view of Francis O'Connor, a New York poet and art historian who has written extensively about Jackson Pollock.[7] Raised Catholic, he has read widely in other religious traditions and currently attends a Unitarian church two or three times a month. Terming New Age beliefs "a lot of nonsense," he worries that crystals, pyramids, and other objects have become mythologized. "All of this is essentially what used to be called divination. I suppose the *I-Ching* is the divining method of choice of the New Agers. . . . But the whole business of divination is taken far out of all proportion to what it was. It's rooted in very simple psychic phenomena of projection, and I think all too much is made of it and it gets people all mixed up and their head all out-of-kilter for what real spirituality is about. It can just become superstition."

O'Connor's skepticism is similar to that of a visual artist in Pennsylvania who describes herself as a visionary but explains that that does not mean she is waiting on some mountaintop for a vision of the future. "The vision I have would be that we become more aware that we are globally interrelated and that anything any one of us does will affect everyone everywhere. I hope consciousness can be raised to a point where it's sensitive to the afflictions and the needs of other people. I see hope in people who have a commitment to values, to ethics. I hope that politics can be reformed. I would love to see a reformation in the political arena where power is used to enrich the world."

Dangers Ahead

If the new millennium itself generates disagreement, there is neverthe-
less virtual agreement among artists that the world is fraught with seri-
ous problems. JoAnn Jones laments the loneliness and isolation many
people experience. Richard Foreman worries about global warming and
the possibility of environmental disaster; he thinks it may be even more
disastrous if people lose hope because of such problems. Pointing to
Adolf Hitler and Saddam Hussein as examples, Robert Mirabal fears the
power of political figures to start wars. He worries too about the survival
of his people. "There's just two thousand of us, and we can lose our lan-
guage because of the mass communication skills that America has mas-
tered. If my culture dies and my language dies, then I'm nothing."

Other artists voice concerns about similar problems. Jennie Avila
mentions the problems of "environment and population," and the need
for people "to be tolerant of one another and to get away from the
rugged individualistic competitive mode and get into a more cooperative
mode." Derek Fell is concerned about terrorism, overpopulation,
famine, and racism. Carla DeSola worries about "ecological destruction
and the proliferation of weapons and the selling of weapons." She says
these are "terrible evils" that result from the "sinful manipulation of
goods for profit." Similarly, for Sharon Thomson, the greatest challenge
is "not to destroy ourselves through an ecological holocaust of one kind
or another—a holocaust that would be provoked by the greed, pride,
and self-interest of a few." Bob McGovern emphasizes the overt preju-
dice that comes from people banding together to exclude and ridicule
others and the tacit intolerance reflected in forms of political correctness
that prevent people from truly adhering to their own values. "It's im-
perative that we not destroy the other, because the other gives illumina-
tion to ourselves, and in a spiritual journey that's what you need—all the
illumination you can get."

Many of these artists are troubled by consumerism. A painter in
Pennsylvania observes, "I look at my grandchildren's rooms and they're

cluttered with toys and things. They don't need all those things. I think the challenge will be to keep life simple and to be committed to family life and to look more and more to the ethics of conducting business and the ethics of the distribution of money." Greg Glazner attributes many of the world's problems to the fact that serious reflection about the deeper mysteries of life (the search for what he calls a "credible mythology") has been replaced by "an immediate surface sense of consumerism." In his view, people want to live comfortably and have good jobs but feel insecure because they lack an understanding of the larger scheme of things. Ann Biddle thinks television and consumerism are two of the nation's most serious evils: "I hate television. It's the thing about American culture I despise. It's polluting our world and the people in it. If this is what we have to contribute to world culture, it's really sad. I feel the same way about consumerism. If you go anywhere outside of this country and you come back and go to the supermarket, you think, 'Why do we need two hundred kinds of cereal?' Why? It is so unnecessary. It's waste, waste, waste."

Many artists attribute specific social problems, including consumerism, to a more general crisis of values. Jon Davis asserts that "we are in the midst of a crisis of meaning. There's no agreed-on truth, there's no agreed-on good. We no longer know what's right and good. People are having a hard time with the edges of cultures and the edges of religions. If you look at a place like Bosnia, the struggle there is for meaning more than it is for territory or about race. We feel like we have to gather the forces and create a group of people who all agree on something in order to have meaning. Because of the assaults on truth from science and elsewhere, we feel this need to gather among people who have a belief that's similar to our own. But at the edges of all those groups, we don't know how to face the meaninglessness." Cynthia West echoes this concern, suggesting that truth and beauty "have pretty well been uprooted."

Richard Rodriguez agrees that too little attention is being paid to truth and beauty, but worries more about the conflicts inherent in ef-

forts to reassert absolutes. "I think we're headed for a real period of international tumult over religion, and I think that the struggle in the next several generations will be between the secular and the orthodox, between the fundamentalist and the nonbeliever. I think they live almost on different planets now, and that those of us in the middle, sort of humanists who may or may not have some religious affiliation, I think we're going to get trampled."

To Come Forth and Shine

Despite these concerns, a certain kind of optimism generally prevails in these artists' views of the future—not that the world is witnessing progress but that people remain capable of surviving the worst. Indeed, it is notable that optimism prevails, not only among artists but among a majority of Americans, despite the fact that hardly anyone believes in progress the way those at the start of the twentieth century did. The woman who laments her grandchildren's clutter asserts, "I choose to believe that there is always hope. I know good people and good people are committed to making the world better, and they're young people and they are committed to values." Dorothy Rudolph's personal struggles lead her to a similar observation: "I believe that you and I and everybody else are like a sparkle, like a flash of light, a sparkle of the uniqueness of whatever Being we are a part of. Knowing my history, I just believe there is an undamageable core inside us that wants to happen, endure, come forth, and shine."

Berrisford Boothe believes it is just part of the human spirit to be optimistic. "I can't run away from AIDS and be afraid of genetic engineering. We're involved. When we're not involved, I'm pessimistic. The human spirit is remarkably resilient, and it has this capacity, just like nature (because it is nature), to reinvent itself, to do the most incredible things at the most amazing moments. If all of us can't have faith in that, then don't paint, don't eat, go somewhere and kill yourself. Just get off."

Mario Sprouse observes, "Even at my darkest times, the future is hopeful and bright. The fact that babies are born every day and that there is an every day, there is a next day, there is a 'this is the day the Lord has made,' means I'm going to rejoice in it."

Although there is an occasional Panglossian outlook, most artists acknowledge reasons for pessimism and emphasize that being optimistic is ultimately rooted in spirituality. Richard Foreman is troubled with doubts as he grows older, but finds reason to be hopeful in a cabalistic account of the Creation. "God withdrew, left an empty space, so the world could coagulate. The world was broken and it scattered like shards of a broken pot. There's a hidden spark in each of these shattered pieces. It is the task of mankind to bring these together and to redeem all of this fallen material. That's the way I think of my work. As we live in this fallen world full of broken pieces, the task in making a work of art is to bring these pieces together and to redeem them—to make something in which the light can re-manifest itself." In *What Did He See?*, Foreman's most autobiographical play, he expresses this understanding of the human task. Two older men, weary and embittered with life, discuss their impending retirements. One contends that all is for naught, so the best choice is to do nothing. The other declares that giving up is morally unacceptable, even though one's goals may go unrealized, because striving in the face of ultimate mystery is what it means to be human.[8]

Optimism appears to be significantly reinforced by the conviction that artists can contribute to the public's awareness and understanding of spirituality. An artist in New York who makes sculptures with contemporary religious themes proposes that art "can give us meaning and a sense of sisterliness, of brotherliness, of knowing that each thing that happens in the world is connected to every other thing." Cynthia West regards her painting and poetry as a way of furthering spirituality because it is a form of meditation and a way of participating in the process of creation. "This is the work of God. It's the suspension of my belief systems and my active mind and the opening of myself to the flow of the

one river of life." Richard Rodriguez feels it would be pretentious to say his writing furthers spirituality, but he regards it as similar to "passing on life." He adds: "I think peasant women [in giving birth] know that in a way I'll never know." Jon Davis's hope is that his writing will encourage others to "be spiritual in the way that Thomas Merton was." He thinks that "we can have our own beliefs as fiercely as we need to" and yet "understand that our neighbor is doing the same thing, and realize that truth is enough of a mystery that we can do both and not be in a contradiction."

In these views, a vital task of the artist is to heighten people's awareness of mystery, uncertainty, and their inability to predict or control. David Ellsworth contends, "We have to observe and analyze, but most of all we have to question; the most important word in the English language is 'why.'" Asking why is a task he believes all artists can encourage, just as he attempts to do in creating pots that do not immediately reveal their purpose. Rick Vise likens art to prayer because both are a way to express thankfulness for "mystery, this divine being, which is everything, and it sets up a field where that thankfulness comes back at me. I don't do it to get anything. It's just like I see something beautiful or I'm moved and I say, 'God, oh, God. Thank you for that.'"

For Berrisford Boothe, art points to divine mystery in several ways, not the least of which are the questions it raises about why someone does it or appreciates it. He often feels that something transcendent is happening when he paints, and sometimes he is drawn into this mystery by others' artistic work. Specifically, he mentions Andres Serrano: "When his work really works for me, as in the Klansmen series, when I look at a huge photoprint of the blue eyes of a white male, and I look at that as a human being, then I look beyond it, through it, at the deep sense of mystery, at why this would happen, and what kinds of fears and powers drive it."

It is worth noting that these artists generally talk about the mystery of life as something benign, rather than as a void to be feared, and this view is rooted in experiences from their work. Meredith Monk says she plays

the piano every day and keeps her voice in shape, but there are more mysterious moments as well: "There are times when you feel that spiritual creative energy coming through you and in a sense you are a medium or a shaman or a midwife of this thing that has to come through you. Those are the times that you know the spirits, whoever they are— he, she, it, or whatever—need to have something said and that you are the person they have chosen to say it." Cynthia West sometimes feels her paints are "a lightning rod for grounding endless force," and Berrisford Boothe says he paints best when he is able to accept an "organic, uncontrolled torrent" of ideas and images, then surrender to whatever happens. Ann Biddle associates her most creative moments in dancing with a "spiritual center" that she can't explain but knows is there. "I know when it's there, and then I know to trust it. I've learned to trust it."

While it is described in favorable terms, this sense of the mystery of life invariably includes an awareness of uncertainty and the presence of evil as well. Jon Davis says Theodore Roethke's poem "The Lost Son" expresses this uncertainty particularly well.[9] "It's about losing his father, who was really important to him, and at the end it says he goes in the winter field and the winter weeds are there. He calls them the beautiful surviving bones, the winter weeds, and all he can come to at the end is 'a lively understandable spirit once entertained you; it will come again, be still, wait.' It ends there, and it always seemed to me that was the best you could do, that you believe in what you've seen and then you wait."

Berrisford Boothe's understanding of "the dark side" stems less from his religious upbringing than from the struggles he has experienced as an artist. "Art has taught me that you can really come in here with the best intentions and start to really mess up. If you're not paying attention, that theme, that wrong turn, that unreconciled emotion can really, really pull you the wrong way, destroy the painting, ruin the day, screw up your personal relationships, pull you off the road. That has nothing to do with some spirit incarnate walking through this door and holding my hand and massaging the back of my skull. It has to do with my not paying attention to the extraordinary ordinary, with not saying, 'This is

okay. I can leave this. I will be creative tomorrow or after a sandwich.'"
He adds, "Evil always rides in under the banner of good. It's the denial
of our ability to be corrupt and selfish and powerful."

Augustine's notion of evil as the absence of good comes to Richard
Rodriguez's mind as he describes people he has visited in jail. "There are
times when I'm in the presence of the mystery of evil like that, when it
has no answer, it has no logic. There is no reason why it exists, and yet
it consumes people. I don't know what to do with that. I find that really,
really compelling and I'm scared of it. It is really out there. It's very
much a part of our society." His optimism about the future is tempered
by the realization that evil of this kind will always exist.

Moments of Transcendence

But in the final analysis, these writers, musicians, sculptors, and painters
are less concerned with identifying aspects of the social world about
which to be optimistic or pessimistic than they are in providing small ex-
periences of transcendence that in themselves become reasons for hope.
It is the creative process itself that momentarily transcends time, offer-
ing an awareness that something other than the ordinary can exist and,
through that existence, reinvigorate the flawed aspirations of ordinary
people.

Katie Agresta remembers writing a piece of music one evening when
she was in deep pain and suddenly feeling that time stood still. "I don't
know how that piece of music came out of me that night. I had no plan
for it. It's one of the most beautiful things I've done. I almost feel like
somebody else wrote it." Berrisford Boothe says he seldom feels he has
created something extraordinary; indeed, he is frequently plagued with
guilt and self-doubt. But then he will see a glimmer of recognition in the
eyes of someone looking at his work and say, "My God. That's it! That's
what I wanted. Right there." Bob McGovern recalls moments working
on a wood sculpture when ordinary time and space seemed to disappear

and spiritual light emanated from the object. "I think you have to be deaf, dumb, and blind not to realize that when you work with a creation you are dealing with something that's bigger and wrapped in the cosmos."

Sometimes ordinary time and space seem to be altered by divine intervention. Dorothy Rudolph says her images "come from the creative spirit within, the God within each person." Another painter says that "there are some times when I don't know where that energy is coming from. The brush leads me and it seems to have nothing to do with my body. It is coming purely from the spirit. It's a very special feeling when I do this. There's a oneness with the sacred, with the divine." A gospel singer calls these moments times of "anointing." Sometimes, she explains, "You feel that your music has been supercharged by the presence of God. Oh yeah! That's very different than when it's not. Creativity is boosted. Your ability to deliver the message becomes much more enhanced and powerful."

Although Greg Glazner says words like "cosmic" and "divine" scare him because they seem like "uppercase words," he acknowledges sometimes feeling something almost divine. "It's just a sense of being connected to something a lot bigger than you are, so that it's no longer about your own ego. The sense is that you're being slipped this stuff, that something that's not your ego is letting you have some material." Carla DeSola's experiences have been similar: "They're like moments of grace, where you suddenly hit something. Like a clap, there's a resonance, there is just a timing that makes it come together, that then gives a sense of an energy that goes beyond one's self. That best happens when you can get over self-consciousness. Sometimes if a dance is particularly meditative, you can latch into a very deep flow from your spirit that then is released without the impediment of your personality." Nancy Chinn emphasizes getting beyond one's ego as well. "You and the work and the unfolding of the work are one. It's a very ego-less, unself-conscious place to be."

Lydia García thinks the act of carving sometimes puts her in a frame

of mind where God's spirit speaks to her more clearly. "I've carved the stations of the cross and as I do that I pray the stations of the cross. Those are the times I have felt Jesus and the pain and the loneliness, like I'm walking through the passion of Jesus." Another artist, a painter, says special moments of revelation have taught her to be less concerned about knowing exactly what to believe. "I think probably there are no easy answers and we have to live somehow or other with joy and with sorrow. Living with ambiguity and mystery is what we're called to do." In her journal Cynthia West expresses the hopefulness that comes from special creative moments: "I dwell in daily ways but also swim and circulate, companion to the widest sweeps of stars."

Experiences like these point unabashedly to the possibility of entire new worlds being found in singular moments of creativity. They inspire artists to keep working, not because they provide answers to life's deepest questions, but because they suggest possibilities greater than those presently known. Like religious teachings about possibilities of spiritual rebirth or about the second coming of Jesus, moments of transcendence keep hope alive. They sometimes bring fresh insights about a problem at hand; more often, they encourage people to keep working at problems whose solutions continue to elude them.

Mystical orientations such as this have often been regarded as having little to do with solving concrete social problems. Many Americans would prefer scientists and engineers to people who offer them moments of transcendence. Yet there can be little doubt that we need both. The problems of environmental destruction, injustice, and materialism to which artists point are perhaps more concretely addressed by public figures, social planners, and movement leaders than by visionaries. But artists provide the occasional opportunity to affirm hope and to see alternative possibilities. Their work goes beyond entertainment, offering new ways of relating to the sacred by combining insights from the past and present. This fusion of spirituality and creativity lies in a hidden reality that cannot be reduced to customs or rules. It emerges in what the poet Wallace Stevens described as a moment of dazzling discovery:

Not to be reached but to be known,
Not an attainment of the will
But something illogically received,
A divination, a letting down
From loftiness, misgivings dazzlingly
Resolved in dazzling discovery.[10]

THE WAY OF THE ARTIST

ARTISTS CAN EASILY BE DISMISSED. Their work may seem to be of little significance to the real issues of contemporary life. They seldom manage large businesses or earn prominence in public office. They spend their time in seemingly unproductive pursuits, often working at other jobs to earn a living. The few who gain tabloid notoriety seem to squander their fortunes in excessive lifestyles and falter miserably in their relationships. Just reading about them in the newspapers, one would hardly expect them to have anything helpful to say about spiritual practice.

This is certainly part of the story. But concentrating only on their foibles overlooks the valuable contributions that artists make to our lives, and not only by providing entertainment or by creating works of beauty. It is only a slight exaggeration to say that artists have increasingly become the spiritual leaders of our time. Many of us, whether we are aware of it or not, look to visual artists, writers, and musicians for spiritual guidance, insight, and inspiration. Artists are sometimes among the few who take time to reflect on the deeper meaning of life and to search for ways to express both the turmoil of their search and the tentative insights they have gained. They usually have more questions than answers, yet their work

celebrates wholeness and coherence as well as bewilderment and mystery. A lament for a lost brother becomes a poem of hope. An image of a she-wolf becomes a symbol of courage. A fanciful song about a mermaid points to the magic waiting in the crevices of everyday life.

Like all of us, artists waver in their commitment to the search for spiritual meaning. The business of making ends meet is never far from their minds. Dreary afternoons slip away in hasty preparations for the next exhibit. Whole days are consumed by bookkeeping and bill paying. These necessities make it difficult for the muse to be heard. Family emergencies, illnesses, working at second jobs, and caring for children crowd out time for the imagination to play. Sometimes success itself becomes their worst enemy.

And yet the sheer effort required to be an artist serves as a personal discipline. The one thing artists know beyond doubt is that practice is essential. The path to improvement runs through years of simply getting up in the morning and spending time perfecting one's technique as a painter, musician, or writer. It takes courage to do this, especially when the rewards are uncertain.

In the midst of the daily grind, most artists think about the hidden realities that sustain them. Some speak easily of God's providence and support. Many refer simply to the spiritual essence in which they are inevitably immersed. They agree that God is ultimately too great to be fully comprehended by fallible human intellect. For some, biblical narratives suggest ways of thinking about God. The truths conveyed in these narratives are understood variously as divine messages or as human efforts to communicate powerful teachings about the sacred. They are less often taken as formulaic doctrines to be adhered to unquestioningly. There is room for interpretation; indeed, room for creativity.

Creative Spirituality

In pondering the diverse ways in which contemporary artists speak about and practice their spirituality, I have been drawn repeatedly to the

importance of creativity. Within established religious communities, it has always been considered dangerous to let people exercise their own creativity in spiritual matters. Communities of faith, after all, are *communities* of believers submitting to the authority of historic teachings and designated leaders, rather than individuals who listen only to the dictates of their hearts. Yet the God worshipped by these communities is understood to be a creator who, among other things, has bestowed on humankind the gift of creativity.

This gift is widely in need of encouragement. Few Americans work at jobs that require them only to follow orders. They are expected to be creative in performing their tasks. In their daily experiences, most Americans need to make complex decisions—including solving such problems as finding good friends, keeping the romance in one's marriage, or helping children sort out their priorities in life. It is odd, then, to think of religious institutions as places where all the answers are already known and where discretion in what to think or do is discouraged.

Creativity has in recent years been the focus of countless how-to books, workshops, and seminars. Many of these aids encourage people to quiet themselves, meditate, pray, or even undergo hypnosis. Techniques abound, such as doodling, answering simple pencil-and-paper tests, and writing down one's dreams. While these techniques may be useful, they are nevertheless unfortunate in that they neglect the larger meaning and the deeper sources of creativity. As artist after artist attests, creativity is the capacity to see and think about things in innovative ways. It ultimately reflects the person's entire being. This is why many artists insist that creativity and spirituality are virtually indistinguishable. And if this view is overstated, it at least suggests that it is especially helpful to understand why creativity is an important aspect of spiritual life, and why artists—like many other Americans—feel compelled to create their own spirituality, rather than accept more traditional paths.

Creative spirituality is not a creed that someone simply invents and certainly not a faith that recognizes no power higher than the self. To be creative about one's spiritual life means recognizing that the teachings

one learns in Sunday school and the insights observed from friends and family have to be *personalized* to be meaningful. One has to connect the dots between religious traditions and daily life, between universal truths and unique personal experience. Even those who approach faith as if it were a philosophical argument or an abstract system of truths need to ponder how *their* unique experiences influence and in turn relate to faith. Being creative also necessitates spending time thinking about one's life and trying to approach questions about the sacred with an open mind. Artistry is a valuable part of the spiritual process, even for those who do not earn their livings as artists. If God is truly majestic and transcendent, some responses to this realization may defy expression in anything but imaginative lyrics and images. After all, there are plenty of these in the Bible itself.

The life stories of contemporary artists are particularly helpful for sorting out some of the criticisms that have been voiced in recent years about spirituality in the broader culture. One of the most recurrent criticisms is that too many Americans shop around for spiritual cues, rather than settling into communities of faith where they can learn discipline or serve others. Spiritual seeking draws criticism because it seems to reflect a shallow consumerist mentality. Just as people mill around looking for gratification at a new restaurant or boutique, so they seem to search for spiritual excitement by going on retreat to hear a popular speaker, learning a technique that promises quick enlightenment, or reading best-selling books that claim insight into the mysteries of life. The concern about such shopping is that it is driven by a desire for easy answers and an unwillingness to devote hard work to spiritual growth.

The rich detail many artists are able to provide about their spiritual struggles suggests something different from the shopping image. While it is true that artists sometimes dabble with this or that spiritual fad, their searching more often is rooted in something much deeper than the desire for titillation. They describe feeling as if they had no choice but to explore. Their childhoods were often turbulent, either because of divorce or family conflicts or because parents were busy and inattentive.

Although many were reared in churches or synagogues and went to Sunday school, they came away with unanswered questions. Many had interests that put them outside the conventional school and church activities; some, perhaps by virtue of their personalities, felt more comfortable spending time alone working on art projects or in nature than being a loyal member of a group. A number encountered turmoil in their adolescence or early adulthood, from trouble at school and questions about their careers to illnesses and broken relationships. These painful events shook them to the core, challenging their beliefs about the meaning of life and forcing them to search for spiritual guidance.

Artists are not unique in being exposed to these kinds of jarring experiences. Large numbers of Americans grow up in families that have been disrupted by divorce, separation, death, or lingering illnesses. A few people in every group, neighborhood, or congregation find it taxing to play by the conventional rules. They ask the "wrong" questions or have ideas that others find unacceptable. Some people simply feel compelled to deepen their relationship with God but find the easy answers offered in Sunday school classes or sermons unsatisfactory. They embark on serious spiritual explorations because they feel compelled to do so. Their explorations may extend over many years and consume a great deal of their time and energy—as much as other people devote to becoming successful in their careers or to developing hobbies.

It is sometimes difficult to distinguish between deep spiritual explorations and casual spiritual shopping. Both may take people from church to church or beyond the bounds of any particular faith. But it is important to recognize that spiritual seeking varies greatly in intensity and in the sources from which it springs. As is evident in the poetry, lyrics, and biographical sketches of many artists, it is often more difficult to undertake an open-ended spiritual journey than to settle complacently into a religious community. Indeed, artists talk frequently as if the spiritual quest were a road of no return. Once they start searching for meaningful ways of relating to God, they are seldom able to stop. Part of what we learn from artists, then, is that pilgrimages leading to spiritual enrich-

ment consist of more than superficial exposure to a variety of religious ideas; they are richest when they are undertaken because one cannot live any other way.

Spiritual life is most likely to involve creativity when it is pursued from deep personal necessity than when it consists only of casual shopping. Those who shop are consumers of other people's ideas. They are guided by whatever the marketplace provides them. Those who are driven into a spiritual quest by some profound part of their being know that an authentic relationship to God may require them to deviate from the crowd.

One of the hardest parts of a spiritual journey is convincing oneself that the effort required is worth it. This is probably the reason that many people spend relatively little time in serious spiritual explorations. It takes courage to keep going, especially if devastating experiences in one's personal life give one reason to suspect that God does not exist. Rather than doggedly attempting to make sense of one's life, it may be easier to lapse into despair or focus only on quick routes to personal gratification.

When artists talk about their spiritual journeys, they usually describe times when they doubted they were getting anywhere. What kept them going was a sense that life still had coherence, even though it had not turned out the way they expected. This sense of coherence is often grounded in some exposure to religious teachings while they were children or reinforced by confidence gleaned from parents and friends. It nevertheless involves deliberate effort to sustain. Many of us have probably had such moments of doubt. Living as we do in a society that frequently uproots us and takes us away from the communities in which compelling belief systems are maintained, we have to work out for ourselves solutions to our most troubling questions about life.

Much of the spiritual work that artists describe is an effort to develop or maintain the conviction that life makes sense. In listening to their stories, I have been impressed with how many times they resort to images of redemption. Although many of them do not refer explicitly to bibli-

cal stories, they implicitly draw on these stories. They speak of turning
points, conversion, recovery, returning home, and periods of wandering.
Their narratives include ideas about progress and explanations for stag-
nant times. Despite the difficulties they endure, they are able to develop
a strong sense of their personal identity.

This is one place where artists' creativity comes into direct relation-
ship with their approach to spirituality. The story of the prodigal son or
the perspective provided by a recovery group may serve as a general
framework for making sense of oneself. But each person must work
through the details of his or her own personal experience to arrive at a
unique sense of identity. Creativity is required to arrange the pieces into
a coherent picture. In some cases, painting pictures offers a concrete way
of finding the conjunction among various parts of one's experience. In
other cases, this connection may come about through keeping a diary,
writing poetry, singing, or noting one's responses to art, music, lectures,
or books.

Artists gain an extra benefit from including creativity as part of their
self-identity. Defining themselves this way builds confidence in their
ability to figure things out. It helps especially when they are plagued
with doubts about the slow progress of their spiritual journey. Knowing
that they are undertaking a journey persuades them that it is okay not to
have all the answers at the start.

Where artists are particularly perceptive is in the emphasis they
place on *practice*, both in their professional work and in their spiritual
lives. The idea of practice has come into prominence in recent years in
wider discussions of spiritual formation. Practice means devoting delib-
erate periods of time to cultivating one's relationship with God, espe-
cially through such daily devotional activities as prayer and inspirational
reading or through participating in worship services or opportunities to
serve others. Practice includes the idea that spiritual life is more re-
warding when a person devotes effort to it. Indeed, one reason that prac-
tice is an appealing concept is that it suggests the need to settle into
some form of spiritual discipline, rather than endlessly shopping for

spiritual gratification. Another reason is that practice connotes commitment, action, a lifestyle of faith, as opposed to simply ascribing intellectually to a set of abstract doctrines. In this way, emphasis on spiritual practice is a corrective to those philosophers and theologians who seem to think that the key to faith is having logical answers to every conceivable question. It is equally helpful in response to the widespread view that religious dogma has become so uncertain that it is impossible to be spiritual at all. But artists' view of practice is different from the one propounded most often.

The common view of practice is that it consists mostly of doing something long enough to learn whatever rules are involved in playing the game well. Chess is a favorite example. Because computers can be programmed to play chess very well, we know that it is essentially a game of rules about how to make decisions in anticipation of possible moves by one's opponent. Although expert chess players learn to devise clever strategies, they never violate the basic rules of the game. Indeed, mastering the game means knowing the rules so well that one need not think about them while playing. If, then, spiritual practice is likened to a game, clergy and other religious authorities gain a way to claim control over the practice. To be good at a spiritual practice means knowing the rules, and these rules are completely inscribed within a single religious tradition of which clergy are the arbiters. In this view, taking classes and listening to sermons are still the best way to learn the rules.

Artists, however, view the notion of practice differently. They understand that the rules must be learned in order to paint, sing, or write. But they also affirm the importance of being creative. An artist goes beyond applying known techniques or following conventional rules. The excitement about being an artist comes from improvising, from pushing the rules to see where they apply and where they do not, and from developing techniques that result in something innovative and unique. Above all, the creative practice of art means that the goal is not winning a competitive game but doing something that is fresh, expressive, and worthwhile.

The same approach is evident when artists engage in spiritual prac-

tices. Although they often follow the teachings of a single religious tra-
dition, they experiment with methods of prayer and meditation that may
reflect a variety of traditions, and their ideas are frequently inspired by
reading widely or by letting their imagination roam freely. Rather than
striving to be like someone else in their relationship to God, they value
gaining fresh insights about God that are uniquely theirs or expressing
what the sacred means to them in creative ways. Creativity comes
through in an openness toward the mystery of God and a recognition
that emotion as well as intellect, desire as well as duty, must be part of
one's relationship to God.

Although creative practice is central to artists' spirituality, many of
them also have much to contribute to our broader understandings of
spirituality and its relevance to how we think about ourselves and our
world. They talk about God, religious diversity, spiritual aspects of the
body, nature, time, social problems, and transcendence. Some adhere
closely to Christian and Jewish perspectives, while others are more eclec-
tic. Different views notwithstanding, there is often an emphasis in artists'
remarks on questioning prevailing assumptions. They want people to see
that spirituality is not removed from ordinary life but infuses it, even to
the point of being part of the human body and the created order.

Artists' marginality in relation to established institutions often gives
them a different vantage point from which to think about contemporary
issues. They focus more on the mysteriousness, wildness, and unpre-
dictability of God than on creeds and commandments. Some are at the
cutting edge of thinking about the ways in which all language inhibits our
experience of reality, while others are drawn to new ideas about the body's
role in spirituality and to the importance of movement, chant, or visuali-
zation in bringing the body more directly into the worship experience.

Making Use of Artistic Perspectives

The potential influence of artists on contemporary approaches to reli-
gion and spirituality is immense. Although artists seldom command reg-

ular audiences the way clergy do, their work is widely distributed through the mass media and in galleries, museums, bookstores, and retreat centers. People look to artists for inspiration because they seem to have expressed something of everybody's personal struggles or simply because they articulate fresh, surprising, and even shocking views.

But the main reason for the current interest in artists' spirituality is that American culture is itself deeply unsettled. While a sizable minority of the public continues to participate regularly in weekend religious services, most Americans believe it important to make up their own minds about spirituality. They may hold the clergy in high regard but feel it equally important to absorb the wisdom of poets and musicians. Many people have been sufficiently exposed to other religions that they find it hard to believe that *their* tradition is the unique repository of truth. When God comes to be understood as an Other beyond human comprehension, precise creedal formulations cease to be as persuasive as they once were. Personal experiences of the sacred and creative ways of expressing these experiences become more important. Artists provide models of how to say something about one's experiences of the sacred when rational discourse comes up short. Artistic work offers people an opportunity to see the sacred in new ways or to express it more vividly in familiar ways.

The danger in leaning too heavily on artistic renderings, however, is that the arts have become so thoroughly commercialized. Many Americans participate in the arts as "quick-fix" consumers or spectators. They listen to a song or read a book that momentarily provides insight about the spiritual life. But they move on quickly to other pursuits, rather than taking time to cultivate their own spirituality. Such use of the arts for instant gratification feeds into spiritual shopping.

This is why it makes sense to understand artists' *lives*. Even though artists generally insist that their works of art go beyond mere self-expression, knowledge about the artist's life can expand our appreciation of a particular work and the creativity behind it. Since many artists are reluctant to give interpretations of their work, preferring that audiences

provide their own, people often turn to newspapers' stylized reviews, which rarely give much insight into the artists' personal lives. But artists' life stories often provide a different perspective, sometimes revealing an intense spiritual journey behind a work of art. Their narratives are full of sadness as well as joy, failure as well as success, questions as well as answers. They show the importance of reflecting on the brokenness of life in order to find coherence. And they reveal the value of spending long hours in prayer and meditation.

Artists' worlds are extraordinarily diverse. To a greater extent than many Americans, artists have exposed themselves to other cultures and religions, whether through classes, travel, or reading. For people who have become restive with a single religious tradition, artists' journeys may resemble their own. In other cases, role models can be found among artists who work entirely from one tradition and who devote much of their energy to enriching this tradition through their work.

In the final analysis, the way of the artist is not about techniques for becoming more creative in one's efforts to get ahead. It is about spiritual practice and incorporating the artist's experimental approach into one's spiritual quest. Creating a satisfactory spiritual life involves taking responsibility for one's relationship to the sacred. It requires focusing one's attention, learning the rules, mastering the craft, and deploying the imagination. It encourages us to confront the pain that arises from broken relationships and to register the wonder that comes from thinking about love and redemption. In these matters, artists have much to teach us all.

APPENDIX

The key methodological question I faced in planning my research was how to identify appropriate people to interview. Although directories of artists exist, there is no comprehensive listing of artists in many fields and no simple way to identify artists who are interested enough in spirituality to want to answer questions about it. The strategy I developed was to concentrate on four geographic regions: northeastern Pennsylvania, northern California, the Santa Fe and Taos region of New Mexico, and New York City. I selected these regions partly for convenience and partly because each is known for its artists and is different from the others. Northeastern Pennsylvania is a largely rural area where artists may live inexpensively but close enough to major metropolitan areas, which provide customers for galleries, places to teach, access to publishers, and opportunities to perform. Although it is the least prominent of the four regions, it has been the home of such nationally known artists as the wood sculptor George Nakashima and the novelist James A. Michener. Northern California shares similar possibilities for a quasi-rural life near a metropolitan area, but the San Francisco Bay Area offers opportunities for artists not available on the East Coast. Both the Santa Fe/Taos region and New York City are of course places where artists concentrate in large numbers. The New Mexico region has been a favorite of European American painters and potters since the late nineteenth century and of Native American artists for many centuries before that. New York City is unrivaled for its choreographers, dancers, and actors, as well as its writers and painters.

For each of these regions, appropriate artists for interviewing were identified through various sources and methods: scanning on-line newspapers for a several-year period for articles about artists and spirituality; searching the Internet for biographies and work samples of artists; using computerized telephone directories to identify organizations specializing in the arts and in music, as well as gallery owners, art schools, booking agents, and artists to contact directly; obtaining membership lists of several national organizations concerned with spirituality or creativity and the arts; contacting people interested in the arts at seminaries, churches, and retreat centers; and asking individual artists for the names of other artists to interview.

From published information, referrals, and telephone calls a brief profile of each potential interviewee was then developed. A matrix was designed to ensure that a wide variety of artists would be selected for interviewing. The matrix called for roughly equal numbers of women and men, a range of ages, some minority representation, some representation of different religious backgrounds, and a variety of specialties within the arts. Three major categories of artistic specialties were identified: visual arts (painting, wood carving and wood sculpture, ceramics, photography, and bead artistry), performing arts (vocal and instrumental music, dance and choreography, and acting and theater production), and literary arts (poetry, plays, fiction, and creative nonfiction). All the interviewees were professional artists (they had received payments for their work). They ranged from people who earn their livelihood entirely from their art to men and women whose art is a serious avocation; most earn some income from teaching, conducting workshops, or working at other jobs.

The artists needed only to be sufficiently interested in spirituality to agree to an interview on this topic. They were permitted to define spirituality in their own way, and their definitions ranged widely, with some emphasizing traditional religious beliefs and involvements, some centering on intense personal commitments to exploring the sacred, some equating spirituality with the artistic endeavor itself, and some questioning the meaning and value of the term itself. As might be expected, the interviewees varied widely in their commitment to spirituality, from those who saw personal spirituality as the most important aspect of their lives to those who spoke more casually about spirituality. They also varied in their religious involvement, ranging from people in religious orders or with seminary training to those who had seldom or never participated in organized religion.

Interviews were conducted with one hundred artists. In addition, more than

two dozen interviews were conducted, for comparison purposes, with people whose lifestyles resembled those of the selected artists or with people who worked in related fields, such as marketing or publishing. Each interview used a semistructured set of questions covering a standard range of topics, but there was flexibility to pursue particular answers in greater depth. Most interviews lasted at least two hours; many lasted three or four hours. The topics included personal background and upbringing, how the interviewees became interested in artistic work, how they currently practice and understand this work, their spiritual journey, their current devotional practices, and their opinions about such issues as creativity, mind and body, religion, nature, and society. All interviews were recorded and transcribed. All of the interviewees signed releases indicating whether they wished to be identified by their real names or remain anonymous (the majority preferred to use their real names). Besides the interviews, information was drawn from the artists' promotional materials, from their writings, and from published reviews of their work.

The questions included in the interviews reflect my training as a cultural analyst whose principal interests have been the changing character of contemporary American religion and culture. I regard art in relation to the society in which it is produced: its meanings are encoded within itself and yet illuminated by considering artists' lives and their connections to other artists, the consumers of their work, and the culture in which they work. In considering artists' spirituality, I was thus interested in how they experience and talk about their spirituality, the relationships they perceive between spirituality and working as an artist, and how these relationships are reflected in their art.

The following artists gave permission to use their real names: Marty Adams, Michael Adams, Katie Agresta, Jay Albrecht, Jennie Avila, Nancy Azara, Ivan Barnett, Ann Biddle, Berrisford Boothe, Joy Broom, Nena Bryans, Richard Cannuli, Enrique Chagoya, Nancy Chinn, Warren Cooper, John D'Amico, Jon Davis, Dirk DeBruyker, Denny Deikeler, Carla DeSola, David Dunn, David Ellsworth, Wendy Ellsworth, Derek Fell, Jorge Fick, Yvette Flunder, Richard Foreman, Beverly Freeman, Jamel Gaines, Lydia García, Robert Garland, Bill George, Greg Glazner, Renee Heckert, Vallorie Henderson, Catharine Hiersoux, Jerome Hines, Celeste Holm, Shelly Horton-Trippe, Barry Johnston, JoAnn Jones, Marcia Keegan, Myra Keen-Morris, Robert Kelly, Shirley Khabbaz, Paul Kim, Tony Kushner, Mark Lamura, Madeleine L'Engle, Robert McGovern, Robert Mirabal, Meredith Monk, Bob Montgomery, Dawn E. Nakanishi, Ed Niederhiser, Sara Novenson, Francis O'Connor, Susanne

Okamoto, Pauline Oliveros, Robert Orduno, Cherly Patterson-Artis, Tracy Pederson, Roberto Pineda, Odean Pope, Michael Puryear, Charles Ramsburg, Len Roberts, Richard Rodriguez, Dorothy Rudolph, Victoria Rue, Laura Lee Russell, Erin Sanders, Andres Serrano, Konrad Sieber, Willi Singleton, Marsha Skinner, John Snyder, Mario Sprouse, Clark Sterling, Colleen Stevens, Sharon Thomson, Candido Tirado, Amy Torchia, Juanita Torrence-Thompson, Robert Tosh, Rick Vise, Robyn Waters, Cynthia West, Flo Wong, Chris Wright, Greg Wyatt, Ellen Young, and Michele Zackheim. About forty of these artists are featured in the book, while insights from the others were drawn on in developing my larger interpretations. Other artists preferred to remain anonymous, but their reflections also contributed to the book.

Numerous gallery owners, museum directors, agents, and publicists assisted in identifying artists who might be interested in participating in my research: Abiba Wynn, Marketing Coordinator, 651—An Arts Center, Brooklyn; Amparo Barone, 92nd Street YMHA, New York City; John Watusi Branch, Executive Director, Afrikan Poetry Theater, Jamaica, New York; Olivia Armas, Archivist and Regeneration Coordinator, Galeria de la Raza, San Francisco; Nancy Hom, Director, Kearny Street Workshop, San Francisco; Tim Burgard, Curator, M.H. de Young Memorial Museum, San Francisco; Luis Chabolla, Executive Director, Galeria Posada, Sacramento; Natalee Griffin-Moore, Director, Studio of Laguna Creek Performing Arts Center, Elk Grove, California; Sister Helen David Brancato, Director, Southwest Community Enrichment Center, Philadelphia; Michael Everett, Assistant Director of Development, Union Settlement House, New York City; Allison Berglass, Director, Gen Art, New York City; Lilly Yeh, Executive Director, Village of Arts and Humanities, Philadelphia; Michelle Geczy, Administrative Assistant, Mid-Atlantic Arts Foundation, Baltimore; Dawn E. Nakanishi, Board Member, Asian American Women Artists Association, San Francisco; Doug Adams, Graduate Theological Union, Berkeley; Nena Bryans, Director, Association Uniting Religion and Art, Philadelphia; Christa Fama, Jazz at Lincoln Center, New York City; Ila Gross, Director, Learning Through an Expanded Arts Program, New York City; Bridgette and Bill George, Codirectors, Little Pond, Bath, Pennsylvania; Virginia Cohen, Communications Specialist, National Endowment for the Arts, Washington, D.C.; Linda Hutchinson, New Mexico Film Commission, Santa Fe; Brandy Bell, Information Specialist, Western States Arts Federation, Denver; Delores Richards, Executive Director, and Mesa Broek, Co-coordinator of the Living Arts Program, Bolinas Museum, Bolinas, California; David McFadden,

Curator, Harwood Museum, Taos; Julia Selton, Director of Education, Mercer Museum, Doylestown, Pennsylvania; Kinshasha Conwill, Director, Studio Museum in Harlem, New York City; Ronald Sosinski, Director, Donahue/ Sosinski Art Gallery, New York City; Jan Peters and Kevin Wallace, Del Mano Gallery, Los Angeles; Julius Vitali, Open Space Gallery, Allentown, Pennsylvania; Rev. Forrest Church and Rev. Richard Leonard, All Souls Unitarian Universalist Church, New York City; Dr. Eugene Bay, Bryn Mawr Presbyterian Church, Bryn Mawr, Pennsylvania; Scott Anderson, Director, California Council of Churches, Sacramento; Trish Pugh-Jones, Director, Cathedral Heritage Foundation, Louisville; Sanra Rivera, Director, Omega Dance Center at the Cathedral Church of St. John the Divine, New York City; Rev. Douglas Monroe, Centennial United Methodist Church, Sacramento; Cana Bors Koefoed, Director, Center for the Sacred Arts, Kutztown, Pennsylvania; Rabbi Susan Oren, Associate Jewish Chaplain, Columbia University, New York City; Pastor Frank Manno, Fellowship Bible Church, Philadelphia; Rev. Margaret Shaffer, Fifth Avenue Presbyterian Church, New York City; Rev. Anastasia Gelhaar, Foundation for Spiritual Freedom, Berkeley; Calvin Gibson, Glide Memorial Methodist Church, San Francisco; Sharon Thomson, The Grail, Philadelphia; Carolina Rose, Executive Director, Interfaith Religious Liberty Association, Sacramento; Claire Ronzani, Codirector, Institute for Spiritual Worship, Jesuit School of Theology, Berkeley; Rev. Cynthia Crowner, Director, Kirkridge Retreat and Study Center, Bangor, Pennsylvania; Rev. Humberto Gomez, Director, Latino Ministry, Sacramento Archdiocese, Sacramento; Richard Walker, Love Fellowship Tabernacle, Brooklyn; Mario Sprouse, Director, The Actors' Workshop, Marble Collegiate Church, New York City; Sister Mary Ann Scofield, Executive Director, and Sister Marguerite Buchanan, Mercy Center, Burlingame, California; Joris Rossi, Director, Morning Star Center for Human Development and Spiritual Awakening, Bethlehem, Pennsylvania; Sally Palmer, Art Director, Pendel Hill Quaker Conference Center, Wallingford, Pennsylvania; Sophie Haviland, Director, The Theater Project, Saint Marks-in-the-Bowery, New York City; Pastor Don Fado, Saint Mark's United Methodist Church, Sacramento; Sister Lorette Piper, Duschene Center, Princeton, New Jersey; Jeff Gaines, Executive Director, Spiritual Directors International, San Francisco; Rabbi Joseph Melamed, Temple Beth Shalom, Sacramento; Dr. JoAnne Tucker, Union Theological Seminary, New York City; Asha Pauyl and Russell Pauyl, University of Creation Spirituality, Oakland; Robert Bangiola, Patron Services Coordinator, and Joe Melillo, Programming Director, Brooklyn

Academy of Music, Brooklyn; John Lakovski, Director, Creative Music Institute, Bethlehem, Pennsylvania; Betsy Morgan, Professor, Eastern College, St. Davids, Pennsylvania; Sister Janet Ruffing, Fordham University, New York City; Anthony Branker, Music Department, Princeton University, Princeton, New Jersey; Teresa Martin and Tammy Lawson, Schomberg Center for Research in Black Culture, New York City; David Cohen, Director, Center for Multicultural Studies, Queens College, Flushing, New York; Tracy Ells, Department of Psychiatry and Behavioral Sciences, University of Louisville, Louisville; Meredith Betz, Patient Services, American Cancer Society, Doylestown, Pennsylvania; Sylvia Kundrats, Keystone Quilters, Quakertown, Pennsylvania; Anthony Martinez, Director, Santa Fe Chamber of Commerce, Santa Fe; David Fry, Booking Agent, Godfrey Daniels Folk Club, Bethlehem, Pennsylvania; Greg Mount, Booking Agent, Keswick Theater, Glenside, Pennsylvania; Matt Choplick, Agency for the Performing Arts, New York City; Danielle Stennet, The Agency Group Limited, New York City; Ira Koslow, Peter Asher Management, Los Angeles; Nan Talese, Doubleday, New York City; Cynthia Parson, Bill Graham Management, San Francisco; Art Fegan, Gurtman and Martha Associates, Nashville; Barbara Dufty, Director, House Foundation for the Arts, New York City; Nancy Gabriel, Artists Division, IMG Artists, New York City; Sue Latham, Arts Management, Woodside, New York; Gilbert Medina, William Morris Agency, New York City; Laurie Jakobsen and Sara Haase, Shore Fire Media, Brooklyn; John Simpson and Tim Conder, Simpson, Berliner, Corcoran, and Rowe, Washington, D.C.; Matthew Nordhouse, Hanover Strings, Hanover, New Hampshire.

In addition, the following organizations, individuals, television and radio stations, periodicals, and newspapers were consulted for lists of artists, gallery and exhibition guides, price sheets, newsletters, clippings, and publicity packets: American Academy of the Sacred Arts, Philadelphia; American Association of Choreographers Guild, New York City; Art Directors and Artists Club of Sacramento; Bethlehem Palette Club, Bethlehem, Pennsylvania; Bill T. Jones/Arnie Zane Dance Company, New York City; Dance Coalition of New Mexico, Santa Fe; Dance Theater of Harlem, New York City; El Museo del Barrio, New York City; Forty Acres and a Mule, Brooklyn, New York; The Lama Foundation, Taos; New Hope Arts Commission, New Hope, Pennsylvania; New Institute of Liturgical Formation, New Brunswick, New Jersey; Sacred Arts Council, New York City; Santa Fe Arts Commission, Santa Fe; Spanish Colonial Arts Society, Santa Fe; Millicent Rodgers Museum, Taos; June

Kelly Gallery, New York City; Munson Gallery, Santa Fe; Paule Anglim Gallery, San Francisco; Sidney Mishkin Gallery, Baruch College, New York City; Waxlander Gallery, Santa Fe; Karen Wright Gallery, Santa Fe; Christians in the Visual Arts, Benecia, California; Birdland, New York City; Blue Note, New York City; Aaron Arrendell, Santa Fe; David Bennett, Birmingham, Michigan; Daniel Coyne, New York City; Michael Coyne, Norwich, Vermont; Eric Hansen, San Francisco; Harold Jovien, Hollywood; Ann Marie Wilkins, Cambridge, Massachusetts; KQED Public Television, San Francisco; WRTI Public Radio, Philadelphia; Bernadette Finnerty, Editor-in-Chief, *Crafts Report*, Washington, D.C.; Paulette Pitner, *Evolving Times*, Sacramento; Susan Taylor, *New Age Vintage West; Common Boundary*, Bethesda, Maryland; *Dance Magazine*, New York City; *Seven Arts Magazine*, Philadelphia; *Bergen Record*, Bergen, New Jersey; *Cleveland Plain Dealer*, Cleveland; *Intelligencer and Record*, Doylestown, Pennsylvania; *Morning Call*, Allentown, Pennsylvania; *Sacramento Bee*, Sacramento; *Santa Fe New Mexican*, Santa Fe; *Tampa Bay Tribune*, Tampa Bay.

NOTES

Introduction

1. David Ellsworth's art can be found in the permanent collections of the Philadelphia Art Museum, the High Museum of Art in Atlanta, the American Craft Museum in New York City, the Museum of Fine Arts in Boston, the National Museum of American Art in Washington, D.C., and the Musée des Arts Decoratif in Paris. He has been the recipient of numerous awards and honors, including having his work displayed at the White House and serving as president of the American Association of Woodturners.

2. Myra Yellin Outwater, "A Turn for the Better: Wood Sculptor No Longer Going against the Grain," *Morning Call* (June 4, 1995); Rick Mastelli, "Pot Dancing," *American Woodturner Magazine* (March 1995), 6. See also Gussie Fauntleroy, "The Subject Is Wood," *Santa Fe New Mexican* (September 15, 1995); and Marian Burros, "Command Performance," *House Beautiful* (May 1994), 92–94.

3. Drawing on publications and archival sources, the spirituality of some artists' and writers' work is examined in Roger Lipsey's *An Art of Our Own: The Spiritual in Twentieth Century Art* (Boston: Shambala, 1997); *Art, Creativity, and the Sacred*, edited by Diane Apostolos-Cappadona (New York: Continuum, 1995, rev. ed.); and Alfred Kazin's *God and the American Writer* (New York: Knopf, 1997).

4. On spiritual seeking, see my book *After Heaven: Spirituality in America*

since the 1950s (Berkeley: University of California Press, 1998) and Wade Clark Roof's *Spiritual Marketplace: Baby Boomers and the Remaking of American Religion* (Princeton: Princeton University Press, 1999).

Chapter 1: Learning from Artists

1. Chinn's watercolors have appeared at exhibitions throughout northern California and in Minnesota, Iowa, Nebraska, Ohio, Texas, North Carolina, and New York. See Deirdre McGruder, "Art and Spirituality: Festival to Help People Get in Touch with Their Faith through Art, Music, Theater, and Dance," *Wilmington Morning Star* (January 10, 1997); Karen Gail Jostad, "Artist Chinn to Inaugurate United Seminary Program," *Minneapolis Star Tribune* (October 26, 1996).

2. Jennie Avila and Amy Torchia's music has gained attention throughout the Mid-Atlantic region, New England, and the Midwest. They have made three albums—*Change Is* (1993), *Live at Godfrey Daniels* (1994), *and Life Becomes Her* (1996)— and they receive invitations to do live performances at least five times a month. Many of their appearances are at cafes, coffeehouses, and bookstores, but they also perform at folk festivals and occasionally open for headliners at major concert halls. See their Web site (http://www.iuma.com/bands/Avila_Jennie_and_Torchia_Amy.html), as well as Jennifer Whitlock, "Give and Take Attitude Helps Folk Singers Excel," *Morning Call* (November 18, 1994), and Bruce Haring, "Where Downloadable Tunes Are Already Available," *USA Today* (October 7, 1997).

3. Christopher Reardon, "Like a Prayer," *Village Voice* (March 11, 1997), 88; see also Jack Anderson, "Dance Review," *New York Times* (October 7, 1997). James Gaines has toured extensively throughout the United States, Canada, Europe, Asia, and the Caribbean, and has performed with such artists as Whitney Houston, Max Roach, Ossie Davis, Olatunje Babtunde, and Cassandra Wilson. Reverend Youngblood is the dynamic orator and organizer who inspired Samuel G. Freeman's book *Upon This Rock: The Miracles of a Black Church* (New York: HarperCollins, 1994).

4. Charles W. Bell, "Amen, They're Dancing in the Aisles," *New York Daily News* (December 2, 1995).

5. Jon Davis, a poet who teaches English and creative writing at the Institute of American Indian Arts, has published *Dangerous Amusements: Poems* (New York: Persea Books, 1987) and *Scrimmage of Appetite* (Akron, Ohio: University of

Akron Press, 1995). He also co-founded and edits the journal *Counter-Measures*. See Ruth Lopez, "Book Notes," *Santa Fe New Mexican* (June 15, 1997), and Craig Smith, "Jon Davis' Voyage into a Realm of Unconscious Reading," *Santa Fe New Mexican* (September 29, 1995).

6. A few of the many other exhibitions include "Child Beloved," a collection of paintings focusing on physical and spiritual aspects of families and parenting, at the Visions Gallery in Albany, New York; "Spirituality," a study in the spiritual tensions between men and women, at the Creative City Gallery in New York City; "Ceremony of Spirit," an exhibition of contemporary Latino art, at the Boise Art Museum; and the Art-Positive exhibit, featuring spirituality in the work of artists with AIDS, at the Edith Baker Gallery in Dallas.

7. Susana Torruella Leval, "Introduction," *Reaffirming Spirituality* (New York: El Museo del Barrio, 1995), 6.

8. Virginia A. Hodgkinson and Murray S. Weitzman, *From Belief to Commitment: The Community Service Activities and Finances of Religious Congregations in the United States* (Washington, D.C.: Independent Sector, 1993), 33.

9. Linda Kent and Joanne Tucker, "Liturgical Dance: The Centuries-Old Partnership of Dance and Religion Remains Vital during This Holiday Season," *Dance Magazine* 70 (December 1996), 72–73.

10. Diane Winston, "The God Project: Students Explore Artistic Visions of the Spiritual," *Dallas Morning News* (June 28, 1997).

11. George H. Gallup, Jr., *Religion in America, 1996 Report* (Princeton, N.J.: Princeton Religion Research Center, 1996), 41. In 1995, 69 percent of the adult U.S. public said yes when asked, "Do you happen to be a member of a church or synagogue?" This figure has varied between a high of 76 percent in 1946 and a low of 65 percent in 1988 and 1990.

12. Mark Chaves, University of Arizona, personal communication.

13. Bureau of the Census, *Statistical Abstract of the United States, 1995–1996* (Washington, D.C.: Government Printing Office, 1995), Table 622.

14. Ibid., Table 649.

15. Virginia A. Hodgkinson and Murray S. Weitzman, *Giving and Volunteering in the United States, 1994* (Washington, D.C.: Independent Sector, 1994), Tables 1.5 and 1.6.

16. Davis, *Dangerous Amusements*, 6.

17. Nancy Chinn, "Doing Good Work," *Environment and Art Letter* (February 1997), 134.

18. Davis, *Scrimmage of Appetite*, 13 (this is a prose poem, without line breaks).

19. Ibid., 59–102.

20. These figures are based on my analysis of data from 404 artists, musicians, and authors who were included in the General Social Surveys conducted between 1972 and 1996 by the National Opinion Research Center at the University of Chicago. Of the 100 artists interviewed for the present study, 34 percent currently identified themselves with Protestant denominations, 23 percent as Catholics, 6 percent as Jews, 17 percent with other religions, and 19 percent as nonreligious.

21. "Public Participation in the Arts: 1982 and 1992," National Endowment for the Arts (October 25, 1993), Research Division Note No. 50.

22. General Social Surveys, 1974–1996, conducted by the National Opinion Research Center at the University of Chicago.

23. "Public Participation in the Arts."

24. National Cultural Alliance, *Importance of the Arts and Humanities to American Society* (Washington, D.C., 1993); this was a national survey of 1,059 respondents. For a summary, see Public Opinion Online (April 14, 1994).

25. *Newsweek Poll* (November 3, 1994), 1–2; survey conducted by Princeton Survey Research Associates.

26. Davis, *Scrimmage of Appetite*, 60.

Chapter 2: Driven to Explore

1. Wendy Ellsworth's work has been featured in national magazines and has been displayed in exhibits at the del Mano Gallery in Los Angeles, the Mendelson Gallery in Pittsburgh, the Stones Gallery in San Francisco, the Philadelphia Museum of Art, the Rochester Art Center, and the Katie Gingrass Gallery in Milwaukee. In addition to creating beadwork, she has written several books about beading and teaches classes at art centers and evening schools. For more on her work, see Donald Miller, "Art Glass Gallery to Open at Mendelson," *Pittsburgh Post-Gazette* (January 18, 1997); Myra Yellin Outwater, "The World on a String," *Morning Call* (April 28, 1996); and Joy Hakanson Colby, "Exhibits," *Detroit News* (May 1, 1997).

2. M. Scott Peck, *The Road Less Traveled: A New Psychology of Love, Traditional Values and Spiritual Growth* (New York: Simon and Schuster, 1980); Barbara Ann Brennan, *Hands of Light: A Guide to Healing Through the Human Energy Field* (New York: Doubleday, 1993).

3. In addition to Lauper, Agresta has taught such well-known contemporary singers as Annie Lennox, Jon Bon Jovi, Phoebe Snow, Carole King, the Hooters, the Fat Boys, Samantha Fox, Bob Seger, Connie Francis, Lisa Bonet, Rosie O'Donnell, Brooke Shields, and Kathleen Turner. See "'Diva' Is Annie Lennox's First Solo Album," *National Public Radio* (July 22, 1992), Morning Edition; "All-Star Vocal Teacher Has Taught Some of the Best," *CNN News* (May 4, 1992); and Jon Pareles, "The Return of Cyndi Lauper," *New York Times* (September 14, 1986).

4. Wade Clark Roof, *Generation of Seekers: The Spiritual Journeys of the Baby Boom Generation* (San Francisco: Harper San Francisco, 1993); Dean R. Hoge, Benton Johnson, and Donald A. Luidens, *Vanishing Boundaries: The Religion of Mainline Protestant Baby Boomers* (Louisville, Ky.: Westminster/John Knox, 1994).

5. McGovern is a professor at the University of the Arts in Philadelphia; his wood carvings bring in a decent income on the side. On McGovern's work, see Lawrence S. Cunningham, "Clay Vessels and Other Poems," *Commonweal* (May 3, 1996), 27.

6. Clark Sterling originated the part of Joel in the Broadway production of *Seven Brides for Seven Brothers* and has performed in the National Tour of *Les Misérables* and the world premieres of *Joan of Arc* and *The Prince and the Pauper*. See Robert Hurwitt, "Shepard Revival Leads Magic Season," *San Francisco Examiner* (April 15, 1997); Steven Winn, "'Oh, Kay!' Bubbles with Gershwin Tunes," *San Francisco Chronicle* (August 22, 1994); Michael Frym, "Joan of Arc," *Daily Variety* (March 2, 1994); Philip Brandes, "Theater Review," *Los Angeles Times* (February 17, 1994); Gerald Nachman, "Ambitious 'Prince,'" *San Francisco Chronicle* (August 3, 1993); Lourdes Livingston, "A Model Cast," *San Francisco Chronicle* (September 7, 1990).

7. Schaeffer's work had been highly critical of contemporary art; see, for example, Francis A. Schaeffer, *Escape from Reason* (Downers Grove, Ill.: Intervarsity Press, 1977) and *The Complete Works of Francis A. Schaeffer* (Chicago: Good News, 1985).

8. Frank Schaeffer temporarily devoted himself to promoting the arts within evangelical Christianity but turned eventually to writing, including two autobiographical novels: *Portofino* (New York: Berkley Publishing Group, 1996) and *Saving Grandma* (New York: Berkley Publishing Group, 1997).

9. Thirty-nine percent were currently divorced or separated, compared with 17 percent in the U.S. population. Sixty of the hundred had lived in more than

one different community while they were growing up, 25 had moved more than five times, and 14 had lived abroad.

Chapter 3: Making Sense of Oneself

1. Michele Zackheim, *Violette's Embrace* (New York: Riverbend Books, 1996), 198; see also Allen Lincoln, "Review of *Violette's Embrace*," *New York Times* (December 15, 1996); Ruth Lopez, "Michele Zackheim," *Santa Fe New Mexican* (September 1, 1996).

2. Zackheim, *Violette's Embrace*, 111.

3. Ibid., 207.

4. Ibid., 59.

5. Quoted in Nancy Doll and Patterson Sims, *Artists in Printmaking and Drawing* (Santa Fe: Western States Arts Federation, 1988), 39.

6. Cynthia West's work has been displayed at the Guadalupe Fine Art Gallery and the Museum of Fine Arts in Santa Fe, the Fuller Lodge Art Center, and the Kirsten Gallery in Seattle. She has also written several volumes of poetry; see her *For Beauty Way* (Santa Fe: Cynthia West, 1990) and *1000 Stone Buddhas* (Santa Fe: Cynthia West, 1993).

7. West, "Mother Pacific," in *For Beauty Way*, 11; also included in the interview with Cynthia West.

8. Warren Cooper is a graduate of the Germantown Friends Preparatory School in Philadelphia, studied composition at the Oberlin Conservatory of Music, and graduated from Oberlin College with a major in philosophy. He produced Verolga Nix's album *Holy* (Vee Jai Jee, 1996); he is also one of the vocalists featured in Men Out Loud's album *Sweet Enuf 2 Eat* (Mercury Records, 1996), and the lead vocalist on several of his own albums, including *Sweet Little Jesus Boy* (Sky Island Sound, 1994), *Doing Church . . . With Jazz* (Sky Island Sound, 1993), and *Victory* (Crown Jewel Productions, 1996).

9. See Sidney Ahlstrom, *A Religious History of the American People* (New Haven: Yale University Press, 1973), 1062–1064.

10. Zackheim, *Violette's Embrace*, 170.

11. The piece was exhibited at Yale University, the Cathedral Church of St. John the Divine in New York, the Museum of Fine Arts in Santa Fe, and the Scottsdale Center for the Arts, and is currently housed in a specially constructed building at the College of Santa Fe. See also Doll and Sims, *Artists in Printmak-*

ing and Drawing, 39; Tom Sharpe, "Tent Is More Than Art," *Albuquerque Journal* (October 1996).

12. Mary Beth Crocker, "In Search of Spirituality Beyond Religion: Women Make a Pilgrimage to the Rustic Loveland Retreat," *Cincinnati Enquirer* (April 3, 1994). The Grail includes approximately 2,000 members in twenty countries; although most are Catholic, the movement is ecumenical.

13. A. M. Weaver, "Berrisford Boothe: The Pondside Prints," in *Berrisford Boothe: Monotypes, the Pondside Prints* (Lehigh, Pa.: DuBois Gallery, Lehigh University, 1995), 2–4. Berrisford Boothe earned his MFA at the Maryland Institute College of Art and is a tenured member of the faculty of Lehigh University, where he teaches art and design. His work has been exhibited at the June Kelly Gallery in New York City, the Esther M. Klein Art Gallery and Fabric Workshop Gallery in Philadelphia, the Dell/Pryor Gallery in Detroit, and the Uumbaji Gallery in Cleveland, as well as at numerous galleries near his home in northeastern Pennsylvania.

14. Flo Wong's work has been displayed at the DeYoung Museum, the Richmond Art Center, the Oakland Museum, and the Brockman Gallery in California, and at exhibits in Texas, Nebraska, Kansas, Massachusetts, and New York. She describes her upbringing in Flo Oy Wong, "Identity Crisis: A Space to Make My Art," in *Art of the Americas: Identity Crisis,* ed. Timothy Anglin Burgard (San Francisco: DeYoung Museum, 1997), 9–11.

15. West, "Translates," unpublished poem.

16. T. S. Eliot, "Ash Wednesday" in *Collected Poems* (New York: Harcourt Brace, 1971), 65.

17. Ibid., 61.

Chapter 4: Art as Spiritual Practice

1. Ann Biddle trained at Kenyon College and at Columbia University, studied in Africa, and since 1989 has taught dance in New York City, where she also specializes in choreography. Her work has been performed at the Dance Theatre Workshop, the Merce Cunningham Studio, Context Studios, and the Harkness Dance Center, and at other venues in New York, Costa Rica, and Japan. She has choreographed performances in such motion pictures as *The Hudsucker Proxy, Six Degrees of Separation,* and *For Love or Money,* and she is co-director of the Dance Education Laboratory, a two-year certification program

that provides training in dance for teachers. Published reviews of Biddle's work include Anna Kisselgoff, "Novices and Veterans," *New York Times* (February 28, 1992); Christine Chen, "Removed Boundaries III," *Nassau Weekly* (February 16, 1995), 9; Tobi Tobias, "Track Work," *Village Voice* (May 9, 1995), 24; Gus Solomons, Jr., "American Dance Guild Presents," *Dance Magazine* (February 1996), 129.

2. Lydia Garcia's work is on permanent display at the Millicent Rogers Museum and the Act I Gallery in Taos and has been featured in exhibitions throughout the United States. Published descriptions of her work include Christina Salyers, "The Madonna," *Bristol Herald Courier* (November 21, 1996); Marilyn K. Reynolds, "Lydia Garcia," *Maclaren Markowitz Gallery Guide* (Boulder, Colo., 1996), 34; Stewart Oksenhorn, "Spirituality Dominates Floria's Folk-Art Show," *Aspen Times* (November 30, 1996); and Janet Tyson, "Images of Jesus," *Fort Worth Star-Telegram* (December 22, 1996).

3. In 1975 Paul Kim won the grand prize in the Young Musicians Competition of Southern California and a year later made his orchestral debut with the Hollywood Philharmonic Orchestra. He then studied at the Juilliard School of Music, the Manhattan School of Music, the Florence Academy, and New York University. He has performed with the New York Philharmonic under the direction of Zubin Mehta, at Carnegie Hall, and with other leading orchestras throughout the United States, Europe, and Asia.

4. Greg Wyatt's other major accomplishments include his seventeen-foot bronze monument *Soul of the Arts* at the Newington-Cropsey Foundation Museum and his twelve-foot monument *Life-Forces* at Lederle Laboratories in Pearl River, New York. He has also produced sculptures for such major corporations as Avon, J.C. Penney, and American Cyanamid, and his work has been exhibited at Harvard University, the Russell Senate Office Building, the National Arts Club, and the Metropolitan Museum of Art. Wyatt has received the Helen Foster Barnett Award of the National Academy of Sculptors and the United States Congress Citation Award. Reviews of his work include Gregory S. Krauss, "Art Exhibit Celebrating Liberty Opens at Dudley House," *Harvard Crimson* (April 5, 1997); Bruno Civitico, "Senate Russell Building Rotunda Exhibition," *American Arts Quarterly* (Summer 1995), 28.

5. Wassily Kandinsky, *Concerning the Spiritual in Art* (New York: Dover, 1977); Wassily Kandinsky, *Complete Writings on Art*, 2 vols., ed. Kenneth C. Lindsay and Peter Vergo (Boston: De Capo, 1984).

Chapter 5: The Circle of Life

1. Madeleine L'Engle, *A Wrinkle in Time* (New York: Farrar, Straus and Giroux, 1962). L'Engle has also received the Sequoyah Award, the Lewis Carroll Shelf Award, the Austrian State Literary Prize, the National Religious Book Award, and the American Book Award, and has been awarded nine honorary doctorates.

2. From her interview; also in Madeleine L'Engle, *The Irrational Season* (New York: Seabury, 1979), 27.

3. Richard Rodriguez, *Hunger of Memory: An Autobiography* (New York: Bantam, 1982), 80.

4. Ibid., 107–108.

5. Tony Kushner, *Angels in America: A Gay Fantasia on National Themes, Part One: Millennium Approaches; Part Two: Perestroika* (New York: Theater Communications Group, 1993, 1994). For reviews, see Kyle J. Scafide, "Angels in America," *Impact* (May 9–24, 1997), 1–5; Andrea Bernstein, "Tony Kushner: The Award-Winning Author of Angels in America Advises You to Trust Neither Art Nor Artists," *Mother Jones* (January 1995), 1–3. See also Tony Kushner, *A Bright Room Called Day* (New York: Theater Communications Group, 1994) and *Slavs!* (New York: Broadway Play Publishing, 1996).

6. From his interview; also in Tony Kushner, *Thinking about the Longstanding Problems of Virtue and Happiness: Essays, a Play, Two Poems, and a Prayer* (New York: Theater Communications Group, 1995), 223.

7. Mario Sprouse has composed more than a hundred songs, arranged more than five hundred songs for concerts and theater performances, and produced or co-produced more than twenty inspirational and jazz albums. His work has been performed by Carmen McRae, Gregory Hines, Phylicia Rashaad, and Cornell Dupree.

8. Kushner, *Thinking about the Longstanding Problems of Virtue and Happiness,* 220.

9. Ibid., 224.

Chapter 6: Body and Spirit

1. Leigh Murray, "Youth on Good Behavior Bond over Piss Christ Attack," *AAP Newsfeed* (December 8, 1997).

2. William H. Honan, "Congressional Wrath: Andres Serrano's Christ in Urine Picture Sparks Possible Fund Cutoff," *Chicago Tribune* (September 7, 1989).

3. Lucy Lippard, "Andres Serrano: The Spirit and the Letter," *Art in America* (April 1990), 238–245.

4. On his *Morgue* series, see also Robyn Bellospirito, "An Interview with Andres Serrano," *The Exhibitioner* (January–February 1996), 14–19.

5. Quoted in T. R. Deckman, "Disputed Artist Explains Works," *The Digital Collegian* (October 2, 1996), 1.

6. Michael Brenson writes: "It is possible to see Mr. Serrano's use of bodily fluids as pure provocation. But you can also believe that Mr. Serrano views them as a form of purification. The fluids make us look at the images harder and consider basic religious doctrine about matter and spirit" ("Andres Serrano: Provocation and Spirituality," *New York Times* [December 8, 1989]).

7. See Carla DeSola, *The Spirit Moves: Handbook of Dance and Prayer*, ed. Doug Adams (Richmond, Calif.: Sharing Company, 1977).

8. Quoted in "Meredith Monk," House Foundation for the Arts (New York, 1997). Meredith Monk's twelve albums include *Dolmen Music* (1991) and *Our Lady of Late: The Vanguard Tapes* (1986), both of which were honored with the German Critics Prize for Best Record of the Year. In addition to the prestigious MacArthur Foundation fellowship and the Scripps American Dance Festival Award, Monk has received three Obies (including an award for Sustained Achievement), two Guggenheim fellowships, two Villager awards, the National Music Theatre Award, two honorary doctorates, and numerous other awards.

9. Alan M. Kriegsman, "Magical 'Quarry' Paradox," *Washington Post* (March 5, 1986).

10. Barry Johnston's work has been shown in numerous galleries and exhibitions throughout the world. He has received the President's Award and the Catharine Lorillard Wolfe Award from the National Arts Club, the Leonard J. Meiselman Award from Allied Artists of America, the Lindsay Morris Memorial Prize from the National Sculpture Society, and the Gold Medal of Honor from Audubon Artists. In 1996 he was commissioned by the National Cathedral in Washington, D.C., to create a sculpture in honor of Archbishop Oscar Romero.

11. Steven Litt, "New Visions of Religious Art," *Cleveland Plain Dealer* (February 27, 1997). Since 1969, Nancy Azara's work has been featured in more than thirty one-woman exhibitions and in more than a hundred group exhibitions. She has received the Jessica Cosgrove Achievement Award from Finch

College, the Susan B. Anthony Award from the National Organization for Women, and the International Friends of Transformative Art Award.

12. See Mark 5:21–43.

13. Michael Feingold, "Digging Monk," *Village Voice* (May 28, 1985), 4.

Chapter 7: The One Earth

1. David Dunn teaches music technology for the College of Santa Fe's Contemporary Music Program and manages a firm called Independent Media Labs. His work has been supported by grants from the National Endowment for the Arts, the Japan Foundation, and commissions from the National Gallery of Victoria in Australia. He has written several books about his work as well as given lectures throughout Europe, Africa, Australia, and North America.

2. Pauline Oliveros has been honored by the Foundation for Contemporary Performance Award, the ASCAP Standard Award, a "Bessie," the Beethoven Prize, and the Gaudeamus Prize, and with fellowships from the National Endowment for the Arts and the Guggenheim Foundation.

3. Derek Fell, *The Impressionist Garden: Ideas and Inspiration from the Gardens and Paintings of the Impressionists* (New York: Random House, 1994), and *Secrets of Monet's Garden: Bringing the Beauty of Monet's Style to Your Own Garden* (New York: Friedman/Fairfax, 1997). Fell's work has also been featured in the *New York Times Magazine*, *Woman's Day*, and *Fine Gardening*, as well as on television, and he has lectured at museums and galleries throughout the world.

4. Trained in spatial arts at San Jose State University, Dawn E. Nakanishi teaches in the visual and performing arts division of Cabrillo College in Aptos, California, and operates a studio in Redwood City. Her installations have appeared at the Yerba Buena Garden in San Francisco, the Creative Arts Center in Sunnyvale, the Institute of Contemporary Art in San Jose, the Virginia Breier Gallery of Contemporary Craft in San Francisco, and many other locations throughout the United States. She received the Craftsperson of the Year Award in 1983 from the Oakland Museum, and in 1994 her *Interpretations of Christmas* was exhibited in the Blue Room of the White House.

5. Dawn E. Nakanishi, unpublished "Artist's Statement."

6. Dawn E. Nakanishi, unpublished statement for *Cycle: Voices Remembered* (1993).

7. Sara Novenson's work has appeared in exhibitions in New York City, Santa Fe, San Francisco, Boston, and Stockholm.

8. From the dustjacket of Greg Glazner's *From the Iron Chair: Poems* (New York: Norton, 1992); see also his *Walking Two Landscapes* (Pittsford, N.Y.: State Street Press, 1984) and *Singularity* (New York: Norton, 1996). His poetry and essays have also appeared in such journals and collections as the *New England Review*, *Southern Poetry Review*, *Poetry*, the *Boston Review*, the *Writer*, and the *Bloomsbury Review*. Glazner teaches creative writing at the College of Santa Fe.

9. "Walking Two Landscapes," in *From the Iron Chair*, 26 (this is a prose poem, without line breaks).

10. See Ludwig Wittgenstein, *Tractatus Logico-Philosophicus*, trans. D. F. Pears and B. F. McGuinnes (Atlantic Highlands, N.J.: Humanities Press, 1974), 71–74.

Chapter 8: Millennial Visions

1. Richard Foreman received the National Endowment for the Arts' Distinguished Artist Fellowship for Lifetime Achievement in Theater in 1990, the American Academy and Institute of Arts and Letters Award for Literature in 1992, an honorary doctorate from Brown University in 1993, a MacArthur Fellowship in 1995, and the Edwin Booth Award for Theatrical Achievement in 1996. He has directed more than fifty plays, three of which have received Obie awards as best play of the year, and written six books, including *Unbalancing Acts: Foundation for a Theater* (New York: Pantheon, 1992) and *No-Body* (New York: Overlook Press, 1997).

2. Foreman, *Unbalancing Acts*, 3–4.

3. Dorothy Rudolph also teaches art classes and seminars on spirituality for women.

4. Robert Mirabal's discography includes *Warrior Magician*, *Song Carrier*, *Land*, and *Mirabal*. He makes his own flutes, several of which have been displayed at the Smithsonian National Museum, and has received the New York Dance and Performer's "Bessie" for composition. For a collection of his writings, see *A Skeleton of a Bridge* (Taos, N.M.: Blinking Yellow Books, 1994).

5. Greg Glazner, *From the Iron Chair: Poems* (New York: Norton, 1992), 80.

6. Robert Garland is Principal Dancer and Resident Choreographer at the Dance Theater of Harlem and has performed with the Philadelphia Dance Company, the Alvin Ailey American Dance Theater, the Pennsylvania Ballet, and the Ballet Hispanico of New York.

7. Francis V. O'Connor, ed., *Jackson Pollock: Supplement Number One to a Catalogue Raisonné of Paintings, Drawings and Other Works* (London: British Museum Publications, 1995); Francis V. O'Connor, *Waves* (London: Edward Arnold, 1986).

8. Foreman, *Unbalancing Acts*, 261–262.

9. Theodore Roethke, *Collected Poems* (New York: Anchor, 1975). In "Why Countermeasures?" (*Countermeasures* 4 [1996]: 4, 29), Jon Davis comments: "The poem dwells in that range of irrational experience often associated with both visionaries and the insane. . . . What excited me when I discovered the poem and still excites me about it is the way it enacts a spiritual journey through madness toward an unstable calm."

10. Wallace Stevens, "The Sail of Ulysses," in *The Palm at the End of the Mind: Selected Poems and a Play*, ed. Holly Stevens (New York: Vintage, 1972), 390.

INDEX

Text: 10/15 Janson
Display: Gill Sans Display
Composition: BookMatters
Printing and binding: IBT